The Unbounded
Community

GARLAND REFERENCE LIBRARY OF THE HUMANITIES
VOLUME 1822

Photograph of Jaroslav Pelikan courtesy of Michael Marsland, Office of Public Affairs, Yale University.

The Unbounded Community
Papers in Christian Ecumenism in Honor of Jaroslav Pelikan

Edited by
William Caferro and Duncan G. Fisher

Garland Publishing, Inc.
New York and London
1996

Copyright © 1996 by William Caferro and Duncan G. Fisher

Library of Congress Cataloging-in-Publication Data

The unbounded community : papers in Christian ecumenism in honor of
 Jaroslav Pelikan / edited by William Caferro and Duncan G. Fisher.
 p. cm. — (Garland reference library of the humanities ; vol.
 1822)
 "This collection of essays, first presented at a conference at Beinecke Li-
 brary at Yale University in April, 1994."—Introd.
 Includes bibliographical references (p.).
 ISBN 0-8153-1596-1 (alk. paper)
 1. Christian union—History—Congresses. 2. Church—Unity—
 Congresses. 3. Church history—Congresses. I. Pelikan, Jaroslav Jan,
 1923–. II. Caferro, William. III. Fisher, Duncan G. IV. Series.
 BX6.5.U53 1996
 270—dc20 95-19418
 CIP

Cover photograph of Jaroslav Pelikan courtesy of Michael Marsland, Office of
Public Affairs, Yale University.

Printed on acid-free, 250-year-life paper
Manufactured in the United States of America

CONTENTS

Acknowledgments

The editors would like first and foremost to thank Robert Babcock, curator of the Beinecke Library, who provided both invaluable support and a venue for the conference. It was largely due to his efforts that the conference was so successful. We would also like to thank Rosalee Williams, who read through the manuscript for technical difficulties and helped perform the Augean task of getting the manuscript "camera ready."

In this regard, we would also like to thank Bobbi and Jason at Garland. And we would like to thank all the participants of the conference and Professor Pelikan himself: it is with admiration that we dedicate this book to him on his seventieth birthday.

Introduction

This collection of essays, first presented at a conference at the Beinecke Library at Yale University in April 1994, celebrates the variety and scale of Professor Jaroslav Pelikan's contributions to historical theology. The field is partly his own creation, and anyone who studies the intellectual genesis of Christendom in its cultural context owes something to this remarkable scholar. On the occasion of his seventieth birthday, and with the advent of his fiftieth year of teaching, we dozen former students were pleased to come together with contributions of our own.

The Unbounded Community means to show how many are the conversations across times and disciplines, and how broad and epistemologically borderless Christian scholarship is. It is surely an appropriate title to commemorate the work of a man whose own academic interests seem similarly boundless. Marcia Colish and William Caferro each offer a piece on Dante: she with respect to the "virtuous" pagan, he with respect to the "treacherous" Greek. Duncan Fisher and Valerie Hotchkiss both treat cloistered sensibilities: how English monks in the tenth century felt responsible for the outside world, and how southern German nuns in the fourteenth century conceptualized the religious development of women. Ann Matter addresses scriptural centrality and mediation in twelfth-century Bible glosses, while Milton Gatch discusses, through the story of Leander van Ess, how scriptural treatments function in Enlightenment Germany. Hilmar Pabel shows us Erasmus' pastoral sense of Christ the Prince of Peace, and William Babcock illustrates Bacon's picture of useful learning in formative Protestantism. As book-end works for our whole project, Patout Burns and Patrick Henry examine Christianity in crisis: how Cyprian means to keep the church together in Roman public hostility, and what Thomas More and Vaclav Havel show us about the unity of our own, post-modern church. Each essay corresponds to a piece of the vast scholarly mosaic laid out by Professor Pelikan over the course of his career.

Professor Pelikan observes, in an early chapter of his *Splendid Century,* Edward Gibbon's rationalist distinction between the pleasing task of the theologian and the more melancholy duty of the historian,

and alerts us to the starting point of his own work—and therefore per-
haps to some measure our own work. Surely every act of scholarship is
to extrapolate from corrupt earthly particulars to some sense of onto-
logical reality; surely when one scholar has written so many volumes
about history and theology, he can mean only to contradict scientific
coyness like Gibbon's at every turn.

Jaroslav Pelikan understands his own story through the pro-
cess of finding unity in disunity, and continuity in change, and each of
us who has studied with him does something like this. This is why we
came together in April of 1994, this is why we chose to do a conference
and *Festschrift* on Christian ecumenism, and this is probably why we
asked to study with him in the first place.

Bibliography of the Works of Jaroslav Pelikan

Compiled by Valerie R. Hotchkiss

1946

Theses

"The Bible of Kralice." B.D. thesis, Concordia Theological Seminary, 1946.

"Luther and the *Confessio Bohemica*." Ph.D. diss., University of Chicago, 1946.

Articles, Essays, Published Lectures

"Luther after Four Centuries." *The Cresset* 9/4 (1946): 14–18.

Reviews

Boehmer, Heinrich. *Road to Reformation*. Translated by John W. Doberstein and Theodore G. Tappert. Philadelphia: Muhlenberg Press, 1946. In *The Cresset* 10/1 (1946): 57–58.

Casey, Robert Pierce. *Religion in Russia*. New York: Harper and Brothers, 1946. In *The Cresset* 10/1 (1946): 52–53.

Fales, Walter. *Wisdom and Responsibility*. Princeton: Princeton UP, 1946. In *The Cresset* 10/2 (1946): 67.

Voices of History. Compiled by Nathan Ausubel. New York: Gramercy, 1946. In *The Cresset* 10/1 (1946): 62.

Zweig, Friderike. *Stefan Zweig*. Translated by Erna McArthur. New York: Thomas Y. Cromwell Co., 1946. In *The Cressett* 10/2 (1946): 47–48.

1947

Articles, Essays, Published Lectures

"The Consensus of Sandomierz." *Concordia Theological Monthly* 18 (1947): 825–37.

"Natural Theology in David Hollaz." *Concordia Theological Monthly* 18 (1947): 253–63.

"The Structure of Luther's Piety." *Una Sancta* 7 (1947): 12–20.

"The Spell of Saint Thomas." [Part 1]. *The Cresset* 10/8 (1947): 13–16.

Reviews

Pfeffermann, Hans. *Die Zusammenarbeit der Renaissancepäpste mit den Türken*. Winterthur: Mondial Verlag, 1946. In *Journal of Religion* 27 (1947): 303–04.

1948

Articles, Essays, Published Lectures

"Luther's Attitude toward John Hus." *Concordia Theological Monthly* 19 (1948): 747–63.

"The Spell of Saint Thomas." [Part 2]. *The Cresset* 11/1 (1948): 12–17.

1949

Articles, Essays, Published Lectures

"History as Law and Gospel." *The Cresset* 12/4 (1949): 12–17 and 12/5 (1949): 19–23.

"Luther's Endorsement of the *Confessio Bohemica*." *Concordia Theological Monthly* 20 (1949): 829–43.

"Luther's Negotiations with the Hussites." *Concordia Theological Monthly* 20 (1949): 496-517.

1950

Books

From Luther to Kierkegaard: A Study in the History of Theology. St. Louis: Concordia Publishing House, 1950; reprinted 1963.

Articles, Essays, Published Lectures

"Doctrine of Man in Lutheran Confessions." *Lutheran Quarterly* 2 (1950): 34-44.

"Form and Tradition in Worship: A Theological Interpretation." In *First Liturgical Institute, Valparaiso University*, 11–27. Valparaiso, IN: Valparaiso UP, 1950.

"The Marxist Heresy--A Theological Evaluation." *Religion in Life* 19/3 (1950): 356-66.

"The Origins of the Object-Subject Antithesis in Lutheran Dogmatics: A Study in Terminology." *Concordia Theological Monthly* 21 (1950): 94-104.

"Practical Politics." In *The Christian in Politics: Proceedings of the Institute of Politics*, edited by Alfred Looman and Albert Wehling, 9–34. Valparaiso, IN: Valparaiso UP, 1950.

"The Relation of Faith and Knowledge in the Lutheran Confessions." *Concordia Theological Monthly* 21 (1950): 321-31.

Reviews

Zwingli, Ulrich. *Zwingli-Hauptschriften*, v. 2, pt. 3 of *Der Theologe*. Edited by R. Pfister. In *Journal of Religion* 30 (1950): 140-41.

1951

Articles, Essays, Published Lectures

"Chalcedon after Fifteen Centuries." *Concordia Theological Monthly* 22 (1951): 926-36.

"Church and Church History in the Confessions." *Concordia Theological Monthly* 22 (1951): 305-20.

"The Temptation of the Church: A Study of Matthew 4:1-11." *Concordia Theological Monthly* 22 (1951): 251-59.

"Theology and Missions in Lutheran History." In *Proceedings of the Thirtieth Convention of the Atlantic District of the Lutheran Church, Missouri Synod*, 33–38. St. Louis: Concordia Publishing House, 1951.

Reviews

Nigg, Walter. *Das Buch der Ketzer*. Zürich: Artemis, 1949. In *Journal of Religion* 31 (1951): 284-85.

1952

Books

The Cross for Every Day: Sermons and Meditations for Lent. With Richard R. Caemmerer. St. Louis: Concordia Publishing House, 1952.

Articles, Essays, Published Lectures

"Amerikanisches Luthertum in dogmengeschichtlicher Sicht." *Evangelisch-Lutherische Kirchenzeitung* 14 (1952): 250–53.

"The Eschatology of Tertullian." *Church History* 21 (1952): 108-22.

"In memoriam: Johann Albrecht Bengel, June 24, 1687 to November 2, 1752." *Concordia Theological Monthly* 23 (1952): 785-96.

"Some Anti-Pelagian Echoes in Augustine's *City of God*." *Concordia Theological Monthly* 23 (1952): 448-52.

"A Survey of Historical Theology." Mimeographed syllabus, Concordia Theological Seminary Mimeo Co., 1952. [Basic outline of *The Christian Tradition*, twenty years before publication of volume 1.]

1953

Articles, Essays, Published Lectures

"Some Word Studies in the *Apology*." *Concordia Theological Monthly* 24 (1953): 580-96.

Reviews

Dillenberger, John. *God Hidden and Revealed: The*

Interpretation of Luther's Deus Absconditus and its Significance for Religious Thought. Philadelphia: Muhlenberg Press, 1953. In *Church History* 22 (1953): 343-44.

[World Council of Churches, Commission on Faith and Order]. *Intercommunion.* Edited by Donald Macpherson Baillie and John Marsh. London: SCM, 1951; New York: Harper, 1952. In *Lutheran Quarterly* 5 (1953): 222-23.

Audio/Visual Recordings

"Martin Luther." Motion picture produced by Lothar Wolff. Research and screenplay by Allan Stone, Lothar Wolff, Jaroslav Pelikan and Theodore Tappert. Lutheran Film Associates, 1953. Video release by Vision Video, Worcester, PA, 1989.

1954

Articles, Essays, Published Lectures

"Four Questions at Evanston." *The American Lutheran* 37/7 (1954): 6–9.

Reviews

Cairns, David Smith. *The Image of God in Man.* New York: Philosophical Library, 1953. In *Church History* 23 (1954): 93-94.

Hyma, Albert. *Renaissance to Reformation.* Grand Rapids: Eerdmans, 1951. In *Church History* 23 (1954): 192.

Kähler, Ernst. *Karlstadt und Augustin: Der Kommentar des Andreas Bodenstein von Karlstadt zu Augustins Schrift De spiritu et litera.* Halle: Max Niemeyer, 1952. In *Archiv für Reformationsgeschichte* 45 (1954): 268.

1955

Books

Fools for Christ: Essays on the True, the Good, and the Beautiful. Philadelphia: Muhlenberg Press, 1955.
English imprint entitled *Human Culture and the Holy: Essays on the True, the Good, and the Beautiful*. London: SCM, 1959.

Editions and Translations

Luther, Martin. *Luther's Works*. American Edition. St. Louis: Concordia Publishing House, 1955–69. General Editor for majority of volumes 1–30. [Individual volumes edited by Pelikan are listed for the year in which they appeared.]

Luther, Martin. *Selected Psalms I. Luther's Works*, 12. St. Louis: Concordia Publishing House, 1955. Translations of Psalms 8, 19, 26, and 51 by J. Pelikan.

Articles, Essays, Published Lectures

"Doctrine of Creation in Lutheran Confessional Theology." *Concordia Theological Monthly* 26 (1955): 569-79.

Reviews

Rupp, Ernest Gordon. *The Righteousness of God*. New York: Philosophical Library, 1953. In *Journal of Religion* 35 (1955): 179-80.

1956

Editions and Translations

Luther, Martin. *Sermon on the Mount (Sermons) and The Magnificat. Luther's Works*, 21. St. Louis: Concordia Publishing House, 1956. "Sermon on the Mount" translated by J. Pelikan.

Articles, Essays, Published Lectures

"Montanism and its Trinitarian Significance." *Church History* 25 (1956): 99–109.

"Tradition in Confessional Lutheranism." *Lutheran World* 3 (1956): 214–22.
Published in German as "Die Tradition im konfessionalen Luthertum." *Lutherische Rundschau* 6 (1956–57): 228–37.

Reviews

Mossner, Ernest C. *The Life of David Hume*. Austin: University of Texas Press, 1954. In *Journal of Religion* 36 (1956): 50-51.

<div align="center">1957</div>

Editions and Translations

Luther, Martin. *Selected Psalms II*. *Luther's Works*, 13. St. Louis: Concordia Publishing House, 1957.

Luther, Martin. *Sermons on the Gospel of St. John: Chapters 1–14*. *Luther's Works*, 22. St. Louis: Concordia Publishing House, 1957.

Articles, Essays, Published Lectures

"Luther's Doctrine of the Lord's Supper." In *Proceedings of the Thirtieth Convention of the English District of the Lutheran Church, Missouri Synod*, 12–33. St. Louis: Concordia Publishing House, 1957.

"Tyranny of Epistemology: Revelation in the History of Protestant Thought." *Encounter* 18 (1957): 53-56.

Reviews

Harbison, E. Harris. *The Christian Scholar in the Age of the Reformation*. New York: Charles Scribner's Sons, 1956. In *Journal of Religion* 37 (1957): 128.

Preus, Robert. *The Inspiration of Scripture: A Study of the Theology of the Seventeenth-Century Lutheran Dogmaticians*. Mankato, MN: Lutheran Synod Book Co., 1955. In *Church History* 26 (1957): 192-93.

Wentz, Abdel Ross. *Basic History of Lutheranism in America*. Philadelphia: Muhlenberg Press, 1955. In *Theology Today* 13 (1957): 558-59.

Audio/Visual Recordings

"Inter-Church Relationships." Sound recording of panel discussion at Third Assembly, Lutheran World Federation, Minneapolis, 21 Aug. 1957. Minneapolis: Donald F. Rossin Co., 1957.

1958

Books

More About Luther. Martin Luther Lectures, 2. With Regin Prenter and Herman A. Preus. Essay on "Luther and the Liturgy," 3–62. Decorah, IA: Luther College Press, 1958.

Editions and Translations

Luther, Martin. *Lectures on Genesis, Chapters 1-5. Luther's Works*, 1. St. Louis: Concordia Publishing House, 1958.

Luther, Martin. *Selected Psalms III. Luther's Works*, 14. St. Louis: Concordia Publishing House, 1958. Translations of "The Four Psalms of Comfort" by J. Pelikan.

Articles, Essays, Published Lectures

"Dogma" and "Dogmatics." In *A Handbook of Christian Theology: Definition Essays on Concepts and Movements of Thought in Contemporary Protestantism*, 80–85. New York: Meridian Books, 1958.

"Flying Is for the Birds." *The Cresset* 21/10 (1958): 6–9.

"Die Kirche nach Luthers Genesisvorlesung." In *Lutherforschung Heute*, edited by Vilmos Vajta, 102–10. Berlin: Lutherisches Verlagshaus, 1958.

"Luther on the Word of God." *The Minnesota Lutheran* 34/10 (1958): 16–25.

1959

Books

Luther the Expositor: Introduction to the Reformer's Exegetical Writings. Luther's Works, Companion volume. St. Louis: Concordia Publishing House, 1959.
Published in Japanese; Tokyo: Seibunsha, 1959.

The Riddle of Roman Catholicism: Its History, Its Beliefs, Its Future. Nashville: Abingdon Press, 1959; London: Hodder & Stoughton, 1960.

Editions and Translations

The Book of Concord: The Confession of the Evangelical Lutheran Church. Translated and edited by Theodore G. Tappert in collaboration with Jaroslav Pelikan, Robert H. Fischer, and Arthur C. Piepkorn. Philadelphia: Muhlenberg Press; St. Louis: Concordia, 1959; reissued 1967.

Luther, Martin. *Sermons on the Gospel of John, Chapters 6-8*.

Luther's Works, 23. St. Louis: Concordia Publishing House, 1959.

Articles, Essays, Published Lectures

"Ein deutscher lutherischer Theologe in Amerika: Paul Tillich und die dogmatische Tradition." In *Gott ist am Werk: Festschrift für Landesbischof D. Hanns Lilje zum sechzigsten Geburtstag*, 27–36. Hamburg: Furch-Verlag, 1959.

"Kerygma and Culture: An Inquiry into Schleiermacher's *Reden*." *Discourse: A Review of Liberal Arts* 2 (1959): 131–44.

"New Light from the Old World." *Christian Century* 76 (1959): 1182–83.

"Totalitarianism and Democracy: A Religious Analysis." In *God and Caesar: A Christian Approach to Social Ethics*, edited by Warren A. Quanbeck, 99–114. Minneapolis: Augsburg Publishing House, 1959.

Introductions and Forewords

Introduction to *Protestant Thought from Rousseau to Ritschl*, by Karl Barth. Translated by Brian Cozens. New York: Harper & Brothers, 1959.

1960

Editions and Translations

Luther, Martin. *Lectures on Deuteronomy*. *Luther's Works*, 9. St. Louis: Concordia Publishing House, 1960.

Luther, Martin. *Lectures on Genesis, Chapters 6-14*. *Luther's Works*, 2. St. Louis: Concordia Publishing House, 1960.

Articles, Essays, Published Lectures

"The Burden of our Separation." *Religion in Life* 29/2 (1960): 200-10.

"Catholics in America." *The New Republic* 142/12 (1960). [Issue devoted to account of symposium with John C. Bennett and Arthur Schlesinger, Jr.].

"Creation and Causality in the History of Christian Thought." *Pastoral Psychology* 10 (1960): 11-20. Also printed in *Issues in Evolution*, v. 3 of *Evolution after Darwin*, edited by Sol Tax and Charles Callender, 29-40. Chicago: University of Chicago Press, 1960. Also reprinted in *Southwestern Journal of Theology* 32 (1990): 10-16.

Reviews

Ambrosius Catharinus Politus, 1484-1553: Ein Theologe des Reformationszeitalters: Sein Leben und seine Schriften. Edited by Joseph Schweizer. Munster: Aschendorf, [n.d.]. In *Archiv für Reformationsgeschichte* 51/1 (1960): 114-15.

1961

Books

The Shape of Death: Life, Death, and Immortality in the Early Fathers. New York: Abingdon Press, 1961; London: Macmillan & Co., 1962; Westport, CT: Greenwood Press, 1978.

Editions and Translations

Luther, Martin. *Lectures on Genesis, Chapters 15-20. Luther's Works*, 3. St. Louis: Concordia Publishing House, 1961.

Luther, Martin. *Sermons on the Gospel of St John: Chapters 14-16. Luther's Works*, 24. St. Louis: Concordia Publishing House, 1961.

Articles, Essays, Published Lectures

"Cosmos and Creation: Science and Theology in Reformation

Thought." *Proceedings of the American Philosophical Society* 105 (1961): 463-69.

"Luther's Attitude toward Church and Councils." In *The Papal Council and the Gospel: Protestant Theologians Evaluate the Coming Vatican Council*, edited by Kristen E. Skydsgaard, 37-60. Minneapolis: Augsburg Publishing House, 1961.
Published in German as "Luthers Stellung zu den Kirchenkonzilien." In *Konzil und Evangelium*, edited by Kristen E. Skydsgaard, 40-62. Gottingen: Vandenhoeck & Ruprecht, 1962.

"Overcoming History by History." In *The Old and the New in the Church: Studies in Ministry and Worship of the World Council of Churches*, edited by G. W. H. Lampe and David M. Paton, 36-42. London: SCM Press, 1961; Minneapolis: Augsburg Publishing House, 1961.

Introductions and Forewords

Introduction to *The Mission and Expansion of Christianity in the First Three Centuries*, by Adolf von Harnack. Translated and edited by James Moffatt. New York: Harper & Brothers, Torchbook Edition, 1961.

Reviews

Cannon, William R. *History of Christianity in the Middle Ages: From the Fall of Rome to the Fall of Constantinople*. New York: Abingdon Press, 1960. In *Religion in Life* 30/4 (1961): 625-26.

1962

Books

The Light of the World: A Basic Image in Early Christian Thought. New York: Harper, 1962.

Articles, Essays, Published Lectures

"The American Church and the Church Universal." *The Atlantic* 210/2 (1962): 90-94.

"Bergson among the Theologians." In *The Bergsonian Heritage*, edited by Thomas Hanna, 54-73. New York: Columbia UP, 1962.

"The Christian as an Intellectual." *Christian Scholar* 45 (1962): 6-11.

"The Early Answer to the Question Concerning Jesus Christ: Bonhoeffer's *Christologie* of 1933." In *The Place of Bonhoeffer: Problems and Possibilities in His Thought*, edited by Martin E. Marty, 145-65. New York: Association Press, 1962.
Published in Korean by Han Kook Bai. Seoul: n.p., 1966.

"Fathers, Brethren, and Distant Relatives: The Family of Theological Discourse." *Concordia Theological Monthly* 33 (1962): 710-18.

"Issues That Divide Us: Protestant." In *Christians in Conversation*. Papers from a colloquium at Saint John's Abbey, Collegeville, Minnesota, 3-19. Westminster, MD.: Newman Press, 1962.

"Karl Barth in America." *Christian Century* 79 (1962): 451-52.

"The New English Bible: The New Testament." *Criterion* 1 (1962): 25-29.

"The Protestant Concept of the Church: An Ecumenical Consensus." In *Proceedings of the Seventeenth Annual Convention [of the Catholic Theological Society of America* (1962): 131-37.

"Religious Responsibility for the Social Order--A Protestant View." In *Religious Responsibility for the Social Order: A Symposium*

by Three Theologians (Jaroslav Pelikan, Gustav Weigel, and Emil L. Fackenheim). New York: National Conference of Christians and Jews, 1962.

"Theological Library and the Tradition of Christian Humanism." *Concordia Theological Monthly* 33 (1962): 719-23.

Introductions and Forewords

Foreword to *The Impact of American Religious Liberalism*, by Kenneth Cauthen. New York: Harper & Row, 1962.

Preface and additional bibliography to *Protestant Thought before Kant*, by A. C. McGiffert. New York: Harper & Brothers, 1962.

Foreword to *The Structure of Lutheranism: The Theology and Philosophy of Life of Lutheranism Especially in the Sixteenth and Seventeenth Centuries*, by Werner Elert. Translated by Walter A. Hansen. St. Louis: Concordia Publishing House, 1962.

1963

Books

From Luther to Kierkegaard: A Study in the History of Theology. 2d ed. St. Louis: Concordia Publishing House, 1963. Published in Japanese; Tokyo: Seibunsha, 1967.

The Lutheran Reformation. With Jerald C. Brauer. [Chicago: n.p., 1963]. Produced as a syllabus by the Commission on College and University Work of the National Lutheran Council.

Editions and Translations

Luther, Martin. *Lectures on Galatians, 1535, Chapters 1-4.*

Luther's Works, 26. Edited and translated by J. Pelikan. St. Louis: Concordia Publishing House, 1963.

Articles, Essays, Published Lectures

"American Lutheranism: Denomination or Confession?" *Christian Century* 80 (1963): 1608-10.

"The Functions of Theology." In *Theology in the Life of the Church*, edited by Robert Bertram, 3-21. Philadelphia: Fortress Press, 1963.

"History of Christian Thought Bookshelf." ["Building a Basic Theological Library," pt. 5.] *Christian Century* 80 (1963): 711-12.

"John Osborne's Luther." *Christianity and Crisis* 23 (1963): 228-29.

"That the Church May Be More Fully Catholic." *The Catholic World* 198/1185 (1963): 151-56.

"The Vocation of the Christian Apologist: A Study of Schleiermacher's *Reden*." In *Christianity and World Revolution*, edited by Edwin H. Rian, 173-89. New York: Harper & Row, 1963.

Reviews

Luther, Martin. *Luther: Lectures on Romans*, edited and translated by Wilhelm Pauck. Louisville: Westminster Press, 1961. In *Union Seminary Quarterly Review* 18 (1963): 173–75.

Introductions and Forewords

"The Basic Marian Idea." Introduction to *Mary, Archetype of the Church*, by Otto Semmelroth. New York: Sheed & Ward, 1963.

1964

Books

Obedient Rebels: Catholic Substance and Protestant Principle in Luther's Reformation. New York: Harper & Row, 1964; London: SCM Press, 1964.

Editions and Translations

Luther, Martin. *Lectures on Galatians, 1535, Chapters 5-6; 1519, Chapters 1-6. Luther's Works*, 27. St. Louis: Concordia Publishing House, 1964. 1535 edition translated by J. Pelikan.

Luther, Martin. *Lectures on Genesis, Chapters 21-25. Luther's Works*, 4. St. Louis: Concordia Publishing House, 1964.

Articles, Essays, Published Lectures

"American Lutheranism: Denomination or Confession." In *What's Ahead for the Churches*, edited by Kyle Haselden and Martin Marty, 187-95. New York: Sheed & Ward, 1964.

"In Defense of Research in Religious Studies at the Secular University." In *Religion and the University*, 1-19. York University Gerstein Lectures. Toronto: University of Toronto Press, 1964.

"Methodism's Contribution to America." In *History of American Methodism*, edited by Emory Stevens Bucke, v. 3, 596-614. Nashville: Abingdon Press, 1964.

"Mortality of God and the Immortality of Man in Gregory of Nyssa." In *Scope of Grace: Essays in Honor of Joseph Sittler*, edited by Philip J. Hefner, 79-97. Philadelphia: Fortress Press, 1964.

"A Scholar Strikes Back." *The Catholic World* 200/1197 (1964): 149-54.

"Thine Alabaster Cities Gleam--The Secularization of a Vision." *A.I.A. Journal* 42/2 (1964): 37-43.

Introductions and Forewords

Introduction to *Luther and Aquinas on Salvation*, by Stephen Pfürtner. New York: Sheed & Ward [1964/65].

1965

Books

The Christian Intellectual. Religious Perspectives Series, 14. New York: Harper & Row, 1965; London: William Collins, 1966.

The Finality of Jesus Christ in An Age of Universal History: A Dilemma of the Third Century. Ecumenical Studies in History, 3. London: Lutterworth, 1965; Richmond: John Knox Press [1965].

Editions and Translations

Luther, Martin. *Lectures on Genesis, Chapters 38-44. Luther's Works*, 7. St. Louis: Concordia Publishing House, 1965.

Articles, Essays, Published Lectures

"In memoriam: Paul Tillich." *The Cresset* 28/12 (1965): 24-25.

"*Justitia* as Justice and *Justitia* as Righteousness." In *Law and Theology Essays on the Professional Responsibility of the Christian Lawyer*, edited by Andrew J. Buehner, 87-98. St. Louis: Concordia Publishing House, 1965.

"Theologian and Thinker [Albert Schweitzer]." *Saturday Review* 48/39 (1965): 21–22.

"Tradition, Reformation and Development." *Christian Century* 82 (1965): 8-10.

Introductions and Forewords

Introduction to *History of the Reformation: A Conciliatory Assessment of Opposite Views*, by John P. Dolan. New York: Desclee de Brouwer, 1965.

Foreword to *The Promise and the Presence*, by Harry N. Huxhold. St. Louis: Concordia Publishing House, 1965.

1966

Editions and Translations

Luther, Martin. *Lectures on Genesis, Chapters 45-50. Luther's Works*, 8. St. Louis: Concordia Publishing House, 1966.

Makers of Modern Theology. Edited and with introductions by J. Pelikan. 5 volumes. New York: Harper & Row, 1966-68.

Articles, Essays, Published Lectures

"Constitution on the Sacred Liturgy--A Response." In *The Documents of Vatican II*, edited by Walter M. Abbott, 179-82. New York: America Press, 1966.

"An Essay on the Development of Christian Doctrine." *Church History* 35 (1966): 3–12.

"Paths to Dialogue." In *1966 World Book Year Book*. Chicago: Field Enterprises Educational Corp., 1966.

"Relevance: The Preoccupations of Theology." In *Jesus Christ Reforms His Church*. Proceedings of the Twenty-Sixth North American Liturgical Week, 30-38. Washington, DC: Liturgical Conference, 1966.

"The Renewal of the Seminary in an 'Age of the Layman.'" [Commencement address, Episcopal Divinity School, Cambridge, MA, 9 June 1966]. *Una Sancta* 23/3 (1966): 4-11.

"Response to Constitution of the Sacred Liturgy." In *The Documents of Vatican II*. New York: Herder & Herder; Associated Press, 1966.

"Tradition, Reformation, and Development." In *Frontline Theology*, edited by Dean Peerman, 101-7. Richmond: John Knox Press, 1966.

"Theology without God." In *Encyclopedia Britannica Year Book, 1966*. Chicago: Encyclopedia Britannica, 1966.

Introductions and Forewords

Introduction to *The Reformation: Causes and Consequences*, by John A. O'Brien. Rev. ed. Glen Rock, NJ: Paulist Press, 1966.

Audio/Visual Recordings

"Tolerance Is Not Enough." Sound recording produced by KUOM, University of Minnesota. Boulder, CO: University of Colorado, 1966.

1967

Editions and Translations

Chrysostom, John. *The Preaching of Chrysostom: Homilies on the Sermon on the Mount*. Edited, translated, and with introduction by J. Pelikan. Philadelphia: Fortress Press, 1967.

Luther, Martin. *The Catholic Epistles. Luther's Works*, 30. St. Louis: Concordia Publishing House, 1967.

Articles, Essays, Published Lectures

"Absolution"; "Agnosticism"; "Agnus Dei"; "Anointing"; "Atheism"; "Atonement"; "Baader, Franz Xavier von"; "Bampton, John"; "Baptism, Christian"; "Barclay, Robert"; "Baur, Ferdinand Christian"; "Bible"; "Bidding Prayer"; "Biddle, John"; "Burnet, Thomas"; "Butler, Joseph"; "Case, Shirley Jackson"; "Catechism"; "Chalice"; "Chapel"; "Charity"; "Christianity"; "Communion, Holy"; "Confirmation"; "Congregation"; "Creationism and Traducianism"; "Dogma"; "Ernesti, Johann August"; "Eucharist"; "Excommunication"; "Exegesis and Hermeneutics, Biblical"; "Faith"; "Frommel, Gaston"; "Gichtel, Johann Georg"; "Grace"; "Hengstenberg, Ernst Wilhelm"; "Hope"; "Idolatry"; "Inspiration"; "Jesus Christ"; "Mary"; "Monophysites"; "Mysticism"; "Predestination"; "Religion"; "Sacrament"; "Sins, Seven Deadly"; "Theology"; "Trinity". In *Encyclopedia Britannica*, 1967 edition.

"After the Monks--What? Luther's Reformation and Institutions of Missions, Welfare, and Education." *Springfielder* 31 (1967): 3-21.

"Confessions of Faith, Protestant." In *New Catholic Encyclopedia*, 1967 edition.

"Continuity and Order in Luther's View of Church and Ministry." In *Kirche, Mystik, Heiligung und das Natürliche bei Luther*, Vorträge des dritten Internationalen Kongresses für Lutherforschung, edited by Ivar Asheim, 143-55. Gottingen: Vandenhoeck & Ruprecht, 1967.

[Interview]. In *Theologians at Work*, by Patrick Granfield, 105–25. New York: Macmillan [1967].

"Luther's Defense of Infant Baptism." In *Luther for an Ecumenical Age*, edited by Carl S. Meyer, 200-18. St. Louis: Concordia Publishing House, 1967.

"Past of Belief: Reflections of a Historian of Doctrine." In *The Future of Belief Debate*, edited by Gregory Baum, 29-36. New York:

Herder & Herder, 1967.

"Theology of the Means of Grace." In *Accents in Luther's Theology*, edited by Heino O. Kadai, 124-47. St. Louis: Concordia Publishing House, 1967.

"Verius servamus canones: Church Law and Divine Law in the Apology of the Augsburg Confession." In *Studia Gratiana* 11 (1967), special issue, *Collectanea Stephan Kuttner*, edited by Alphons M. Stickler, v. 1, 367-88. Also published separately, Bonn: n.p., 1967.

Reviews

Dewart, Leslie. *The Future of Belief: Theism in a World Come of Age*. New York: Herder & Herder, 1966. In *Theological Studies* 28 (1967): 352-56.

1968

Books

Spirit versus Structure: Luther and the Institutions of the Church. New York: Harper & Row, 1968; London: William Collins, 1968.

Editions and Translations

Interpreters of Luther: Essays in Honor of Wilhelm Pauck. Edited by J. Pelikan. Philadelphia: Fortress, 1968.

Luther, Martin. *Lectures on Genesis, Chapters 26-30. Luther's Works*, 5. St. Louis: Concordia Publishing House, 1968.

Luther, Martin. *Lectures on Titus, Philemon, and Hebrews*. *Luther's Works*, 29. St. Louis: Concordia Publishing House, 1968. Titus and Philemon lectures translated by J. Pelikan.

Essays and Articles

"Adolf von Harnack on Luther" In *Interpreters of Luther: Essays in Honor of Wilhelm Pauck*, 253-74.

"After the Campus Turmoil: A Plea for Reform." *Panorama— Chicago Daily News*, 15 June 1968.

"Faculties Must Reassert Powers They Defaulted." *Los Angeles Times*, 16 June 1968.

"Jozef Miloslav Hurban: A Study in Historicism." In *Impact of the Church upon Its Culture: Essays in Divinity*, edited by Jerald C. Brauer, v. 2, 333-52. Chicago: University of Chicago Press, 1968.

"Renewal of Structure versus Renewal by the Spirit." In *Theology of Renewal, Proceedings of the Congress on the Theology of the Renewal of the Church*, edited by L. K. Shook, v. 2, 21-41. Montreal: Palm Publishers, 1968.
Published in French as "L'Esprit et les structures selon Luther, étude sur 'La Captivite babylonienne de l'Église'." In *La Theologie du Renouveau*, edited by Laurence K. Shook and Guy-M. Bertrand, v. 1, 357-74. Montreal: Éditions Fides, 1968.

"Wilhelm Pauck: A Tribute." In *Interpreters of Luther: Essays in Honor of Wilhelm Pauck*, 1-8.

Introductions and Forewords

Foreword to *The Church in the Churches*, by James O. McGovern. Washington, DC: Corpus Books, 1968.

Introduction to *The Church in the Modern World in the Words of Albert Cardinal Meyer*, edited by Michael P. Dineen. Waukesha, WI: Country Beautiful, 1968.

1969

Books

Development of Christian Doctrine: Some Historical
Prolegomena. New Haven: Yale UP, 1969.

Editions and Translations

Luther, Martin. *Lectures on Isaiah, Chapters 1-39*. *Luther's
Works*, 16. St. Louis: Concordia Publishing House, 1969.

Twentieth-Century Theology in the Making. 3 volumes. Edited
and with introductions by J. Pelikan. London: Fontana, 1969-70; New
York: Harper & Row, 1971. [English edition of selections from the 2nd
edition of *Die Religion in Geschichte und Gegenwart*.]

Articles, Essays, Published Lectures

"The Christian Religions." In *East Central Europe: A Guide to
Basic Publications*, edited by Paul L. Horecky, 329-33. Chicago:
University of Chicago Press, 1969.

"Theology and Change." In *Theology in the City of Man*, Saint
Louis University Sesquicentennial Symposium, 375-84. New York:
Cross Currents Corporation, 1969; reissued 1970.

Introductions and Forewords

Foreword to *The Anabaptists and the Czech Brethren in
Moravia 1526-1628*, by Jarold Knox Zeman. Paris: Mouton, 1969.

Foreword to *Christus Victor: An Historical Study of the Three
Main Types of the Idea of the Atonement*, by Gustaf Aulen. New York:
Macmillan Company, 1969.

1970

Editions and Translations

Luther, Martin. *Lectures on Genesis, Chapters 31-37. Luther's Works*, 6. St. Louis: Concordia Publishing House, 1970.

Articles, Essays, Published Lectures

"De-Judaization and Hellenization: The Ambiguities of Christian Identity." In *The Dynamic in Christian Thought*, edited by Joseph Papin, 81-124. Villanova: Villanova UP, 1970.

"*Didakhe* and *Diadokhe:* A Personal Tribute to Johannes Quasten." In *Kyriakon*, Festschrift Johannes Quasten, edited by Patrick Granfield and Josef A. Jungmann, v. 2, 917-20. Munster: Verlag Aschendorf, 1970.

"Eve or Mary." In *Women's Liberation and the Christian Church*. Graymoor/Garrison, NY: [n.p.], 1970. [From conference sponsored by the Graymoor Ecumenical Institute, 11-12 November 1970].

"Law and Dogma: Some Historical Interrelations." In *Proceedings of the Canon Law Society of America, 31st Annual Convention*, edited by T. Gumbleton, et al., 69-77. Washington, DC: Canon Law Society of America, Catholic University, 1970.

"Luther, Martin" and "Lutherans." In *World Book Encyclopedia*, 1970 edition.

"The Pope and the Jews." *New York Times*, 28 October 1970: 47. [Fifth anniversary of the Vatican II Declaration].

Audio/Visual Recordings

"Tradition and Authority in the History of Christian Doctrine." Sound recording of a lecture delivered at Princeton Theological Seminary on 20 April 1970. Princeton, NJ: Princeton Theological Seminary Speech Studios, 1970.

"Women in Christian Theology." Sound recording of lecture delivered at Princeton Theological Seminary. Princeton, NJ: Princeton Theological Seminary Speech Studios, 1970.

1971

Books

The Christian Tradition: A History of the Development of Doctrine; volume 1: *The Emergence of the Catholic Tradition (100-600)*. Chicago: University of Chicago Press, 1971.

Historical Theology: Continuity and Change in Christian Doctrine. New York: Corpus Books; London: Hutchinson, 1971.

Articles, Essays, Published Lectures

"Eve or Mary: A Test Case in the Development of Doctrine." *Christian Ministry* 2 (1971): 21-22.

"Historical Theology: A Presentation." *Criterion* 10 (1971): 26-27.

1972

Editions and Translations

Luther, Martin. *Notes on Ecclesiastes; Lectures on the Song of Solomon; Treatise on the Last Words of David. Luther's Works*, 15. Edited and translated by J. Pelikan. St. Louis: Concordia Publishing House, 1972.

Articles, Essays, Published Lectures

"Dukedom Large Enough: Reflections on Academic Administration." *Concordia Theological Monthly* 43 (1972): 297-302. [An address at the inauguration of Robert V. Schnabel as president of

Concordia College, Bronxville, NY, February 5, 1972].

Introductions and Forewords

Foreword to *Portrait of the Elder Brother: Jews and Judaism in Protestant Teaching Materials*, by Gerald S. Strober. New York: American Jewish Committee and National Conference of Christians and Jews, 1972.

1973

Editions and Translations

The Preaching of Augustine: Our Lord's Sermon on the Mount. Edited and with introduction by J. Pelikan. Translated by Francine Cardman. Philadelphia: Fortress, 1973.

Articles, Essays, Published Lectures

"'Council or Father or Scripture': The Concept of Authority in the Theology of Maximus Confessor." In *The Heritage of the Early Church: Essays in Honor of the Very Reverend Georges Vasilievich Florovsky*, edited by David Neiman and Margaret Schatkin, 277-88. *Orientalia Christiana Analecta*, 195. Rome: Pontificale Institutum Studiorum Orientalium, 1973.

"The Liberation Arts." *Liberal Education* 59 (1973): 292–97.

"*Puti Russkogo Bogoslova*: When Orthodoxy Comes West." In *The Heritage of the Early Church: Essays in Honor of the Very Reverend Georges Vasilievich Florovsky*, edited by David Neiman and Margaret Schatkin, 11-16. *Orientalia Christiana Analecta*, 195. Rome: Pontificale Institutum Studiorum Orientalium, 1973.

"Worship between Yesterday and Tomorrow." In *Worship: Good News in Action*, edited by Mandus A. Egge, 57-69. Minneapolis: Augsburg Publishing House, [1973]. Also printed in *Studia Liturgica* 9/4 (1973): 205-214.

Audio/Visual Recordings

"The Sermon on the Mount and Its Interpreters" [Chrysostom, Augustine, Luther]. 1973 Cole Lectures. [Three lectures: "The Lordship of Christ"; "The Meaning of Discipleship" ; "The Ethics of the Kingdom"]. Sound recordings made at Vanderbilt University Divinity School, 1973.

<div align="center">1974</div>

Books

The Christian Tradition: A History of the Development of Doctrine; volume 2: *The Spirit of Eastern Christendom (600-1700)*. University of Chicago Press, 1974.

Articles, Essays, Published Lectures

"Angel and Evangel [Rev 14:6-7]." *Concordia Theological Monthly* 45 (1974): 4-7.

"The Doctrine of *filioque* in Thomas Aquinas and its Patristic Antecedents: An Analysis of *Summa Theologiae*, Part I, Question 36." In *Saint Thomas Aquinas 1274-1974: Commemorative Studies*, edited by Armand A. Maurer, v. 1, 315-36. Toronto: Pontifical Institute of Mediaeval Studies, 1974.

"Luther Comes to the New World." In *Luther and the Dawn of the Modern Era: Papers for the Fourth International Congress for Luther Research*, edited by Heiko A. Oberman, 1-10. Leiden: E. J. Brill, 1974.

"Paul M. Bretscher, Christian Humanist." *The Cresset* 37/9 (1974): 4.

Reviews

"Hazelton's Pascal: A Review Article." *Andover Newton Quarterly* 15 (1974): 145-148.

1975

Articles, Essays, Published Lectures

"Continuity and Creativity." *Saint Vladimir's Theological Quarterly* 19/3 (1975): 1-7.

1976

Articles, Essays, Published Lectures

"A Decent Respect to the Opinions of Mankind." *Scholarly Publishing* 8 (1976): 11-16.

"Quality and Equality." *New York Times*, 29 March 1976: 29.

"The Research University and the Healing Professions." *Criterion*, Autumn 1976.

"The Ukrainian Catholic Church and Eastern Spirituality." In *The Ukrainian Catholic Church 1945-1975*, edited by Miroslav Labunka and Leonid Rudnytzky, 114-27. Philadelphia: St. Sophia Religious Association of Ukrainian Catholics, 1976.

"We Hold These Truths to be Self-Evident: Reformation, Revolution, and Reason." In *The Historical Context and Dynamic Future of Lutheran Higher Education*, edited by J. Victor Hahn, 8-17. Washington, DC: Lutheran Educational Conference of North America, 1976.

"What Gibbon Knew: Lessons in Imperialism." *Harper's* 253/1514 (1976): 13-18.

Reviews

Our Common History As Christians: Essays in Honor of Albert C. Outler. Edited by John Deschner, et al. London & New York: Oxford UP, 1975. In *Perkins Journal* 29 (1976): 39-41.

Audio/Visual Recordings

"Conditions of Christian Reconciliation." Sound recording. Kansas City, MO: National Catholic Reporter, 1976.

1977

Articles, Essays, Published Lectures

"Christianity," by H. H. Walsh, revised by Jaroslav Pelikan. In *A Reader's Guide to the Great Religions*, 2d rev. edition by Charles J. Adams, 345-406. New York: Macmillan Company and The Free Press, 1977.

1978

Books

The Christian Tradition: A History of the Development of Doctrine; volume 3: *The Growth of Medieval Theology (600-1300)*. University of Chicago Press, 1978.

Articles, Essays, Published Lectures

"Historical Reflections on the Fortieth Anniversary of Saint Vladimir's Seminary." Crestwood, N.Y.: Saint Vladimir's Seminary Press, 1978.

"*Imago Dei*: An Explication of *Summa Theologiae*, Part I, Question 93." In *Calgary Aquinas Studies*, edited by Anthony Parel,

27-48. Toronto: Pontifical Institute of Mediaeval Studies, 1978.

"Lex orandi: The Dogma of Prayer in Historical Perspective." In *Conference II: The People of God at Prayer*, edited by Colman J. Barry. Collegeville, MN: Institute for Spirituality, St. John's University [1978]. Also available as sound recording.

"The New Pope and the Old Schism." In *New York Times*, 8 November 1978: A27.

<div align="center">1979</div>

Articles, Essays, Published Lectures

"A First-Generation Anselmian, Guibert of Nogent." In *Continuity and Discontinuity in Church History: Essays Presented to George Huntston Williams*, edited by F. Forrester Church and Timothy George, 71-82. *Studies in the History of Christian Thought*, 19. Leiden: E. J. Brill, 1979.

"A Gentleman and a Scholar." *The Key Reporter* [Phi Beta Kappa] 45/2 (1979-80): 2-4.

"The Jewish-Christian Dialogue in Historical Perspective." *Bulletin of the American Academy of Arts and Sciences* 32/7 (1979): 18-30.

"Voices of the Church." In *Proceedings of the Thirty-Third Annual Convention [of the Catholic Theological Society of America]*, edited by Luke Salm, 1-12. The Bronx, NY: [n.p.], 1979.

"The Wisdom of Prospero." In *Minutes of the Ninety-fourth Meeting* [of the Association of Research Libraries], 67-72. Washington, DC: ARL, 1979.

<div align="center">1980</div>

Articles, Essays, Published Lectures

"Luther Comes to America." In *Encounters with Luther:*

Lectures, Discussions, and Sermons at the Martin Luther Colloquia 1970-1974, edited by Eric W. Gritsch, v. 1, 58-68. Gettysburg, PA: Institute for Luther Studies, 1980.

"The Research Library, an Outpost of Cultural Continuity." *Imprint of the Stanford Library Associates* 6/2 (1980): 5-10. [Address delivered at the dedication of the Green Library, Stanford University.]

"The Two Sees of Peter: Reflections on the Pace of Normative Self-definition East and West." In *The Shaping of Christianity in the Second and Third Centuries*, v. 1 of *Jewish and Christian Self-Definition*, edited by E. P. Sanders, 57-73. Philadelphia: Fortress Press; London: SCM Press, 1980.

Audio/Visual Recordings

"The Place of Luther's Reformation in the History of Christine Doctrine." Sound recording of lecture given at a conference at the Lutheran School of Theology, Chicago, 19-24 October 1980.

1981

Articles, Essays, Published Lectures

"Negative Theology and Positive Religion: A Study of Nicholas Cusanus *De pace fidei*." *Prudentia* supplementary number (1981): 65-78. [Aukland: University of Aukland, 1981].

"The 'Spiritual Sense' of Scripture: The Exegetical Basis for Saint Basil's Doctrine of the Holy Spirit." In *Basil of Caesarea: Christian, Humanist, Ascetic*, edited by Paul Jonathan Fedwick, v. 1, 337-60. Toronto: Pontifical Institute of Mediaeval Studies, 1981.

Introductions and Forewords

Foreword to *The Christian Trinity in History*, by Bertrand de

Margerie. Translated by Edmund J. Fortman. *Studies in Historical Theology*, v. 1. Still River, MA: Saint Bede's Publications, 1981.

1982

Articles, Essays, Published Lectures

"The Doctrine of the Image of God." In *The Common Christian Roots of the European Nations: An International Colloquium in the Vatican*, 1, 53-62. [Rome: Tipo. Poliglotta Vaticana, 1982]; Florence: Le Monnier, 1982.

"From Reformation Theology to Christian Humanism." *Lutheran Forum* 16/4 (1982): 11-15.

"The Place of Maximus Confessor in the History of Christian Thought." In *Maximus Confessor*, Actes du Symposium sur Maxime le Confesseur Fribourg, edited by Felix Heinze and Christoph Schoenborn, 387-402. Paradosis: Études de litterature et de théologie ancienne, no. 27. Fribourg: Éditions Universitaires Fribourg Suisse, 1982.

"Special Collections: A Key into the Language of America." *Books at Brown* [Friends of the Library of Brown University] 29-30 (1982-83): 1-10.

"The Two Cities: The Decline and Fall of Rome as Historical Paradigm." *Daedalus* 111/3 (1982): 85-92.

Introductions and Forewords

Introduction to *Martin Luther: An Illustrated Biography*, by Peter Manns. Translated by Michael Shaw. New York: Crossroad, 1982.

Foreword to *The Secular Mind: Transformations of Faith in Modern Europe: Essays Presented to Franklin L. Baumer*, edited by W. Warren Wagar. New York: Holmes & Meier, 1982.

Audio/Visual Recordings

"Darwin's Legacy." Recorded at the 18th Nobel Conference, Gustavus Adolphus College, 5-6 October 1982. St. Peter, MN: The College, 1982.

1983

Books

Scholarship and its Survival: Questions on the Idea of Graduate Education. Princeton: Carnegie Foundation for the Advancement of Teaching, 1983.

Articles, Essays, Published Lectures

"Darwin's Legacy." In *Darwin's Legacy: Nobel Conference XVIII, Gustavus Adolphus College*, edited by Charles L. Hamrum. San Francisco: Harper & Row, 1983.

"The Enduring Relevance of Martin Luther 500 Years after His Birth." *New York Times Magazine*, 18 September 1983, 42-45; 99-104.

Introductions and Forewords

Preface to *The Triads*, by Gregory Palamas. Edited by John Meyendorff. Translated by Nicholas Gendle. Classics of Western Spirituality. New York: Paulist Press, 1983.

1984

Books

The Christian Tradition: A History of the Development of Doctrine; volume 4: *Reformation of Church and Dogma (1300-1700)*. University of Chicago Press, 1984; reprinted in 1985 and 1989.

The Vindication of Tradition. Jefferson Lectures in the Humanities, 1983. New Haven: Yale UP, 1984; reprinted in 1986.

Articles, Essays, Published Lectures

"The Aesthetics of Scholarly Research: An Address for the Sesquicentennial of Tulane University." Delivered at a University convocation on Friday, September 21, 1984. New Orleans: Tulane University, 1984.

"Scholarship: A Sacred Vocation." *Scholarly Publishing: A Journal for Authors and Publishers* 16/1 (1984): 3-22.

"Some Uses of Apocalypse in the Magisterial Reformers." In *The Apocalypse in English Renaissance Thought and Literature: Patterns, Antecedents, and Repercussions*, edited by C. A. Patrides and Joseph Wittreich, 74-92. Ithaca, NY: Cornell UP, 1984; Manchester: Manchester UP, 1984.

Reviews

John Paul II, Pope, and Andre Frossard. *Be Not Afraid*. Translated by J. R. Foster. New York: St Martin's Press, 1984. In *New York Times Book Review* 89/17 (22 April 1984): 12.

Audio/Visual Recordings

"J. S. Bach, the Fifth Evangelist." Sound and video recording of the Women's Auxiliary Lecture delivered at Lutheran Theological Seminary, Philadelphia, 5 December 1984.

1985

Books

Comparative Work Ethics: Judeo-Christian, Islamic, and Eastern. With Joseph Mitsuo Kitagawa and Seyyed Hossein Nasr. Occasional Papers of the Council of Scholars, no. 4. Washington, Library of Congress, 1985.

Jesus Through the Centuries: His Place in the History of Culture. New Haven: Yale UP, 1985; New York: Perennial Library, 1987.
Published in Dutch by Kok Agora, 1988.
Published in German as *Jesus Christus: Erscheinungsbild und Wirkung in 2000 Jahren Kulturgeschichte*, translated by Cornelia Hermanns. Cologne: Benziger, 1986.
Published in French as *Jésus au fil de l'histoire: sa place dans l'histoire de la culture*, translated by Christine Malamoud. Paris: Hachette, 1989.
Published in Italian by Gius Laterza Figli, 1988.
Published in Japanese by Shinchi Shobo, 1991.
Published in Polish by Spoleczny Insytut Wydaw Zuak, 1993.
Published in Serbo-Croat by Graficki Zavod Hrvatske, 1992.
Published in Spanish as *Jesús a través de los siglos: su lugar en la historia de la cultura*. Barcelona: Herder, 1989.

Maria: Die Gestalt der Mutter Jesu in jüdischer und christlicher Sicht. With David Flusser and Justin Lang. Freiburg: Herder, 1985.
[English translation]. *Mary: Images of the Mother of Jesus in Jewish and Christian Perspective.* Philadelphia: Fortress Press, 1986.

Spirit of Medieval Theology. Etienne Gilson Series, 8. Toronto: Pontifical Institute of Mediaeval Studies, 1985.

Articles, Essays, Published Lectures

"Humanism: Two Definitions and Two Defenses." *Southern Humanities Review* 19 (1985): 193-202.

"Jesus, the Monk Who Rules the World." [Reprint from *Yale Review*, Spring 1985]. *Books and Religion* 13/7 (1985): 1-19.

"The Man Who Belongs to the World." [Excerpt from *Jesus through the Centuries*.] *Christian Century* 102 (1985): 827-831.

Introductions and Forewords

Introduction to *Maximus Confessor: Selected Writings*, edited by George Berthold. Classics of Western Spirituality. New York: Paulist Press, 1985.

Introduction to *Nature*, by Ralph Waldo Emerson [facsimile of first edition]. Boston: Beacon Press, 1985.

Foreword to and supplementary bibliography for *The Reformation of the Sixteenth Century*, by Roland Bainton. Boston: Beacon Press, 1985.

1986

Books

Bach among the Theologians. Philadelphia: Fortress Press, 1986. Published in Italian as *Bach teologo*. Piemme, 1994.

The Mystery of Continuity: Time and History, Memory and Eternity in theThought of Saint Augustine. Charlottesville: University of Virginia Press, 1986.

Scholarship Today: The Humanities and Social Sciences. With Jacques Barzum and John Hope Franklin. Three papers from a symposium sponsored by the Council of Scholars. Washington, DC: Library of Congress, 1986.

Articles, Essays, Published Lectures

"'Determinatio Ecclesiae' and/or 'communiter omnes doctores': On Locating Ockham within the Orthodox Dogmatic Tradition." *Franciscan Studies* 46 (1986): 24, 37-45.

"King Lear or Uncle Tom's Cabin?" *The Teaching of Values in Higher Education*, 9–18. Washington, DC: Woodrow Wilson International Center for Scholars, 1986.

Reviews

Maccoby, Hyam. *The Mythmaker: Paul and the Invention of Christianity*. San Francisco: Harper & Row, 1986; Weidenfeld & Nicolson [n.d.]. In *Commentary* 82/5 (1986): 76-78.

Introductions and Forewords

Foreword to *The Proper Distinction between Law and Gospel*, by C. F. W. Walther. St. Louis: Concordia Publishing House, 1986.

1987

Reviews

"Speak of the Devil." Review of Jeffrey B. Russell, *The Devil* (Cornell UP, 1977), *Satan: The Early Christian Tradition* (Cornell UP, 1981); *Lucifer: The Devil in the Middle Ages* (Cornell UP, 1984); and *Mephistopheles: The Devil in the Modern World* (Cornell UP, 1986). In *Commentary* 83 (1987): 63-66.

Introductions and Forewords

"The Odyssey of Dionysian Spirituality." Introduction to *Pseudo-Dionysius: The Complete Works*, edited by Paul Rorem. Classics of Western Spirituality. New York: Paulist Press, 1987.

1988

Books

The Excellent Empire: The Fall of Rome and the Triumph of the Church. Rauschenbusch Lectures, new series, 1. San Francisco: Harper & Row, 1988; reprinted 1990.

The Melody of Theology: A Philosophical Dictionary. Cambridge, MA: Harvard UP, 1988.

Paths to Intellectual Reunification of East and West Europe: A Historical Typology. [Princeton, NJ]: International Research and Exchanges Board, 1988.

Articles, Essays, Published Lectures

"Sobornost and National Particularity in Historical Perspective." *Cross Currents* 7 (1988): 7-17.

"Writing as a Means of Grace." In *Spiritual Quests*, edited by William Zinsser, 85-101. Boston: Houghton Mifflin, 1988.

Introductions and Forewords

Foreword to *A Century of Church History: The Legacy of Philip Schaff*, edited by Henry W. Bowden. Carbondale: Southern Illinois UP, 1988.

1989

Books

The Christian Tradition: A History of the Development of Doctrine; volume 5: *Christian Doctrine and Modern Culture (since 1700)*. Chicago: University of Chicago Press, 1989.

Articles, Essays, Published Lectures

"How to Carry On Your Private Education in Public--And Get Paid for It." An address delivered on the occasion of the Second Annual Authors' Dinner at the University of Alabama, 17 February 1988. [Tuscaloosa]: University of Alabama Press, 1989.

"Philosophy as a Woman: The Allegorical Vision of Boethius." Kathryn Fraser Mackay Lecture, 1989. Canton, NY: St. Lawrence University, 1990.

"Russia's Greatest Heretic [L. N. Tolstoy]." Archbishop Gerety Lectures 1988–89, 1–12. South Orange, NJ: School of Theology, Seton Hall University, 1989.

Reviews

Norwich, John J. *Byzantium: The Early Centuries*. New York: Viking [1989]. In *Commentary* 88 (1989): 58-60.

Introductions and Forewords

"The Church between East and West: The Context of Sheptyts'kyi's Thought." Introduction to *Morality and Reality: The Life and Times of Andrei Sheptyts'kyi*, edited by Paul Robert Magocisi. Edmonton: Canadian Institute of Ukrainian Studies, University of Alberta, 1989.

"Jefferson and His Contemporaries." Afterword to *The Jefferson Bible: The Life and Morals of Jesus of Nazareth*, by Thomas Jefferson. Boston: Beacon Press, 1989.

Foreword to *Martin Luther's Basic Theological Writings*, edited by Timothy F. Lull. Minneapolis: Fortress Press, 1989.

<div align="center">1990</div>

Books

> *Confessor between East and West: A Portrait of Ukrainian Cardinal Josyf Slipyj*. Grand Rapids: Eerdmans, 1990.

> *Eternal Feminines: Three Theological Allegories in Dante's Paradiso*. New Brunswick, NJ: Rutgers UP, 1990.

> *Imago Dei: The Byzantine Apologia for Icons*. Bollinger Series, 35, 36. New Haven: Yale UP; Princeton UP, 1990.

> *The World Treasury of Modern Religious Thought*. Boston: Little, Brown, 1990.

Articles, Essays, Published Lectures

> "Canonica regula: The Trinitarian Hermeneutics of Augustine." In *Collectanea Augustiniana*, I, *Augustine: "Second Founder of the Faith,"* edited by Joseph C. Schnaubel and Frederick Van Fleteren, 329-343. New York, Bern: Lang, 1990. Also in *Proceedings of the Patristic, Mediaeval and Renaissance Conference* 12/13 (1987–88): 17–30.

> "Fundamentalism and/or Orthodoxy? Toward an Understanding of the Fundamentalist Phenomenon." In *The Fundamentalist Phenomenon: A View from Within; A Response from Without*, edited by Norman J. Cohen, 3-21. Grand Rapids, MI: W. B. Eerdmans, 1990; reprinted in 1991.

> "Judaism and the Humanities: Liberation from History." In *The State of Jewish Studies*, edited by Shaye J. D. Cohen and Edward L. Greenstein, 255-267. Detroit: Wayne State UP, 1990.

> "Newman and the Fathers: The Vindication of Tradition." In *Studia Patristica*, 18/4, edited by E. Livingstone, 379-390.

"Orthodox Theology in the West: The Reformation." In *The Legacy of St. Vladimir*, edited by John Breck, et al., 159-165. Crestwood, NY: St. Vladimir's Seminary Press, 1990.

"Whose Bible? Second Thoughts on Listening to *Messiah*." Program notes for December 1990 issue of *Stagebill* for the Musica Sacra performance of Handel's *Messiah*.

Introductions and Forewords

Introduction to *The Varieties of Religious Experience*, by William James. New York: Library of America, 1990.

1991

Books

Jesus, Not Caesar: The Religious World View of Thomas Garrigue Masaryk and the Spiritual Foundations of Czech and Slovak Culture. Westminster Tanner-McMurrin Lectures on the History and Philosophy of Religion at Westminster College, 3. Salt Lake City: Westminster College of Salt Lake City, 1991.

Articles, Essays, Published Lectures

"Christian Mysticism East and West." *James I. McCord Memorial Lectures, Fall 1990*, 3–15. Princeton: Center of Theological Inquiry, 1991.

Introductions and Forewords

Foreword to *Life of Christ*, by Giuseppe Ricciotti. *Library of*

Great Lives. Norwalk, CT: The Easton Press, 1991.

<center>1992</center>

Books

The Idea of the University: A Reexamination. New Haven: Yale UP, 1992.

 On Searching the Scriptures, Your Own or Someone Else's. Companion guide to *Sacred Writings* series. New York: History Book Club, 1992.

Articles, Essays, Published Lectures

 "The University's Secret Weapon." Address to the Charter Meeting of Friends of Yale University Press, 10 September 1992. New Haven: Friends of Yale University Press, 1992.

Editions and Translations

 Sacred Writings. Edited by J. Pelikan. 6 volumes. New York: History Book Club, 1992.

Articles, Essays, Published Lectures

 "John Meyendorff, 1926-1992" [obituary]. *Christian Century* 109 (1992): 837.

 "Unity and Reconciliation: The Historical Dialectic." [Address to General Board of National Council of Churches]. *Mid-Stream* 31 (1992): 123-128.

Reviews

 The Anchor Bible Dictionary, 6 volumes. Edited by David Noel Freedman. New York: Doubleday, 1992. In *New York Times Book Review* 97 (20 December 1992): 3.

1993

Books

Christianity and Classical Culture: The Metamorphosis of
Natural Theology in the Christian Encounter with Hellenism. New
Haven: Yale UP, 1993.

Audio/Visual Recordings

"'And alas, Theology too': Goethe's *Faust* and the Christian
Tradition." [Three lectures: "The Pantheistic Scientist"; "The
Polytheistic Artist"; "The Monotheistic Moralist"]. Sound recording (3
cassettes) of the Willson Lectures presented at Southwestern
University, Georgetown, TX, 30-31 March 1993.

"Public Poet, Public Critic." Part of *Soundings* (radio program)
on "Education and Culture: East and West." With Nagayo Honma.
Programs nos. 643-44. Research Triangle Park, NC: National
Humanities Center, 1993.

1994

Books

La tradition chrétienne. 5 volumes. French translation of *The
Christian Tradition*. Paris: Presses Universitaires de France, 1994.

Articles, Essays, Published Lectures

"The Individual's Search for Truth--and Its Limitations." In
Individualism and Social Responsibility, edited by W. Lawson Taitte.
Andrew R. Cecil Lectures on Moral Values in a Free Society, 15.
Dallas: University of Texas at Dallas, 1994.

"Orthodox Christianity in the World and in America." In
World Religions in America: An Introduction, edited by Jacob Neusner,

131-50. Louisville: Westminster/John Knox Press, 1994.

Audio/Visual Recordings

Christians of the East. [Video recording]. Yale Great Teachers Series. Florence, KY: Brenzel Publishing in cooperation with the Association of Yale Alumni, 1994.

1995

Books

Faust the Theologian. New Haven: Yale UP, 1995.

THE UNBOUNDED
COMMUNITY

The Holiness of the Churches

J. Patout Burns

Introduction

The correspondence and treatises of Cyprian, bishop of Carthage and leader of the African church for about a decade beginning in 249, provide an extraordinary opportunity to examine the inner workings of the Christian movement at a crisis point. In fact, we have more information about this community under the impact of the Decian Edict, which required participation in the state cult, than about any contemporary social group. My topic is the holiness of this church, which encompassed its fidelity to God and Christ, its anticipation of the heavenly kingdom, the efficacy of its rituals, and in particular its separation from the various practices of the Roman state cult.[1]

We have inherited a straightforward understanding of Cyprian's views on the holiness of the church. Under pressure to relax standards in response to widespread apostasy during the Decian persecution, Cyprian is said to have narrowed the earlier ideal of purity and holiness from the whole communion to the individual bishop whose uprightness would guarantee the sanctity and efficacy of the sacraments in each local church.

Thus, Cyprian's ecclesiology has been viewed as a compromise between the rigorism of Novatian and the laxism of his local rival, Fortunatus. In this way, Cyprian set the stage, perhaps inadvertently, for a prolonged conflict among his heirs, who managed to discover and exploit the incoherence characteristic of moderate positions. As will certainly be expected, I intend to challenge this received interpretation and to complicate it a bit—by analyzing the problems Cyprian faced and the solutions he adopted in terms of the social organization of the North African church. I want to contrast two related communions, the local church and the college of bishops, in an attempt to account for the different standards of holiness which Cyprian applied to them. I suggest that the difference can be correlated with a contrast between an internal differentiation of roles or hierarchial structure in the local church and the egalitarianism of the college of bishops.[2]

Holiness under Assault

A touchstone of the church's holiness in the third century seems to have been its rejection of the demonic idolatry of the Roman civic cult and indeed of every competing form of religious observance. Christian religious separatism was vulnerable, however, because the faithful were dependent upon the Roman economy. They owned property and conducted their financial affairs according to the imperial legal system.[3] As a consequence, not only were they sensitive to threats of confiscation in extraordinary times of persecution but they faced disabilities in ordinary business. In making contracts, for example, they had to give and receive oaths which invoked the traditional deities. Over time, various stratagems had been developed by which the Christians might appear to fulfill these legal requirements without actually participating in the forbidden cult.[4] The religious status of these procedures, as the persecution proved, was ambiguous.

The Decian persecution struck at the point of vulnerability created by Christians' dependence on the Roman economy. While the emperor's edict does not seem to have forbidden Christianity or any

other religious practice, it did require a formal participation in the Roman cult. The initial penalty for refusal to comply was exile and forfeiture of property.[5] Most Christians in Carthage voluntarily obeyed the edict, either performing the required sacrifice or resorting to customary subterfuges to acquire a certificate attesting to their compliance. Other Christians withstood the interrogation, suffered confiscation of goods and were sent into exile. When the imperial government introduced torture, imprisonment and deprivation some confessors died as martyrs.[6]

Those Christians who had been declared excommunicate because of their compliance with the imperial edict then sought help from the imprisoned confessors, begging that when they came before Christ to receive their crowns, the martyrs among them would intercede to win forgiveness of their fellows' sin of idolatry.[7] The confessors were happy to be of service and even commissioned surviving colleagues to act as their agents in providing letters of peace to the lapsed.[8] Some presbyters welcomed these apostate Christians back into communion immediately upon their sponsoring martyr's death, without further evidence of repentance.[9] Eventually, the Carthaginian confessors declared a general amnesty and directed the bishops to readmit all apostates.[10]

The failed Christians and their advocates among confessors and clergy presented a distinct threat and challenge for the church. In one way or another, they had refused to uphold their baptismal oath of loyalty to Christ and failed to maintain their immunity from contamination by idolatry. The apostates approached the Lord's table still reeking of meat and incense from demonic rituals.[11] To admit them to communion after they had publicly denied Christ and repudiated the church would destroy the identity of Christians as a distinct social group and ruin their eucharist as a symbol and anticipation of the heavenly banquet.[12]

Yet the bishops could not simply reject the apostates, could not cast them out into exterior darkness with no hope of salvation. The sinners claimed the advocacy of martyrs who were even then reigning with Christ and would assist him in judging the world and the church.[13] Some, moreover, had apparently stilled God's anger and won Christ's favor by prayers and works of repentance after their initial failure. In a second trial, they were found restored and rearmed; they won the crown of martyrdom.[14] Thus, Cyprian and his colleagues were faced with the

challenge of protecting the church's holiness without denying all hope of salvation to the fall.

The Holiness of the Local Church

During the persecution, Cyprian had attempted to rule his church from a self-imposed exile by the use of letters and emissaries. His surviving correspondence and the orations he delivered to the church upon his return provide an extraordinary record of the development of the crisis and its gradual solution. Cyprian assured his people that God remained firmly in control of world events and of the church's destiny in particular. The persecution had been a chastisement through which God intended to correct Christians who had become too attached to their property, too entangled in the affairs of the empire, too divided and contentious as a community. The appropriate response, therefore, was repentance which displayed their commitment to Christ and to the church. [15] He particularly recommended alms-giving since it would reduce the attachment to property which had proven a stumbling block for many and would reestablish mutual sharing and interdependence in the community. [16] Still more important was a repudiation of the authority of the martyrs who had commanded immediate admission to communion without demanding formal and public repentance by the sinners. [17] To satisfy God and the church, the lapsed must declare their allegiance by publicly mourning their failure and display their loyalty to the bishops by following the stages of the ritual of reconciliation. [18]

To deal with the lapsed who sought readmission to communion, Cyprian and his African colleagues adopted a series of policies which protected the holiness of the church from contagion by using different categories of membership. In their judgment, refusing the fallen any hope of recovering the peace of communion would have undercut the church's credibility as the necessary entryway to the Kingdom of Heaven and denied the efficacy of its intercession. Penitents would be driven to return to the pleasures of life in the empire or to seek the advocacy of the martyrs in the laxist schism. [19] Meeting shortly after the end of the persecution, therefore, they agreed to reconcile all the certified who had submitted to penance after failing.

Christians tainted by idolatrous sacrifice, however, were to be granted peace only at the last moment of their lives, so that the church might present and commend them to Christ himself for judgment.[20] To accommodate the lapsed, therefore, the bishops transformed the penitential state, which had heretofore been assigned a definite term, into a permanent form of church membership.[21]

Two years later, in anticipation of a renewal of persecution, the bishops decided to offer peace to all who had persevered as penitents so that they might march out to battle in the church's army.[22] Again the bishops protected the credibility of their boundaries and offices. If the penitents were forced to defend their faith outside the camp of Christ, a successful confession might show that the church's support was unnecessary for victory. Defeat and failure, however, would expose the bishops to charges of being false shepherds who neglected to feed and care for the flock of Christ in time of trouble.[23]

Even upon their admission, however, penitents were placed in a restricted class in order to protect the holiness of the church. None of them was allowed to retain or receive positions of leadership, to be ordained or serve as clergy.[24] The reconciled lapsed remained in a marginal status within the communion which corresponded to the ambiguity of their own relationship to Christ, who had threatened to disown them.[25] Thus the community was able to arm them for defending the faith and to intercede for them before the bar of Christ's judgment, even as it continued to repudiate their treason and to suspect their repentance. As passive participants and recipients of the church's charity, they would not pollute the communion by idolatry.

In defending these decisions against attacks by Novatian and his rigorist allies, Cyprian appealed to such fidelity as the lapsed had actually demonstrated toward Christ and the church. Some Christians, he explained, had sacrificed or obtained certificates in order to protect the faith of their families and dependents. They had provided shelter and support to fugitives and exiled confessors during the persecution. Others had refused to sacrifice, confessing themselves Christians, and accepted the certificate in exchange for paying a fine. Afterward, he claimed, the lapsed had continued to display their loyalty by prayers, alms and public professions of sorrow.[26] Thus the bishops both acknowledged the lapsed's devotion and protected the church's holiness by accepting them into a restricted membership as penitents and communicants.

The Holiness of the College of Bishops

We turn now to the other communion whose holiness was endangered by the persecution and the conflicts which followed--the college of bishops. Lapsed who had been admitted to communion were only one among many classes of membership in the church. Surviving evidence does not specify rights and responsibilities of all the others but does distinguish catechumens, confessors, standing faithful, virgins, widows, indigent, and various offices among the clergy. Behavioral expectations placed upon each of these different groups by the community as a whole seldom appear in documentary evidence precisely because they were the shared assumptions, the common sense, constituting the society itself.[27] Moral standards are explicitly discussed and defended when they have been challenged or questioned. Cyprian, for example, attacked the appointment of a presbyter as financial guardian for a child and the living arrangements of consecrated virgins.[28] Similarly, the confessors' challenge to clerical authority during the persecution and the establishment of rival colleges of bishops in Africa and Italy afterwards resulted in extensive discussions of episcopal office, which have survived.

Cyprian's person was often under attack but he usually defended the office of bishop rather than his own conduct. A particular bishop, he asserted, was chosen by God to serve as foundation for the unity and holiness of a local church community.[29] The bishop received power to purify the water of baptism, to consecrate eucharistic bread and wine, to sanctify oil for anointing and to confer the Holy Spirit by the imposition of hands.[30] Acting as Christ's delegate until the eschatological judgment, he was authorized and commanded to bind and loose.[31] As the community's representative before God, he offered its prayer of praise and appeal for forgiveness.[32] To fulfill his office, of course, the bishop had to be free from all taint and blemish of Roman idolatry.[33] Cyprian judged that a good bishop would also break away from the Roman economy and all desire for the goods it promised.[34]

The bishop's power and conditions for its retention and exercise were determined not by the local church but by the worldwide community, which was constituted by the bishops themselves. Like the local church community, the college of bishops maintained a distinct boundary by established rituals of admission and exclusion. Upon the

death of its bishop, a local community met with bishops of neighboring churches to elect a replacement. The candidate chosen or accepted by the community was then admitted to office by the attending bishops and subsequently acknowledged by his colleagues as a member of their communion.[35] This episcopal community reached concrete form in the regular meetings of regional synods which set common policy on issues affecting all local churches.[36] It was also actualized in the regular correspondence by which the bishops informed and consulted with one another in order to maintain a consistent pastoral practice.[37] During the persecution, for example, Cyprian had to ordain additional clergy to serve as couriers for the letters through which he coordinated the policy of the African bishops with that of the Roman clergy.[38] In this way, the bishops acted as a unified college, persenting a solid front to challenges, such as those of the rigorists and laxists, and providing financial and personal support in time of crisis, such as the ransoming of hostages taken in barbarian raids or supporting confessors condemned to the imperial mines.[39]

As a social organization, the college of bishops enforced a behavioral code of conduct similar to that of the local church communion. But those standards were enforced differently, particularly in the case of idolatry. No bishop who had been guilty of sacrifice or accepting a certificate of compliance during the persecution could retain or ever regain his place as a member of the college.[40] As First Corinthians warned that no Christian could share the cup of Christ and the cup of demons, so Leviticus and Exodus established that priests must be free of all spot or blemish.[41] The presence of an idolater in the communion of bishops would pollute everyone who approved him and render them similarly unfit to exercise the spiritual power of the group.[42] Any local church communion which tolerated an unworthy bishop would be polluted in turn by his sin and deprived of sanctifying efficacy in its rituals.[43]

The difference in Cyprian's attitudes toward the local church communion and the universal communion of bishops can be grasped, I suggest, by analyzing his contrary explanations of the function of the persecution. Because they were closely bounded groups, both communities relied on personal, face-to-face pressures to establish and enforce their moral codes. The cosmos itself was, correspondingly, under the control of personal forces which were responsive to moral activity.[44] Thus suffering which the Christians endured was recognized

as a divine action and had to be assigned a moral cause. In addressing the local church, as we have seen, Cyprian explained that persecution had been brought on by the sinfulness of the people and was intended to correct them, to move them to repentance and thus purified to restore them to the church.[45] This same divine action, however, was meant to expose and expel the corrupt bishops and thus to cleanse the episcopal college of their presence.[46]

The same difference can be discerned in Cyprian's use of the image of the separation of wheat from tares or chaff. He charged that Novatian had usurped God's own authority in excluding from penance and reconciliation those Christians who had fallen in the imperial persecution, which attacked the local church.[47] But when the rigorists and laxists directed an assault at the unity of the college of bishops, Cyprian asserted that God was wielding the winnowing fork, separating the good from the evil and purifying the communion.[48] Indeed, he asserted that schism, unlike idolatry, was an unforgiveable sin, removed not even by the blood of martyrdom.[49] Evidently, Cyprian thought that God enforced a level of purity in the college of bishops which the bishops themselves were forbidden to apply in their local churches.

The reason for this difference in the application of standards of purity, I suggest, was that the college of bishops, unlike the local communion, did not permit any differentiation of roles or hierarchy of offices. Because its ideal, according to Cyprian and his African colleagues, was egalitarian, it could allow no variation in behavioral standards. As a consequence, it could protect itself from contamination only by discovering and expelling deviants.

To understand the meaning of this hypothesis, it will be helpful to recall Cyprian's explanation and justification of episcopal office. In his letters and his treatise on the unity of the church, he asserted that Christ had selected his apostles and established them as bishops. The power to sanctify and govern the church was granted first to Peter and only later to the whole group of apostle-bishops. Thus Christ demonstrated that a single power of caring for the church was shared by the entire group and exercised individually in the particular communities founded upon each bishop. The college of bishops expanded as the church spread throughout the world and extended through time as one bishop succeeded another. But the one sanctifying power conferred by Christ continued to be held in common by the community of bishops.[50]

Cyprian insisted on the equality of all bishops who had been chosen by God to form the college. In his pronouncements and even in his practice, he asserted that no bishop had been given the right to exercise authority over any of his colleagues.[51] He revised the text of *On the Unity of the Catholic Church,* it will be recalled, to counter the bishop of Rome's jurisdictional pretensions.[52] The college could act as a group in expelling a member who had violated its standards of conduct but no single bishop could excommunicate or force his pastoral practice on another.[53] When a synod of bishops did not reach a consensus on some issue, each member was free to follow his own judgment and answer to Christ for the governance of his church. But a bishop who remained in communion with a fellow bishop who had been judged unworthy or supported a rebellion against one of his colleagues demonstrated that he did not share the common spirit of the college and, consequently, had to be expelled himself.[54]

Cyprian was not so naive as to think that bishops of major cities, such as Carthage, Rome and Caesarea, exercised no influence over their colleagues in Africa, Italy and Cappadocia. But neither personal resources nor wealth of a church nor even the apostolic foundation of a see conferred religious authority on a bishop. Nor could these factors justify an hierarchial differentiation of rights and responsibilities within the college of bishops. Christ had made all bishops equal and made each immediately responsible, within the whole, for his actions.

An egalitarian community repudiates the authority of offices and refuses to concede special rights to classes of membership. In practice, then, it must enforce its moral code with similar disregard for persons and stations. When such a community defines itself by rejecting some particular evil, such as idolatry, it must require the full measure of purity from each individual. The whole community can be polluted and even destroyed by tolerating a single contaminated member. Unlike an hierarchial society, the community built on equality cannot relegate the unworthy to restricted roles or assign responsibility for purity to a particular class within the group. To retain its identity, it must expel the offender and refuse readmission to the contaminated.

I suggest that the different holiness and purity requirements which Cyprian applied to the communion of the faithful and the college of bishops can be correlated with the internal structures of the two societies: the local church justified differentiating roles, the universal

church repudiated hierarchy. So long as the church remained a tightly bounded community, segregated from an encompassing and threatening culture, it could retain the unworthy only by establishing and justifying a hierarchy of roles within its communion. Until it developed a hierarchy of bishops or found another means of explaining the origin and transmission of their power, it could not avoid instability and schism.

 Cyprian's rival in Rome, in contrast, asserted a hierarchy within the college of bishops with a supreme authority residing in his own see.[55] He was thus willing to tolerate sacrificers in Spain, a rigorist in Gaul, a rebel in his own city, but not an egalitarian in Carthage.

NOTES

1. The correspondence of Cyprian may be found in Hartel's edition, *CSEL* 3.2; *epistulae* 1–57 are now available in Diercks' edition in *CCSL* 3B. G.W. Clarke's translations in *ACW* 43, 44, 46, 47 (New York: Newman, 1984, 1986, 1989) provide not only an English version but full historical and literary notes. The further divisions of paragaph used in Clarke will be used throught in anticipation of the publication of the full text of the letters by Diercks. M. Bevenot's edition of *de lapsis* and *de unitate* are to be found in *CCSL* 3:243–268; his translations and commentary are in *ACW* 25 (New York: Newman, 1057).
2. For a parallel study of the controversy on rebaptism, please see my, "On Rebaptism: Social Organization in the Third Century Church," *JECS* 1:367–403.
3. In *laps.* 6–12 (*CCSL* 3:223–227), Cyprian assigns the love of property as the principal cause for the failure of many.
4. Tertullian, *idol.* 23 (*CCSL* 2:1123) reports with disapproval procedures by which a Christian allowed documents to be drawn up which attested to a required oath, which he had avoided taking. The Roman clergy's description of the process fills in some detail, *ep.* 30.3.1 (*CCSL* 3B:142).
5. In *ep.* 66.4.1 (*CSEL* 3.2:729), Cyprian reports the opening words of the decree of confiscation of his own goods.
6. *Ep.* 11.1.2 (*CCSL* 3B:56–57); *laps.* 1–4, 7–10 (*CCSL* 3: 221–226); a more sympathetic portrait of the failures can be found in *ep.* 55.13.2–14.1 (*CCSL* 3B:270–272).
7. An example of such a letter and the confessors' response can be found among Cyprian's letters, *epp.* 21,22 (*CCSL* 3B:111–119).
8. *Ep.* 22.2.1 (*CCSL* 3B:117).
9. *Epp.* 15.1.2, 16.2.3 (*CCSL* 3B:86–87, 92–93); *ep.* 59.12.2 (CSEL 3.2:679).
10. *Ep.* 23 (*CCSL* 3B:120).
11. *Lap.* 15 (*CCSL* 3:229); *ep.* 59.12.2 (*CSEL* 3.2:679). In *laps.* 23–26 (*CCSL* 3:234–236), Cyprian described the punishments visited upon those who approached the eucharist unworthily.
12. In his attempt to restrain the confessors from giving letters of peace, Cyprian suggested that even the pagans would laugh at the Christians' failure to uphold their professed standards, *ep.* 15.3.1

(*CCSL* 3B:88).

13. *Ep.* 15.3.1 (*CCSL* 3B:88). Even the bishops could anticipate facing the martyrs as judges.
14. *Laps.* 13 (*CCSL* 3:228); *ep.* 24,25 (*CCSL* 3B:121–124).
15. *Laps.* 5–7 (*CCSL* 3:223–224) picks up the theme which had been sounded during the persecution in *ep.* 11.1.2–4.2 (*CCSL* 3B:58–61).
16. *Laps.* 35 (*CCSL* 3:240–241).
17. Cyprian assigned the intercessory power of the martyrs to the eschatological judgment of Christ; thereby disbarring them from intervening in the episcopal tribunal, *laps.* 17 (*CCSL* 3:230).
18. Cyprian attacked the authority of the martyrs in *laps.* 17–20 (*CCSL* 3:230–233).
19. *Ep.* 55.6.1 (*CCSL* 3B:261–262).
20. *Ep.* 55.17.3 (*CCSL* 3B:276).
21. *Ep.* 57.2.1 (*CCSL* 3B:302) seems to indicate that this was to have been a permanent state for the sacrificers.
22. *Ep.* 57.1.2 (*CCSL* 3B:302).
23. *Ep.* 57.4.3 (*CCSL* 3B:306–307).
24. *Epp.* 55.11.3 (*CCSL* 3B:269); 67 (*CSEL* 3.2:735–743).
25. *Ep.* 55.20.3 (*CCSL* 3B:279–280) effectively expresses the fear in which the reconciled lapsed anticipated the judgment of Christ.
26. *Ep.* 55.13.2–14.2 (*CCSL* 3B:270–272).
27. Cyprian, for example, considered his own voluntary exile a form of confession but suggested that other clergy who withdrew had deserted their offices. Contrast *laps.* 3 (*CCSL* 3:222) to *ep.* 34.4.1 (*CCSL* 3B:169).
28. *Epp.* 1,4 (*CCSL* 3B:1–5,17–26).
29. *Epp.* 48.4.2; 55.8.1 (*CCSL* 3B:230,264), 59.5.1–3, 66.1.2,4.2 (*CSEL* 3.2:671–673,727,729); *unit. eccl.* 17 (*CCSL* 3:261–262).
30. *Unit. eccl.* 29,32 (*CCSL* 3:237,239); *epp.* 67.6.3; 69.8.3,10.2–11.3; 70.1.3,2.2,3.1; 73.9.2 (*CSEL* 3.2:741,757,759–760,767–769,785).
31. *Epp.* 57.1.1 (*CCSL* 3B:301); 59.4.1–5.1 (*CSEL* 3.2:670–672).
32. *Laps.* 32 (*CCSL* 3:239).
33. See in particular, *ep.* 67.1.1–2.2 (*CSEL* 3.2:735–737).
34. *Laps.* 6 (*CCSL* 3:223–224); *ep.* 1 (*CCSL* 3B:1–5).
35. *Epp.* 44.3.2 (*CCSL* 3B:214); 59.5.2 (*CSEL* 3.2:672). The importance of letters of communion is evident in the problems associated with granting them to Cornelius, *epp.* 45.1.3; 48 (*CCSL*

3B:217,228–230). The laxists tried to gain communion the African bishops had provided him with a list of all the bishops who were accepted into their communion, *ep.* 59.9.3 (*CSEL* 3.2:676).

36. Reports from these meetings are to found among Cyprian's letters: *epp.* 57,64,67,70,72. The proceedings of the meeting at Carthage on 1 September 256 are recorded in *sent. episc.* (*CSEL* 3.1:435–461).

37. Thus *epp.* 24,25,44,45,47–52,55,56,59–63,65,69,71,73,74,76,80.

38. *Ep.* 29.1.1 (*CCSL* 3B:137–138).

39. *Epp.* 62,76–79.

40. *Epp.* 55.11.1–3 (*CCSL* 3B:268–269); 65.1.1–2.2; 67.1.1–2 (*CSEL* 3.2:721–724,735–736).

41. Lev. 21:17, Ex. 19:22,30:20–21; cited in *epp.* 65.2.1, 67.1.1 and 72.2.2 (*CSEL* 3.2:723,736,777).

42. *Ep.* 67.9.3 (*CSEL* 3.2:743).

43. *Ep.* 65.4.1 (*CSEL* 3.2:724–725).

44. Mary Douglas, *Cultural Bias*, reprinted in *In the Active Voice* (London: Routledge, 1982),209–212.

45. *Ep.* 11 (*CCSL* 3B:56–66); *laps.* 5–6 (*CCSL* 3:223–224).

46. *Ep.* 65.3.2–3 (*CSEL* 3.2:724).

47. *Epp.* 54.3.1–3; 55.25.1–2 (*CCSL* 3B:253–255,287–288).

48. *Unit. eccl.* 10 (*CCSL* 3:256).

49. *Unit. eccl.* 19 (*CCSL* 3:263); *epp.* 55.17.2 (*CCSL* 3B:275–276); 60.4 (*CSEL* 3.2:694).

50. *Epp.* 45.3.2; 55.24.2 (*CCSL* 3B:221,286); 69.11.1, 73.7.1–2 (*CSEL* 3.2:759,783); *unit. eccl.* 4–5 (*CCSL* 3:251–253).

51. *Ep.* 55.21.1–2 (*CCSL* 3B:280). Thus in his first letter on rebaptism to Magnus, 69.17 (*CSEL* 3.2:765–766), in the letter of the African synod of May 256 to Stephen, 72.3.2 (*CSEL* 3.2:778), in his own subsequent letter to Iubianus, 73.26.1–2 (*CSEL* 3.2:798), and in introducing the vote of the bishops at the synod in September 256, *Sent. episc.* (*CSEL* 3.1:436).

52. Bévenot's introduction to the *CCSL* edition provides a brief history of the discovery of this revision (*CCSL* 3:244–247).

53. Thus the African bishops acted against Privatus of Lambaesis and his associates, *ep.* 59.10.1–2 (*CSEL* 3.2:677–678).

54. This was essentially Cyprian's charge against Marcian of Arles; *ep.* 68.5.2 (*CSEL* 3.2:748–749).

55. *Epp.* 75.17.1, 24.2–25.1 (*CSEL* 3.2:821, 825–826).

Anglo-Saxon Monasticism and Public Suitability of the *Rule*

Duncan G. Fisher

The most important consequence of the decline in the vitality of English religious culture by the early tenth century was the shift of responsibility for ministry among people onto the reforming foundations in the orbits of Wessex and Mercia. The monastic order in England had had serious problems during the century, having atrophied in size and resolve to the point that proper observance was unknown anywhere. For a number of reasons, having to do with economic and political pressures as much as a need for trained clergy, observance of the Benedictine Rule was revived under a short succession of kings and purged of its dead weight: those collections of canons who called themselves monks but did not live after the Rule in some traditional form. The proper interpretation of traditional observance was the operative theme for the reformers. To the people who gave up their possessions to buy admittance into one of the reformed houses and live in quiet contemplation necessarily went some amount of responsibility for the life of the surrounding community in spite of any popular wishes to the contrary, since these new houses had also novel rights to economic and therefore political privileges. The people who wished to renounce the society of humankind now found themselves responsible for its well-being, but involved in a pattern of life which had not yet adapted to the requirements of the task.

Tenth-century reformers hoped that, eventually, their own patterns of life and work would change to suit their new role, and the monks did take over many of the practical duties of landlord and judge, and also teacher and counsellor. And they spoke of this in a way that was soon identifiable as their own. Their mature sense of mission in society, to whatever extent it existed, was based on an interpretative authority bound up in a unique sensitivity to Christ's direction in human affairs. As Jaroslav Pelikan and E.H. Kantorowicz both observe, Christocentrism is the hallmark of the tenth-century west, and this because it was the west's most monastic century. [1] Involving Jesus consciously in the language of earthly affairs at a personal and at an administrative level is the foundation on which the monastics built their notions of contribution to the larger church. Christocentrism in this sense colored every aspect of how they taught and governed. For institutional reformers, this was a powerful concept, and in the tenth century it endowed the monastics with terrific psychic and social leverage.

The rescue of society on earth, outside the cloister walls, informed the particular changes which first had to happen within those walls: monastic figures had to be presented to the population as legitimate agents of authority and interpretation, and the people needed to be made to understand the way in which these agents expected to function. But the task of preparing those agents involved learning a set of basic assumptions regarding monastic life. The first premise was that living by a rule put a person in a position to know and judge patterns of earthly life. This was itself a corollary of the idea that the Rule was the only reliable way to achieve sanctification.

The movers of the tenth-century reforms of monastic life in England did not see themselves as models of the end-product of reform, but only as agents of change. These people understood their project of reform to benefit not only themselves, but the larger population on earth, and this was their focus. They recognized that they were the caretakers not only of their own souls, but also the souls of their countrymen; they labored to bring their own hearts and minds to more intimate union with God, and they sought, by intercessory prayer and efforts at teaching, to effect a rescue of as many other souls from the fallen world as they could. A lifestyle like theirs presupposed a commitment to understanding and serving a near and active God to the exclusion of all else, and it meant separation from the course of

ordinary life.[2] To a great degree, they actually considered theirs an unnatural life, existing as it did only because of certain pressures and needs from the unrighteous world around it. Their lifestyle functioned for the salvation of every believer, but they would not have recommended it for every believer.

In a different sense, the reformers considered their way of life supremely natural to the human spirit. They understood the world to be in a state of spiritual disrepair,[3] in which each individual's instinct to seek God, which should be the strongest of things,[4] was dysfunctional. As bringers of restoration, the religious reckoned that their task was to educate the population to this dysfunction, and encourage people to direct their attention heavenward. As bringers of restoration, they would draw earthly society to a more truly normal state, to a way of living natural in every sense.

The religious lived and worked at a remove in order to effect this, in a manner very different from that of the rest of the world; their sense of the social order most suitable for understanding God's plan for his creation, and for transmitting that information to others, was different from that of the rest of the world as well. It was shaped by a particular understanding of the state of things, and how life in it differed from its intended shape. The concept of ideal life, in the sense of natural life, was not equivocal, however. The religious did not imagine that good living meant one thing for the people in the world and something different for them, whatever its physical setting. Ideal living meant conformity with the dictates of pre-ordained social order as much as it meant being involved in a supernatural apprehension of God's will. The outlines of godly society were present in the natural order,[5] in the rhythms of ordinary personal life. All things, even inanimate objects, were known to have an assigned function in the process of creation. Alfred has Boethius hear the voices of his earthly blessings saying that his inordinate desire for them rendered them less useful in a larger sense. "Through your fault," they say, "we cannot obey our Creator's will."[6] Inordinate zeal for earthly blessings was a perversion of the very concept of earthly blessings. In the same way, inordinate desire for one's own glorification was incompatible with the schema of creation. Nebuchadnezzar's punishment for pride, as Alfred forced Gregory's *Regula Pastoralis*[7] to say, was nothing less than madness,[8] which was separation from ordinary participation in life.

Their sense of natural order was not a highly structured thing, like that of a Lucretius or of an Isaac Newton, but it was an awareness that since creation is begotten of God, and designed so that it seeks its end in God,[9] it has ingrained tendencies to particular patterns of organization. There were physical structures and limitations in place which determined the proper layout of the order. Humans, being fashioned most explicitly in the Lord's image, have this tendency as well, but we have the peculiar option of resisting our inborn inclinations. People know instinctively the source of all good, and we each show its influence in some way, as the moon reflects the light of the sun,[10] and the sum total of every person's reaction to divine influence forms the society of God's creation on earth.

This unique place which humans occupy in creation—that they are able to transgress the divine imperative if they wish—is at the heart of Benedictine revivalism in the 970's. The highest expression of recognizing the need for the conformity of human society to the needs of creation was the willingness to remove oneself from it, to a life of isolated ascetic contemplation.[11] Who would elevate society must first elevate himself. Bede had taken the words of the prophet Jeremiah to heart, who spoke of someone who senses the need for disciplined, receptive introspection early in life. The person who bears the yoke in his youth can quickly transcend the distractions of the world, becoming blind to his physical needs; he sits in solitude and is silent, and he raises himself—as Bede amends this—above himself.[12] This is what makes him an able evaluator of the legitimacy of all that is around him.

Arguing from Bede to establish the *ethos* of the tenth century is an unreliable mechanism by itself, of course, but this is the classic outline of an individual's sanctification, and contemporary homilies build on it. The path for those who would be sanctified becomes a lonely one. The novice contemplative begins his journey under the imposition of a rule, in the company of others like him, and under the administration of an abbot. His relation to the rest of the world is gradually severed as completely as possible, however. Only in this advanced state may he consider himself to be master of his surroundings. Cuthbert went alone to the island of Farne and became nothing less than its monarch; and he built himself a one-man compound and called it a "city" worthy of his power.[13] This was the paradigm for self-mastery. He had trained long to be independent from people for his spiritual needs and his emotional wants, and he now

relied on them for nothing, not even food or shelter. His dwelling was like a city because it contained the equipment needed for every act of maintaining life, not only spiritual, mental, and aesthetic, but physical as well.

English tradition had always affirmed the suitability of collective life under a rule for most people, religious or not. Few, it was thought, could reach such a level of self-mastery that they could live apart from other people and do it fruitfully. The established style of the saints' *lives* was always to show contemplative solutions to the needs of souls on earth. Bede, that favorite chartist of holy lives and ways, was enough impressed with the salvific implications of coenobitic community that he asked the congregation at Lindisfarne to reward him for his work on the prose *Vita Cuthberti* by putting his name [14] on the role of the house and praying for him as though he were one of them. And as a youth, Cuthbert, by temperament a hermit, had been persuaded by nothing less than a vision to begin "spiritual discipline," in order that he attain eternal happiness, and that he do it in the company of the mighty men of God. [15] Still, he did understand this to mean eventual separation from at least the main elements of society, and this is what he managed to do, except for a tenure "compelled to submit to the yoke of the episcopacy." [16]

The necessary image of the English communal monastic vocation was not one of total removal from society, even though certain physical separation was necessary; here vocation dovetails with life in the wider Christian world. Since the monastic undertaking was for the benefit of all souls, it contained a powerful element of the desire to edify the rest of humanity. The removal which monastic *familiae* required was for their own improvement, but it was not to happen at the expense of the larger body of the faithful. The Anglo-Saxon proselytizers were vigorous persuaders concerning the legitimacy of new [17] life in Christ, and also of the special directive power which those who had taken holy vows rightfully possessed concerning the proper way to live and believe. The population at the mouth of the Tyne had seen the seas calmed by one of these men and the lives of several brothers saved. [18] As Bede tells the story, Cuthbert performed this miracle, and another like it, [19] not to save lives but to correct the errors of the watching townsmen, who had been hostile to the new community of monks.

The will to edify did not find its only expression in stories of miracles. The monks endeavored to impart pieces of moral guidance as well. They reasoned that serving up living examples of virtuous life had the capability of raising hearts to more burning desire for the kingdom of heaven. [20] A life of good works figured in one's own advancement to heaven too, of course. [21] Sometimes the improvement of souls was effected through repetitive admonition, [22] but the proper [23] way to teach was by example first and precept later, and it could truly bring results. In this manner they even taught virtue to each other: one of the most venerable of the teachers of the life of perfection was the old abbot Boisil, [24] from whom many were said to have learned their most important lessons by watching and imitating.

The sentiment that monks ought to teach souls how to be saved, and how to live lives most pleasing to God in the meantime, so central to the collective sensibility of the Anglo-Saxons, influenced the way the cloistered population spent its time from day to day. Alfred had said that the earthly moral guidance in the books of the holy fathers was a straight avenue to salvation, and therefore so was its physical transmission;[25] this was the focus of cloistered lifestyle which made the monks so important to lay populations as teachers of the new life in Christ. As scribes and translators and commentators and preachers, they were guardians of the costliest treasure imaginable, since their world counted for every individual's potential salvation. It was Alfred's own prayer, in fact, that by helping in the transmission of some books by himself, his work might be judged "useful" in this world, [26] just as the work was judged of those who fought, who worked, and who prayed.

Intellectual activity itself was central to the formation of a godly society. For the safety of Christian community, it was people's duty to be made learned enough to understand God as far as it was in their individual capacity to do that.[27] Only the monks were prepared for that job in either a literary sense or a spiritual sense. The will to teach was known to be nothing less than a function of thoroughness of conversion. Tireless preaching was a mark of a sanctified soul.[28] Augustine had taught that the dynamic of conversion was a concerted effort to increase knowledge. [29] For the English, not to cherish learning, or not to transmit it to others, was judged to be the sort of life led by a nominal Christian only. [30]

The degree to which someone was an authority on proper ways of living and understanding depended on the degree of his

conversion, the mechanics of which the Anglo-Saxons knew as complex and hard to perceive in other people. They had a sense of the evidence of when a soul had been converted, of course: an unassuming manner, for example, and the wearing of plain clothes suggested that a person—monk or not—might be involved in a life of interior perfection.[31] Bede added that it was possible to overdo this. Devotion to good works was a good sign too, and hospitality in particular.[32] In fact the religious were not the only people who could be moved to acts of righteousness, and Bede has a favorite story in a laywoman who demonstrates this in her almsgiving even though she has no formal schooling in virtue, as it were.[33] The exact difference in the moral enlightenment of monks and laymen is not clear at all: Bede tells the bishop Eadfrid that his book production is out of "brotherly compliance."[34] Does he mean to affirm the communal bonds of the Rule, or does he just intend to remind a powerful ecclesiastic of his first calling as one of the brothers? Perhaps he wishes to illustrate an instance in which a person involved in a monastic vocation can perform an act of piety unavailable to people in the secular world.

Extreme evidence of conversion in the manner of the monk is prophetic gifts.[35] This is an extension of a high-order contemplative's authority to interpret divine directives. Where the common Christian is counselled to wait and watch, a figure like this is able to move laterally through history, by visions,[36] and vertically through creation, by open conversations with angels.[37] These are clearly reserved for the cloistered, and the senior ones at that. The frequency and character of miraculous events changed as the visitant matured: usually they started as dreams, then they became waking visions, and then they were celestial visitations.[38] Holy figures knew each other's secrets, too: they could judge the sincerity of their pupils and they had a reliable intuition about the holiness of strangers.[39]

Evidence of conversion like this, to Anglo-Saxon monastics, was a kind of single-mindedness.[40] The souls bound for salvation were the ones least concerned by earthly matters, except as they related to divine things. These were the people who understood that virtuous living presupposed diligent study of the mind and rationale of God; such a person hungers for enlightenment in this world in order to feast at banquets in the next.[41] One recognized a sanctified person by his sensitivity to the immanence of distractions: this was Cuthbert, who complained that even if he lived on a rock alone in the middle of the

ocean (which he did), he would still worry that his love of money, even if useless there, could snatch him away from his work of private edification: this was lauded in secular persons but remained an ascetic sensibility.[42]

Still, for universal evidence of conversion, faith and hope and charity were the tenth-century standard. These and the knowledge that travail in this world is not eternal were the anchor lines[43] to heaven, and they could be conspicuously available everywhere. Even a flock of birds, which had stolen food from one anchorite, once they were made to understand the holiness of the man they had wronged, returned to him in contrition, and exhibited with weeping and outstretched wings what Bede calls the ideal attributes of the converted soul: humility, prayers, gifts, and obedience, that mainstay of Benedictine life.[44]

To the extent that monastic lifestyle was bound up in changing hearts, it implied or presupposed the authority of its practitioners over other people. And in various ways the cloistered population was given spiritual and civil responsibility over its neighbors; tenth-century charters preserved reformed houses from political interference by lay lords, and the generous land grants which usually went with these charters made the houses economically powerful, which itself conferred on them a further kind of communal imperative. Political and economic incentives for such arrangements were strong, but occasionally secular patrons took an interest in the spiritual lives of their foundations as well. Boisil, Eata and Cuthbert were actually thrown out of Ripon by Ælhfri when they would not observe Roman usage. Generally, though, the supreme evaluators of lifestyle were the monks themselves, and in this lay their authority.

Conversion and all its supernatural benefits lay open to anyone, but the best interpreters of apostolic opinion were those who lived "spiritually," as one contemporary put it.[45] Even the ecclesiastics, those who were secular clergy that is, who had the authority to administer the sacraments, could be distracted from the proper view of things by virtue of their temporal responsibilities. Apostolic succession notwithstanding, even these people would do better to take vows. Dunstan's colleague on the continent, one Heriger of Lobbes, took pains to include a bishop in his gallery of rogues who misunderstood and misrepresented the truth about the real presence in the Eucharist, for example.[46] This man's folly, he felt, was in his failure to penetrate that

mystery by understanding its "internal aspect";[47] even here, this requires a contemplative mind-set first.

It was not precisely as teachers that monastics knew they would have to approach the transmission of religious information, but as spiritual fathers. In fact, they became the teachers of doctrine only as the burden of doing so devolved on them by default. To the extent that the monasteries maintained schools for boys who were destined for neither the cloisters nor lives as canons, they became an *ad hoc* teaching order. But they did not see themselves this way; they were not as instructors in the liberal arts, but as masters to legions of apprentices. Life under the Rule was not for that, so to say. In Benedictine eyes, the job was not to train pupils so much as to edify companions.[48]

NOTES

1. J. Pelikan, *The Growth of Medieval Theology (600-1300)* (Univ. of Chicago, 1978), p. 106. E.H. Kantorowicz, *The King's Two Bodies: a Study in Medieval Political Theology* (Princeton, 1957), p. 61.

2. Vercelli *Homily XVI*, ed. Paul E. Szarmach (Toronto, 1981), p. 46, ll. 144-52: *7 nu se man, se epæt pence pæt he of pysse gehrorenlican worulde pone heofonlican rice begite, he onne sceal eallinga o erne weg gefaran 7 o rum dædum don. . . . 7 he sceal pysse worulde wuldor forseon 7 ealle yfele lustas anforlætan; . . . 7 he sceal halige wæccan 7 singalice gebedu for Gode begangan; he sceal fæstan gegangen 7 pa lufian mid clæne ælmessan 7 mid mycle <mildheortnesse> . . . forwyr<ne>dnesse habban on his life; 7 he sceall beon ælmesgeorn for Godes naman 7 for his sawle.*

3. Man had chosen his way out of Paradise, giving in to pride, wilfullness, and unnecessary desires. Vercelli XVI, ed. Szarmach, p. 46, ll. 139-44.

4. For a sense of the natural with respect to service of the Lord, see Bede, *Sancti Cuthberti Lindisfarnensis Episcopi, Liber de Vita et Miraculis, PL* 94, cols. 735-790, at 760, ll. 31-39: *Non solum autem aeris, sed et maris animalia superioribus exposuimus, viro venerabili praebuere obsequium. Qui enim auctori omnium creaturarum fideliter et integro corde famulatur, non est mirandum si ejus imperiis ac votis omnis creatura deserviat. At nos plerumque idcirco subjectae nobis creaturae dominium perdimus, quia Domino et Creatori omnium ipsi servire neglimus.* Also Alfred's translation of the Augustinian *Soliloquies*, I, ed. H. L. Hargrove, as *King Alfred's Old English Version of St. Augustine's Soliloquies* (New York, 1902), p. 11, ll. 6-8: *Gehiere, gehyre me, Drihten, forpam pu eart min God, and min Drihten, and min feder, and min sceapen, and min gemetgyend, and min tohopa, and min sped, and min wyr scipe, and min hus, and min e el, and min hæle, and min lyf.* Also Alfred's version of Boethius' *Consolatio*, xli.4, ed. W.J. Sedgefield, as *King Alfred's Old English Version of Boethius' 'De Consolatio Philosophiae'* (Oxford, 1899), p. 145, ll. 10-13: *Ac se wisdom meg us eallungra ongitan swylce swylce he is; forpæm se wisdom is God.* And *Consolatio* xxv, ed. Sedgefield, pp. 57-8, discussing how all of nature knows its proper course.

5. "Natural order" is easily overstated. But Heriger, for example, saw the root of our ability to understand our surroundings by the power of dialectic argument embedded in the laws of nature. *De corpore et sanguine Domini* (*PL* 139:185): *Non enim ars illa, quae dividit genera in species et species in general resolvit, ab humanis machinationibus est facta; sed in natura rerum ab Auctore omnium artium, quae verae artes sunt, et a sapientibus inventa, quae verae artes sunt, et a sapientibus inventa, et ad utilitatem solveris rerum indaginis est usitata.*

6. Alfred, *Cons. Phil.* vii.5, ed. Sedgewick, p. 19, ll. 19-21: *Nu <pu eart scyldig>ra ponne we, æg er <ge for pinu ag>nu unrihtlustum ge eac forpæmpe we ne moton for pe fulgan ures sceppendes willan. ..*

7. The *Pastoral Care*, IV, ed. Henry Sweet, as *King Alfred's West-Saxon Version of Boethius' 'Consolatio Philosophiae'* (Oxford, 1899), p. 38, ll. 13-19.

8. Dan. IV.27.

9. Alfred, *Cons. Phil.* xxxv.3, ed. Sedgewick, p. 97, ll. 9-13: *Purg good God gesceop eal ping, forpæm he wilt furh hine self<ne> ealles pæs pe we ær cwædon æt good wære; 7 hie is ana sta olfæst wealdend 7 stiora 7 steorro er 7 helma, forpæm he riht 7 <ræt eallu> gesceaft<um>, swa swa god stiora anum scipe.*

10. Alfred, *Cons. Phil.* xxxiv.5, ed. Sedgewick, p. 86, ll. 7-8.

11. Bede, *Vita Cuthberti* 39, *PL* 94:756, ll. 39ff.: *Ac postquam in eodem monasterio multa annorum curricula explevit, tandem diu concupita, quaesita ac petita solitudinis secreta, comitante praefati abbatis sui simul et fratrum gratia, multum laetabundum adiit. . . . laetabatur ad eorum se sortem pertingere, de quibus canitur in psalmo: Ambulabunt sancti de virtute in virtutem, videbitur Deus deorum in Sion. Et quidem in primis vitae solitariae rudimentis secessit ad locum quemdam qui a exterioribus ejus cellae partibus secretior apparet.*

12. Bede's own amendment. *Vita Cuthberti* I, *PL* 94:735, ll. 1-8: *Principium nobis scribendi de vita beati Cudbereti Jeremius pro pheta consecrat, qui anachoriticae perfectionis statum glorificans ait: 'Bonum est viro cum portaverit jugum ab adolescentia sua; sedebit solitarius et tacebit, quia levabit se super se.' Hujus namque boni dulcedine accensus vir Domini Cudberetus, ab ineunte adolescentia jugo monachicae institutionis collum subdidit.*

13. Bede, *Vita Cuthberti* 17, *PL* 94:757, ll. 27-30: *Qui videlicet miles Christi, ut devicta tyrannosum acie monarchus terrae quam adierat factus est, condidit civitatem suo aptam imperio, et domos in hac aeque civitatie congruam erexit.*

14. *Vita Cuthberti, Praefatio, PL* 94:734, ll. 30-2: *Sed et me defuncto pro redemptione ancinae meae quasi familiaris et vernaculi vestri orare, et missas facere, et nomen meum inter vestra scribere dignemini.*

15. Bede, *Vita Cuthberti* 4, *PL* 94:739, ll. 11-14: *Compunctus est multum hoc visu Deo dilectus adolescens, ad subeundam gratiam exercitu spiritalis, ac promerendae inter magnificas viros vitae felicitatisque perennis confestim Deo laudes, ...*

16. Bede, *Vita Cuthberti* 24, *PL* 94:765, ll. 8-13: *... obsecrant donec ipsum quoque lacrymis plenum dulcibus extrahunt latebris, atque ad synodum pertrahunt. Quo dum perveniret, quamvis multum renitens, unanima omnium voluntate superatur, atque ad suscipiendum episcopatus officium collum submittere compellitur.* To his mind, monastics were the best qualified to be clergy, however. His favorite examples were bishop Eadred, abbot of Lindisfarne, the famous Aidan, and the priest Herefrith, "our reverend brother." Closer to the tenth century than Bede, the document, "*Be Munecum*" (xiii, xiv), "of monks," makes it clear that such figures should "busy themselves in ecclesiastical needs, as befits them." *Institutes of Polity*, in *Ancient Laws and Institutes*, ed. Benjamin Thorpe (London, 1840), pp. 430ff.

17. Bede, *Vita Cuthberti* 3, *PL* 94:739, ll. 10-14: Hostile Tynesiders once cried, *"Nullus . . . hominem pro eis roget, nullius eorum misereatur deus, et qui veteres culturas hominibus tulere, et novae qualiter observari debeant nemo novit."*

18. Bede, *Vita Cuthberti* 3, *PL* 94:738.

19. Bede, *Vita Cuthberti* 36, *PL* 94:775-6.

20. Bede, *Vita Cuthberti, Prol., PL* 94:734, ll. 23-6: *... Sed cum eundem libellum relegentes pia sanctissimi Patris memoria vestros animos ad desideria regni coelestis ardentius attolitis, ...*

21. Vercelli XVI, ed. Szarmach, p. 46, ll. 158-9: *7 mid pyllicum dædum we magon pa heofonlican rice begitan 7 on becuman ...*

22. Bede, *Vita Cuthberti* 16, *PL* 94:754, ll. 46ff.: *Igitur ad Lindisfarnensum ecclesiam, sive monasterium vir Domini*

adveniens mox instituta monachica fratribus vivendo pariter et docendo tradebat.

23. Blickling Homily II, ed. R. Morris, *The Blickling Homilies of the Tenth Century* (London, 1967), p. 19, ll. 12-15: *He ma cegde 7 geornor bæd æt Hælend him miltsade æt is ponne æt we sceolan beon gelærede mid pysse bysene, ponne we beo mid mycelum hungre yfelra gepohta abisgode,* . . . Bede, *Vita Cuthberti* 26, *PL* 94:766, ll. 15-19: *Commissam namque sibi plebem et orationibus protegebat assiduis, et admonitionibus saluberrimis ad coelestia vocabat, et quod maxime doctores jubat, ea que agenda docebat, ipse prius agenda praemonstrabat.* That they teach by example was sometimes a point of law: I Edmund 1, ed. Robertson, *Codes*, p. 6, ll. 8-9: *Hæt is ærest æt hi budon, æt pa halgan hadas pe Godes folc læron sculon lifes bisne,* . . .

24. Bede, *Vita Cuthberti* 8, *PL* 94:744-6.

25. Alf., *Aug. Sol.*, III, ed. Hargrove, p. 66, ll. 4ff. Also Alfred's preface to the same work, p. 2, ll. 18ff. John the Scott refused to say that there can even be any contradiction among the Fathers: *De divisione naturae* (*PL* 122:762).

26. Alfred, *Aug. Sol., Pref.*, ed. Hargrove, p. 1, ll. 15-18.

27. Alfred, *Cons. Phil., Proem.*, ed. Sedgewick, p. B, ll. 2-8.

28. Bede, *Vita Cuthberti* 16, *PL* 94:754, ll. 46ff.

29. *De vid. Deo*, III. Also *De symbolo, sermo ad catechumenos*, 1, 1 (*PL* 40:627), concerning the duty of the institutional Church to process revealed information and present it coherently.

30. Alfred's preface to the *Pastoral Care*, ed. Sweet, p. 4, ll. 4-8. Also *Canones Dom[i]ni Abbonis Abbatis* (*PL* 139:476).

31. Bede, *Vita Cuthberti* 16, *PL* 94:756, ll. 26-32: *Vestimentis utebatur communibus, ita temperanter agens, ut horum neque munditiis neque sordibus esset notabilis. Unde usque hodie in eodem monasterio exemplo eijus observatur, ne quis varii aut pretiosi coloris habeat i ndumentum, sed ea maxime vestium specie sint contenti, quam naturalis ovium lana ministrat.*

32. Bede, *Vita Cuthberti* 7, *PL* 94:743 [upon discovering an angel]: . . . *invenit inibi quemdam sedentem juvenem, quem hominem aestimans, solito mox humanitatis more suscepit.*

33. Bede, *Vita Cuthberti* 14, *PL* 94:751-2.

34. Bede, *Vita Cuthberti, Praefatio, PL* 94:733: . . . *per quam legentibus universis et vestrae desiderium volentis et obeditionis nostrae pariter assensio fraterna claresceret,* . . .

35. Bede, *Vita Cuthberti* 11, *PL* 94:749, ll. 7-9 [referring to Cuthbert]: *Coepit inter ista vir Dei etiam prophetiae spiritu pollere, ventura praedicere, praesentibus absentia nuntiare.*

36. Gregory, *Dialogues* II, ii, printed in a *Life* of Benedict, *PL* 66:132-4.

37. Eddius Stephanus, *Life of Wilfrid* LVI, ed. B. Colgrave (Cambridge, 1927), p. 120, ll. 31ff.

38. Bede, *Vita Cuthberti* 7, *PL* 94:744, ll. 21-22: *Denique saepius ex eo tempore angelos videre et alloqui,* . . .

39. Bede, *Vita Cuthberti* 9, *PL* 94:747, ll. 21-5: . . . *ut nullus praesentium latebros ei sui cordis celare praesumerit, omnes palam quae gesserent confitendo proferrent, quia nimirum haec eadem illum latere nullo modo putabant,* . . . Boisil knew instantly the intentions of his new student. Bede compares this with the prophet Nathaniel's first impression on a crowd of followers (*Vita Cuthberti* 6, *PL* 94:742): *Praevidens in spiritu quantus conversatione esset futurus quem cernebat, hoc unum dixit astantibus: "Ecce servus Dei."*

40. Alfred, *Regula Pastoralis*, IV, ed. Sweet, p. 37, ll. 13-19.

41. Bede, *Vita Cuthberti* 6, *PL* 94:742, ll. 6-8.

42. Bede, *Vita Cuthberti* 8, *PL* 94:746, ll. 25-32.

43. Alfred, *Sol. Aug.* I, ed. Hargrove, p. 22, ll. 17-18; Alfred, *Cons. Phil.* xxvii.2, ed. Sedgewick, p. 62, ll. 22ff.

44. Bede, *Vita Cuthberti* 20, *PL* 94:760, ll. 8-11.

45. Heriger of Lobbes, *De Corp. et Sang. Dom.* I, *PL* 139:179, col. 179: *Quia, "animalis homo non percipit ea, quae sunt Spiritus Dei," haesitamus vehementer, ne minus spiritualiter viventes, cum de spiritualibus responsa paramus,* ...

46. Her., *De Corp., PL* 139:179: *Et his quidem, qui dixerunt, secessi obnoxium . . . is est, Heribaldo ...*

47. Her., *De Corp., PL* 139:180: *Sed iterum cum internum aspectum ad eum dirigimus* . . .

48. See Dom Leclercq's graceful discussion of the growing difference in orientation between the schools for clerics and the educative process in the cloisters by the time of the Scholastics, in chapter 7 of his *Love of Learning and the Desire for God. A Study of*

Monastic Culture (New York: Fordham University Press, 1961) pp. 112-153.

The Bible in the Center: The *Glossa Ordinaria*

E. Ann Matter

In the fourth volume of *The Christian Tradition*, *Reformation of Church and Dogma (1300–1700)* Jaroslav Pelikan lays out quite nicely one of the central issues of the reception of the Bible in the western Christian tradition. Speaking of Luther, the staunch advocate of *sola scriptura*, theology based on the Gospel alone, Pelikan shows that Luther's biblical stance raised two major problems: was the word of God, the Gospel of Christ, identical with the Bible? And, what is the relationship between the word of God and the people of God?[1] These are questions which Luther inherited, as he did inherited so many things, from a long tradition of theological inquiry. The Bible was always at the center of Christian thought, yet the Bible was always mediated by the people of God. And, of course, as the history of Christian thought easily shows us, debates about the proper interpretation of the Bible have been the fuel of the development of Christian doctrine. In this paper, I wish to explore some of this dynamic through an investigation of issues of centrality and mediation in the *Glossa ordinaria*, the standard glossed Bibles of the mid-twelfth century.

Three generations of scholars have now acknowledged the fact that the *Glossa ordinaria*, printed in Migne's *Patrologia Latina* under the name of the Carolingian scholar Walafrid Strabo, is a compilation of the twelfth century.[2] As study of the *Glossa* manuscript tradition has

allowed us to refine our knowledge of this important collection of medieval biblical learning, we have begun to understand its shape and its sources. One of the most important insights of this process is the awareness that the *Glossa ordinaria* to each book (or collection of books) of the Bible had an independent development, and was copied in an independent manuscript tradition. Although medieval libraries sometimes collected a complete set (or several sets) of glossed books of the Bible, there does not seem to have been a tradition of copying out an entire *Glossa ordinaria* in one manuscript or even in matching manuscripts, at least not until the age of printing.[3]

The *Glossa ordinaria* involved three texts, intimately related to one another on the page: the words of the Bible, written in the center in large letters; the smaller *Glossa marginalis*, (usually in a relationship of 2:1 or 3:1) framing the Bible verses; and the *Glossa interlinearis*, written between the lines of the Bible text, above key passages.[4] The relationship of the marginal and interlinear glosses to one another seems to differ from book to book, and needs to be considered separately in the case of each book of the Bible. In the final result, nevertheless, the three parts of a glossed Bible were certainly in some literary relation to one another, since they were meant to be read together. The concept of such an integrated text was not an invention of the twelfth century, but derives from a long tradition of glossed books in Latin, found in Carolingian manuscripts copied at German scriptoria, including Fulda, Saint Gall, Reichenau, and Tegernsee.[5]

What changes and is specific to the *Glossa ordinaria* is the fact that this type of integrated text actually represents a continuation of the patristic tradition of biblical commentary. The content of the commentary arranged around the biblical text in gloss manuscripts is ultimately patristic, often mediated through Carolingian compendia or reworkings of patristic exegesis, and then further selected and adapted for twelfth-century students of the Bible. Margaret Gibson has demonstrated this process of increasing "refinement" of biblical commentary from the fifth to the twelfth century in her discussions of the *Glossa ordinaria* to Isaiah and Jeremiah.[6] In the *Glossa ordinaria*, then, we find three historical moments of Latin biblical interpretation, the late antique world of the Latin fathers, the monastic world of the Carolingian period, and the twelfth-century schools. It can be said, in fact, that the *Glossa ordinaria* shows us the last moment of the

development of a tradition of compilation, done always in more concentrated form, of patristic biblical learning.

What happens to the Bible in this process? Well, of course, the Bible remains in the center, literally in the center of the page. But how is it read in this context? Strategies for reading the *Glossa ordinaria* must have involved, as a number of scholars have noted, a type of intertexuality we are hard put to recreate.[7] In my opinion, we also have difficulty understanding both how this intertextuality functioned and why, that is, what for. In his study of the *Glossa* on Genesis 38, the rape of Tamar, Stephen Barney interprets the interpretation, giving a sensitive reading of the interplay of ideas between the biblical story and the *Glossa*, and then remarks:

> This little biblical text floating in its sea of gloss nearly drowns, a sad *testimonium in aqua*. The interpretation of the *Gloss* springs from a theory of reception of a dead original; it is, with a vengeance, commentary as a cultural artifact. What the *Gloss* neglects to notice reveals its interest: it does not mention Judah's apparent incest, or Tamar's apparent prostitution. The sexuality of the chapter is submerged under a law of Christian exegesis, that Judah, like all the patriarchs, "significat Christum," at least when he is not for awhile required to "signify the judging Jews." Because the Christian community had canonized Hebrew scripture as a sacred text, it had to cope with it, and its coping amounts to displacing and submerging the life of the text itself. The community of interpretation as always is more powerful than the text it preserves. The *Glossa ordinaria*, then, displays medieval exegesis in its apt visible form on the page, and sacred scripture recedes like a *dieu caché*, like the God missing from Tamar's conception, an ostensibly ultimate authority nearly hidden beneath the flood of supplemental authorities, and rendered inaccessible and inane, something slightly, in a Kafkaesque way, embarrassing.[8]

This, it seems to me, presents a formidable challenge to a scholar of medieval biblical interpretation. Is it true that the *Glossa ordinaria* drowns its "dead original," the biblical text? To get at this

question, I wish to examine the form and suggest the function of several manuscript copies of the *Glossa*, and then return to Barney's analysis for some reflections on the function of sacred text and our understanding of medieval strategies of interpretation.

Let us consider first the relationship between the biblical text and the *Glossa* as it is laid out on the page. The first example I would call to your attention is the gloss on the opening part of the book of Daniel, a twelfth-century manuscript from the Parisian house of canons of Saint Victor (Plate 1).[9] This text presents us with an almost classical early *Glossa ordinaria* layout: a large central column of Bible text written in a hand approximately twice as large as the surrounding gloss. It is easy here to see how the page was laid out: with the text of the Bible written in ever other line, and the marginal gloss on every line.

The interlinear gloss is slightly smaller than the marginal gloss, except for in the middle of the folio, where the interlinear gloss *becomes* the marginal gloss, here glossing the "part" of the vessels carried away from the house of God as the part of the books of the philosophers which is the truthful dogma. In general, the interpretations of both the interlinear and marginal glosses are allegorical in Cassian's technical sense, using the historical events described to look ahead to the church of Christ.

These same observations are equally true of Plate 2, from a thirteenth-century glossed book of Ruth from the cathedral of Augsburg.[10] This text is the last in a series of glossed books of the Bible copied together: Lamentations, Tobit, Judith, Esther, and Ruth. Tobit, Judith, Esther, and Ruth were a favorite combination, appearing together in many *Glossa ordinaria* manuscripts, even though these books did not fall together in the order of the Vulgate Bible. This was, apparently, a collection of favorite Bible stories.

Right away, in the first two glosses (both taken from the Carolingian exegete Hrabanus Maurus) a clear allegorical reading is outlined. In the outer margin, we are told that the man who went out from Bethlehem is Christ, the wife who went out with him, the Church. In the gloss placed in the inner margin, the man is interpreted as the ten commandments, his wife as the Synagogue. Much of Hrabanus's commentary is taken from Jerome, and shows it in its concern for onomastical allegory; for example, Chelion, one of the sons of Elimelech and Noemi, signifies (onomastically) consummation, and (allegorically) the apostles. The interlinear gloss continues these two

lines of interpretation, giving more onomastical meanings, or allegorical interpretations. For example, the interlinear gloss on Noemi, "Pulchra es amica mea etc." is a quotation from the Song of Songs which serves to continue the allegory of Noemi as the Church, since this is the overwhelming majority tradition of Song of Songs commentary in medieval Latin Christianity.[11]

This Augsburg manuscript thus seems easy to interpret on the one hand, reading it the way Barney read the gloss on Genesis 38. Here is an allegory which has overshadowed the "plain sense" of the biblical text. But looking at the *manuscript page*, something Barney did not do, raises some other questions of textuality. These questions are both about how Ruth and the *Glossa* to Ruth were to be read, and how they were produced. For one thing, looking at this page, it is hard to conceive of the "little biblical text floating in its sea of gloss" and nearly drowning. I submit that there is little doubt which of the texts on this page is the boss. Not only is the Bible text strikingly bigger, but it also, for the last eight lines of Bible text, takes up two of the three columns in which the folio was ruled.

This breaking of the boundaries between text and gloss was probably done because there was relatively little commentary for these verses. As a group of design students with whom I looked at *Glossa ordinaria* manuscripts pointed out to me, the trick to layout on these pages is to allow creatively for the combination of texts.[12] The Saint Victor manuscript shows one response to this problem: a rigidly laid out page with a uniform Bible text and gloss filling in where there is gloss to fill in. The Augsburg manuscript is more flexible, allowing for the text of Ruth to fill the page when the gloss is scant. This is a development noted by de Hamel as fairly common in *Glossa ordinaria* manuscripts (other than manuscripts of the Psalter and the Pauline Epistles) after the middle of the twelfth century.[13] Nevertheless, both manuscripts clearly place the Bible in the center of the page. These are glossed *Bibles*.

Furthermore, I would argue that the very nature of the *Glossa ordinaria* makes the reading of the Bible text the absolute priority, because the *Glossa* is not a coherent text in its own right, but depends upon the Bible to make any sense at all. A look at Plates 3 and 4 will help to show what I mean by this. These examples are from the same manuscript, a thirteenth-century codex from the Sorbonne, containing a glossed Jeremiah and Lamentations.[14] Plates 3 and 4 show the openings

of Jeremiah and Lamentations. Now, looking at these manuscripts, one could have more sympathy for Barney's image of the poor little Bible text swimming, even drowning, in a sea of commentary. The layout of commentary on the page has grown far more elaborate, taking up as many as three of the four columns ruled on the page. In the case of the beginning of Lamentations, the prefatory material actually pushes the *incipit* of the text down to the bottom quarter of the page. Nevertheless, the points I made about the Saint Victor and Augsburg manuscripts apply here as well: the Bible text is much larger than the marginal and interlinear gloss, and, especially with the elaborate and showy decorated *incipits*, grabs the attention of the reader.

One reason that the Bible text is set out in such a dramatic way is that it *can* be read all the way through, whereas the commentary texts cannot. The *Glossa ordinaria* is not a coherent text of its own. It is entirely dependent on the biblical text to provide the context that gives it sense. The layout of this Sorbonne manuscript makes this discrepancy startlingly clear. Unlike the large commentaries of Carolingian scholars, which are virtuosic in the way they weave together various texts into a coherent whole,[15] unlike the Jewish commentaries on the Mishnah which, in the age of printing, were made to wind around each other whole,[16] the marginal gloss was never intended to be read as a text in its own right. It was meant to be read, along with the interlinear gloss, in polyphony, or perhaps in syncopation, with the biblical text. This is a Bible laid out to give the reader the opportunity to engage in mental dialogue, to read the Bible with various levels of commentary built in, with or without interpretations attached.[17]

Recognizing this, of course, does not solve our problem, it just clarifies it. To say that the *Glossa ordinaria* must be read along with the text of the Bible to make any sense at all does not help us with the dilemma of how this reading proceeded. The problem is already apparent in the examples given in Plate 1. Which of the two glosses which head the *incipit* of Daniel in the Saint Victor manuscript should be read first: the quotation from Jerome that tells us Daniel means the judgment of God, or the longer discussion (also from Jerome) of the historical background to the story of Daniel? Which has precedence, history or allegory? Or, in the case of the Augsburg manuscript, in which the flanking marginal glosses give different allegorical interpretations, should one read first that Elimelech and Noemi signify

the ten commandments and the Synagogue, or Christ and the Church? Or is the answer more mechanical than that: does one start reading from the right or the left, or from the inside or the outside of the page?

The Sorbonne manuscript of the *Glossa ordinaria* to Jeremiah and Lamentations really highlights this problem by providing us with so many opportunities: where to begin? Right? Left? Inside? Outside? Plate 5 shows an opening from the Sorbonne manuscript, giving the *Glossa ordinaria* to Lamentations 1:18–21. Here the Bible text is one small column of as many as five columns marching across the page. The marginal gloss gives rather long passages (almost all from the Lamentations commentary of Paschasius Radbertus, the first Latin commentary on Lamentations alone)[18] but weaves them together in such a way as to make any sense of continuity in reading of the gloss alone virtually impossible. In one case, the gloss on Lamentations 1:18, "et videte dolorem meum," the marginal gloss becomes quite central, being placed right in the middle of the central column where it actually interrupts the reading of Lamentations.

It should be noted that these glosses are marked as to lead the reader to a particular interpretation: the two bottom inside columns of folio 98v, for example, offer an allegorical and a moral reading of Lamentations 1:19, "Vocavi amicos meos." This is easily explained from the source history of this particular part of the *Glossa ordinaria*: Gilbert of Auxerre ("the Universal Gilbert"), compiler of the *Glossa* to Lamentations, used Paschasius Radbertus fully for his gloss, keeping the distinction of the levels of reading Radbertus brought to the interpretation. But what it suggests for the reader is much more interesting: the possibility that the *Glossa ordinaria* may have been intended as the medieval equivalent of our modern reference Bibles. The evidence of this page suggests that the reader had a maximum of choice: the glosses could be consulted if needed, or not pursued at all, at the discretion of the individual.

Now, this investigation of a few of the thousands of manuscripts of the *Glossa ordinaria* which have survived allows us to return to Stephen Barney's assessment of the function of the *Glossa* with a new perspective. I appreciate Barney's insight into the power of the community of interpretation, but I do not think the *Glossa ordinaria* can support his claim that "the community of interpretation . . . is more powerful than the text it preserves." This may be the impression given by printed editions of the *Glossa ordinaria* (Barney used the *Patrologia*

Latina and a 1498 Basel printing of the *Glossa* with the *Postillae* of Nicholas of Lyra).[19] The text of the Bible is always at the center of any inquiry into the *Glossa*, simply because the *Glossa* does not exist, as a coherent text, in isolation from the Bible text it glosses. The manuscripts make this clear.

I think it is *what* the *Glossa ordinaria* has to say that is really at the basis of Barney's critique, that is, he simply does not like the allegorical interpretations of the Bible which the *Glossa* makes so readily available to the reader. When Barney says the gloss "displays medieval exegesis in its apt visible form on the page, and sacred scripture recedes like a *dieu caché*," he is assuming that medieval exegesis is an entity separable from the sacred scripture. The irony of this, of course, is that Barney did not really see the medieval *Glossa ordinaria* in its "apt visible form on the page," since he did not see the manuscripts.

Furthermore, Barney gives us a very contemporary reading of the Bible, a reading which assumes that the story of Judah and Tamar, for example, is "about" sexuality, but not "about" Christ and the Church. On the other hand, the very compilation of the *Glossa ordinaria* shows that medieval readers had very different assumptions about the Bible, beginning with the belief that the Bible was a tool of the Christian doctrinal enterprise. They were able to develop a tool of communication admirably suited to bring the many things a biblical verse could mean into easy reach of the reader of that verse. We still have a great deal to learn about the *Glossa ordinaria*, but we will never get anywhere in this quest until we begin with the desire to understand how medieval readers perceived the gloss.

Readers of the Bible in other times and places of the Christian tradition have actually been closer to the spirit of the *Glossa ordinaria* than we might think. Although Luther also rejected its form and function, he understood and proclaimed the principle that had shaped its development: that the word of God cannot be removed from the people of God. The *Glossa ordinaria* is testimony to the medieval Christian grappling with the dynamic tension between revelation and interpretation. It merits careful study, and will reward us with better understanding of the medieval world of text and reader.

NOTES

1. Jaroslav Pelikan, *The Christian Tradition: A History of the Development of Doctrine* vol. 4, *Reformation of Church and Dogma (1300-1700)* (Chicago: University of Chicago Press, 1984) 181–182.

2. This was first recognized by Beryl Smalley, *The Study of the Bible in the Middle Ages* (Oxford: Oxford University Press, 1941). The argument of this book was based on a series of Smalley's earlier articles: "Gilbertus Universalis Bishop of London (1128–1134) and the Problem of the 'Glossa Ordinaria' I," *Recherches de théologie ancienne et médiévale* 7 (1935) 235–262; "Gilbertus Universalis Bishop of London (1128–1134) and the Problem of the 'Glossa Ordinaria' II," *Recherches de théologie ancienne et médiévale* 8 (1936) 24–64; and "La *Glossa Ordinaria*," *Recherches de théologie ancienne et médiévale* 9 (1937) 365–400. For the most recent discussion of the development of the *Glossa ordinaria* see Margaret Gibson, "The Glossed Bible" in *Biblia Latina Cum Glossa Ordinaria: Facsimile Reprint of the Editio Princeps Adolph Rusch of Strassburg 1480/81* (Turnhout: Brepols, 1992) VII-XI. For a discussion of the false attribution to Walafrid Strabo, see Karlfried Froehlich, "The Printed Gloss," in *Biblia Latina Cum Glossa Ordinaria* (1992) XII-XXVI. For the inadequacies of the *Patrologia Latina* edition of the Gloss, published by J. P. Migne in *Patrologia Latina* 113–114 (Paris: 1879) as a work of Walafrid Strabo, see Froehlich, XXV-XXVI.

3. Margaret Gibson, "The Twelfth-Century Glossed Bible," *Studia Patristica* ed. E. Livingstone 23 (1989) 232–244.

4. For the most detailed description of the layout of the *Glossa ordinaria*, see Christopher de Hamel, *Glossed Books of the Bible and the Origins of the Paris Booktrade* (Woodbridge: D. S. Brewer, 1984).

5. Gibson (1989) 233–236.

6. For Isaiah, see Gibson (1989) 239; for Jeremiah see Gibson (1992) VII–IX.

7. Lesley Kordecki, "Let Me 'telle yow what I mente': The Glossa Ordinaria and the Nun's Priest's Tale," *Exemplaria* 4 (1992) 365-385; Stephen A. Barney, "*Ordo paginis*: The Gloss on Genesis 38," *South Atlantic Quarterly* 91 (1992) 929-943.

8. Barney, p. 940.
9. Paris, Bibliothèque nationale, latin 1478; For the library of Saint Victor, see the introduction of Gilbert Ouy to *Le catalogue de la bibliothèque de l'Abbaye de Saint-Victor de Paris de Claude de Grandrue, 1514* (Paris: Editions du Centre national de la recherche scientifique, 1983).
10. Munich, Bayerische Staatsbibliothek clm 3803.
11. E. Ann Matter, *The Voice of My Beloved: The Song of Songs in Western Medieval Christianity* (Philadelphia: University of Pennsylvania Press, 1990) 49–85.
12. I am grateful to Professor Marco Frascari, of the School of Art and Architecture at the University of Pennsylvania, for giving me the opportunity to discuss the *Glossa ordinaria* with his students in the context of his seminar on "Space," spring, 1993.
13. de Hamel, pp. 14–27.
14. Paris, Bibliothèque nationale latin 15513.
15. John Cavadini, " The Sources and Theology of Alcuin's 'De Fide Sanctae et Individuae Trinitatis'," *Traditio* 46 (1991) 123–146.
16. David Stern, "The Typography and Topography of the Talmud," unpublished paper; see also Eliezar Berkovits et al., "Talmud, Babylonia," *Encyclopedia Judaica* 15, 764-766.
17. Mary Dove has suggested that the *Glossa ordinaria* called for a "spiral reading" of the Bible and the accompanying commentaries, "The Glossed 'Osculetur me' and the Ready Reader," paper delivered at the Twenty-Ninth Congress on Medieval Studies, Western Michigan University, Kalamazoo, Michigan, May, 1994.
18. E. Ann Matter, "The Lamentations Commentaries of Hrabanus Maurus and Paschasius Radbertus," *Traditio* 38 (1982) 137-163.
19. Barney, p. 942. Kordecki used a Paris 1590 printing of the *Glossa*, p. 365.

The Virtuous Pagan: Dante and the Christian Tradition

Marcia L. Colish

The ultimate focus of this paper is Dante's treatment of virtuous pagans in the *Divine Comedy*. In deciding whether and where to place them in the other world, Dante had a wealth of existing theories concerning the possibility of their salvation to choose from, both in the high theological culture of medieval Christianity and in the tradition of popular Christian literature, both in Latin and in the vernaculars. Neither of these registers of Christian culture produced a monolithic answer to the question of whether a virtuous pagan could be saved. In addition to providing Dante with a range of options, this fact is itself interesting. Another notable feature of this background is the phenomenon of crossover. Theological ideas were appropriated by writers of popular Christian literature; and professional theologians took seriously the beliefs recorded by popular authors. Texts were transferred from Latin to Greek and back again; and the same notions were cycled back and forth between the learned languages and the vernaculars. In this basic sense, ecumenicity goes with the territory. On another level, it goes with the territory in that some authors addressing the salvation of the virtuous pagan can be called ecumenical maximalists, in holding that salvation could literally be universal. Proponents of this view represent it strongly against others who place more stringent conditions on access to heaven. It has often been said by

church historians that Christian beliefs, as expressed in the prayer life of the church, shape official doctrine: *lex orandi, lex credendi*. This commonplace holds true for the present topic. But so does the obverse. For the beliefs of medieval Christians as to who could be saved also controlled what and whom they prayed for. *Lex credendi* affected *lex orandi* as well.

Although, as these introductory remarks indicate, high and popular Christian culture influenced each other and the traffic was a two-way street, for purposes of convenience let us look at the popular tradition first, and then at the theologians, before turning to Dante. Evidence of the popular belief that pagans could be saved begins quite early, starting with the second-century saint's life of the first post-biblical martyr, Thecla, who prays the pagan Falconilla out of hell and into heaven.[1] This *vita*, first written in Greek, circulated in Latin as well during the Middle Ages. In some later versions, authors are uncertain as to whether Falconilla had been translated directly into heaven or brought back to life so that she can become a Christian herself, or granted posthumous grace by a divine miracle,[2] themes we will encounter in another connection. A similar story is told in the *Passion of St. Perpetua*, dating to the early third century, in which Perpetua prays into heaven her brother Dinocrates, who had died at the age of seven.[3] The text says nothing about his beliefs or moral condition.[4] In both of these accounts, the emphasis is placed on the power of the suffrages of a major saint.

Another approach to the idea that souls in hell could be assisted, if not liberated from hell entirely, is found in the narratives concerning the Irish St. Brendan, in which damned souls obtain a temporary reprieve from punishment by divine mercy. This idea is found both in the *vitae* of Brendan, who lived in the sixth century, and in the *Navigation of St. Brendan*, a text first written in Latin in the tenth century in the Rhineland,[5] whose story was retold repeatedly in many vernaculars thereafter. The historic Brendan was a traveling man, visiting Scotland, England, and Brittany.[6] The particular voyage that interests us, in these texts, has much in common with Old Irish tales of trips to the other world. Brendan and his company of monks take ship in quest of the isle of the blessed. Enroute, they stop at an island inhabited by birds who turn out to be fallen angels, although they did not fall as hard as Lucifer. God grants them a reprieve from hell on Sundays and holidays and they even enjoy a limited vision of God.[7]

These angels in avian form appear in the *vita* of Brendan as well as in the *Navigation*. The latter text reports a second miraculous reprieve. Brendan's company meets Judas Iscariot on another island, who tells them that he, too, is relieved of his sufferings by God's mercy on Sundays from Christmas to Epiphany, on Easter and Pentecost, and on the feasts of the Purification and Assumption of the Virgin.[9] A second *vita* of Brendan was written, so the author tells us, to set the record straight,[10] thereby testifying to the emergence of alternative versions, which omits the avian angels but includes the reprieved Judas.[11] In all of these versions, Brendan arrives at the isle of the blessed, with successive accounts describing it in more circumstantial detail. In some cases Brendan sees saved inhabitants of the isle or an angelic choir whose singing he cannot hear. But the only person with whom he converses on the island is its angelic steward.[12]

The vernacular retellings of the Brendan story embroider the tale and add new episodes to it.[13] Sometimes they abridge the story, as does a Lucchese version of ca. 1300 in which Brendan becomes a Venetian and is allowed to hear the angelic choir, the latter detail also appearing in a thirteenth-century Venetian version.[14] But the key point, the reprieve from hell for the fallen angels and Judas by God's mercy, remains standard. The potential that this legend had for fanciful add-ons is revealed in another Italian version in which Judas relates that, aside from betraying Christ, he commited other major sins, such as murdering his father, marrying his mother and siring many children in this incestuous union, defrauding customers in his profession as a merchant, practicing usury, theft, and the receiveing and fencing of stolen goods, as well as criticizing Mary Magdalene for wasting precious oils when she bathed Christ's feet. Also, in this version, Judas asks Brendan to pray for him, reflecting the assumption that the intercession of prayer, as well as divine mercy, can help him.[15]

The propensity of the *Navigation* for attracting ludicrous addenda such as these provoked a reaction against its authenticity in some quarters by the thirteenth century. The Saxon poet Nicholas of Bibera ridicules it as the product of a deranged mind and as not to be believed. Indeed, he finds it noxious in that it stimulates a false hope (*infelix spes*) as to who can be saved; Jacques de Vitry takes his stand by omitting Brendan's life in any form from the *Golden Legend,* his anthology of saints' lives; Vincent of Beauvais pointedly distinguishes the *vita* of Brendan, which he thinks accurately reports the doings of

this austere and holy abbot, from the *Navigation*, which should be severed from it because of its cockeyed and apocryphal content (*propter apocrypha quaedam delirimata, quae in ea videntur continere, penitus ab opere isto resecavi*).[16] These qualms, however, do not appear to have had a chilling effect on the credibility of the tale, since vernacular versions continued to abound. And, as the sequel will show, Brendan received a hearing in some highly educated quarters as well.

In the *vitae* of Thecla and Perpetua, pagans are saved irrespective of their virtue; in the Brendan legend, sinners who are presumed to believe in Christ are granted temporary remission of the fires of hell. Yet another approach is found in a third popular tradition, in which salvation or help is granted to a virtuous pagan, the Emperor Trajan, as a consequence of the prayers of Gregory the Great. Gregory's *vitae* received a wide hearing in both the Latin and Greek churches. It is true that this emperor was treated as an example of virtue in late antiquity by pagan and Christian authors alike.[17] But the text that launched the idea that Gregory had prayed Trajan out of hell is the earliest Latin *vita* of Gregory, by an anonymous monk of Whitby writing ca. 704–14,[18] whose account was recycled, with notable alterations, by both Latin, Greek, and vernacular authors after his time.

The Whitby monk has a decidedly English "take" on Gregory, who appeals to him as a subject because of his mission to England after his encounter with the fair-haired *Angli* in the Roman marketplace, whom he mistakes for angels.[19] The author is interested, to some degree, in Gregory's career as pope, since some of the miracles ascribed to him show Gregory wielding the power of the keys with respect to the living and the dead,[20] including Damasus, a previous pope.[21] The opening of the Gregory-Trajan story in this *vita* had an extremely durable appeal. Trajan's virtue is recalled to Gregory's mind by the representation of him on the column of Trajan, which he sees while strolling in Trajan's forum. Gregory is struck with sorrow that such a just ruler should be damned merely because he was a pagan. At this juncture, the author flags a theological objection posed by the action Gregory takes and offers his own solution to it: "Some of our people also tell a story related by the Romans of how the soul of the Emperor Trajan was refreshed and even baptized by St. Gregory's tears" (*sancti Gregorii lacrimis animam Traiani imperatoris refrigeratam vel baptizatam*).[22] The event in Trajan's life that triggers Gregory's prayers is his stopping to hear the plea of a poor widow when he was riding in

haste to battle. Her son, she says, has been murdered; she has the perpetrators in hand; but they refuse to pay the recompense: we are in the realm of the Germanic *wergeld*. Trajan tells her that he will deal with the matter when he returns. But, the widow asks, "Suppose you don't return? Who will do justice for me?" Trajan takes her point and settles the matter then and there, making the murderers pay up. As the author notes, on recalling this event, Gregory recognized that Trajan, although a pagan, had fulfilled the biblical injunction to succor the widow and the orphan. Repairing to St. Peter's, he prayed and wept floods of tears, until a divine revelation told him that his prayers had been heard and that Trajan had been transferred from hell to heaven. Further, the revelation told him that he should regard this divine concession as unique and not presume to pray for any other pagan.[23] Before moving on, we may note that this text leaves open the question of whether the exception was made because Gregory was a great saint who was also invoking a papal privilege or whether Trajan can be regarded as baptized after the fact by Gregory's tears, and hence de-paganized. On balance, the closing peroration of the voice from heaven suggests that Trajan is saved although a pagan.

Chronologically, the next *vita* of Gregory is the one written in the eighth century by Paul the Deacon, better known for his *History of the Lombards*. The first edition of this work was published in 1887 and it says nothing about Trajan.[24] The *vita* of Gregory ascribed to Paul in both the *Acta Sanctorum* and Migne's *Patrologia latina* is a pseudonymous and interpolated version written a century later which draws on the intervening *vita* of Gregory by John the Deacon,[25] to whom we now turn.

John's *vita* of Gregory was commissioned in the late ninth century, by Pope John VIII, who made the papal archives available to him. John draws on this rich documentary evidence as well as on Gregory's writings to produce a full-blown life and times of his subject. Having covered these matters in detail, he turns to Gregory's miracles, where he locates the Trajan story.[26] John opens with the now-standard stroll in the forum but introduces several changes in the rest of the account. He places more emphasis than the Whitby monk does on the fact that Trajan was in a terrible hurry (*ad imminentis bellis procinctam festinanti vehementissime*). The widow's complaint notes that her murdered son had been innocent and that murder is a capital crime: we are back in the realm of Roman law. John lengthens the conversation

between Trajan and the widow. After she says, "Suppose you don't return?" Trajan says that his successor will judge the case. She then asks, "What profit will you gain, if someone else gets the credit for doing justice for me?" Her argument, that both Trajan and she will benefit if he stops and renders justice on the spot, is what convinces him to do so. Her plea, according to John, appeals to Trajan's justice and *pietas* alike.

John also rings some changes on Gregory's action, in comparison with the Whitby monk. To begin with, John criticizes Gregory for praying for Trajan. It is theologically impossible to alter the status of the damned, he notes, a point that Gregory himself makes in Bk. 4 of his *Dialogues*, where Gregory does indeed state that persons damned for unbelief or impiety cannot be helped by prayer. John does give Gregory an out here, since he has described Trajan as pious. In any event, he thinks that Gregory's prayers did have a positive effect. This effect is not Trajan's translation to heaven, but the lightening of Trajan's punishment in hell. Finally, having told this miracle story after a number of other miracles ascribed to Gregory, John observes that, while everyone believes in the other miracles, this one is generally held to be unworthy of credence (*omnino incredibile videtur*) because of the theological impropriety of Gregory's prayers, prayers which he nevertheless presents as having a beneficial effect.

The interpolated *vita* of Pseudo-Paul, written shortly after John's *vita*, takes a different tack. The author's coverage of Gregory's life and pontificate is less broad-gauged than John's. He makes it clear that he disagrees with John's judgment of Gregory's actions in the Trajan story. Far from criticizing him, the author describes him as "a priest most perfect and acceptable to God" (*vero perfectissimus et acceptabilis Deo sacerdos*) in the now-canonical opening scene in the forum. [27] In this version, the widow describes her son as her only son, the prop of her old age, and weeps as she enters her plea. She adds that the murderers tried to kill her as well. Pseudo-Paul cuts off the conversation that John had extended, ending it where the Whitby monk does, omitting the discussion of who will get the credit. Gregory's response in this account is initially like the one in the Whitby *vita*. He is moved to tears and prayers because he sees in Trajan the fulfillment of the biblical injunction concerning widows and orphans. Pseudo-Paul does not suggest that Gregory's tears can be construed as baptism but sides with the Whitby monk as to their outcome, the translation of

Trajan to heaven. But he portrays Gregory as sensitive to his own presumption in asking God to save an unbaptized pagan. Hoping to mitigate that presumption in God's sight, Pseudo-Paul's Gregory offers God a trade-off. He agrees to accept punishment for himself if Trajan is saved. Let us note that, in the original version of this theme, the deity does not take up Gregory's offer and exact a *quid pro quo*. Thus, although Pseudo-Paul regards the idea of praying a pagan out of hell and into heaven as problematic, even when the pagan is virtuous, he finds a happy resolution in the thought that all things are possible to God. Further, and on this point he concludes, in opposition to John he states that no one murmured or questioned the translation of Trajan to heaven, for all acknowledged God's power and mercy in the event. For this author, it is divine power and mercy, and not the charisma of a saintly intercessor, that is stressed.

In the next chapter of the Gregory-Trajan legend we move to the Greek church, to a work erroneously ascribed to the eighth-century theologian John of Damascus but which must date to the late ninth or early tenth century because it makes use of the *vitae Gregorii* of both John the Deacon and Pseudo-Paul. The author clearly prefers Pseudo-Paul's version.[28] The text is a sermon encouraging prayer for the dead. Pseudo-Damascene brings forward Thecla[29] and Trajan[30] to make the same points. In each case, the person prayed into heaven was a pagan. Second, God will hear the prayers of ordinary Christians and not just those of great saints. And third, the efficacy of the prayers of Thecla and Gregory for their respective pagans is not to be doubted. Given John the Deacon's challenge to the credibility of the Trajan legend, Pseudo-Damascene takes pains to stress its acceptance by everyone in east and west alike. With respect to Trajan, he emphasizes the emperor's virtue; incorrect belief was the only blot on his record. Still, since such pagans can be prayed out of hell and into heaven, how much the more can Christians who have died in the faith be helped by the prayers of their co-religionists. In addition, in opposition to people who say that few were saved in Christ's harrowing of hell, Pseudo-Damascene thinks that the reverse was the case. Many were saved thereby, he asserts, so long as they lived upright lives.[31] Living Christians, he concludes, should imitate God's mercy and generosity in their suffrages for the dead.

Psuedo-Damascene's reference to Thecla is not surprising, since her story appeared originally in both Greek and Latin; but his

familiarity with the lives of Gregory he cites requires more explanation. The key figure here is likely to have been Anastasius Bibliothecarius, a bilingual cleric stationed at Rome, an associate of John the Deacon, and a man active in the affairs of the church, since he attended the Fourth Council of Constantinople in 869–70.[32] Anastasius is known to have translated a saint's life from Greek into Latin;[33] and he may well have rendered this service in reverse to the *vitae Gregorii* of John and Psuedo-Paul, or at least have conveyed their substance orally to his Greek-speaking colleagues, whence it made its way to Pseudo-Damascene.

In any event, the confusion between this author and the John of Damascus revered as an authority in the Greek church helps to explain what happened next, the institutionalization of prayers for the dead, including the damned, by the Greek church and its Slavic daughter churches. By the thirteenth century, these churches had set aside the third Saturday before Lent for prayer for the dead of all sorts, in a formal liturgy whose perdurance can be documented until the sixteenth century.[34] Aside from this influence on the liturgy, Pseudo-Damascene also had a marked influence on the eschatology of the eastern churches.[35] From the eleventh century onward, the belief that the prayers of living Christians could save pagans who were damned, or mitigate their sufferings, received support from eastern theologians; and Trajan was even enrolled in their calendar of saints. These developments are related to the fact that the doctrine of purgatory was not taught in the eastern churches. That fact, paradoxical in the light of the Latin ancestry of the Gregory-Trajan legend, in turn became a stumbling block impeding the hoped-for reunion of the Greek and Roman churches at the Council of Ferrara-Florence in 1438–39.[36]

While these events were taking place in the east, the Trajan story was being recalled and amplified in the west. In 1062, the Holy Roman Empress Agnes referred to Trajan as a pagan prayed into heaven, in Pseudo-Paul's version of the story, in a letter requesting the abbot and monastic community of Fruttuaria to pray for her. Her reasoning is parallel with that of Psuedo-Damascene.[37] Wider attention was given to Trajan in the twelfth and thirteenth centuries by a variety of authors. John the Deacon's version, with the mitigation of suffering and the critique of Gregory, is repeated by the chroniclers John Bromyard, Theodore Engelhus, Matthew Paris, the authors of the *Annals of Magdeburg*, the *Chronica majora*, the *Flores historiarum*,

and by Caesarius of Heisterbach.[38] In his *Pantheon et speculum regum*, Godfrey of Viterbo combines the Whitby monk's theme of Gregory's tears acting as posthumous baptism with Pseudo-Paul's theme of Gregory's willingness to accept punishment in exchange for Trajan's salvation, which Godfrey sees God as accepting, afflicting him with a gimpy leg.[39] Bonino Mombriso simply recapitulates Pseudo-Paul in his own life of Gregory, as Sicard of Cremona does in his chronicle.[40]

In the same period a new and more political note is struck in references to Trajan, by chroniclers and other authors alike. In a Latin sermon by Honorius Augustodunensis, echoed in a German sermon later in the twelfth century, the preachers, specifically addressing judges, draw on the long version of the conversation between Trajan and the widow given by John the Deacon but yoke it with Trajan's salvation according to Pseudo-Paul, adding only that an angel delivered the heavenly message to Gregory but omitting his willingness to accept punishment.[41] A similar combination of these two sources is found in the *Kaiserchronik*, except for the fact that the author sees Gregory's action as problematic and reintroduces the theme of punishment, as a divine requirement rather than as a Gregorian offer. He departs from Psuedo-Paul in that the punishment is actually imposed, but stresses, with him, the theme of divine omnipotence as well as the object lesson for rulers to be found in Trajan.[42] This latter idea is emphasized even more by John of Salisbury, who makes his own combination of John the Deacon and Pseudo-Paul in his *Policraticus* of ca. 1159. This work brings Trajan forward amid a host of Roman leaders held up for emulation as exemplary statesmen. In Trajan's case, excellence as an administrator and as a general in the field as well as learning, generosity, moderation, and justice are the virtues John praises. He cites the long version of the conversation between Trajan and the widow from John the Deacon but agrees with Pseudo-Paul that he was transferred to heaven, omitting the punishment offer but including the heavenly message about the exceptional nature of the concession. Given John's focus on the good ruler, in reporting on the salvific outcome of Gregory's intercession he is less interested in Gregory's holiness or papal authority and in God's omnipotence than in the virtues of Trajan and the fact that both Gregory and God recognize and reward them.[43]

The *Policraticus* was widely read in the later Middle Ages and exerted considerable influence; although the Latin translation of

Pseudo-Damasecene's sermon in ca. 1180 made that author's conflation between John the Deacon and Pseudo-Paul available as well.[44] Thirteenth-century authors influenced by one or both of these texts include Helinand of Froidmont, the immediate source of Vincent of Beauvais, the authors of the *Fiori di filosofi* and *Novellino*, the political theorists Giles of Rome and Bartholomew of Lucca, and the author of an Anglo-Norman French life of Gregory.[45] Vincent of Beauvais was no doubt the most widely read of the authors just mentioned. He provides a detailed account of Trajan's reign in the section of his *Speculum historiale* dealing with Roman history. It is here that he relates Trajan's encounter with the widow, adding a few new details. The murdered son is described as most just and most innnocent (*justissimus, innocentissimus*). Vincent gives the long version of the conversation and provides the widow with another argument, the point that, in addition to getting credit for himself by stopping and rendering justice, Trajan will also be setting a good example thereby. Vincent also describes the widow's satisfaction as condign.[46] Arriving at Gregory's era, he gives a life and times even fuller than John the Deacon's. In his standard opening of the Trajan episode, Vincent adverts to the sculptural relief bringing this event to Gregory's mind. But, since he had already related it, he does not repeat it here, referring the reader to the earlier part of the text. He agrees with Pseudo-Paul that Trajan is saved by Gregory's prayers and, with John of Salisbury, omits Gregory's offer to take on punishment. With the *Policraticus*, Vincent presents Trajan's translation to heaven as in no way problematic.[47] Elsewhere in the same work Vincent reprises Gregory's career briefly, but without mentioning Trajan.[48]

The thirteenth century also witnessed the emergence of versions of the Gregory-Trajan story that add new embellishments or that change certain features of the original plot. In several German sources, Trajan stops to confer with his counsellors before hearing the widow's plea, and an account of the malefactors' trial is included. This latter amplification occurs in Spanish versions of the tale as well.[49] A more substantial change is found in a number of German and Italian chronicles, the idea that it was Trajan's son who accidentally killed the widow's son, running him over on horseback. Trajan judges his son guilty and, at the widow's instance, spares his life but blinds him in one eye. A Spanish romance gives this latter story.[50] Yet another popular

version sees the widow's problem as requital for an insult done to her daughter's honor.[51]

With this array of possibilities, and others, before him, Jacques de Vitry, faced with the task of presenting the life of Gregory in his *Golden Legend* in ca. 1228–30, responded not by choosing among available versions but by anthologizing all those he knew. He prefaces his collection of *vitae Gregorii* with an attempt to provide a history of the text, which is defective because he is ignorant of the Whitby monk's *vita* and because he reverses the order of the versions by John the Deacon and Pseudo-Paul.[52] Jacques divides the story into two parts, the first covering the conversation between Trajan and the widow and the second dealing with what Gregory's prayers accomplished. His two alternatives for the conversation are John the Deacon's account and the one in which Trajan's son accidentally kills the widow's son. But, rather than blinding him in one eye, Jacques has Trajan giving his son to the widow as a servant and surrogate son, and also endowing her munificently.[53] Given the number of authors faithful to John the Deacon's version in all respects, including John's criticism of Gregory, the fact that Jacques omits that point looks to be deliberate. He follows Pseudo-Damascene's view that God pardoned Trajan thanks to Gregory's tears and prayers, as the sole exception to the anti-pagan rule stated by the heavenly voice.[54] But, now moving to the second part of the story, in what did that pardon consist? Jacques lists all the alternatives we have already encountered and adds a new one, for which the earliest known textual witness is Peter Abelard, writing a century earlier. As Jacques indicates, some say that Trajan was translated directly into heaven. Some say that he remained in hell but that his physical sufferings were lightened, although he continued to suffer the moral punishment of the damned, deprivation of the vision of God. We see here a reworking of John the Deacon's verdict, in the light of an early thirteenth-century theological distinction taught by the scholastics of Jacques's generation. Some say that the heavenly voice told Gregory that he would have to suffer for praying a pagan out of hell and that he was given a choice between illness for the rest of his life and two days' punishment in purgatory. According to Jacques, everyone who supports this view, which we may note is a refinement on Pseudo-Paul, agrees that he chose illness, although they disagree on whether the illness was gout, fever, or stomach pains. Finally, and here is the innovation of which Abelard is the first known witness, some say

that Trajan was brought back to life by Gregory's prayers so that he could embrace Christianity and earn salvation the way that other Christians do.[55] Jacques presents all these versions of the story as equally plausible.

Variety, as canonized by Jacques de Vitry's smorgasboard approach to Gregory and Trajan, continued to mark treatments of this subject in fourteenth-century literature. Although it takes us beyond Dante's time, as does the eastern churches' use of Pseudo-Damascene, this issue is of interest as a gauge of how influential Dante's own treatment of this theme was to be. A virtuous pagan judge is saved by the prayers of St. Erkenwald, in the fourteenth-century English poem by that title. The protagonist both resurrects the judge and prays him into heaven on the model of the Whitby *vita* since his tears are held to constitute baptism *ex post facto*.[56] There is a fourteenth-century Norman French poetic life of Gregory offering two accounts, which the author presents not as alternatives but as referring to two separate incidents in Trajan's reign. One version adopts the strategy favored by many of the poet's predecessors, combining the long conversation in John the Deacon, along with his objections to the salvation of a pagan, with the idea that Gregory's prayers none the less translated Trajan to heaven.[57] The second version the poet gives is the one where Trajan's son accidentally runs over the widow's son. He gives his own personal twist to this version, accenting the emotions of both interlocutors and the widow's sensitivity to the difficulties Trajan faces in judging and sentencing his own son. Trajan is, indeed, troubled; but he courageously does his duty out of pity as well as justice, also making a monetary settlement on the widow and giving her his son as a servant. Unlike all other versions of the encounter between Trajan and the widow, in this one the emperor is not presented as hurrying off to war when she makes her plea. The moral pointed by the poet in relating this second version would have found favor with John of Salisbury and the author of the *Kaiserchronik*: a good ruler does his duty, come what may, without being influenced by personal considerations. And, it is Trajan's conspicuous merit that attracts the attention of both Gregory and God. In the poet's second version, he attaches the *quid pro quo* of punishment for Gregory in exchange for Trajan's salvation, in which God offers the alternatives cited by Jacques de Vitry. What the author stresses in noting that Gregory chose illness is not only Trajan's justice and pity but also Gregory's perfect charity, in agreeing to undergo what

the text presents as unmerited suffering for another man's salvation. God's omnipotence and His ability to suspend His own rules receive attention in the second version, as does the power of intercessory prayer. But the poet's primary emphasis is on Gregory's salvific suffering as a form of *imitatio Christi*,[58] an idea that surfaces elsewhere in popular Christian literature.

In particular, it surfaces in visionary literature of the high Middle Ages, although not all visionaries are convinced that Trajan and other virtuous pagans are saved. In the thirteenth century, Mechthild of Hackeborn reports a conversation with God in which she inquires about the posthumous fates of a number of people, including Trajan. Noting that Trajan lacked faith and baptism, God says only that no man knows what He chose to do with Trajan.[59] The pilgrim in Philippe de Mézières's *Songe du viel pelerin* has a vision in which eighty-some pagans and Old Testament figures are presented as damned for their vices, with a corresponding array of pagans and Old Testament figures praised for their virtues. While Philippe does not expressly say that the latter group goes to heaven, the parallel structure of the two passages suggests that such is the case.[60] On the other hand, the fourteenth-century visionary Julian of Norwich thinks that God will eventually save infidels and sinners alike, although she names no names, while her contemporary, Brigitta of Sweden, is quite certain that Trajan and other virtuous pagans are saved.[61] This position is also taken, unconditionally, in *The Vision of Piers Plowman*.[62]

While the visionaries just mentioned do not suggest that intercessors have to undergo unmerited suffering as the trade-off for the salvation of pagans, this same theme, already noted in the fourteenth-century Norman life of Gregory, receives attention from several female visionaries, from Mechthild of Magdeburg, Beatrice of Nazareth, and Hadewijch of Brabant in the thirteenth century to Marguerite Porete and Catherine of Siena in the fourteenth. Barbara Newman sees the willingness of these holy women to endure the pains of hell themselves, if God will release the damned in exchange, as a specifically feminine expression of intercessory spirituality, as well as an instance of what she calls the mystics' *demande d'amour*, a challenge to God to show equal or greater love toward the damned than the love that the mystic herself displays.[63]

While Newman presents the apostolate to the damned, with no consideration of their beliefs or morals, as a note peculiar to female

visionaries, this theme recalls the Norman life of Gregory and also points us in two other directions, leading us to the second subdivision of the medieval Christian tradition within which Dante needs to be contextualized, the subdivision inhabited by the professional theologians. The first direction takes us to the doctrine of universalism, the belief in the possible salvation of all mankind. This doctrine is found in paleo-Christian, apologetic, and patristic theology. While it is more marked among the Greeks, it is also taught by the Latins. In addition to perpetuating the disagreements of earlier theologians on the requirements for salvation, scholastic theologians disagree themselves on another matter, a second direction we will take, the question of whether all souls condemned to hell stay there. Even in the high Middle Ages, when the lines between the transient state of purgatory and the eternity of hell and heaven were being drawn with increasing sharpness,[64] these same distinctions were also under attack. Both earlier and later, theological opinions on both these subjects were far from unanimous.[65]

The idea that the preaching and/or baptism of living Christians could save persons damned for their lack of faith and baptism goes back to the paleo-Christian period. The *Shepherd of Hermas* states that such preaching to the dead is efficacious.[66] The rite of preaching to the dead and their surrogate baptism fell into disuetude quite soon among orthodox Christians. But a tradition arose of interpreting 1 Corinthians 15:29: "What do people mean by being baptized on behalf of the dead? If the dead are not raised up, why are people baptized on their behalf?" not as referring to the general resurrection but to the retroactive baptism and salvation of the dead who would otherwise remain damned. Starting with the apostolic fathers, this exegetical tradition is strongly represented among the Greeks; it is Latinized by Tertullian, Ambrosiaster, and Augustine; and it continues in the west through the Carolingian exegetes to monastic and scholastic theologians in the twelfth century. Peter Lombard accepts this reading of 1 Cor. 15:29 on the authority of Ambrosiaster, and so does Thomas Aquinas in the next century. For adherants of this exegetical tradition, vicarious posthumous baptism can save Jews and pagans alike.[67]

There is also ample evidence of the defense of the salvation of non-Christians in patristic theology, the exegesis of 1 Cor. aside. The Greeks are particularly supportive of this idea.[68] Apologetic and patristic writers subdivide virtuous pagans into two groups, one

embracing pagans who lacked a knowledge of Christian revelation either because they lived before the Christian era or because it was physically inaccessible to them and the other made up of Old Testament figures who lived before or outside of God's covenant with Israel. One patristic commonplace explains the salvation of pagans who lived before the time of Christ by asserting that God granted them a special revelation, making them Christians *avant la lettre*. Defenders of this notion include Clement of Alexandria, Cyril of Jerusalem, Irenaeus, Pseudo-Justin, Gregory of Nyssa, Eusebius, Basil, Nilus, and above all, John Chrysostom. Dionysius the Pseudo-Areopagite agrees and thinks that these pagans receive God's special revelation through the ministry of angels. Proponents of this view argue not only for the provision of the Christian faith before it became generally available but also for the provision of the supernatural grace enabling its recipients to lead upright moral lives. Among the Latins, Hilary of Poitiers, Jerome, Ambrose, Ambrosiaster, and Augustine support this theory, as do some of Augustine's fifth-century defenders. A more radical approach to the non-biblical pagans was the argument that they held, by reason, the same truths that Christianity teaches, and that their moral conduct, guided by the natural law, was on a par with Christian standards. This position was advanced most forcefully by Origen and it appealed to apologists like Minucius Felix and Tertulllian, when he was in an accomodating mood, as a strategy for minimizing the differences between paganism and Christianity, so as to make conversion look easy. This line of reasoning is summed up well by Eusebius in his *Ecclesiastical History*. Although the name of Christian is new, he says, "nevertheless our life and method of conduct, in accordance with the precepts of religion, has not been recently invented by us, but from the first creation of man, so to speak, has been upheld by the natural concepts of the men of old who were friends of God."[69]

In the passage just quoted, Eusebius includes as well the holy pagans of the Old Testament, whose salvation is also a certitude for Justin Martyr, Clement of Alexandria, and Augustine.[70] The most influential proponent of that idea in the west is undoubtedly Gregory the Great, who, along with Augustine, bequeathed to his posterity some striking self-contradictions concerning the salvation of the virtuous pagan. Gregory states in his *Dialogues* that faith in Christ as well as piety are required for salvation. But, in his *Moralia*, the figure he uses as the hook on which to hang his moral and contemplative theology is

Job. Gregory calls Job blessed and a moral exemplar while acknowledging that he was a gentile who knew nothing of biblical revelation. He cites as an authority Ezekiel, who includes Job among the pre-Israelites and non-Israelites who were liberated from hell to show that virtuous pagans *(iusti gentiles)* can be saved.[71] Augustine also cites Job as an example of a non-Jewish or pre-Jewish Old Testament worthy in his *City of God*.[72] Aside from the special revelation theory, he invokes another doctrine, predestination, to explain the salvation of Job and others in the same category. Yet, in the *City of God* and other works, Augustine rejects the idea that virtuous pagans can be saved. Some, for him, are not virtuous because their behavior fails to accord with Christian standards. Lucretia, the suicide, and Cato of Utica, the divorcé, are cases in point. Even those who are virtuous are to be excluded because their motivation was a this-wordly one. As his debate with the Donatists heated up, Augustine was also moved to develop the *extra ecclesiam nulla salus* doctrine. And, aware of popular hagiography, he tries to undermine the efficacy of Perpetua's prayers for Dinocrates, either by claiming that Dinocrates had been a catechumen when he died or that he had actually been baptized in infancy although raised as a pagan.[73] Taking another line of attack, in his treatise comparing the morals of the Manichees with those of Christians, Augustine redefines the cardinal virtues as modes of charity, a position he reiterates in his commentary on the Gospel of John.[74] From this perspective, the virtuous pagan is a contradiction in terms, since to possess the cardinal virtues one must first possess the Christian theological virtues. Quite apart from the larger disagreements within the patristic tradition, Augustine alone could provide support for a wide variety of arguments concerning the salvation of the virtuous pagan.

While some of the positions given by some of the fathers are repeated by the Carolingian theologians, the next real chapter of this part of our story takes us to the twelfth and early thirteenth centuries. Most scholars who have surveyed the theological tradition on the virtuous pagan underrate this period, which is a mistake, since some important contributions were made to it then. For instance, a new name is added to the list of holy pagans of the Old Testament by Honorius Augustodunensis, Ahashueras, the husband of Judith, who saved the Jews from their planned massacre by Haman. "This king," he says, "although a gentile, is a type of Christ" (*Hic rex, quamvis gentilis, typum Christi gessit*), high praise indeed.[75] At the same time, and on a

more repressive note, a pervasive concern of twelfth-century theologians was to attack head-on the most universalist of the early Christian theologians, Origen, who had taught that souls can backslide and be converted eternally, so that Lucifer might even be saved. The desire to refute this teaching animated monastic and scholastic theologians alike.[76] And, it was in this largely unpropitious environment that Abelard emerged with his own defense of the virtuous pagan.

Abelard is one of the most interesting theologians in our story, for two reasons. First, he dragooned the virtuous pagan to the defense of his own idiosyncratic theological agenda. And second, despite the laurels he won as a logician and as a proponent of source-criticism, his handling of the Gregory-Tragan story displays both internal inconsistencies and a garbling of his sources. There are two main areas where Abelard used the virtuous pagan as a weapon in battles where much more was at stake. As an ethicist, he holds that full knowledge and conscious choice are the conditions that make an intention virtuous or vicious. Therefore, as he argues in his *Ethics*, ignorance of the Christian revelation or of the Christian moral law is an extenuating factor. If a person is a non-believer because no one acquainted him with the gospel, either because he lived before the time of Christ or physically outside of its hearing, and if that person lives an upright life according to his best lights, following the natural law, God will not deprive him of eternal felicity.[77] We recognize here the laxist patristic position. What outraged Abelard's contemporaries was his application of it to the argument that the people who put Christ to death committed no sin, according to the revelation and faith vouchsafed to them. Unbelief is no bar to salvation in Abelard's sixth letter to Heloise, either. Here, he cites the most concessive version of the Gregory-Trajan story and concludes, "St. Gregory prayed for the soul of Trajan to enter heaven;" and in other cases, too, "God has conceded miraculous power to unbelievers in virtue of their continence and disregarded the error of their unbelief."[78]

But Abelard offers a different scenario for Trajan in his *Sic et non*. Despite his excellent advice about the need to verify sources given in the preface, when he assembles the conflicting authorities on the necessity of baptism for salvation in the body of the text, Abelard presents, as the position of John the Deacon, a version of the story not found either in John or in any known text prior to the *Sic et non* itself,

the one in which Gregory brings Trajan back to life so that he can believe, be baptized, and be saved as a Christian.[79] At another point in the *Sic et non*, also garnished with conflicting authorities, Abelard raises the question of whether or not Christ freed everyone in the harrowing of hell. The authorities he cites include universalists; he also include Gregory the Great's position in the *Dialogues*.[80] Since Abelard did not put the answers in the back of the book, we cannot be certain how he wanted his students to resolve these debates. On the basis of his *Ethics*, and on the basis of his still more notorious appeal to the virtuous pagan in his *theologiae*, it is likely that universal salvation or something close to it was his position.

The single issue in Abelard's systematic theologies that inflamed his opponents the most was the claim that the Platonists' World Soul was equivalent to the Christian Holy Spirit and that these pagans, by the use of natural reason alone, had known and professed the doctrine of the Trinity, which Christians regarded as a mystery of the faith. Abelard opens his attack on that standard view in his *Theologia "summi boni"* and amplifies it in his *Theologia christiana*. Here, in addition to the knowledge of the Trinity, he also argues that the Platonists, and other pagans before and after the advent of Christ, had manifested great virtues, as had holy pagans of the Old Testament, such as Job. In dealing with the non-biblical pagans, Abelard, like John of Salisbury and the *Kaiserchronik* later in the century, lists a batch of virtuous Roman emperors before turning to Trajan. Trajan, he asserts, was saved "without faith and the grace of baptism" (*sine fide et gratia baptismatis*) thanks to Gregory's tears and prayers. As in the *Sic et non*, he cites John the Deacon as his source. But, in the *Theologia christiana*, he is non-commital as to whether Trajan was restored to life or sent to heaven directly, neither option squaring with what John the Deacon thinks.[81] Perhaps his own confusion about Trajan's fate is what inspires Abelard to drop him in his final argument regarding the Platonists in the *Theologia "scholarium"*, invoking instead what he hoped would be a tried and true patristic argument, the idea that the Platonists and other pagan philosophers had been granted a special revelation and were Christians before the fact.[82]

Among scholastics in the first half of the twelfth century, Abelard was not alone in asking whether baptism was necessary for salvation. This question also received attention from theologians in the mainstream who were growing restive with the hard-line Augustinian

position on the damnation of unbaptized infants. Both the Abelardian author of the *Ysagoge in theologiam* and the early followers of Gilbert of Poitiers take a bold line here, invoking Augustine on predestination against Augustine on infant baptism. As they argue, since God, by His unchanging decree, has chosen His elect from all eternity, He will save the elect, baptized or not.[83] And, while Peter Lombard thinks that baptism is a divine institution that should be observed, it is in his treatise on baptism that he states a doctrine later to be developed into the distinction between God's absolute and ordained power. God, says the Lombard, is not required to follow the rules He lays down for mankind: "His power is not constrained by the sacraments" (*suam potentiam sacramentiis_non alligavit*).[84]

This conclusion would seem to open the door to the salvation of non-Christians; but mainstream theologians in the twelfth century are not necessarily in accord on that point. As we have seen, in this area Abelard contradicts himself. So does the Lombard. On the one hand, he states the mid-century consensus on what is required for virtue that wins salvation. Natural virtue is not enough. Before the fall, Adam on his own could only remain in the state of innocence (*stare*). In order to improve morally (*proficere*) and to develop merit-bearing virtue, he needed grace cooperating with his free will. Postlapsarian man needs both operating (*prevenient*) and cooperating grace in order to attain merit.[85] This analysis makes salvation by natural virtue impossible. None the less, and inconsistently so, the Lombard offers a small toe-hold for natural virtue. He notes that a Jew or pagan is quite capable of having good intentions, good faith, and good deeds, which he manifests in his own virtue and in service to others, "drawn by natural piety" (*naturale pietate ductus*).[86]

Later in the twelfth century, both parts of the Lombard's legacy received support. His most important disciple, Peter of Poitiers, agrees that grace is needed for meritorious virtue. Although his analysis of the cardinal virtues is much fuller than the Lombard's, he stands with Augustine in redefining them as modes of charity, thus making them inaccessible to non-Christians.[87] The same teaching is repeated by other Lombardians such as Stephen Langton and Prepositinus of Cremona, and by non-Lombardians such as Simon of Tournai and Alan of Lille; and it is perpetuated in the early thirteenth century by Hugh of St. Cher and William of Auxerre.[88] On the issue of the insufficiency of natural virtue, Alan is easily the harshest theologian of the day. His analysis of

virtue is also pertinent for his definition of the state of moral neutrality. Alan begins with the point that virtue is the activation of man's natural moral aptitude. This activation process has two dimensions. A moral act is virtuous with respect to its exercise (*officium*) and with respect to its end (*finis*). Now the proper end of virtue is the love of God. The proper exercise of virtue pays regard to times, places, persons, and circumstances. With this reasoning in place, Alan argues that neither Jews nor pagans can possess virtue, categorically. A pagan may, for instance, practice chastity. But his behavior lacks a virtuous end, since he is not being chaste to please God. A chaste Jew may aim at pleasing God, Alan concedes. But his practice of chastity is imperfect because it fails to conform to the current Christian rules governing sexual ethics. Alan is unwilling to consider the claim that each of these moral agents is acting according to his best lights and that, in the case of the Jew, these lights include God's law as it has been revealed to him. Alan leaves both the pagan and the Jew in a moral twilight zone, accounted neither vicious nor virtuous despite the formal or material parity of their behavior with Christian norms, to use Aristotelian language that he does not apply. The abnegation of virtue which the pagan and Jew manifest, necessarily for Alan, can also be a moral option for a Christian whose behavior is consistent with the Christian definition of chastity but who is not judged to be chaste because he is motivated neither by chastity nor by unchastity but by apathy toward the whole subject. [89]

 At the same time as the virtuous pagan was being defined out of existence by arguments such as these, another development, also launched by the Lombard, was inspiring late twelfth and early thirteenth-century scholastics to expand the ranks of departed souls who could be prayed into heaven, extending this possibility to some souls held to be damned. The springboard for this development is the analysis of the four states of souls in the resurrection, found in the theologians' accounts of last things.[90] This doctrine goes back to Jerome and Augustine but the form in which the Lombard put it on the scholastic agenda is the form given to it by Gregory the Great. As the Lombard reprises his teaching, some resurrected souls, the well and truly damned, go directly to hell; others, the well and truly saved, go directly to heaven. The other two groups, unlike the first two, are judged in the last judgment. The middling good (*mediocriter boni*) are judged and saved, after a purgatorial interim; the middling bad (*mediocriter mali*)

are judged and damned, although their punishments are lighter than those of the well and truly damned. Along with Gregory, the Lombard maintains that the *mediocriter boni* can be speeded on their way to heaven by the prayers of fellow Christians, which he recommends, but that neither category of the damned can be helped in any way by prayer.[91]

It was just this last point that some theologians in the two generations after the Lombard found unacceptable. The first post-Lombardian to question his treatment of the four states of souls doctrine was Peter of Poitiers. While he agrees that the totally damned cannot be helped, he asks whether, for the *mediocriter mali*, a major good deed would wipe out the damned person's sin and turn the balance. Peter of Capua gives an affirmative answer to this question. For both theologians, however, the alteration in the sinner's state would have had to occur by his own action before he died. But by the end of the twelfth century, an anonymous follower of Peter of Capua could assert that a member of the *mediocriter mali*, if he was a pagan who had virtue "out of natural piety and not out of charity" (*ex naturale pietate et non ex caritate*), could be prayed out of hell successfully and that the church should do so.[92]

A variety of other reasons are given by contemporaries extending the benefits of prayer to the *mediocriter mali*, regardless of why they were damned.[93] Some want to limit the concession to Christians only, or to persons with an unformed or implicit faith, as opposed to heretics. The author of an anonymous *Summa* written at the turn of the thirteenth century appeals to the *Navigation of St. Brendan* to bolster this point, arguing that, on the model of Judas, such souls can receive temporary reprieves from infernal punishment on Sundays and holidays. A much more generous and influential contribution to the relaxation of the state of the *mediocriter mali* is made by Prepositinus. Laying out the state of contemporary opinion at the turn of the century, he notes that the rigorists hold that only the souls of those in purgatory can be helped by prayer. But, he states, there is view held more commonly (*sententia communior*) which extends help to the *mediocriter mali* as well, according to which these damned souls can be helped by prayer both to mitigate their sufferings, or, if God wills it, to remit their sins entirely and remove them from hell. Prepositinus supports the mitigation theory in his *Quaestiones* and sides with the more merciful salvific view in his *Summa theologia*.[94] In both of these

texts, what he accents is the treasury of merits in the chuch and their availability through the church's corporate worship.

But if Prepositinus does not refer to non-Christian virtue or to saintly intercession in these texts as they have come down to us, it seems that he adverted to those ideas in his oral teaching. For, in the next generation of Parisian scholastics, William of Auxerre, citing Prepositinus by name as his source in his *Summa aurea*, brings Brendan to bear on the question, although in a manner quite different from the anonymous summist referred to above.[95] As William cites him, Prepositinus introduced a new wrinkle into the Brendan legend. Having arrived at the isle of the blessed, Brendan converses with one of its glorified inhabitants, who, it turns out, is a Jew. Since he is not one of the Jewish worthies traditionally believed to have been saved in the harrowing of hell, Brendan asks why he is there. The Jew replies that he enjoys refreshment (*refrigerium*), a code word for heaven, because he was virtuous. Continuing, William remarks that, in line with this innovative version of the Brendan story which he received from Prepositinus and whose credibility he does not question, some say that, before the judgment day, the church can assist the damned by its prayers, Prepositinus's own recommendation. Earlier in the *Summa aurea* William also urges the church to pray for all the dead, since no one knows the posthumous destinations of souls before the judgment day.[96] In his treatise on last things, William indicates that Prepositinus had continued to soften his teaching after he wrote his *Summa*. In the final version of his position, he notes, Prepositinus held that the prayers of the church can aid the damned both before and after the judgment day, as well as when souls who will be damned are still alive. However sinful a person may be, William adds, his natural aptitude for virtue cannot be destroyed utterly. So it is not just the suffrages of the church but the retention of the power to will the good by the damned that makes their improvement possible.

In considering current opinions on how the prayers of the church help the *mediocriter mali*, William cites one of the opinions noted in the *Golden Legend*, invoking the contemporary scholastic distinction between the substantial and accidental sufferings of the damned, the first being deprivation of the vision of God, which remains permanent, and the second being physical suffering, which can be mitigated. William also cites the opinion holding that these souls can be prayed out of hell. He brings the Gregory-Trajan story to bear on this

point and offers two versions of it, the Whitby and Pseudo-Paul accounts adopted by John of Salisbury and the *Kaiserchronik*, in which Trajan is prayed directly into heaven, and the account in which Trajan is resuscitated and converted, found in Abelard and Jacques de Vitry. William supports the second version, adding that the concession is extended to few and that it does not constitute a general rule. None the less, he sees Gregory's miracle as one among several instances in which saintly intercession recalled the damned to life. In sum, William holds that there are three real possibilities. A virtuous Jew can be translated from hell to heaven. Second, the prayers of the church can mitigate the sufferings of the *mediocriter mali* destined to remain in hell. Third, virtuous pagans can be prayed back to life, in order to be converted and saved as Christians. The one alternative that he finds unpersuasive is the praying of a virtuous pagan directly into heaven.

William's teaching was followed in the early thirteenth century by John of Treviso and Roland of Cremona. Other scholastics in this period, such as Hugh of St. Cher and Geoffrey of Poitiers, took a more restrictive position, accepting only the possibility that prayers could mitigate the sufferings of the damned, and only if they were believers. More in line with Prepositinus, John of la Rochelle argues that the power of prayer is so great that it can help save some of the damned entirely. A different approach is offered by another contemporary Franciscan theologian, Alexander of Hales. As an ethicist, he holds that all moral acts are conditioned by their ends.[97] Thus, virtues ordered to this life are neutral with respect to the next life. With this doctrine in hand, he turns to the states of souls in the resurrection and adds to the available destinations in the next life a new limbo, composed of "ancients who are not travellers" in "a place neither of merit nor demerit" (*antiqui in limbo non erant viatores. . .eorum locum sit neque meriti neque demeriti).* Alexander agrees with Augustine and Alan of Lille that the virtues of pagans are formally defective, since they lack the right final cause. But unlike Alan, he has created a special habitation for them outside of hell proper. At the same time, Alexander argues vigorously against the thesis that all the ancient philosophers were damned for their lack of knowledge of the Christian faith. Such a universal damnation, he asserts, would have been unjust and it never happened. For, he notes, reprising an ancient patristic argument, some of the philosophers arrived at conclusions that concur with Christian teachings by natural reason. As for the saving mysteries that can be

grasped only by faith, no one, according to Alexander, is to be blamed if circumstances prevented him from hearing the gospel or if he did hear it but God did not choose to grant him the grace enabling him to believe it, before or after the fact, as He did in selected cases such as Job's. In sum, the philosophers whose natural theology is in accord with Christianity, so far as it goes, can be analogized to simple Christian souls saved by their implicit faith, or to people afflicted with invincible ignorance, who are excused and saved. These pagans too can be saved so long as they are sincere seekers after truth.[98] While on one level the virtues of pagans are insufficient to get them to heaven, requiring the creation of a special limbo to house them in Alexander's eschatology, on another level he offers a rather sweeping acceptance of the salvation of pagan philosophers whose ideas are compatible with Christianity, while also retaining a place for the special revelation theory. This latter option is favored by another thirteenth-century Franciscan, Roger Bacon.[99]

We now move to the last chapter of the development of scholastic theology relevant to Dante, the generation of Albert the Great, Bonaventure, and Aquinas. Each of these figures has his own position on the virtuous pagan and on prayer for the *mediocriter mali*. All refer to the Gregory-Trajan story and interpret it differently. The harshest of the three is Bonaventure. He agrees that Gregory prayed Trajan out of hell and directly into heaven. But the point he wants to make is that this is a unique exception to the general rule.[100] The general rule is that only the *mediocriter boni* in purgatory can be helped by prayer. Bonaventure rehearses the opinions of those who would extend the benefits of prayer to the *mediocriter mali*, ranging from comfort in their sufferings to suspension or mitigation of those sufferings to their removal altogether. He firmly rejects all these alternatives. As he sees it, the "more general and truer opinion" (*opinio communior et verior*) is that "suffrages for the damned are not efficacious; nor should the church seek to pray for them" (*suffragia damnatis non prosunt, nec ecclesia intendit orare pro eis*).[101] Still, in order to preserve God's omnipotence, Bonaventure concedes that nothing prevents God from relaxing the punishments of the damned if He wishes.[102] This exception aside, the posthumous habitations envisioned by Bonaventure include the heaven of the well and truly saved, purgatory containing souls enroute to heaven, the hell of the more heavily or lightly damned minus Trajan alone, and two limbos,

neither of which resembles the limbo of pagans with unmeritorious virtues of Alexander of Hales. One of Bonaventure's limbos contains the Old Testament worthies awaiting salvation at the last judgment and the other contains unbaptized infants,[103] this latter limbo testifying to a new thirteenth-century consensus on their fate.

Unlike Bonaventure, Albert the Great rejects the credibility of the Gregory-Trajan story.[104] In his reprise of the four states of souls doctrine, he agrees with Augustine, Gregory, the Lombard, and Bonaventure that the *mediocriter boni* are the only souls advanced to heaven by prayer. He shares with Bonaventure the limbo of Old Testament worthies awaiting salvation and the limbo of unbaptized infants.[105] Although he asserts that only the souls in purgatory undergo change, Albert contradicts himself by urging the church to pray for the dead, even for known sinners. With Hugh of St. Cher and Geoffrey of Poitiers, he thinks that prayer can mitigate the sufferings of the *mediocriter mali* if they are Christians.[106]

Aquinas raises the same questions, agreeing with Bonaventure and Albert on the limbo of Old Testament worthies and the limbo of unbaptized infants. But he treats the difficulties surrounding Trajan and prayer for the damned his own way. In presenting the Trajan story, Aquinas gives two versions of it, the resuscitation so that he could become a Christian as found in Abelard, Jacques de Vitry, and, more recently, William of Auxerre, and the direct translation to heaven as given by Pseudo-Damascene. With respect to the latter, although he acknowledges the wide credence that Pseudo-Damascene receives in east and west, Aquinas finds his teaching thoroughly irrational and devoid of authority.[107] At the same time, he finds a new theological rationale for the salvation of Trajan according to the resuscitation scenario. Agreeing with the rigorists that only the *mediocriter boni* can be helped by prayer, he thinks that we should recognize in Trajan a person who was somehow wrongly classified as a soul eternally damned. While he rejects prayer for any of the damned as a lapse into the Origenist heresy and while he dismisses the mitigation of suffering theory or the idea that the damned can be comforted by the prayers of living Christians, Aquinas, in his commentary on the *Sentences*, his disputed questions on truth, and his *Summa theologiae* alike proposes a solution to the problem represented by Trajan by reclassifying him as a soul predestined to salvation. Since he was not preordained to remain in hell forever, Gregory's prayers could revive him. Further, for Aquinas,

Trajan is not a unique case but a member of an entire cohort of souls who are "not finally damned" (*non finaliter damnati*). These souls are members of the elect, destined to be saved whether sooner or later.[108] How and why Trajan and the other members of this cohort get classified incorrectly in the first place and therefore endure centuries of undeserved punishment in hell is a question that Aquinas neither raises nor answers.

In the case of pagans living in the Christian era, Aquinas thinks that they need to have been exposed to Christian teachings, even if baptism is waived, in order for this salvation to be part of God's eternal plan for them, on the model of Cornelius in the New Testament.[109] As for pagans living before the Christian era and before the institution of baptism, he concedes, with Alexander of Hales and more generously than any of his contemporaries, that those who followed the natural law, living upright lives and practicing the true religion out of their rational understanding of natural theology, were not spurned by God. Aquinas develops this teaching most fully in connection with the holy pagans of the Old Testament in the preface to his commentary on the Book of Job. With Gregory the Great he agrees that Job can be numbered among the saints. But he extends the same judgment to virtuous pagans living under the natural law before the biblical law was available.Here, Aquinas yokes the universalistic view of salvation found in some of the fathers, summed up so clearly by Eusebius, with the doctrine of special revelation, placing both under the heading of the divine providence guiding mankind since the beginning.[110] Aquinas agrees that grace is needed for virtue to be meritorious toward salvation. In the case of the virtuous pagans he deems to be saved, God arranges the infusion of grace after the fact, by His providence and omnipotence, so that a deed performed by a virtuous pagan that was good but not meritorious when he performed it can be turned, after his death, into a virtue that counts toward his salvation.[111] Aquinas does not apply this analysis to Trajan. But it offers another possible resolution of the question of how a virtuous pagan can be saved.

As we move finally from the theological and popular attitudes to the virtuous pagan to Dante, three generalizations can be made. First, although there is range of views on whether virtuous pagans could be saved among the theologians, early and recent, there is notable support for the affirmative answer to that question. Second, on balance,

universalism or generosity toward the virtuous pagan is statistically more in evidence in the popular tradition. And third, since authors in both groups took account of each other's views, both groups need to be seen as providing the large menu from which Dante made his choices. This fact has not always been appreciated in the earlier scholarship in Dante and the virtuous pagan. Some authors continue to reflect the notion that the *Divine Comedy* is the *Summa theologiae* of Aquinas set to music.[112] Some see him as responding primarily or exclusively to the popular tradition.[113] Still others see Dante as departing from the medieval Christian tradition, whether learned or popular, in favor of a proto-humanist, in the sense of secularist, position.[114] Finally, some see him as taking a more rigorous line than the available theology required.[115] We will have to assess the merits of all these interpretations in considering Dante himself.

Dante shows a good deal of independence in assigning souls to their posthumous destinations, in the light of the traditions on which he could draw. In some respects he does take a sterner position on the requirements for salvation and for the efficacy of prayers for the dead than were held within the orthodox consensus. In some areas the choices he makes are original, and unexplained. Dante draws a clear distinction between the eternity of hell and the transitory state of purgatory. The famous inscription above the gate of hell mentions its eternity twice as well as the hopelessness of its denizens.[116] In purgatory, Manfred states that souls in this realm can be assisted by the prayers of their fellow Christians; Vergil and Dante the traveller confirm the theology undergirding this idea.[117] Many souls in purgatory request the prayers of others.[118] But one of them, Belaqua, adds a stipulation not found even in the most rigorist of theologians. Such prayer, he asserts, is efficacious only if those offering it are in a state of grace; his stay in purgatory will be long "unless prayer first aid me which rises from a heart that lives in grace."[119]

Dante also handles the doctrine of limbo his own way. As we have seen, like Augustine, Alan of Lille and Alexander of Hales could conceive of pagans whose virtues, ordered to this-worldly ends, do not win heaven for them, with Alexander providing a special limbo for them. Alan can also conceive of souls in a state of moral apathy. For Alexander, it is not apathy but a defective moral finality that sets his virtuous pagans apart, to receive neither praise nor blame. As we have also seen, by the second half of the thirteenth century, a consensus had

arisen on the existence of two limbos, housing two other categories of souls, Old Testament worthies awaiting salvation and unbaptized infants. Dante agrees with all recent scholastics on the limbo of unbaptized infants, whom he describes as "little innocents."[120] But he rejects the current consensus position on the limbo of Old Testament worthies. As Vergil relates, all the Old Testament worthies who were going to be saved were saved in the harrowing of hell. This group includes worthies living before or outside of the covenant as well as covenanted Jews, some of whom Dante sees and mentions again in the Empyrean.[121] Vergil's speech is a response to Dante's question as to whether anyone has been freed from limbo by his own or another's merit.[122] In the case of the Old Testament worthies it is their own virtue that led to their liberation, regardless of the dispensation under which they lived. At the same time, Dante describes this group as believers in Christ, and not just the messiah to come according to the revelation available to them in their own era.[123]

Dante imports two other innovations into his treatment of limbo. One is his creation of the limbo of the morally neutral, who live "without infamy and without praise,"[124] for which his only real precursor is Alan of Lille. But, while Alan consigns Jews and pagans to the state of moral abnegnation categorically, reserving the judgment of moral indifference on the grounds of apathy to Christians alone, Dante treats all the souls in this limbo as guilty of terminal moral apathy. And, aside from his well-known allusion to Pope Celestine V, "who from cowardice made the great refusal,"[125] we learn nothing about the identity of the souls in this limbo and whether or not Dante shares Alan's views on the relevance of their religious beliefs to their moral condition. And, unlike Alan or anyone else, he includes in this limbo not only human souls but apathetic angels who neither served God nor rebelled against Him.

Dante's final innovation with respect to limbo concerns his limbo of virtuous pagans. According to Alison Morgan's census, the vast majority of Greek and Roman pagans in the *Comedy* are found in this limbo.[126] Let us recall that there is a precedent for this idea in Alexander of Hales. But Dante proposes different criteria for admission to this limbo than Alexander does for the philosophers he thinks are saved. As Vergil explains why the inhabitants of this limbo are there, including himself, he touches on a key theme to which Dante will revert, the idea that God reigns everywhere although He elects only

some to His city, thus laying the foundation, in the doctrine of predestination, that will account for the treatment of some souls to be met up the road.[127] Vergil gives three reasons why these virtuous pagans are lodged here: lack of Christian faith,[128] lack of baptism,[129] and moral conduct that, although it was upright, lacked the theological virtues as its inspiration and involved sins of omission.[130] The fact that some of the pagans in this limbo had no access to Christian teaching cuts no ice with Dante. He takes a far mor stringent line here than Alexander, Aquinas, or Gregory, associating himself with the most rigorous stance available, derived from the anti-Donatist Augustine.

When we turn to the actual population of this limbo, we find that it is divided into two groups. Dante's assignment of souls to both groups would have raised the eyebrows of Augustine and Alexander alike; and some of his choices conflict with principles that Dante himself espouses elsewhere in the *Comedy*. The first group comprises ancient worthies who were standard classical examples of virtue. But it includes Marcia, a divorcée who remarried while her former husband was alive, and Lucretia, a suicide. Both ladies are roundly castigated in Augustine's *City of God*. Also present, rubbing elbows with Julius Caesar, is Brutus, who led a successful revolt against the Tarquins and installed the Roman Republic, ancestor of the Brutus who participated in the assassination of Julius Caesar. Saladin is also present in this first group. Both from the standpoint of the traditional Christian teachings on divorce and suicide, from the standpoint of Dante's pro-Caesarian political agenda, and from the standpoint of his glorification of crusading against the Muslims as an ideal form of cooperation between church and state, these choices are peculiar.[131]

The second group in the limbo of virtuous pagans includes persons who made a contribution to literature,[132] philosophy, and science. The array of philosophers is extensive. Many of them held positions that do not square with Christian doctrine, the condition for salvation stipulated by Abelard, Alexander of Hales, and the universalists among the apologists and church fathers. Among the philosophers we find Avicenna and Averroes. For many of Dante's contemporaries, their teachings on the unity of the intellect, and, in the case of Averroes, on the eternity of matter as well, were deeply problematic and incompatible with Christianity. No such problem exists for Dante. He extends a still greater courtesy to the Latin Averroist, Siger of Brabant, by placing him in the heaven of the

theologians.[133] In his staffing of the limbo of virtuous pagans, then, Dante is independent and both more and less generous than his predecessors and contemporaries. On the one hand, the hopelessness of his virtuous pagans shows him firmly rejecting the laxist line on whether the *mediocriter mali* can be helped in any way. But the amenity of life in this limbo suggests that these pagans have been spared the sufferings of hell, by divine decree.

Notwithstanding the creation of his own version of the limbo of virtuous pagans, as all readers of the *Comedy* know, Dante places some pagans in purgatory and heaven. There are four who merit our attention, leaving aside Statius, since Dante thinks he converted to Christianity during his lifetime.[134] His treatment of Statius as a soul in purgatory repenting for the dissimulation of his faith for fear of persecution while alive, who will eventually enter heaven, is unremarkable. The other four pagans lived and died as pagans, to all appearances. Dante provides an elaborate theological rationale for the salvation of two of them, Trajan and Riphaeus the Trojan. The other two, Rahab and Cato of Utica, are harder nuts to crack; and the reader is not given as much assistance in understanding why they occupy the places to which Dante assigns them.

One of the souls making up the beak of the eagle of justice in the heaven of just rulers, and Beatrice, are our informants on how and why Trajan and Riphaeus were saved. But, well before their lengthy speeches in *Paradiso* 19 and 20, Dante sets the stage, in Trajan's case, on the first ledge of purgatory. In a passage capitalizing on the visual reference on Trajan's column that brings Trajan to Gregory's mind, Dante presents the souls in this part of purgatory, who need to be perfected in humility, learning about that virtue by means of sculptured reliefs depicting Mary with the angel of the Annunciation, David dancing before the Ark of the Covenant, and Trajan and the widow. In telling Trajan's story, Dante uses the long conversation found in John the Deacon's version. In keeping with the accent on visual aids in this canto, his description of the meeting between Trajan and the widow is colorful and easy to visualize. The two are surrounded by Trajan's soldiers, a "throng of horsemen, and above them the eagles in gold moved visibly in the wind."[135] Another new touch is the language in which the widow pleads. She sues not for justice but for "vengeance" (*vendetta*).[136] The aspects of Trajan's moral character that Dante stresses in *Purgatorio* are threefold. As noted, the general principle he

is designed to illustrate is humility. And, when he accedes to the widow's request, Trajan says that "justice requires it and pity bids me stay."[137] This yoking of justice and pity is also found in the Norman French life of Gregory written somewhat later in the fourteenth century.

In the heaven of Jupiter, on the other hand, justice alone is the moral rubric under which Trajan appears, along with Riphaeus. The soul speaking from the eagle's beak answers a question disturbing Dante the traveller, as it had disturbed many other medieval Christians. Is it really fair to condemn to hell pagans who lived upright lives and who, through no fault of their own, were unaware of the gospel message and the need for baptism? The response states the rigorist position: God's will, which is just by definition, has mandated Christian belief as an entrance requirement for heaven, whenever and wherever a person may have lived.[138] Since he adopts this rule, Dante limits his options for explaining the salvation of Trajan and Riphaeus. Encountering Trajan first, he notes that the emperor learned the hard way "how dear it costs not to follow Christ."[139] He accepts the idea that Trajan was originally damned, ignoring the qualification Aquinas imparts to that notion. Beatrice now intervenes with an explanation not found in any of the theologians. She juggles the principle just stated, that God makes no exceptions, with an assertion of the power of Gregory's prayer and perfect charity, adding to the mix the doctrine of election outlined by Vergil at the beginning of *Inferno*: "*Regnum celorum* suffers violence from fervent love and from the living hope which vanquishes the Divine will: not as man overcomes man, but vanquishes it because it wills to be vanquished."[140] This statement suggests that God wants His saints to pray for the salvation of damned persons even though they know that this is impossible. It suggests a psychodrama between God and the would-be intercessor that has more in common with the *demande d'amour* of the female visionaries studied by Newman than it does with any other approach to this problem we have encountered, learned or popular. As Beatrice continues, she explains that, in actuality, both Trajan and Riphaeus were Christians when they died: "They came forth from their bodies not, as you think, Gentiles, but Christians, with firm faith."[141] In Trajan's case what follows is the outcome found in Abelard, Jacques de Vitry, and William of Auxerre and accepted in modified form by Aquinas. Gregory's prayers persuade God to bring Trajan back to life so that he can believe and make charity the formal cause of his virtues, winning him salvation

when he dies the second time. [142] No mention of baptism is made here, although its necessity for salvation is stated both by Vergil and by the speaker in the eagle's beak, and although it would have been available to a resuscitated Trajan.

As for Riphaeus, the just man mentioned in passing in the *Aeneid* (*Aeneid* 2.339, 2.394. 2.426–427), the theological principle that Dante invokes in his case is special revelation, which enables him to become a Christian before the fact, [143] a solution which had attracted considerable support from the fathers on up and which had been reinforced recently by Alexander of Hales, Roger Bacon, and Aquinas. Dante prefers this approach to the salvation of the virtuous pagan under the natural law, which the most universalist theologians accept and which Alexander and Aquinas give a positive hearing. While scarcely a laxist, Beatrice, in her closing remarks, links the theme of predestination, the real solution to the problem, with William of Auxerre's point that we, the living, are in no position to know who the elect really are. As she observes, although a blessed soul herself who enjoys the vision of God, she does not know either: "O predestination, how remote is thy root from the vision of those who see not the First Cause entire! And you mortals, keep yourselves restrained in judging; for we, who see God, know not yet the elect." [144] This injunction to mercy suggests that living Christians should be generous with their prayers for the dead despite the extremely stringent requirements that Dante lays down for their efficacy and for admission to heaven and despite the fact that he has, in effect, vaporized the problem of the salvation of the virtuous pagans in the heaven of Jupiter by turning Trajan and Riphaeus into Christians.

But what of his other two pagans, Rahab and Cato? Rahab of Jericho is a holy pagan of the Old Testament, a non-Israelite. Her story is told in the Book of Joshua, where her moral standing seems rather dubious. To begin with, she is a harlot by profession. She entertains Joshua's scouts sent to spy out the land before the battle of Jericho. Betraying her own people and lying to her king, she gives the scouts inside information useful to the Israelites and helps them escape the city undetected. It is true that the Book of Joshua, like other military histories, has a double standard when it comes to treason. But another problem is the stated motivation for Rahab's collusion with the enemy. She observes that the Israelites have been chalking up one military victory after another following their dramatic escape from Egypt. Their

army seems invincible; and, in her estimation, they are likely to defeat Jericho as well. Further, their policy toward the vanquished is: take no prisoners. Rahab is presented as making a deal with Joshua out of enlightened self-interest, betraying Jericho in exchange for her own safety and that of her family. Joshua keeps that agreement after he has conquered Jericho and slaughtered all its other inhabitants (Joshua 2:1– 21, 6:17, 6:22–24). On the face of it, Rahab seems to be a strange candidate for sanctity. She does not appear on Vergil's list of Old Testament worthies when he explains why they are no longer in limbo.

But Rahab is less problematic as a saint for Dante than she may be to us moderns. True, she was a harlot; but her current location is the heaven of Venus, which is populated by souls who had led irregular sexual lives but who had repented and brought their erotic drives under the control of reason, or had developed compensatory virtues. [145] In the Book of Joshua, there is nothing to suggest that Rahab continued in her original profession after the battle of Jericho; so she could be presumed to have changed her ways. For Dante, her betrayal of Jericho is actually a virtue, since she aided the Israelites. [146] The matter of her motivation for so doing would have been the easiest objection for a medieval reader of the New Testament to refute. For the Epistle to the Hebrews states that Rahab had faith that saved her, presenting her as a convert to Judaism (Hebrews 11:31); and the Epistle of James says that she possessed good works (James 2:25). Despite her lack of baptism and explicit faith in Christ, Dante thus has little difficulty treating Rahab as an Old Testament worthy with full credentials. Indeed, he asserts that "she was taken up before any other soul of Christ's triumph," [147] remarkable praise for a saint whom he does not place in the Empyrean.

If Dante can find places in heaven for Trajan, Riphaeus, and Rahab by converting them to Christianity or Judaism, as the case may be, the role he assigns to Cato as the gatekeeper of purgatory is harder to explain. As Paul Renucci has noted, Cato presents difficulties because he was a suicide, an enemy of Julius Caesar, and a pagan—and we might add, a divorced man—and there were no medieval legends proposing his salvation, despite his glowing reputation in Lucan's *Pharsalia* and other classical works as a moral exemplar. Renucci regards Dante's treatment of Cato as a rare case in which his proto- humanism overcomes his Thomist theological scruples.[148]

It is true that Dante provides an extremely laconic reference to Cato's transfer from the limbo of virtuous pagans. Cato simply says, "I came forth from there," without elaborating on why.[149] Three possible answers may be suggested for Dante's unusual treatment of Cato, beyond the notion that Lucan's praise of Cato sounded more sweetly in his ears than Augustine's dispraise of him. First, we may note Dante's differential handling of suicide. He places one suicide, Lucretia, in the limbo of virtuous pagans because of the point she makes thereby about death over dishonor. He places Dido and Cleopatra in the circle of lust in hell, and Pier della Vigna in the circle reserved for sinners against nature, because of their differing motivations for suicide.[150] The fact that Cato is a suicide is freely acknowledged by Vergil. Despite its anti-Caesarian inspiration, this act on Cato's part is presented as a praiseworthy bid for liberty.[151] Second, the *Purgatorio* indicates that, although he is a pagan, Cato is destined for heaven. Vergil describes the body he left at Utica as "the raiment which on the great day will be bright."[152] Why should this unique privilege be granted to a person whose actual or future conversion to Christianity is nowhere intimated? Cato is, indeed, the sole example of a virtuous pagan in the *Comedy*, living an upright life under the natural law, who will be saved. Is this Dante's one and only concession to the universalist tradition? The answer Vergil gives offers a different reason for Cato's salvation: "The eternal edicts are not violated by us."[153] In the end, Cato's eccentric case is subsumed under the heading of divine providence and predestination, as are the cases of Trajan and Riphaeus. This principle, announced early by Augustine, figures in the teachings of rigorists, moderates, and laxists alike in their address to the virtuous pagan.

In placing Dante's treatment of this subject in the context of the medieval Christian tradition, three main conclusions may now be drawn. First, Dante is extremely eclectic, and sometimes downright idiosyncratic. It would be a mistake to read him as a disciple of just the popular tradition, just the learned tradition, or, *a fortiori* as the disciple of a single master. With the exception of his innovations in treating limbo and the conditions he places on the efficacy of prayers for the souls in purgatory, all the positions he draws on have antecedents both ancient and recent; and he makes his own combination of the materials he uses. Second, with respect to his four virtuous pagans, the version of the Trajan story in the *Comedy*, in which Trajan is revived and converted, does not antedate Abelard. Like other medieval authors who

tell this tale and who opt either for Trajan's resuscitation or for his direct translation into heaven, Dante feels free to match his chosen version of the outcome with John the Deacon's account of the conversation between Trajan and the widow, while rejecting John's view of what Gregory accomplished. Riphaeus, Rahab, and Cato are unusual candidates for salvation. But, in each case, a rationale is found that allows Dante to accommodate them within his chosen theological perspective. As to what that perspective is, finally, Dante is more of a rigorist that any theologian or popular author up to his time. The one exception is his lowering of the requirements for the admission of philosophers to his limbo of virtuous pagans. But some predecessors would have admitted some of these philosophers into heaven. In other respects, he goes farther than anyone discussed in this paper in narrowing the conditions giving a soul access to heavenly bliss; and he imposes unique restrictions on the efficacy of prayer for the dead. He solves the problem of the salvation of virtuous pagans by converting them into Christians, for the most part, with Cato remaining the sole exponent of the original theme. Still and yet, although Dante is far less ecumenical than are many medieval Christian authors, Beatrice's speech in *Paradiso* 20 shows Dante supporting another side of the question, even if that support is muted in relation to his overall doctrine in the *Comedy*. God wants His saints to pray for the impossible, for the sheep not of His flock. God wants His saints to think that their own charity can move a deity Who has already decided to hear their prayers. And so, prayer for the damned may not be a mistake. Since we cannot know who the elect are, we should err on the side of mercy in our prayers. This is not the position that Dante weighs the most heavily; but it is still present in the *Comedy*. It would have won a nod from John Chrysostom, Pseudo-Damascene, the visionaries, and the scholastics who defended prayer for the *mediocriter mali*. In the end, mercy does, to some degree, temper the eternal justice to which Dante ascribes the arrangements in his other world.

NOTES

Part of the research for this paper was supported by the National Endowment for the Humanities in connection with a NEH summer seminar in 1993, on concepts of heaven from late antiquity through Dante, led by Jeffrey B. Russell at the University of California, Santa Barbara. I would like to thank the NEH for its financial support and my colleagues in the seminar, especially Barbara R. Kline and Edgar S. Laird, for feedback and bibliographical suggestions.

1. The text is the *Vita Pauli* and the part treating Thecla, ch. 28-29, has been translated by Ross A. Kraemer, ed., *Maenads, Martyrs, Matrons, Monastics; A Sourcebook on Women's Religion in the Greco-Roman World* (Philadelphia: Fortress Press, 1988), pp. 280-88. This text is discussed by Louis Capéran, *Le problème du salut des infidèles: Essai historique*, 2nd ed. (Toulouse: Grande *Frühmittelalterliche Studien* 20 (1986): 137 and n. 2, which offers an excellent bibliographical orientation to patristic reactions to this text.

2. Rordorf, "La prière," pp. 251-54.

3. *Passio S. Perpetuae* 3, ed. J. Armitage Robinson (Cambridge: Cambridge University Press, 1891), p. 62.

4. Ibid. 7-8, pp. 72-74. On this text, see Rordorf, "La prière," p. 255; Peter Dronke, *Women Writers of the Middle Ages: A Critical Study of Texts from Perpetua to Marguerite Porete* (Cambridge: Cambridge University Press, 1984), pp. 11-12; Nieske, "Vision und Totengedanken," p. 137.

5. Carl Selmer, ed., *Navigatio sancti Brendani abbatis from Early Latin Manuscripts* (Notre Dame: University of Notre Dame Press, 1959), pp. xxviii-xxix. James J. O'Meara, trans., *The Voyage of Saint Brendan: Journey to the Promised Land* (Atlantic Highlands, NJ: Humanities Press, 1978), p. xiv gives a date of ca. 800 but with no supporting evidence.

6. For the historical Brendan, see O'Meara, trans., *The Voyage*, pp. xiv-xv; Selmer, ed., *Navigatio*, pp. xviii-xix; Ioannes Orlandi, ed. *Navigatio sancti Brendani* (Milan: Istituto Editoriale Cisalpina, 1968), pp. 131-60.

7. *Navigatio*, ed. Selmer, pp. 86-87; trans. O'Meara, p. 21.

8. *Vita S. Brendani prima* 14, ed. Carolus Plummer in *Vitae sanctorum Hiberniae*, 2 vols. (Oxford: Clarendon Press, 1910), 1:107.

9. *Navigatio*, ed. Selmer, p. 90; trans. O'Meara, pp. 56-58.

10. *Vita secunda sancti Brendani abbatis de Cluain Ferta*, ed. Carolus Plummer in *Vitae sanctorum_Hiberniae*, 2 vols. (Oxford: Clarendon Press, 1910), 2:270.

11. Ibid. 43-44, 2:286-87.

12. *Navigatio*, ed. Selmer, pp. 291-92; trans. O'Meara, pp. 69-70; *Vita S. Brendani prima* 64-66, 1: 133-34; *Vita secunda* 54-57, 2:291-92.

13. For the spread of the Brendan story, see Carl Selmer, "The Beginning of the St. Brendan Legend on the Continent," *Catholic Historical Review* 29 (1943); 169-76; idem, "The Vernacular Translations of the *Navigatio sancti Brendani*: A Bibliographical Study," *Mediaeval Studies* 18 (1956): 145-57; St. John D. Seymour, *Irish Visions of the Other World: A Contribution to the Study of Mediaeval Visions* (London: SPCK, 1930), pp. 83-96; Reinhold Grimm, *Paradisus coelestis, paradisus terrestris: Zur Auslegungsgeschichte des Paradieses im Abendland bis um 1200* (Munich: Wilhelm Fink Verlag, 1977), pp. 108-10; Mario Esposito, "Sur la *Navigatio sancti Brendani* et ses versions italiennes," *Romania* 64 (1938):328-46, which lists ninety-nine MSS. preserving the legend in Italian alone; Eileen Gardiner, *Medieval Visions of Heaven and Hell: A Source Book* (New York: Garland Publishers, Inc., 1993), pp. 68-89.

14. E.G. Waters, ed., *An Old Italian Version of the Navigatio sancti Brendani*, Publications of the Philological Society, 10 (Oxford: Oxford University Press, 1931), p. 4 for Brendan's naturalization as a Venetian; Francesco Novati, ed., *La 'Navigatio sancti Brendani' in antico veneziano* (Bergamo: Istituto Italiano d'Arte Grafiche, 1896).

15. Pasquale Villari, *Antiche leggende e tradizione che illustrano la Divina Commedia* (Pisa: Arnaldo Forni, 1865), pp. 97-98.

16. Nicholas of Bibera, *De sancto Brendano versus satirici*, ed. Carolus Plummer in *Vitae sanctorum_Hiberniae*, 2 vols. (Oxford: Clarendon *Speculum quadruplex*, 4 vols. (Graz: Akademische Druck-u. Verlagsanstalt, 1965 [repr. of Douai, 1624 ed.]), 4:843

(in some editions of this text, the locus is 22.81). On these
figures, see Mario Esposito, "Notes on Latin Learning and
Literature in Medieval Ireland, IV," *Hermathena* 24 (1935): 165;
idem, "Sur la *Navigatio*," p. 344.

17. Claudianus, *Panegyric on the Fourth Consulate of Honorius*, ed.
and trans. William Barr (Liverpool: Francis Cairns, 1981), pp.
30, 36; Sidonius Apollonaris, *Carmina* 7.115 in *Poems and
Letters*, trans. W. Bettenson, 2 vols. (Cambridge, MA: Harvard
University Press, 1963), 1:126.

18. Bertram Colgrave, ed. and trans., *The Earliest Life of Gregory
the Great by an Anonymous Monk of Whitby* (Lawrence, KS:
University of Kansas Press, 1968), pp. 45-48, for the date. The
discovery and dating of this text are also discussed by Oronzio
Limone, "La vita de Gregorio Magno dell'anonimo di Whitby,"
Studi medievali ser. 3:14/1 (1978): 37-40.

19. *The Earliest Life* 9, ed. and trans. Colgrave, pp. 90-93.

20. Ibid. 28, p. 124.

21. Ibid., pp. 124-27.

22. Ibid. 29, p. 126 for the Latin, p. 127 for Colgrave's trans.

23. Ibid., pp. 126-29.

24. Hartman Grisar, ed., "Die Gregorbiographie des Paulus
Diakonus in ihrer ursprünglichen Gestalt, nach italienischen
Handschriften," *Zeitschrift für katholische Theologie* 11
(1887):158-73. The date is discussed pp. 168-60.

25. The distinction between the real and the interpolated versions of
Paul's *vita* is noted by Grisar, "Die Biographie," pp. 158-60;
Limone, "La vita di Gregorio," pp. 40, 50-51, who also provides
the best existing comparison of the different Latin versions; Suso
Brechter, *Die Quellen zur Angelsachsenmission Gregors des
Grossen: Eine historiographische Studie*, Beiträge zur
Geschichte des alten Mönchtums und der Benediktenordens, 22
(Münster: Aschendorff, 1941), pp. 138-43; J. R. Seeley, "Paul
Ewald and Pope Gregory I," *English Historical Review* 3
(1888):301-03; Ernst Friedrich Ohly, *Sage und Legende in der
Kaiserchronik: Untersuchungen über Quellen und Aufbau der
Dichtung*, Forschungen zur deutsche Sprache und Dichtung, 10
(Darmstadt: Wissenschaftliche Buchgesellschaft, 1968 [repr. of
1940 ed.]), p. 20. I owe access the the last-mentioned work to the
assistance of Janet C. Meisel. This material has been reprised

more recently by Gordon Whatley, "The Uses of Hagiography: The Legend of Pope Gregory and the Emperor Trajan in the Middle Ages," *Viator* 15 (1984): 25-30; Whatley summarizes the history of the Gregory-Trajan story in non-theological authors again in idem, "Heathens and Saints: *St. Erkenwald* in Its Legendary Context," *Speculum* 61 (1986):330-42.

26. John the Deacon, *Sancti Gregorii magni vita* 2.44, PL 75:105B-106A. Good orientations to this work are provided by Seeley and Limone, as in n. 25 above, and Claudio Leonardi, "Pienezza ecclesiale e santità nella 'Vita Gregorii' di Giovanni Diacono," *Renovatio* 12 (1977):51-66. I would like to thank Mark D. Jordan for his help in obtaining a copy of the Leonardi reference.

27. Pseudo-Paul the Deacon, *Vita sancti Gregorii magni* 27, PL 75: 56D-57C.

28. Pseudo-John of Damascus, *Oratio de iis qui in fide dormierunt*, PG 95:247-78 for the whole sermon. Its existence and its reference to the Trajan story are noted by Gaston Paris, "La légende de Trajan," *Bibliothèque de l'École des hautes études*, section des sciences philologiques et historiques, 35 (1878):280. The fact that the author is not John of Damascus and that he wrote after John the Deacon *mmaginazioni del medio evo* (Turin: Loescher, 1915), pp. 374-75; Franz Diekamp, "Johannes von Damaskus 'Ueber die im Glauben Entschlafenen," *Römische Quartalschrift* 17 (1903): 371-74; Rordorf, "La prière," pp. 251, 258-59; Ohly, *Sage und Legende*, p. 120; Capéran, *Le problème*, pp. 167-68.

29. Pseudo-John of Damascus, *Oratio* 9, PG 95:253D-256A.

30. Ibid. 16, PG 95:261D-264A.

31. Ibid. 13, PG 95:257B-258B.

32. Leonardi, "Pienezza ecclesiale," pp. 51-66.

33. Ohly, *Sage und Legende*, pp. 120-21.

34. Rordorf, "La prière," pp. 251-52; M. Jugie, "La doctrine des fins dernières dans l'église Gréco-Russe," *Echoes d'Orient*, 17 (1914-15):8-10. In a personal communication dated 25 May 1994, Barbara Newman notes that there are still, to this day, "soul Saturdays" set aside in Orthodox churches, on which souls are given liturgical suffrages without respect to their beliefs. I would like to thank her for this information.

35. Jugie, "La doctrine des fins dernières," pp. 5-22.

36. Rordorf, "La prière," pp. 249-50; Jugie, "La doctrine des fins dernières," pp. 5-8; Robert Ombres, "Latins and Greeks in Debate over Purgatory, 1230-1439," *Journal of Ecclesiastical History* 35 (1984):1-19.

37. Tilman Struve, ed., "Zwei Briefe der Kaiserin Agnes," *Historisches Jahrbuch* 104 (1984):424. The text reads: "quia namque ille unus homo ab inferni claustris exoravit paganum, multi vos facile salvabatis christianam unam."

38. Graf, *Roma*, p. 379; Whatley, "Uses of Hagiography," pp. 32 n. 25, 35-36; Cindy L. Vitto, *The Virtuous Pagan in Middle English Literature*, Transactions of the American Philosophical Society, 79:5 (Philadelphia: American Philosophical Society, 1989), pp. 41- 42.

39. Whatley, "Uses of Historiography," pp. 35-36.

40. Graf, *Roma*, p. 380; Ohly, *Sage und Legende*, p. 122 n. 8.

41. Honorius Augustodunensis, *Sermo generalis, ad judices*, in *Speculum ecclesiae*, PL 172: 863C-864A. Noted by Ohly, as is the German copy, *Sage und Legende*, pp. 120 n. 5.

42. *Deutsche Kaiserchronik*, ed. Edward Schröder, Monumenta Germaniae Historica, deutsche Chroniken, 1:1 (Hannover, 1892), p. 192; see also Ohly, *Sage und Legende*, pp. 122-28; Graf, *Roma*, pp. 385-86; Vitto, *Virtuous Pagan*, pp. 40-41.

43. John of Salisbury, *Policraticus* 5.8, ed. and trans. Cary J. Nederman (Cambridge: Cambridge University Press, 1990), pp. 79-81. Other scholars who have noted John's politicized treatment of Trajan include Paris, "La légende," p. 268; Graf, *Roma*, p. 381; Whatley, "Uses of Hagiography," pp. 32-35.

44. On John's later influence, see André Pezard, "Du *Policraticus à la Divine Comédié*," *Romania* 70 (1948-49):1-36, 163-91; Amnon Linder, "The Knowledge of John of Salisbury in the Later Middle Ages," *Studi medievali* ser. 3:18/2 (1977): 315-66; Paris, "la légende," p. 264; Graf, *Roma*, pp. 380-86; Whatley, "Uses of Hagiography," pp. 34-35. Whatley, p. 38, gives the date of the Latin translation of Pseudo-Damascene.

45. Paul Meyer, ed., "La vie de saint Grégoire le Grand, traduit du latin par Frère Angier, religieux de Sainte-Frideswide," *Romania* 12 (1883):145-208.

46. Vincent of Beauvais, *Speculum historiale* 10.46, in *Speculum quadruplex*, 4:385.

47. Ibid. 22.22, 4:868.
48. Ibid. 21.81, 4:843-44. In some editions of this work, the passage occurs at 22.81.
49. Paris, "La légende," p. 275.
50. Graf, *Roma*, pp. 386-89; Vitto, *Virtuous Pagan,* p. 39.
51. Graf, *Roma*, pp. 390-91; Vitto, *Virtuous Pagan,* p. 40.
52. Jacobus de Voragine, *The Golden Legend*, trans. Granger Ryan and Helmut Ripperger (New York: Arno Press, 1969), p. 177.
53. Ibid., pp. 184-85. On Jacques, see also Paris, "La légende," p. 280; Vitto, *Virtuous Pagan*, p. 43; Graf, *Roma*, pp. 387-88.
54. Jacobus, *Golden Legend,* pp. 184-85.
55. Ibid.
56. Clifford Peterson, ed. *St. Erkenwald* (Philadelphia: University of Pennsylvania Press, 1977). On this text, see Whatley, "Heathens and Saints," p. 331 n. 10, who gives an excellent bibliography on the poem; Vitto, *Virtuous Pagan*, pp. 1-5.
57. Olle Sandquist, ed., *La vie de saint Gregore: Poème normand du XIVe siècle*, Études romanes de Lund, 43 (Lund: Lund University Press, 1989), pp. 138-46. This text dates to 1326 and there are eight MS. versons of it. It should not be confused with another French saint's life of a saint named Gregory, *La Vie de pape saint Grégoire: Huit versions françaises médiévales de la légende du bon pécheur,* ed. Hendrik Bastiaan (Amsterdam: Rodopi, 1977). This latter text, which has Middle English versions as well and also dates to the fourteenth century, is not about Gregory the Great but relates the life of an Acquitanian named Gregory, born of an incestuous union between a brother and sister, who is exposed and rescued, raised by local monks without knowing who he is, who then unknowingly contracts an incestuous union with his mother. When his identity is discovered, he becomes an ascetic recluse to do penance; news of his holiness leads to his election to the papacy and his ability to pardon his mother sacramentally.
58. *La vie de saint Gregore*, ed. Sandquist, pp. 146-51.
59. Paris, "La légende," p. 286 n. 2. The Latin text of Mechthild of Hackeborn, *Liber spiritualis gratiae*, 5. 16. 332, has been edited by Ludwig Pacquelin in *Revelationes Gertrudianae ac Mechtildianae* (Paris, 1875). There was a fifteenth-century translation into Middle English, *The Booke of Gostly Grace of*

Mechtild of Hackeborn, ed. Theresa A. Halligan, Pontifical
Institute of Mediaeval Studies, Studies and Texts, 46 (Toronto:
Pontifical Institute of Mediaeval Studies, 1979). The text is
attached to this book in microfiche form; the locus in the
microfiche for the parallel passage is p. 570. I thank Barbara
Kline for this citation. Mechthild's reference to the salvation of
Trajan has also been noted by Mary Jeremy Finnegan, *The
Women of Helfta: Scholars and Mystics* (Athens, GA: University
of Georgia Press, 1991), pp. 40-41.

60. Philippe de Mézières, *Le songe du viel pelerin*, ed. G. W.
Coopland, 2 vols. (Cambridge: Cambridge University Press),
2:471 ff.

61. Graf, *Roma*, p. 439; Vitto, *Virtuous Pagan*, p. 49; Paris, "La
légende," p. 286 n. 2. Clifton Wolters, in the intro. to his trans. of
Julian of Norwich, *Revelations of Divine Love* (Baltimore:
Penguin Books, 1966), p. 36, sees her as "trembling on the brink
of universalism"; but Julian clearly moves squarely into
universalism in ch. 27, 32-34, pp. 103, 109-13.

62. Vitto, *Virtuous Pagan*, pp. 1-5, 49 ff. gives the most exhaustive
treatment of this theme in that work; see also Whatley, "Uses of
Hagiography," pp. 50-63.

63. Barbara Newman, "On the Threshold of the Dead: Purgatory,
Hell, and Religious Women," in *From Virile Woman to Woman-
Christ: Studies in Medieval Religion and Literature*
(Philadelphia: University of Pennsylvania Press, 1995). I am
indebted to Barbara Newman for allowing me to use and cite this
paper prior to its publication.

64. Jacques Le Goff, *The Birth of Purgatory*, trans. Arthur
Goldhammer (Chicago: University of Chicago Press, 1984) dates
this phenomenon too late and offers unacceptable reasons for its
occurrence, but, with these caveats, is of some use.

65. Some of the scholars cited above who seek theological
backgrounds for popular literary treatments of the virtuous pagan
give insufficient attention to the patristic writers and treat the
scholastics as more unanimous than they were, as is the case
with Whatley, "Uses of Hagiography," p. 31, 36-40; idem,
"Heathens and Saints," pp. 343-63. A more nuanced treatment of
the theological tradition on this subject is provided by Vitto,
Virtuous Pagan, pp. 5-36.

66. R. Joly, ed. and trans., *Le Pasteur d'Hermas*, Sources chrétiennes, 53 (Paris: Les Éditions du Cerf, 1958), p. 329. See also Rordorf, "La prière," p. 258.

67. Mathis Rissi, *Die Taufe für die Toten: Ein Beitrag zur paulinischen Tauflehre*, Abhandlungen des Alten und Neuen Testaments, 42 (Zürich: Zwingli Verlag, 1962), pp. 6-14; Rordorf, "La prière," pp. 258-59.

68. Extremely useful surveys are provided by Capéran, *Le problème*, pp. 38-168; S. Harent, "Infidèles," *DThC*, 7/2: 1726-1849. Their findings are reprised by Vitto, *Virtuous Pagan*, pp. 5-17. We will follow these scholars here except where new research has uncovered material not included by them.

69. Eusebius, *The Ecclesiastical History* 1.4.4, trans. Kirsopp Lake (London: William Heinemann, 1926).

70. Jean Daniélou, *Holy Pagans of the Old Testament*, trans. Felix Faber (London: Longmans, Green and Co., 1957), pp. 10-11, 18-20.

71. Gregory the Great, *Moralia in Iob*, dedicatory epistle, 1, 2; praefatio 1.1-2.5, ed. Marcus Andraien, CCSL 143 (Turnhout: Brepols, 1979), pp. 2, 3-4, 8-11; the quotation is at 2.5, p. 11.

72. Augustine, *City of God* 18.47, trans. Gerald G. Walsh and Daniel J. Honan (Washington: Catholic University of American Press, 1964), pp. 166-67.

73. Rordorf, "La prière," p. 256; Neiske, "Vision und Totengedanken," p. 312.

74. On this point, see Marcia L. Colish, *The Stoic Tradition from Antiquity to the Early Middle Ages*, repr. ed., 2 vols. (Leiden: E. J. Brill, 1990), 2:212-20. For other patristic Christianizations of the cardinal virtues in Jerome and Ambrose, see ibid., pp. 55-66, 263- 66.

75. Honorius Augustodunensis, *Sermo*, domenica XXII, in *Speculum ecclesiae*, PL 172:1071A.

76. See, in general, Jean Leclercq, "Origène au XIIe siècle," *Irénikon* 24 (1951):425-39; on the harrowing of hell and salvation of Lucifer in particular, see Ralph V. Turner, "*Descendit ad inferos*: Medieval Views of Christ's Descent into Hell and the Salvation of the Ancient Just," *Journal of the History of Ideas* 27 (1966):173-94 (although he overlooks Gregory the Great's treatment of Job); C. A. Patrides, "The

Salvation of Satan," *JHI* 28 (1967): 467-78. Patrides emphasizes the continuing appeal of the universality of salvation in the Greek church even after Origenism was condemned at the Second Council of Constantinople in 553.

77. Peter Abelard, *Ethics*, ed. and trans. David E. Luscombe (Oxford: Clarendon Press, 1971), p. 64. Odon Lottin, "La nature du péché d'ignorance depuis le XIIe siècle jusqu'au temps de Saint Thomas d'Aquin," in *Psychologie et morale aux XIIe et XIIIe siècles*, 6 vols., (Louvain: Abbaye de Mont César, 1948-60), 3/1:11-96 omits Abelard although he reports the view of Robert of Melun, a scholastic influenced by him, who raises the question of the direct revelation of the Christian faith to pagans and thinks it possible but unlikely, p. 29.

78. *Letters of Abelard and Heloise*, 6, trans. Betty Radice (Baltimore: Penguin Books, 1974), p. 182.

79. Peter Abelard, *Sic et non* q. 106.26, ed. Blanche B. Boyer and Richard McKeon (Chicago: University of Chicago Press, 1977), pp. 348-49.

80. Ibid. q. 84.8, p. 302.

81. Peter Abelard, *Theologia "summi boni"* praefatio, 1.5.38-39, ed. Constant J. Mews, CCCM 13 (Turnhout: Brepols, 1987), pp. 85, 98-99; idem, *Theologia christiana* 2.23-24, 2.108, 2.112, ed. Eligius M. Buytaert, CCCM 12 (Turnhout: Brepols, 1969), pp. 142, 180, 182. The quotation is at 2.112, p. 182. This aspect or stage of Abelard's argument is treated by Mario Frezza, *Il problema della salvezza dei pagani da Abelardo al seicento* (Naples: Fausto Fiorentino, 1962), pp. 17-21.

82. Peter Abelard, *Theologia "scholarium"* praefatio, 1.94-103, 1.107-09, 1.123-34, ed. Constant J. Mews, CCCM 13 (Turnhout: Brepols, 1987), pp. 313-14, 356-58, 360-61, 368-73.

83. *Ysagoge in theologiam*, ed. Artur Michael Landgraf in *Écrits théologiques de l'école d'Abélard* (Louvain: Spicilegium Sacrum Lovaniense, 1934), pp. 187-88; Nikolaus M. Häring, ed. "Die *Sententie magistri Gisleberti Pictavensi episcopi* I" 7.6-7, 7.9-11, 7.25, 7.28, *Archives d'histoire doctrinale et littéraire du moyen âge* 45 (1978): 148, 148-49, 150, 151, 152. On this issue as it was debated more widely in this period, see Artur Michael Landgraf, *Dogmengeschichte der Frühscholastik*, 4 vols. (Regensburg: Friedrich Pustet, 1952-56), 3/1:216-53 and more

recently Marcia L. Colish, *Peter Lombard*, 2 vols. (Leiden: E. J. Brill, 1994), 1:533- 36.

84. Peter Lombard, *Sententiae in IV libris divisae* 4. d. 4. c. 2-4.10, 3rd. rev. ed., ed. Ignatius C. Brady, 2 vols. (Grottaferrata: Collegium S. Bonaventurae ad Claras Aquas, 1971-81), 2:252-58. The quotation is at c. 4.10, p. 258. See Colish, *Peter Lombard*, 2:538-39.

85. Peter Lombard, *Sent*. 2. d. 24. c. 2, d. 25. c. 1-d. 29. c. 2, 1:450-52, 461-93.

86. Ibid. d. 41. c. 2, 1: 564.

87. Peter of Poitiers, *Sententiae* 3.17, PL 211:1080C.

88. Sten Ebbesen and Lars Boje Mortensen, ed., "A Partial Edition of Stephen Langton's *Summa* and *Quaestiones* with Parallels from Andrew Sunesen's *Hexaemeron*," *Cahiers de l'Institut du moyen âge grec et latin* 49 (1985): 159-60; Stephen Langton, *In 2 Sent*. d. 25. c. 1, in *Der Sentenzenkommentar des Kardinals Stephan Langton*, ed. Artur Michael Landgraf, Beiträge zur Geschichte der Philosophie und Theologie des Mitelalters, 37:1 (Münster: Aschendorff, 1952), pp. 93-95; Simon of Tournai, *Institutiones in sacrum paginum* 6.96-104, ed. Richard Heinzemann (Munich: Ferdinand Schöningh, 1967), p. 66; Odon Lottin, ed., "Le traité d'Alain de Lille sur les vertus, les vices, et les dons du Saint-Esprit," in *Psychologie et morale*, 6:57-60, 145-46. For Prepositinus and others, see the material in unpublished MSS. presented by Odon Lottin, "Les premières définitions et classifications des vertus au moyen âge," in ibid., 3:2/1: 99-150; Landgraf, *Dogmengeschichte,* 1/1: 163-83.

89. Alan of Lille, "Le traité" 1.1, ed. Lottin, 6:47-50; Nikolaus M. Häring, ed. "Magister Alanus de Insulis Regulae caelestis iuris" 89.1-2. 89.4-7, *AHDLMA* 48 (1981): 195, 196. This point in the *Regulae* has also been noted by James Simpson, "The Information of Alan of Lille's 'Anticlaudianus': A Preposterous Interpretation," *Traditio* 47 (1992): 127, 137-38.

90. The only overview of this subject is Artur Michael Landgraf, "Die Linderung der Höllenstrafen nach der Lehre der Frühscholastik," *ZkT* 60 (1936): 299-370, repr. in *Dogmengeschichte*, 4/2: 255-350.

91. Peter Lombard, *Sent*. 4. d. 47. c. 2-3, 2: 537-40. He had earlier articulated the same doctrine drawing on Augustine and Jerome

as well as Gregory in his commentary on Psalm 1, Peter Lombard, *In Ps*. 1:6, PL 191: 64C-65C. The editor of the *Sentences*, Ignatius C. Brady, thinks that the Lombard added the reference to Gregory after the first redaction of the Psalms commentary, 2: 538 n.

92. Landgraf, "Die Linderung," pp. 311-27. The quotation is on p. 317 n. 30.

93. Ibid., pp. 327-70.

94. *Praepositini cancellarii de Sacramentis et de novissimis (Summa theologicae pars quarta)*, ed. Daniel Edward Pilarczyk, Collectio Urbaniana, ser. 3, textus ac documenta, 7 (Rome: Editiones Urbanianae, 1964), pp. 114-16; *Quaestiones Praepositini*, as transcribed from MS. Troyes 964, f. 155r-156r; MS. Paris, Mazarine 1708, f. 233rb-234va; MS. Paris, Bibliothèque Nationale lat. 18.103, f. 86va-86vb by William J. Courtenay. I am deeply indebted to him for allowing me to consult and cite this material.

95. William of Auxerre, *Summa aurea* 4. tract. 18. c. 4. q. 1. a. 1, ed. Jean Ribailler, 5 vols. (Paris/Grottaferrata: CNRS/Collegium S. Bonaventurae ad Claras Aquas, 1980-87), 4:526-39, for the whole discussion of the subject under the heading of last things. Landgraf, "Die Linderung," p. 331 n. 73 prints part of this text, which was unedited when he published his paper.

96. William of Auxerre, *Summa aurea* 1. tract. 12. c. 4. q. 6-7, 1:239- 41.

97. Alexander of Hales, *Glossa in quatuor libros Sententiarum Petri Lombardi, In 1 Sent*. ad 1. d. 1. c. 12, *In 2 Sent*. ad 2. d. 24. c. 9, ed. Collegii S. Bonaventurae, 4 vols. (Quaracchi: Collegium S. Bonaventurae, 1951-57), 1:12, 2:213.

98. Ibid., *In 3 Sent*. d. 25. c. 2-4, d. 26. c. 7, 3:295-98, 314-15. The quotation is on p. 314. Alexander's argument concerning the philosophers has also been noted by Harent, "Infidèles," *DThC*, 7/2: 1849-50.

99. Whatley, "Heathens and Saints," p. 347

100. Bonaventure, *In 4 Sent*. d. 20. p. 1. dub. 3, in *Opera onmia*, ed. Collegii S. Bonaventurae (Quaracchi: Collegium S. Bonaventurae, 1899), 4: 528.

101. Ibid. d. 45. a. 2. q. 1-2, d. 46. a. 1. q. 1, 4: 942, 957-58. The quotation is on p. 958.

102. Ibid. d. 46. q. 1-2, 4:959-60.
103. Ibid. d. 45. a. 2. q. 1-3, 4:936-37, 940-42.
104. Albert the Great, *In 4 Sent*. d. 20. a. 18, in *Opera omnia* (Paris: L. Vivès, 1894), 29:852-56.
105. Ibid. d. 43. a. 20. responsum, d. 44. a. 45, d. 45. a. 5-6, in *Opera omnia*, ed. C. A. Borgnet (Paris, 1894), 4:530, 603-04, 613-14.
106. Ibid. d. 45. a. 1-3, d. 46. a. 2, 4:606-11, 630.
107. Thomas Aquinas, *In 1 Sent*. d. 43. q. 2. a. 2 ad 5, *In 4 Sent*. q. 2. 7:522-23, 11:366-67.
108. Ibid., *In 1 Sent*. d. 43. q. 2. a. 2 ad 5, 7:523; *Quaestiones disputatae de veritate* q. 6. a. 6 ad 4, in *Opera omnia* (Rome, 1970), 22/1:195; *Summa theologiae* suppl. q. 89.9.6. a. 7, q. 94. a. 2, q. 99. a. 6, in *Opera omnia,* Leonine ed. (Paris, 1854), 4:642, 658-59, 680. The quotation is from the *Sentence* commentary cited first in this note. See also Paris, "La légende," p. 28.
109. Thomas Aquinas, *Quaest. disp. de ver*. q. 14. a. 11, in *Opera omnia*, Leonine ed. (Paris, 1859), 9: 245-46. This point is noted by Harent, "Infidèles," *DThC*, 7/2:1856.
110. Thomas Aquinas, *The Literal Exposition of Job* prologue, trans. Anthony Danico, intro. by Martin D. Yaffe, American Academy of Religion Classics in Religious Studies, 7 (Atlanta: Scholars Press, 1989), pp. 67-69. See also idem, *In 4 Sent*. d. 1. a. 6. q. 3, 7: 477.
111. Thomas Aquinas, *In 2 Sent*. d. 28. q. 1. a. 1-3, 6:640-42.
112. Capéran, *Le problème*, pp. 206-12; F. Ruffini, "Dante e il problema della salvezza degli infedeli," *Studi danteschi* 14 (1930): 79-92; Paul Renucci, *Dante disciple et juge du monde gréco-latin* (Paris: Les Belles Lettres, 1954), pp. 307, 321-22, 400-01 n. 787; Gino Rizzo, "Dante and the Virtuous Pagan," in *A Dante Symposium in Commemoration of the 700th Anniversary of the Poet's Birth (1265-1965)*, ed. William De Sua and Gino Rizzo, University of North Carolina Studies in the Romance Languages and Literatures, 58 (Chapel Hill: University of North Carolina Press, 1965), pp. 115-39; Kenelm Foster, *The Two Dantes and Other Studies* (Berkeley: University of California Press, 1977), pp. 152-55, 171-85, 187, 225-53; Vitto, *Virtuous Pagan*, pp. 43-49.

113. Nancy J. Vickers, "Seeing is Believing: Gregory, Trajan, and Dante's Art," *Dante Studies* 101 (1983):67-85; Alison Morgan, *Dante and the Medieval Other World* (Cambridge: Cambridge University Press, 1990), passim and esp. p. 58.

114. Whatley, "Uses of Hagiography," p. 48; Christopher Ryan, "The Theology of Dante," in *The Cambridge Companion to Dante*, ed. Rachel Jacoff (Cambridge: Cambridge University Press, 1993), pp. 136-52.

115. David Thompson, "Dante's Virtuous Pagans," *Dante Studies* 96 (1973):145-62.

116. Dante Alighieri, *Inferno* 3.2, 3.8-9, in *Divine Comedy*, trans. Charles S. Singleton, 3 vols. (Princeton: Princeton University Press, 1970-75). All references and quotations will be drawn from this edition.

117. *Purgatorio* 3.141 for Manfred, 6.32-42 for Vergil, 11.31-33, 11.29-130 for Dante the traveller.

118. *Purg*. 5.70-72, 5.133, 6.25-27, 8.71-72, 13.50-51, 13.127-29, 13.147, 23.88-89, 26.130.

119. *Purg*. 4.133-34.

120. *Purg*. 7.31.

121. *Inf*. 4.52-61, *Paradiso* 32.122, 32.128-32.

122. *Inf*. 4.49-50.

123. *Par*. 32.19-24.

124. *Inf*. 3.34-51. The quotation is at 3.36.

125. *Inf*. 3.50.

126. Morgan, *Dante*, p. 58. It must be noted, however, that in her census, which gives a total of eighty-four pagans, with fifty-one in this limbo, Morgan omits the Muslim worthies in the limbo of virtuous pagans and omits Rahab in her count of those in heaven. Capéran, *Le problème*, pp. 206-12, errs in seeing no scholastic precursors of Dante's view of the limbo of virtuous pagans.

127. *Inf*. 1.127-29.

128. *Inf*. 1.125, 1.130-31; *Purg*. 7.7-8, 7.25-26.

129. *Inf*. 4.35.

130. *Inf*. 4.34-42; *Purg*. 7.25-26, 7.34-36.

131. *Inf*. 4.114-29. The praise of crusading and other wars against Muslims is given in the speech of Cacciaguida and in Dante's placement of other crusaders in heaven, *Par*. 15.139-41, 18.43-48.

132. *Inf.* 4.82-105.
133. *Inf.* 4.118-44. For Siger, see *Par.* 10.136-38, who, Dante thinks, "demonstrated invidious truths," 10.138.
134. *Purg.* 22.73, 22.89-90.
135. *Purg.* 10.79-81.
136. *Purg.* 10.83. For the whole passage, see 10.34-98.
137. *Purg.* 10.93.
138. *Par.* 19.67-108.
139. *Par.* 20.46-47.
140. *Par.* 20.94-99.
141. *Par.* 20.103-04.
142. *Par.* 20.106-17.
143. *Par.* 20.118-26.
144. *Par.* 20.130-35.
145. T. K. Swing, *The Fragile Leaves of the Sybil: Dante's Master Plan* (Westminster, MD: Newman Press, 1962), pp. 210-11.
146. *Par.* 9.124-25.
147. *Par.* 9.119-20.
148. Renucci, *Dante*, pp. 302-11, who gives a good guide to previous scholarship on this point.
149. *Purg.* 1.90.
150. *Inf.* 5.61-63 for Dido and Cleopatra, *Inf.* 13.32 for Pier della Vigna.
151. *Purg.* 1.71.
152. *Purg.* 1.74-75. The view that Cato is destined for heaven, as soon as the transitory state of purgatory, and with it, his role there, ends, is supported by numerous commentators. See, for instance, Paget Toynbee, *Concise Dictionary of Proper Names and Notable Matters in the Works of Dante* (Oxford: Clarendon Press, 1914), p. 128; Charles S. Singleton, *Purgatorio: Commentary* (Princeton: Princeton University Press, 1973), pp. 15-16.
153. *Purg.* 1.76.

Dante and the Problem of Byzantium

William Caferro

One of the issues that has most interested Professor Pelikan throughout his career has been the relationship in the Middle Ages between the Latin West and Byzantine East. How much did they know about each other? What were their attitudes toward each other? Such questions have proven formidable, and despite the work of Pelikan and others, our knowledge remains dim. The following is a discussion of western attitudes toward Byzantium in terms of one of western Europe's keenest minds, Dante Alighieri. The focus will be on Dante's attitude as reflected in his greatest work, the *Commedia*. Did Dante, who expressed so many opinions about so many things in the *Commedia*, also have an opinion—or opinions—about Byzantium, Western Europe's cultured, rich and, at times, contentious neighbor?

An immediate difficulty for anyone who wishes to discuss Dante is the enormous body of secondary literature that exists on the subject. The connection between Dante and Byzantium, however, is one topic that has not as yet received a great deal of attention. When we turn East, we find the famous literature on Dante and Islam, but not an equivalent one on Dante and Byzantium. Much of what has been written has focused on Dante's relationship with Ravenna, where the poet spent his last years and probably completed the *Commedia*. Ravenna was, and is, a city in which the Byzantine influence is clear, particularly through the famous mosaics in San Vitale and St.

Appolinare in Classe. In the sixth century Ravenna was the seat of the Byzantine exarch, a military/political appointee whose task was to make the emperor's will known throughout Italy. Corrado Ricci, an unabashed chauvinist on behalf of Ravenna, was one of the first to find thematic and iconographic correspondences between the mosaics and the *Commedia*.[1] Ricci's treatment was, however, cursory, one more of enthusiasm than care. His work inspired numerous other studies, the most prominent of which are those of Eugenio Chiarini and Giovanni Pascoli.[2] In the last few years, Rachel Jacoff and Jeffrey Schnapp have produced excellent studies on the impact of the mosaics on the *Commedia*, focusing particularly on thematic links with the *Paradiso*.[3] Beyond the material relating to Ravenna, there is surprisingly little. The great *Dantista* Bruno Nardi discussed aspects of the general problem in several works, but arrived at no conclusions.[4] In an article published in 1950, C.A. Trypanis made the interesting assertion that Dante had used the Byzantine treatise, "On Virtues and Vices," written either by Efrem the Syrian or John of Damascus, to construct the order of sins in the *Inferno*.[5] This was sternly refuted by Agostino Pertusi, who took issue both with the substance of the treatise, which he claimed did not correspond to the *Inferno*, and with the nature of its transmission to Italy.[6] Pertusi then put forward his own theories regarding Byzantine influences in the *Commedia*.[7] He found a vague "echo" of the Franco-Venetian conquest of Byzantium in canto XII, 17 of the *Inferno* and canto XIX, 145-48 of the *Paradiso*, but admitted that Dante otherwise showed little knowledge: "the balance," he said, "is in great part negative."[8] Historians have remained silent on the issue. The basic statement is that of Deno Geanakoplos, who devoted much of his career to investigating issues East/West in the Middle Ages. In *Interaction of "Sibling" Byzantine and Western Cultures in the Middle Ages and the Italian Renaissance (330-1600)*, Geanakoplos touched upon the issue briefly, commenting that although Dante was influenced "by the philosophy of Aristotle and the mysticism of the Byzantine Dionysius the Areopagite," but for "a bare mention of Justinian," he knew " nothing of the many remarkable theological, literary and artistic achievements of Byzantium."[9]

The aim here is to pursue the issue more vigorously, to give a more comprehensive accounting of the role of Byzantium in the *Commedia*. What Byzantine political events, personages, theology,

philosophy are included? Are the omissions and silences significant? Can we speak of an "agenda" involving Byzantium?

The words of Professor Geanakoplos provide a convenient starting point. It is clear that both the pseudo-Dionysius and Aristotle had an enormous impact on the *Commedia*, and one does not have to read very carefully to find it. The structure of the *Paradiso* is patterned directly after the pseudo-Dionysius' *Celestial Hierarchies*. Dante, for all his craft, his allegory, his subterfuge, credits his source not once but twice: in canto X of the *Paradiso* Dionysius is the light "who saw farthest into the nature and ministry of the angels"; and in canto XXVIII Dante mentions Dionysius by name, "and Dionysius set himself with such zeal to contemplate these orders that he named them and distributed them as I do." Moreover, unlike his knowledge of so many other things, Dante's familiarity with the pseudo-Dionysius appears to come directly from the treatise, available in the West in several translations, and not through an intermediary. [10] One could even argue that Dante's entire journey in the *Commedia*–through the *Inferno*, the *Purgatorio* and the *Paradiso*—is nothing more than the fleshing out of pseudo-Dionysius' model of "illumination," "purgation" and "perfection."

Dante's debt to Aristotle is somewhat more subtle and has, over the years, been the subject of much debate. Dante was certainly less open about his source; Aristotle was, unlike the pseudo-Dionysius, not Christian. Nevertheless, it is fair to say that Aristotle's influence is substantial and, without disturbing the ghost of Etienne Gilson, that it is felt chiefly, though by no means exclusively, through Thomas Aquinas. [11] It is perhaps most apparent in the light imagery which pervades the *Paradiso*, which is a sensual light and leads, willy nilly, to the development of a theory of knowledge much like that of Aristotle and Aquinas.

The problem for our larger issue, "Dante and Byzantium," is that neither Aristotle nor the pseudo-Dionysius were strictly speaking Byzantine, nor were they viewed as such by Dante. Aristotle lived during the era of Alexander in the fourth century B.C, well before the establishment of the Byzantine Empire. The pseudo-Dionysius, whatever his real identity, was identified by Dante and the rest of the Latin West as a follower of Paul, converted while the saint was on a mission in Greece. Thus, like Aristotle, the pseudo-Dionysius predates Byzantium. Indeed consideration of these two points out, as Scartizzini

once warned, the dangers inherent in trying to weed out specific strands of thought in the *Commedia*.[12] For example, when Dante enters the first celestial sphere, the sphere of the moon (Piccarda) he gazes up at the pseudo-Dionysius' "Celestial Hierarchies" and how the souls, the various lights, are arrayed in their various spheres. Dante is puzzled and he turns to Beatrice, who has been called Dante's big sister with a Ph.D.; Beatrice replies that while the souls may appear to Dante to be arrayed in various spheres they were all, in fact, in the Empyrean. The reason they appear this way, she says, is because "it is necessary to speak thus to your faculty, since only from sense perception does it grasp that which it then makes fit for the intellect."(*Par*, IV, 40-42). Or, in other words, "nihil est in intellectu quin prius est in sensu," the theory of knowledge taken from Aristotle or from Aristotle through Thomas. Notice what has occurred. The hierarchies of the pseudo-Dionysius have led Dante to consideration of Plato and this is, in turn, resolved by a consideration of Aristotle's/Thomas' theory of knowledge. Dante's philosophy is, like his theology and everything else about him, distinctly his own.

Are there, then, any contemporary Byzantine figures or political events? One major political event involving Byzantium that is, in fact, covered by Dante, and in unusual detail, is the Sicilian Vespers.[13] The Sicilian Vespers was an uprising in 1282 against the French, specifically Charles of Anjou, the brother of St Louis. Charles had been given Sicily and southern Italy as a papal fief some years earlier. The French were disliked by the natives. The incident supposedly started when a French soldier took liberties with a Sicilian woman. Folklore has it that to root out the French, who often pretended to be Italians, suspects were forced to say "ceci," a word that the French found difficult to pronounce properly. In actuality, the uprising was instigated in large part by the Byzantine Emperor Michael VIII Palealogus, who feared, with good reason, that Charles would use his Sicilian holdings as a base for an attack against Constantinople. Twenty years earlier, Michael Palealogus had helped lead the Byzantine reconquest of Constantinople. The Byzantine empire had been conquered by the West in the Fourth Crusade in 1204 and the rulers had been in exile until Paleologus engineered the reconquest in 1261. Dante presents the major protagonists: Charles of Anjou, "he of manly nose" (*Purg*., VII, 113) as Dante calls him in one place, or simply " il nasuto," the nose (*Purg*., VII, 124) as he calls him elsewhere, and Peter III of

Aragon (*Purg* VII, 112–116, 125, 129), Charles's chief adversary, with whom Michael Paleologus conspired. Dante likewise includes several of the incidents leading up to the outbreak of hostilities.[14] Michael himself, however, is not included. Nor are there any references to Byzantine involvement.

Another political event involving Byzantium mentioned by Dante is the Second Crusade (1147–49). Dante refers to the crusade during his conversation with his ancestor Cacciaguida in canto XV of the *Paradiso*. The Second Crusade was a thoroughly unsuccessful crusade, during which the Byzantines behaved treacherously. They poisoned the crusaders' food and overtly assisted the Muslims. Byzantine perfidy was well known to western contemporaries, and recapitulations of the event inevitably include censure and condemnation. Dante, however, lets fly no moral invective. Here again he does not mention the Byzantines at all. His indignation is focused squarely on the Muslims.

A certain irony should be pointed out, an irony of which Dante was probably not aware. Cacciaguida claims to have died in the service of the Emperor Conrad: "I followed the Emperor Conrad, and he girded me with knighthood . . . There I was set free from the entanglements of the deceitful world. . ." (*Par*, XV, 128-133) Emperor Conrad has been identified by scholars as Conrad III Hohenstaufen.[15] According to the account of Odo of Deuil, a French monk and chaplain of King Louis VII, who went on the crusade, Conrad's army was betrayed by its Byzantine guides on a narrow pass at Iconium. "The Greek guide," Odo wrote, "ordered them to take eight days food. They (the crusaders) were led to impassable territory by the guide who slipped away and told the Turks to attack. The Turks bided their time and after Conrad and his men ran out of food, they attacked."[16] Odo states that not only did the overwhelming number of Conrad's army die, Conrad himself was mortally wounded. The few survivors cursed the "idol," the name the crusaders had given the Byzantine ruler, Manuel Comnenus, whom they blamed.[17] Thus it is likely that Dante's ancestor died of Byzantine treachery.

The other great events East/West are simply not there. Dante makes no reference to the schism of 1054 that divided the two churches, and no mention of Michael Cerularius, the willful Patriarch of Constantinople who was instrumental in causing it. There is nothing about the First Crusade or of Alexius Comnenus, the Byzantine

Emperor, who did or did not ask for help, depending on whom we believe.[18] Nor is there anything about his daughter Anna, who wrote about the event. The Normans Robert Guiscard and Bohemond, however, two major antagonists of Alexius are in the *Commedia*, in the Paradiso no less, as warrior saints. Dante seems unconcerned that these two, particularly Robert Guiscard, killed more Christians, particularly Byzantine Christians, than infidels. Guiscard's only experience with the Muslims was the Norman raid on Sicily and this was primarily conducted by his brother Roger. Dante makes no reference to the Crusade of 1204, the one that took Constantinople, or the Christian kingdom that lasted until 1261. This is an exclusion that has also perplexed Pertusi.

The overall political exclusion of Byzantium is most apparent in canto XIX of the *Paradiso* when the Eagle, the "uccell' di dio" and symbol of the Roman Empire, gives a lengthy speech about the final judgment. It this speech the eagle canvasses the known world. It speaks to the Scot, the Englishman, the Ethiopian; to Bohemia, to Norway, Rascia, Hungary, Portugal. It does not, however, speak to Byzantium.

Perhaps we should stop here and say what might be obvious: maybe Dante simply knew nothing about Byzantium. Bruno Nardi in fact once noted that "the ignorance of Dante . . . does not surprise those who know the not few gaps in the culture of the Florentine poet, who thought and meditated more than he read."[19] Perhaps this is simply one of those gaps. Indeed, Pertusi quotes these same words to explain his inability to find anything more than "echoes" of Byzantium in the work of one who spent substantial time in Ravenna.

Such a conclusion, though tempting, would nevertheless be premature. In the first place, Dante's contemporaries display far greater knowledge of Byzantium. The Pisan chronicler, Ranieri Sardo, who was very sparing in his descriptions, found space to discuss the Byzantines.[20] Sardo mentioned the Byzantines in his descriptions of both the first and second crusades. In each instance he condemned their treacherous behavior, which led, at the end of the second crusade, to open violence with Pisan crusaders. Likewise, the Lucchese chronicler, Giovanni Sercambi, included Michael Paleologus' reconquest of Constantinople in his account of the events of the year 1258.[21] More importantly, the Florentine chronicler, Giovanni Villani, made frequent mention of the Byzantines. Dante may not have known history, but he certainly knew Villani. Scholars long ago established a connection

between the work of the chronicler and the poet, who were friends. Some have indeed asserted that Dante's depiction of Romeo in canto VI of the *Paradiso* was taken directly from Villani.[22] Villani's account of the Second Crusade, unlike Dante's, includes a description of Byzantine treachery. Villani accused the Byzantines of causing the death of many crusaders by mixing chalk into their feed.[23] Villani's treatment of the Sicilian Vespers includes specific mention of Michael Paleologus and his negotiations with Peter of Aragon.[24] Villani also deals with the reconquest of the Latin kingdom by Michael Paleologus and several interactions between the cities of Constantinople and Florence, most notably the arrival of a sacred relic sent by the Emperor Manuel Comnenus.[25] In Dante's own lifetime, Villani chronicled the events of the mercenary captain, Roger di Flor, who (1302) won a name for himself at the head of a mercenary company in Byzantium that fought for the Emperor Andronicus II.[26] Further, Villani discussed the great church council at Lyons (1274) that occurred during Dante's youth, making reference again to Michael Paleologus, who played a major role in the event.

Other Florentine chroniclers who Dante might have been familiar with such as Ricordano Malispini and Sanzanome also show awareness of the Byzantine. Malispini, for instance, relates the details of the sack of Constantinople in 1204.[27] Like Villani, Malispini also includes a discussion of Michael Paleologus' role in the reconquest of Constantinople as well as Paleologus' negotiations with Peter of Aragon during the Sicilian Vespers.[28]

Second, Dante shows greater awareness of Byzantium in his own work. In a famous letter to the cardinals at Carpentras (1314) Dante mentions John of Damascus (d 754), among others, as the proper subject of study, as opposed to the false decretals in vogue in the contemporary day.[29] John of Damascus was undeniably Byzantine, a citizen of the empire living in the lively, cosmopolitan Syrian city whose name he bears. Likewise, in the *De Monarchia* Dante mentions the Emperor Michael Paleologus. He states that Charlemagne received his crown from Hadrian when Michael was on the throne in Byzantium.[30] The problem here of course is that Michael was not on the throne when Charlemagne was made Emperor, Irene was. But Dante's error with Byzantium was no greater than his error with the Roman Papacy. Hadrian was not pope when Charlemagne was

crowned, Leo was. Yet no one would claim Dante knew nothing of the papacy.

Moreover, it should be pointed out that lack of thoroughgoing knowledge of an historical person or event never prevented Dante from including them if he so desired. The founder of Islam, Mohammed, appears in the eighth circle of the *Inferno* (*Inf.*, XVIII, 22-63). He is depicted as a schismatic, i.e., a dissenter from within the religion. In this he ranks above Cassius and Brutus, two who stabbed Julius Caesar, who are in the ninth circle at the very core of hell with the devil. Dante's depiction of Mohammed is of course erroneous. But nevertheless it is consistent with the generally hazy view in the West at the period. Villani too saw Mohammed as a schismatic. The Florentine chronicler Malispini saw him as a Nestorian Christian gone mad, another common view.

We might assume that given Mohammed's obvious importance Dante had to include him. But Mohammed is not the only Muslim in the *Commedia*. Dante also makes mention of the philosophers Avicenna and Averroes, and the crusader Saladin. The inclusion of Saladin, who fought against the Richard the Lion-Hearted and the Christians in the third crusade, is particularly strange. Saladin is incongruously placed in the first circle of the *Inferno* with so-called virtuous pagans. These include the shades of Socrates, Cicero, Plato, Euclid. Fast company for a man who killed Christians for a living. Saladin appears to have earned his place more from a medieval tradition of his munificence and kindness toward captives. In any case, however, Dante knew little of the actual man.[31] Clearly Dante was not reticent to speak of the Muslims, despite the fact that he was no better informed about them than of Byzantium.

If the *Commedia* lacks contemporary Byzantine figures and events, what of the theological issues separating the two sides? Here one might perhaps expect most of all to see some sort of inclusion. Many of major issues separating the East and West were in fact theological: the *filioque* and eucharist to name two. Indeed, the *Commedia*, the *Paradiso* in particular, is devoted to harmonizing the various theological trends of the day. It is in the *Paradiso*, the circle of the sun, that Thomas, a Dominican, tells the story of St Francis and the Franciscans while St. Bonaventure, a Franciscan, tells the story of Dominic and the Dominicans. Thomas and Bonaventure, rivals in life, are placed in concentric circles and move together in harmony. It is also

in the circle of the sun that Thomas introduces, in reverential tones, Siger of Brabant, of "double truth" fame and Bonaventure introduces Joachim da Fiore, of "three eras" fame, whom he had condemned in life. Is there room for harmony with the erring Byzantines?

The fact that one of the books of the *Commedia* is the *Purgatorio* separates Dante right away from the East, which did not recognize purgatory. On the divisive issue of the *filioque*—(literally, "and from the son") an addition to the Nicene Creed made by western theologians, which had the Holy Spirit proceed from both the son and the father[32]—Dante is distinctly western in outlook. Just before we meet Thomas Aquinas in canto X of the Paradiso Dante makes one of his frequent references to the trinity and says: "Looking on his son with the Love ("Amore") of which the one and the other eternally breathe forth (eternalmente spira) . . ." This is a standard reference to the *filioque* and one of several that occur in the *Commedia*. "Amore" should be understood here, as throughout the Commedia, to represent the "Holy Spirit," a symbolism not restricted to Dante. We have then the Holy Spirit proceeding from (spirating from) the Father and the Son.

The eucharist is a bit more elusive. One could conceivably read the entire *Commedia* and not notice any overt reference to the eucharist. There is, to be sure, a reference; it occurs in canto XVII of the *Paradiso*. This reference has often been judged inadequate, because it is part of a much larger agenda that is not concerned with the Eucharist per se. The rest of the sacraments, and much more, are represented, for their own sake in the pageant of the Church Militant in cantos XXIX, XXX, XXXI of the *Purgatorio*. In these cantos, the Church Militant, which resembles a float in the Tournament of Roses parade, drifts across the stage, as it were, loaded with symbolism. It contains symbols of the gospel writers, heavenly virtues, faith, hope and love, Dominic and Francis are in the wheels of the car. Smack in the middle of all there is Beatrice whose appearance elicits "benedictus qui venis" (Purg., XXX, 19). This has been compared to the Corpus Christi procession and the arrival of the host at the mass; Beatrice cast in the role of the Eucharist. If we accept Beatrice as the "eucharist," our question then might be whether she is leavened or unleavened, which is of course unanswerable.

An interesting theological omission is the second Council of Lyons, the important East/West Council which took place during

Dante's lifetime (1274). Its task was to reunite the two churches and, to this end, brought out all the prominent churchmen of the day, including Aquinas and Bonaventure, who both ironically died enroute. Certainly there is no special dispensation given to the Popes who had something to do with the Council. Nicholas III (1277–1280) who worked hard to uphold the union made at Lyons, is in the third bolgia (canto XIX) as a simonist.[33] Clement IV (1265–1268) who listened to Michael Paleologus' plea to open up negotiation on church unity, is mentioned only in the context of his unfair condemnation of Manfred, the illegitimate son of Frederick II, "Stupor mundi." Pope Gregory X, who was instrumental in arranging the union, is not mentioned at all.

The omission is of further interest. In the canto XX of the *Purgatorio* Dante introduces Charles of Anjou as the one who "drove Thomas back to heaven" (Purg, XX, 69). This was a rumor, and Dante was fond of such things. It should be noted, however, that the motivation behind the deed, so the rest of the rumor went, lay in the fact that Anjou did not want Thomas to appear at the Council of Lyons lest he single-handedly reunite the churches and thus frustrate Anjou's political ambition. Dante repeats the rumor, but not its context.

So where is Byzantium? We turn at last to Justinian. Our original quote said there was "only the barest mention" of Justinian, but this is in fact wrong. Justinian has a whole canto of his own, the only character in the *Commedia* so honored. Indeed, most descriptions in the *Commedia* are extremely brief. The famous duo in the *Inferno*, Paolo and Francesca, about whom so much has been written, get only a few lines. Justinian, on the other hand, rambles on for a whole canto and gives a long account of the exploits of the Roman Empire.

And there is no denying that the historical Justinian was Byzantine. He ruled from Constantinople in sixth century and took upon himself the task of recapturing much of the West. Dante certainly had seen Justinian, as well as his wife Theodora and their glittering Byzantine court in the mosaics in Ravenna.

So can we now conclude that Dante generally ignored Byzantium, but for a "not-so bare" mention of Justinian? The answer is negative. To come to such a conclusion is, I believe, to misinterpret the *Commedia*, or, worst of all, to not interpret it at all. I assert that despite the inclusion and prominence of Justinian, Dante thoroughly and purposefully excluded all things Byzantine from the *Commedia*. I stress that the omission was intentional, requiring at times great skill. It was

nevertheless necessary to preserve an important agenda, one that was dear to Dante, and one that runs both throughout the *Commedia* and throughout much of the poet's work in general. The figure Justinian is central to this agenda and, ironically, points out most clearly why no Byzantines can be included.

If we look at canto VI of the *Paradiso* we see that Justinian's role is first and foremost as lawgiver, specifically as author of the *Corpus Iuris Civilis*. Indeed, he is first introduced in his connection with the law: "Caesar I was, Justinian I am, who by the will of primal love (primo amor) removed from the laws what was superfluous and vain" (*Par.*, VI, 10–12) Later this is referred to as his "high task" (alto lavoro). The great military deeds are specifically imputed to Belisarius, his general ("I committed my arms to my Belisarius"). Dante portrays the codification of Roman law as nothing less than the transformation of "divine law" into human law. When Justinian is corrected in his faith—he had been a monophysite—by the pope, he was given the task by God to transform divine law into human law. From there Justinian tells the exploits of the so-called "bird of God, the Roman Eagle," or symbol of ancient Rome. He relates the deeds of Rome back to the time of their ancestors, the Trojans. The description is punctuated with continual reference to "living justice" (viva giustizia), a technique Dante uses here for emphasis. It is clear throughout this canto that an overt almost clumsy attempt is being made to equate Rome with law, Rome with justice, Rome with the divine plan, and all somehow in the person of Justinian.

The argument is a familiar one. If we remove Justinian, the discussion in canto VI of the *Paradiso* is strikingly similar to that in Book II of the *De Monarchia*. Here Dante attempts to establish why the Romans were suited for world rule. He argues essentially that the Romans were chosen by God and justifies their "choice" in several ways, but particularly on the grounds that the Romans were the most "noble."[34] They were most noble because they were the direct descendants of Aeneas, who was "noble" and who founded the Roman race. Dante's sources here, as he says openly, are Vergil and Livy.[35]

Traces of this argument can also be found earlier in book IV of the *Convivio*. Here again Dante stresses the connection between the Romans and the Trojans. He argues, among other things, that God's choice of the Romans was made manifest when Jesus chose to be included in the Roman census and chose to submit to Roman law.

Dante also stresses the coincidence between the arrival of Aeneas in Latium with the birth of King David of the Jews, God's other "chosen" people.

This fascination with Rome has not gone unnoticed by scholars. In their pioneering studies both Nancy Lenkeith and Charles Till Davis have dealt extensively with the issue. In subsequent years their ideas have circulated in various forms in numerous works.[36]

Dante's concern with this issue—which would certainly make him more a man of the Middle Ages than of the Renaissance—was understandable. One of the great quests in Dante's life was to see an end to the civil strife that had caused him such personal misfortune. It should never be forgotten that Dante was an exile, because he never forgot it. And his call for peace was not the only one of the age. Remember that Dante's contemporary Marsilio of Padua chose to call his political treatise "Defender of the Peace." Likewise, Petrarch, in his *canzone* "Italia mia," cried out "peace, peace, peace (*pace, pace, pace*)" as he surveyed contemporary Italy.[37]

The question for Dante was how to effect this peace, how to achieve harmony. Dante saw world empire, the re-establishment of Rome, as the only real possibility for peace. He saw in his contemporary, Henry VII, the current Holy Roman Emperor, a chance to attain this. It is no surprise that Henry is in the highest level of paradise, in the Empyrean (*Par.*, XXX, 136–138). Indeed, the *Commedia* can be read as Dante's most eloquent call for peace.

In Justinian's canto we have seen the recurrence of the word "justice" during Justinian's rehash of the deeds of the Roman Empire, establishing in essence a parallel between the two. This is, however, only the tip of the iceberg; the word "justice" in fact pervades the *Paradiso* and is the operative term through which Dante transforms the Romans into a "chosen" people. It is by affixing the term "just" to the Romans that Dante will make them the "chosen" people. Nowhere does Dante state the connection more openly than in canto XVIII when the Eagle, the symbol of the Roman empire, the "uccell di dio" (bird of God) forms itself into the letters "diligite iustitiam qui iudicatis terram" (Love justice, you who judge the earth), the opening lines of the Book of Wisdom. The argument in the *Paradiso* is very much the same as the *De Monarchia*, except that the term "justice" has come to replace the term "noble."

The connection between "justice" and God's "choice" is so strong that it influences Dante's choice of who to save. Those who are described as "just" appear to have earned a place in paradise even if their salvation was otherwise dubious. Ripheus, a thoroughly fictional character, who appears briefly in book two of the *Aeneid*, is in heaven too. This is because he was described by Vergil as "most just."[38] He thus merits a place in eye of the eagle, with the just rulers. The Roman Emperor Trajan, the man who wrote to Pliny for advice on the proper mode of persecuting Christians, is given a place in heaven for doing "justice" for a poor widow.[39]

In this equation, "justice" equals "chosen," Justinian is the key figure. It is with Justinian that Dante is able to show, in more dramatic terms, God's choice of Rome. The selection of the Jews was made manifest by spectacular events: burning bushes, parting seas. One might well ask, where are the supernatural signs of God's favor toward the Romans? Certainly in "paradiso" one might expect sterner stuff. This indeed does occur in the person of Justinian. It is through Justinian that divine law, God's Law, is transformed into earthly law. This makes for a very neat parallel between the Jews and the Romans, something Dante had already tried rather clumsily to do in the *Convivio*. As God gave the Jews, and Moses, law, God also gave the Romans, Justinian, law, i.e., the *Corpus Iuris Civilis*. This is the symbol of God's choice; Justinian is Moses and Abraham rolled into one. It should not surprise us then that Justinian gets a whole canto. To complete the connection, should the reader not get the message, Dante has Justinian speak his final words to Dante in both Latin and Hebrew. Indeed, it could be argued that Dante's treatment of Justinian is not unlike St. Paul's treatment of Abraham in his letter to the Romans.

Where then does this leave Byzantium? One might well ask, does not "Rome" include Byzantium? Certainly, the Byzantines saw themselves as Romans. There was the matter of the "translatio imperii" and the idea of Constantinople as the second Rome. The Byzantines referred to themselves as "Romans" in their own documents. But did Dante see them as Romans?

The answer is negative. I base this assertion both on evidence from the period in general and from the *Commedia* in particular. Contemporary Italian chroniclers refer to the Byzantines not as Romans—as they referred to themselves—but as "Greeks." In his descriptions of the Second Crusade, the Fourth Crusade, and the career

of Roger di Flor, Villani refers to the Byzantines as "Greeks." This is also true of Ricordano Malispini, the Pisan chronicler Ranieri Sardo and the Lucchese chronicler Giovanni Sercambi.

Moreover, Dante, who based so much of his justification of the Romans on the *Aeneid*, and on the connection between Troy and Rome, need go no further than the *Aeneid* to find out what the ancestors of the present-day Greeks were. If the Trojan was, like Aeneas, "just," the Greek was, like Sinon and Ulysses, "false." Evidence from the *Commedia* makes clear that Dante was indeed heavily influenced by the *Aeneid* in his depiction of Greeks. Sinon, who convinced the Trojans in book two of the *Aeneid* to accept the horse, resides at the very base of hell, in canto XXX, below Mohammed. He is introduced to us as "false Sinon Greek from Troy (falso Sinon, greco da Troia)." When Sinon ultimately speaks his discourse abounds with the term "false" in its various forms. "I spoke falsely (*falso*)," Sinon says, "thou did falsify (*tu falsasti*) the coin, and here I am for one fault (*fallo*) and thou for more than any other devil."[40] Ulysses, whom Dante is a bit more sympathetic toward (he too was an exile), can also be found in the *Inferno*, in canto XXVI, with the False Counselors. Nowhere is Dante's attitude more clear than when he describes in canto XX of the *Paradiso* Constantine's donation, an act for which he had singular contempt. Dante turns on the great Emperor, the founder of Byzantium, and accuses him with both bitterness and irony of making himself the "Greek."[41] What little Dante knew of the modern Greek only reinforced the ancient stereotype.

Dante, for all his concern for harmony and peace, simply cannot find a way to harmonize "just" with "false"; "Roman" with "Greek." It is, in short, an impossible task. Any attempt would ultimately destroy his cherished agenda of portraying the Romans as the "chosen" people. The entire construct, as Dante well knew, was extremely fragile. The poet need go no further the Augustine's *City of God*, a book that had an enormous influence on him in general and on the *Commedia* in particular, to find a strong dissenting opinion on the Romans. There could therefore be no ambiguity in his treatment of the Romans, and what better way to avoid this than to exclude the Byzantines altogether.

NOTES

1. Corrado Ricci, *L'ultimo rifugio di Dante* (Milan, 1921).
2. Eugenio Chiarini, "Riflessioni su un vecchio problema: Dante eRavenna" in *Atti del convegno internazionale di studi dantesch* (Ravenna, Sept 10-12, 1971), pp. 217-237; Giovanni Pascoli, *Ravenna e la Romagna negli 'Studi Danteschi'* Edited by Francesco Giugni (Ravenna, 1966). Chiarini's " Riflessioni" is a useful starting point because it cites much of the extant bibliography.Other studies of note are Ugo Bosco's *Dante vicino* (Caltanisetta-Roma, 1966), U. Cosmo's *Vita di Dante* (Florence, 1965) and M. Apollonio's *Dante, Storia della Commedia* (Milan, 1951). One should also consult Chiarini's entry for Ravenna in the*Enciclopedia dantesca*, IV, (Rome, 1973), pp. 861-65.
3. Rachel Jacoff, "Sacrifice and Empire: Thematic Analogies in San Vitale and the Paradiso" in *Renaissance Essays in Honor of Craig Hugh Smyth* (Florence, 1985), pp. 317-331. Jeffrey T. Schnapp, *The Transfiguration of History at the Center of Dante's Paradiso* (Princeton: University Press, 1986). Jacoff focused her attention on the mosaics of San Vitale. Schnapp devoted a chapter to the effect of the mosaics of San Appolinare in Classe on the canto 15 (Cacciaguida) of the *Paradiso*. It is Schnapp's contention that the mosaics "played a decisive mediating role in Dante's Christian reworking of his Virgilian-Ciceronian models in the central cantos of the *Paradiso*." (p.177)
4. See Bruno Nardi, *Dante e la cultura medievale* (Bari, 1942); *Nel mondo di Dante* (Rome, 1944); *Saggi di filosofia dantesca* (Florence, 1967).
5. C.A. Trypanis, "Dante and a Byzantine Treatise on Virtues and Vices," *Medium Aevum*, 19 (1950), pp. 43-49.
6. Pertusi's refutation appears under the citation "Bizintina, Civiltà" in the *Enciclopedia dantesca*, vol. 1 (Rome, 1970), pp. 639-640.
7. Agostino Pertusi, "Cultura greco-bizantina nel tardo Medioevo nelle Venezie e suoi echi in Dante" in *Dante e la cultura veneta* in *Atti del Convegno di Studi organizzato della Fondazione Cini.* Edited by V. Branca e G. Padoan (Venice, 1967), pp. 157-197. Much of Pertusi's article is reprinted in the *Enciclopedia dantesca.*
8. Pertusi, "Cultura greco-bizantina," p. 176.

9. Deno J, Geanakoplos, *Interaction of "Sibling" Byzantine and Western Cultures in the Middle Ages and the Italian Renaissance (330-1600)*. (New Haven: Yale University Press, 1976), p. 116. In addition to Geanakoplos, there is a very brief article by the German Byzantinist Franz Dölger. It deserves mention here primarily for its uniqueness. Dölger took the issue from the opposite vantage, investigating the impact of Dante on Byzantine literature. The article appears to have had little impact on Dante scholarship. Franz Dölger, "Die Byzantinishe Literatur und Dante," *Compte-rendu Deuxième Congrès International des ètudes byzantines* (Belgrade, 1913), pp. 47-48.

10. Pertusi, who also saw the importance of the pseudo-Dionysius, makes this point. This is to clear Dante of the charge that he knew of the pseudo-Dionysius only through Thomas Aquinas.

11. Etienne Gilson, *Dante as Philosopher*. Translated by David Moore (New York: Sheed and Ward, 1949). Gilson took issue with Mandonnet and Wicksteed, who saw Dante as essentially a mouthpiece for Aquinas. P. Mandonnet, *Dante le Theologien* (Paris, 1935); P. Wicksteed, *Dante and Aquinas* (London, 1913). It is now generally agreed that Dante had read Aristotle independently of Aquinas. This is particularly clear in the *De Monarchia*.

12. Scatizzini called the search for the sources of Dante's thought not only "foolish" but "childish" as well, G. A. Scartizzini, *Concordanza della Divina Commedia di Dante Alighieri* (Leipzig, 1901), p. xii.

13. The event is dealt with specifically in *Par*, VIII, 73-75. All citations are from John D. Sinclair's translation (New York, Oxford University Press, 1961-70) of the *Commedia*.

14. This includes a lengthy treatment of Manfred, Peter of Aragon's brother-in-law, who inherited Sicily from his father Frederick II, but was defeated and killed in 1266 at Benevento by Charles of Anjou. *Purg*, III, 103-145.

15. Some early scholars (Pietro, Buti, Landino) identified Conrad as Conrad II of Franconia (1027-1039), who at the request of the bishop of Milan waged war against the Saracens in southern Italy in 1026. It is now generally agreed that Cacciaguida's "Currado" was Conrad III Hohenstaufen (1127-1152). Enrico Pispisa, author of the citations for both Conrads in the *Enciclopedia dantesca*,

points out that Conrad III was a contemporary of Cacciaguida, not Conrad II. *Enciclopedia dantesca*, vol. 2 (Rome, 1970), p. 218.

16. Odo of Deuil, *De profectione Ludovici VII in Orientem*. Edited and translated by Virginia Gingerick Berry (New York: Columbia University Press, 1948), p. 98.

17. Odo of Deuil, p. 100.

18. I refer to the so-called "spurious letter" written by Alexius to the West requesting help.

19. Bruno Nardi, *Dante e la cultura medievale*. (Bari, 1942), p. 91.

20. Ranieri Sardo, *Cronaca di Pisa*. Edited by O. Banti. In *Fonti per la storia d'Italia* (Rome, 1963), p. 21-22, 31-32.

21. Giovanni Sercambi, *Le croniche*. In *Fonti per la storia d'Italia*. Edited by Salvatore Bongi (Rome, 1892), p. 36.

22. What has remained unclear--and has been the subject of a lively debate--is the exact nature of the connection: some have maintained that Dante took from Villani, others that Villani took from Dante and still others that they took from a mutual third source, Ricordano Malispini. There is an abundant literature on the subject. Charles T. Davis gives a good summation and evaluation of the early literature in an appendix (pp. 244-262) to his *Dante and the Idea of Rome* (Oxford, Clarendon Press, 1957). The issue was taken up again by Giovanni Aquilecchia in an article entitled "Dante and the Florentine Chroniclers" originally published in *The Bulletin of John Rylands Library* (vol. 48, 1965-66) and recently reprinted, with a collection of the author's other essays, in *Schede di Italianistica* (Turin, 1976), pp. 45-72. More recently, Charles T. Davis dealt with the issue anew in *Dante's Italy, and other Essays* (Philadelphia: University Press, 1984).

23. Giovanni Villani, *Istorie fiorentine*. Edited by Achille Mauri (Milan, 1834), pp. 57-58.

24. Giovanni Villani, *Istorie fiorentine*, pp. 138-141. Villani does not, however, blame Michael for the outbreak of the conflict. The full story of Michael's clandestine activities was only uncovered in the modern era.

25. Villani, pp. 68 (relic sent by Manuel Comnenus), 98 (reconquest of Constantinople).

26. Villani, p. 193.

27. Ricordano Malispini, *Istoria fiorentina* (Florence, 1718), p. 80.

28. Malispini, p. 139.

29. Dante wrote: "Everyone has taken avarice to wife, what shameful sins the Bride of Christ must own, her daughters-in-law are neither Charity nor Justice but the daughters of the horse leech . . . Gregory, Ambrose, Dionysius and Bede have been cast aside in favor of Speculum Iuris and the decretals of Innocent II and the Bishop of Ostia." *Opere di Dante Alighieri.* Edited by Fredi Chiapelli (Milan, 1963-78), pp. 409-410 (epistole XI).

30. *De Monarchia*, III, 11. In *On World Government*. Translated by Herbert W. Schneider (New York: Bobbs-Merrill Co., 1957), p. 70-71.

31. It should be noted that the Muslims Avicenna and Averroes are also included by Dante, but as philosophers who had great influence the West, Dante was more familiar with them.

32. The Byzantines did not accept the *filioque*, arguing that it destroyed the unity of the godhead.

33. George Ostrogorsky, *History of the Byzantine State* (New Jersey: Rutgers University Press, 1957), p. 412.

34. *De Monarchia*, II, 3, 2. The Latin is "Romanus populus fuit nobilissimus." (in *Opere di Dante Alighieri*, p. 351)

35. *De Monarchia*, II, 3, 6-7 (in *Opere di Dante*, p. 351.)

36. The two basic studies are those of Charles Till Davis, *Dante and the Idea of Rome*. (Oxford, Clarendon Press, 1957) and Nancy Lenkeith, *Dante and the Legend of Rome*. (London, 1952). An interesting recent treatment is Rachel Jacoff's "Sacrifice and Empire" cited above. Unlike Lenkeith and Davis, she deals at greater length with the figure of Justinian.

37. Francesco Petrarch, *Sonnets and Songs*. Translated by Anna Maria Armi (New York: Pantheon Books, 1946), pp. 202-211.

38. ". . . cadit et Ripheus, *iustissimus* unus qui fuit in Teucris. . . " *Aeneid*, II, 426-7; Virgil, *The Aeneid*. Edited by R. D. Williams (London: MacMillan, 1972). p. 38. The italics are my own.

39. *Purg*, X, 91-93: "Or ti conforti; ch' ei convene ch' i solva il mio dovere anzi ch' i mova: giustizia vuole e pietà mi ritene."

40. *Inf*, XXX, 115-117. This is more clear in the Italian: "S'io dissi falso, e tu falsasti il conio/disse Sinon; "e son qui per un fallo,/e tu per piu ch'alcun altro demonio."

41. *Par*, XX, 56-57. Professor Geanakoplos noted a tendency among Latins to equate the Greek of classical antiquity with that of Byzantium. He points out that "perfidious Greek" was used as a

pejorative. Deno J, Geanakoplos, *Interaction of "Sibling" Byzantine and Western Cultures*, p. 17.

"An Overabundance of Grace": Women's Convent Chronicles in Fourteenth-Century Dominican Cloisters

Valerie R. Hotchkiss

 In the first half of the fourteenth century women at several Dominican convents in Southwest Germany and Alemannic Switzerland began to record the lives of their members in collections now known as *Schwesternbücher, vitae sororum,* or convent chronicles.[1] Like earlier convent histories, such as Hrotsvitha von Gandersheim's *Primordia Coenobii Gandeshemensis* (tenth century), the *Schwesternbücher* usually include accounts of the founding of the convent and the lives of important abbesses, prioresses, and confessors. But a distinctive characteristic of these chronicles is that they also recount the lives of less prominent nuns and lay sisters. Moreover, they do not narrate complete lives, but focus rather on episodes of the women's lives within the community, especially their ascetic practices, mystical experiences, and deaths. The purpose of these chronicles is not to record the history of the convent through descriptions of its leaders, but to substantiate the community's spirituality with depictions of the "overabundance of grace" (der genaden uberlast), as one author puts it,[2] with which God has blessed them and to establish paradigms of religious development for women.

The authors of five of the nine extant *Schwesternbücher* are known by name. Anna von Munzingen (fl. 1316–27) wrote what is perhaps the earliest example of this genre, an account of thirty-four women at the convent of Adelhausen bei Freiburg in Breisgau.[3] Christina Ebner (12771356), the visionary and correspondent of Heinrich von Nördlingen, chronicled the lives of her fellow nuns at Engelthal.[4] Elisabeth von Kirchberg (wrote ca. 1296) wrote about the sisters at Kirchberg,[5] and Elsbet Stagel, perhaps the best known author (†1360) because of her correspondence with and writings about Heinrich Suso, collected the stories of forty sisters at Töß (completed in 1336).[6] A prioress of Unterlinden, Katherina von Gebersweiler (†1330/45?), is the author of the only Latin chronicle that survives (forty-two lives). The remaining eight are written in Middle High German with Swabian and Swiss characteristics.[7] Four anonymous *Schwesternbücher* come from the convents of St. Katharinental bei Dießenhofen, Ötenbach (ca. 1340) in Zürich, Weil near Esslingen, and the so-called Ulmer *Schwesternbuch* which is now attributed to the nuns of Gotteszell near Schwäbisch Gmünd.[8] Given the large number of Dominican convents in southwest Germany at the beginning of the fourteenth century (over seventy),[9] it is possible that other *Schwesternbücher* were produced that have not survived or have not yet been discovered.

The prototype for collecting the lives of members of the order is probably the thirteenth-century *Vitae Fratrum ordinis praedicatorum* of Gerard de Fracheto (†1271), which, by the early fourteenth century, had been widely disseminated, especially among Dominican houses. The women certainly had other models, however, such as the works of Caesarius of Heisterbach (ca. 1180–ca. 1240), and the late thirteenth-century biographies of the mystics Mechthild of Hackeborn (*Liber specialis gratiae*) and Gertrude the Great (*Legatus divinae pietatis*) from the influential Cistercian monastery of Helfta.[10]

Medievalists have not entirely overlooked the *Schwesternbücher*. Indeed, in the late nineteenth and early twentieth centuries considerable interest led to the publication of editions of most of them. The early scholarship on the lives, however, is marked by a tendency to devalue them as products of simple women whose writing, while "charming," lacks the theological import of traditional mystical thought.[11] The nineteenth-century editor of the Adelhausen chronicle, for example, explains that, "[d]iese Visionen sind nicht immer frei von

Extravanganzen und Beimischungen krankhafter Phantasie. Dieses wird gemildert durch eine kindliche Naivetät."[12]

This condescending view was challenged by Hester Reed Gehring, who, in a 1957 dissertation, attempted to legitimate the language of the *Schwesternbücher* by documenting their use of the terminology of male mystics and more abstract female mystics.[13] Walter Blank and, most recently, Beatrice Acklin Zimmerman also trace the theological influences on the sisters.[14] These scholars have shown that the language of the *Schwesternbücher*, though deceptively simple at times, draws upon the mystical writings of thirteenth-century women and, more importantly, upon the teachings of Meister Eckhart, Johannes Tauler, Heinrich Suso, and Heinrich von Nördlingen—all Dominicans of the *Gottesfreunde* movement who had close relations with these women's cloisters and even direct contact with some of the authors of the *Schwesternbücher*.[15] Though the more recent studies indicate that the authors of these chronicles were well-read, efforts to place the convent chronicles within the framework of conventional mysticism result, I think, in a tendency to ignore their uniqueness.

Though steeped in the speculative tradition of Tauler, Eckhart, and Suso, the authors of the *Schwesternbücher* do not presume to undertake theosophic investigations. They are also unlike the self-reflective theological writings by other, more prominent women such as Hildegard von Bingen or Mechthild von Magdeburg. Instead, the convent chronicles offer brief third-person accounts of the communal life and spiritual experiences of minor mystics who did not usually leave written accounts of their own. They reflect a practical mysticism based on the teachings of the men of the *Gottesfreunde* movement, but reconfigured in significant ways for a female audience. The visionary or mystical experience remains central and defining, but the context of the experience is a community of women in which children learn and play (many of the women entered the monastery before age ten), the sick and senile require care, women work as artisans and scholars, crops are planted and harvested, and vernacular songs fill the work areas. There is a natural flow between earthly and divine encounters, between communal and spiritual lives. The collective nature of the texts also sets them apart, for, although they portray individuals, the assembly of so many reports of the miraculous and the mundane in convent life leaves the impression of a group portrait, a communal history of cloistered life and women's spirituality.

The *Schwesternbücher*, which were written at a time of reform in the Dominican order, not only record the spiritual vitality of the communities, but also function as *specula monialium*, or practical handbooks on conventual behavior. Elsbet Stagel, for example, tells the nuns of Töß that she wrote the lives: ". . . da mit wir an ir hailig leben gemanet werdent."[16] [So that we may be admonished by their holy lives.] Moreover, some of the more endearing vignettes were obviously recorded for the benefit of the many children living in the convents. A pedagogic function clearly underlies many anecdotes, as in Christina Ebner's account of a vision of a twelve year old girl named Irmelin:

Einez tagez da saz ez mit anderen kinden ob dem tisch an einem vastag, da ez umb zwelf jar waz. Da waz der kinde maisterin von in gangen. Da wurden die andern kint reden: da viel ez nider und wart onmehtig. Da ez doch wider zu im selber kom, da fragten sie ez, waz im geworren wer. Da sprach ez: "Awe kint, da solt ir sweigen ob dem tisch. Ich han gesehen einen als greulichen teufel, der hat alle ewere wort angeschriben, und da von bin ich omehtig worden."[17]

[Once, when she was twelve years old, she was sitting at the table with the other children on a day of fasting. The children's mistress had left them alone. Then the other children started to speak to one another, and she [Irmelin] fell down and fainted. When she came to herself again, they asked what was wrong with her. She said, "O children, you should be silent at the table. I saw a very gruesome devil who wrote down all your words, and, because of that, I fainted."] Other didactic comments are addressed to adults. Katherina von Gebersweiler, to cite only one example, praised the sister Adelheid von Rheinfeldern for paying attention at daily services and never falling asleep during a sermon.[18]

The chronicles also offer instruction to the nuns on how to partake of the overabundance of grace in their own experience. Indeed, the lives function as a kind of *vade mecum* of practical mysticism, illustrating how certain patterns of virtue will lead to ecstatic experiences of the divine.[19] Most *vitae* establish certain prerequisites for revelation, noting the woman's virtues, chief among which are usually *Gehorsamkeit, Demütigkeit*, and *Geduld*. Regular and sometimes extreme ascetic practices, a willingness to suffer sickness, and steadfast adherence to the rules of the order are also necessary to attain revelation.

In most of the lives, the mystical experience is represented as a generally accessible achievement. Elisabeth von Kirchberg prefaces her book with an explanation of two levels of mystical experience—the *genad jubilus*[20] and the *genad contemplativa*. The former, she explains, can be achieved when one frees oneself from ephemeral things and, through charismatic prayer, experiences "ein genad, die unmessig ist . . . die so uberflussig ist, das hercz, sel und gemut und alle die audern des menschen durch gossen werden mit unseglicher sussikeit."[21] [A grace which is unquantifiable, which is so overabundant that heart, soul, and spirit [*gemut*] and all one's veins are supersaturated with an indescribable sweetness.] The *genad contemplativa* denotes an even more intense experience of the divine in which, according to Elisabeth, "des menschen synn auf geczogen sein in got wunderend und schauend in dem spigel der ewigkeit die gruntlosen wunder gotes, under weilen neigt sich got wider in die sel, und fleusset in sie mit seiner genad."[22] [Human reason is pulled up into God, wondering at and gazing in the mirror of eternity at the endless wonder of God, during which God nears the soul and flows into it with his grace.] She refers to these levels throughout the collection, offering models of behavior for attaining them in the biographies of women from the convent.[23]

Every devout nun and laysister in these chronicles experiences some form of *genade* or grace. Furthermore, the mystical events usually remain rooted in earthly and human experience. The ideal of an overabundance of grace is often expressed in physical terms, with women feeling the spirit fill up their bodies like a fluid, pressing tears from their eyes or blood from the nose and mouth. Theological conversations between the soul and the godhead are far less common than experiences of simple conversations with Christ as a child or as a comforting friend. In many cases, there is a de-sublimation of the mystical event, reflecting, perhaps, the broadening of the base of mysticism in the fourteenth century.

The texts document an attempt to foster the development of a female communal identity. Defining virtue and holiness through repeated patterns of behavior, the authors represent individual female identity within the parameters of an exclusively female religious and social community. Though the concept of *abegescheidenheit*, or detachment, promoted by Meister Eckhart and his followers, remains a state of mind conducive to mystical experience, the social setting of the convent colors the women's spirituality, which, it seems, must find

expression within the community. For example, Elisabeth von Kirchberg tells of a sickly nun who stood at the door to the workroom where her fellow sisters were busy at their tasks. She saw angels playing among them and a beautiful young man who pinned a rose on each woman's dress. When the woman at the doorway asked for a rose, he answered, "Ich gib niman, denn der in der samnung ist."[24] [I give it to no one, unless she is in the group.]

The *Schwesternbücher* record many lives in which the active and contemplative ideals are combined, as in the example of Metzi von Walthershoven: "si was alle ir tag ein usgenomne persone an aller heilikeit und ubte die zwei leben miteinander: activam vitam et contemplativam, und trug also gäntzeklich und also gar des convente burde und sorge uff ir, dz es wunder was, das si dise gnade möhte geüben."[25] [She was an especially holy person and she practiced the two lives, the active and the contemplative, together at the same time. And she bore the weight of the convent and all its worries upon herself, so that it was a wonder that she could practice this kind of grace.] As an aside, it is worth noting that the experience of grace, as defined in these texts, is not a passive act; they *practice* grace (*gnade üben*), consciously pursuing mystical experience through their actions. In other cases, there are even examples that elevate community needs over personal ecstatic experience. Two separate anecdotes tell of a troubled nun who comes upon a woman in conversation with Christ, whereupon Christ advises the latter to break off their communion in order to comfort a fellow sister.[26]

Though their language may have been influenced by male mystics, the women's use of imagery is informed by female experience. Indeed, the majority of the women's visions—for which the authors claim written or oral sources—relate in some way to the realities of female experience, both religious and secular, in the Middle Ages. With overwhelming frequency, Christ appears to the nuns as a child (described in the dialect, for example, as "ein liebes kindli," "truttes sunli," and "Jesus suzzelin"). Of course, we can look again to their spiritual guides, in this case Heinrich Suso, for the emphasis on Christ the child, but the prevalence of this type of experience in these chronicles is distinctive. Several stories are told of nuns who laughed shortly before dying when they saw a beautiful little boy playing at the foot of their bed.[27] The St. Katharinental chronicle illustrates both the focus on the child and the significance of communal responsibility in

the story of Ite von Hollowe, who was distracted by a divine encounter while working in the kitchen. As she rolled herbs into a ball in preparation for drying:

"do erschain ir unser herr als ein kindli und nam ir die ballun uss der hand und warff ir si do wider; also baliet si und das Jesusli mit enander und was ir als wol mit dem Kindlin, das si vergass das si tuon solt und do es dem ynbis nahen began, do was es unberait, davon ward sie betrübt. do ershein ir der botten einer und trost si und sprach: du solt nit betrübt sin, es wirt alles wol bereit und do man solt enbyssen, do was es als wol bereit als ob sie nie kein sumekeit daran het gehan."[28] [Then our lord appeared to her as a child and took the ball out of her hand and tossed it back to her. Thus she and the little Jesus child played toss, so that soon she forgot what she was supposed to be doing, and when dinner time was approaching, it was all unprepared and, therefore, she became sad. Then one of his messengers appeared to her and comforted her, saying, "Don't be sad, it will all be well prepared." And when it was time to eat, it was as well prepared, as if she had never dallied at all.]

Numerous examples could be also cited of nuns playing with the baby Jesus during Mass or on their sickbed when he visits them.[29]

Related to this affinity with the child are the frequent visions of Mary in her maternal role. In one case, Mary leaves the child with a nun—to babysit, as it were—until she returns for him.[30] Particularly striking is the maternal vision that Anna von Munzingen reports the community experienced at a Christmas Eve Mass when they saw a beautiful woman walk down the aisle "groß als ein frowe, die schier eines kindes genesen sol."[31] [Big as a woman, who expects a child very soon.] In the morning the woman appeared again, no longer pregnant, with a baby boy on her arm whom she presented to each sister in turn. Even more remarkable is the perception of Willbirch von Offeningen at Kirchberg who, "sunderlich in einem advent was sie so gar vol genad unsers herren, das ir was recht, wie sie unsers herrn swanger wer."[32] [Especially during one advent, she was so full of the grace of our Lord, that it seemed to her as if she were pregnant with our Lord.] Maternal mystical relations are by far the most prevalent in all the *Schwesternbücher*. There are a few cases in which Christ appears as a young man and numerous references to the spousal relation between

Christ and religious women, but, in general, the visions tend to be more familial than erotic.

The passion of Christ, a central image in most mystical writing, also plays a significant role in the *Schwesternbücher*. They pray for and are granted sickness and suffering, making connections between their femaleness and Christ's passion.[33] Richi von Stocken in the Adelhausen chronicle suffers not as Christ, but as a woman *with* Christ on the cross: "Herre ich hangen an dime ruggen, du muost mich von dir schutten, ich kum niemer von dir!"[34] [Lord, I shall hang on your back; you would have to shake me loose, otherwise I'll never separate myself from you.] In less heroic scenes, however, women remain content to suffer long illnesses because, as Christ states in the Töß chronicle: "Ie siecher du bist, ie lieber du mir bist."[35] [The sicker you are, the dearer you are to me.] In their preoccupation with illness and pain, deflections to the woman's view also occur, as in the account of a nun who prayed not to feel Christ's passion, but to suffer as Mary did under the cross.[36]

The emphasis on suffering, maternal experiences of Christ, and identification with female saints suggests an interest not only in a feminized spirituality, but also in the female body. In their focus on femaleness, the women of these chronicles draw upon a variety of women's physical experiences, including allusions to maternity, menstruation, and the sexual relationship of husband and wife. The body, though sometimes left behind when the soul communes with God in the *genad contemplativa*, also becomes the locus for the community's perception of divine power among them. This manifests itself, in particular, in the frequent references of uncontrollable crying, spontaneous outbursts of song, reports of levitation or illumination, effusions of blood as a sign of *genade*, and the pervasive image of illness as a physical manifestation of successful *imitatio Christi*.

Also related to the body is the ingrained notion of virginity as wholeness and the supreme ideal for Christian women. There is, however, considerable ambivalence about the woman's body in anecdotes from two different chronicles in which widows use the authority of their visions to reclaim the desired status of virgin.[37] Christ assures a Weiler nun that she is now as pure as a virgin: "ich wil dich reinigen mit meinem rosenvarben plut und alz lawter machen alz da du auss der tawff kömde, und will dich zyren ... mit mein selbs magtum."[38] [I will purify you with my rose colored blood, and I shall

make you as pure as you were when you came from the baptismal font, and I shall adorn you with my own maidenhood.] Whereas a woman at Adelhausen has a dream in which she is taken up to heaven where angels use bloodletting instruments to press out every drop of sinful blood before giving her a transfusion of virgin's blood. This apparent obsession with virginity reflects, of course, the ideal for religious women prevalent in Christianity at least since Augustine. These visions of reclaimed virginity exalt the ideal, but also seem to empower women to reconfigure the body according to it.

Though the act of making virgins out of widows is extreme and perhaps unique to the *Schwesternbücher*, the collections contain many examples of the authority of spiritual revelation.[39] In fact, the women's visions and ecstatic experiences are often in competition with the male-controlled sacramental church. The majority of encounters with the baby Jesus take place during the Mass. Other forms of *genade* occur during the celebration of the Eucharist, as when women lose consciousness when overfilled with grace after receiving communion or see visions of Mary singing with them in the choir and, quite commonly, of the Christ child in the host. Tensions between male priests and the women are evident in several incidents in which the power of revelation is used to challenge gender hierarchy in the church. For example, a woman at Kirchberg reprimands a priest who tries to "test" her spiritual authority by offering a host that has not been consecrated.[40] Another woman takes on the role of the preacher when, inspired during a service, she brings the priest and other listeners to tears with her words.[41] Even the language of the Mass is challenged with divine sanction when Hailrat of Engelthal experiences "genade" and begins to sing the responses in German—the mother tongue, as it were—instead of Latin![42] Occurring independently of male sanctioned worship, the visionary activities of these women endow them with a special authority. The conflict between the ecstatic mysticism of the nuns and the sacramental church is most evident in the story of Adelheit von Brisach who, "alwegen an em donrstage ze nacht, so gieng si mit unsers Herren marter als emsklich umbe, dz si in die krancheit kam, das si mordens an dem fritag niemer zu messe möchte komen noch uff."[43] [Every Thursday night suffered terribly with our martyred Lord, so that she became sick and could never get up for Friday morning Mass.] For this she was upbraided by the preacher from the pulpit and called a heretic ("ketzerin"). She responded by going up

to the pulpit and jumping up and down, singing in high spirits: "Laudate Dominum omnes gentes!" (The Latin is quoted within the German text.) Furthermore, we are told that young children followed her, running around the sanctuary helping her sing. Only amazement—and not reprimand—is recorded for this addition to the Mass.

Not surprisingly in these communities so consciously female in their approach to understanding the divine, identity often has its basis in dichotomies. They accept cultural stereotypes of women, but interpret them to their advantage. The Pauline paradoxes of strength in weakness and the wisdom of Christ's fool become models for perfection in the *Schwesternbücher*. In general, the ideal for devout woman has its basis in paradox and inversion: the sick are strong; those in pain are content; the meekest nun has authority through her visions; women instruct men; the child is wise; and death is a time for laughter. Concepts of inversion inform Christianity in general, but for women, conscious of their subordinate place in society and the church, such antithetical understandings can define models for behavior and offer hope for salvation.

The aim of the *Schwesternbücher* may be didactic, but they also function, quite consciously, as a form of women's history, a history written by women with the explicit understanding that it is of and for women. These uniquely female productions provide sources for engaging recent feminist criticism concerning women's stories and women's symbols. I would make no claims about innate differences in male and female perception and communication, but I would argue that we should grant the genre of the *Schwesternbuch* its unique status as a conscious effort to describe acceptable female experiences of the divine, to define female models, and to address contemporary women's concerns in order to create a religious identity for women. In these books the mystical experience not only serves the traditional function of supporting ideals of individual salvation, but also affirms the beneficial role of communal life in spiritual development. The *Schwesternbücher* offer, through the use of examples, a clear pattern for female holiness and a general conviction that women, precisely because they are socially subordinate in man's world, enjoy special grace, indeed, "der genaden uberlast" in God's domain.

NOTES

1. For information on the *Schwesternbücher* manuscripts, see Siegfried Ringler, *Viten-und Offenbarungsliteratur in Frauenklöstern des Mittelalters. Quellen und Studien* (Munich: Artemis, 1980). An important early study of the chronicles is Hieronymus Wilms, *Das Tugendstreben der Mystikerinnen, dargesteelt nach alten Chroniken der deutschen Dominikannerinnen und nach den Aufzeichnungen begnädigter Nonnen des Mittelalters* (Vechta i. Oldenburg: Albertus Magnus Verlag, 1927).

2. Christina Ebner, "Der Nonne von Engelthal Büchlein von der genaden uberlast," ed. Karl Schröder, *Bibliothek des litterarischen Vereins*, 108 (Tübingen: Laupp, 1871), 1. Hereafter cited as Engelthal.

3. Anna von Munzingen, "Das Adelhausen Schwesternbuch," ed. J. König, *Freiburger Diözesanarchiv* 13 (1880):129-236. Hereafter cited as Adelhausen.

4. See note 2.

5. Elisabeth von Kirchberg, "Die Nonnen von Kirchberg," ed. F.W.E. Roth, *Alemannia* 21 (1893):103-123. Cited as Kirchberg.

6. Elsbet Stagel, *Das Leben der Schwestern von Töß*, ed. Ferdinand Vetter in *Deutsche Texte des Mittelalters*, Bd. 6 (Berlin: Weidmannsche Buchhandlung, 1906). Cited as Töß.

7. Katherina von Gebersweiler, "Les Vitae Sororum d'Unterlinden," ed. J. Ancelet-Hustache, *Archives d'histoire doctrinale et littéraire du moyen-âge* 5 (1930):317-509. Cited as Unterlinden. It appears likely that the Adelhausen chronicle also was written in Latin originally, but survived and was transmitted through the fifteenth-century German translation by Johannes Meyer. See Walter Blank, "Die Nonnenviten des 14. Jahrhunderts," (Diss., Freiburg i. Breisgau, 1962), 58.

8. For editions, see "Die Nonnen von St. Katharinental bei Dieszenhofen," ed. A. Birlinger, *Alemannia* 15 (1887):150-183 (Katharinental); "Die Stiftung des Klosters Oetenbach und das Leben der seligen Schwestern daselbst," ed. H. Zeller-Werdmüller and J. Bächtold, *Zürcher Taschenbuch* NF 12 (1889):213-276 (Ötenbach); "Mystisches Leben in dem Dominikanerinnenkloster Weiler bei Esslingen im 13. und 14. Jahrhundert," ed. Karl

Bihlmeyer, *Württembergische Vierteljahreshefte für Landesgeschichte* NF 25 (1916):61-93 (Weil); and [Ulmer Schwesternbuch], ed. F.W.E. Roth, *Alemannia* 21 (1893):123-148 ([Ulm]). See Hans Peter Müller, "Das Schwesternbuch von Kloster Kirchberg (1237-1305)" in *Der Sülchgau. Jahresgabe des Sülchgauer Altertunmsverein* 21/22 (1977/78), 42-56, for attribution to the nuns of Gotteszell.

9. Statistical information from Valerie M. Lagorio, "The Medieval Continental Women Mystics," in *An Introduction to the Medieval Mystics of Europe*, ed. Paul Szarmach (Albany: SUNY Press, 1984), 172.

10. See *Revelationes Gertrudianae et Mechthildianae*, ed. Ludwig Paquelin (Poitiers: H. Oudin, 1875). For more information on the monastery at Helfta, see Mary Jeremy Finnegan, *The Women of Helfta: Scholars and Mystics* (Athens: University of Georgia, 1991).

11. Karl Schröder, the editor of Ebner's "Von der genaden uberlast," warns: "Wer systematische, theologische Erörterungen oder Darstellungen sucht, dem werden freilich unsere Blätter wenig bieten" (p. 46).

12. J. König in his edition of the Adelhausen *Schwesternbuch*, 147. See also Schröder, 47.

13. Hester Reed Gehring, "The Language of Mysticism in South German Convent Chronicles of the Fourteenth Century," (Diss., University of Michigan, 1957).

14. Blank, "Die Nonnenviten," and Beatrice Acklin Zimmerman, *Gott im Denken berühren: Die theologischen Implikationen der Nonnenviten* (Freiburg: Universitätsverlag, 1993).

15. Elsbet Stagel was a friend and correspondent, as well as the first biographer of Heinrich Suso; Meister Eckhart visited St. Katharinental (see Katharinental, 177) and also appears as a character in the Ötenbach chronicle; Konrad von Fuessen served as confessor to Christina Ebner and Heinrich von Nördlingen was a frequent visitor to Engelthal.

16. Töß, 16.

17. Engelthal, 8. One can imagine the desired impact of this anecdote on the children's table. Elsbet Stagel also makes it clear that the lives were to be read aloud for the edification of the nuns (Töß, 16).

18. Unterlinden, 397.
19. In [Ulm], 23, for example, the author emphasizes the usefulness of the *vitae* as a models: "Wer got lob und danck wil sagen umb die überflussigen genad die er sein auserwelten heimlichen freunten mit teilet, sie süln dise nach gende gescriben wunder auch ze herzen legen den worten, das sie hie und in der ewige wunne teilhaftig werden der selben trostlichen genaden." [Whoever wishes to praise and thank God for the overabundant grace which he shares with his chosen intimate friends, they should take these recorded miracles to heart so that they might share now and in eternity in the same comforting grace.]
20. For more on *jubilus*, see Herbert Grundmann, "Die geschichtliche Grundlagen der deutschen Mystik," in *Altdeutsche und Altniederländische Mystik* (Darmstadt: Wissenschaftliche Buchgesellschaft, 1964), 87-89.
21. Kirchberg, 105. The term *jubilus* is also used in the Engelthal *Schwesternbuch*.
22. Kirchberg, 105.
23. This is in keeping with the teachings of the *Gottesfreunde* who assumed the action of the Spirit in all believers and maintained the feasibility of the *unio mystica* for between God and man.
24. Kirchberg, 112.
25. Adelhausen, 48.
26. Katharinental, 158-59 and 162. See also Engelthal, 22. According to Gehring, 142, Meister Eckhart cited a similiar anecdote in a sermon.
27. For example, Töß, 27 and 48. Other examples of laughter at the time of death include, Adelhausen, 30; Töß, 27 and 41; and Katharinental, 158.
28. Katharinental, 160.
29. For example, Engelthal, 21, 24, 29, 32, and 43; Katharinental, 179; Kirchberg, 114. It should be remembered that the women often served as foster mothers for the children in the convent and were more familiar with the lives of children than might be expected of nuns.
30. Katharinental, 159.
31. Adelhausen, 177.
32. Kirchberg, 113.
33. See Katharinental, 153; Töß, 22; Adelhausen, 168.

34. Adelhausen, 159.
35. Töß, 37.
36. Kirchberg, 110: "Ir was auch unmassen we umb unser frauen smerczen, und begert gar ser, das sie befunde, als vil muglich wer, wie unser frauen wer unter dem creucz. Des gewert sie unser herr." [She was immeasurably sorry for our lady's pain, and she desired very much to feel, as much as possible, what it was like for our lady under the cross. And our Lord granted this to her.]
37. Weil, 71 and Adelhausen, 155.
38. Weil, 71.
39. For example, several women claim visionary evidence of the efficacy of their prayers when souls from purgatory come to thank them for clearing the way for them to go to heaven, as in Adelhausen, 166 and Katharinental, 160.
40. Kirchberg 111.
41. Engelthal, 21.
42. Engelthal, 7. As the fifth response to "Virgo Israel," she does not use the Latin "In caritate perpetua," but answers in German, "Ich han dich gemint in der ewigen minne, da von han ich dich zu mir gezogen mit miner barmhertzikeit." Upon hearing these German verses, many nuns fell unconscious.
43. Adelhausen, 154.

The Prince of Peace: Erasmus' Conception of Jesus*[1]

Hilmar M. Pabel

I.

In his well known study of the place of Jesus in cultural history, Jaroslav Pelikan identifies a title for Jesus which had special significance in the doctrinal divisions and military conflicts born of the Reformation of the sixteenth century. Jesus was the Prince of Peace. Many prominent Protestant reformers, such as Luther and Calvin, continued to espouse the just war theory that medieval schoolmen had developed from Augustine. A few radical reformers, such as Thomas Müntzer, declared a holy war of annihilation against all of Christ's enemies, especially if they happened to be princes whose ideas of government conflicted with those of Müntzer. Yet was war in accordance with the teaching of Christ? Pelikan notes that some Christians emerged "who bore witness to an understanding of the person and message of Jesus by which holy war was not holy and just war was not just." Among those who espoused a Christian pacifism were "certain Anabaptists, Quakers, and other peace groups of the Radical Reformation," but at the head of the list Pelikan mentions Erasmus of Rotterdam.[2]

A little more than twenty-five years ago Georges Chantraine
remarked that pacifism was not only the most lasting but the best
researched aspect of the Erasmian heritage.[3] Erasmus' concept of peace
is quite different from the modern one. Using feminine imagery,
Erasmus held: "Peace is the mother and nurse of all that is good."[4]
More than an agent of moral perfection, peace or concord was also a
spiritual reality, and war was a privation of peace. Modernity, however,
views war and peace primarily in terms of politics and thinks of peace
as an absence of war. The maintenance of peace is coterminous with the
regulation of warfare.[5] To use the expression of an eminent military
historian, we find ourselves in "that humdrum condition of political life
that we know as peace"[6] when we are not marching off into battle.

Modern ideas about war and peace have affected the scholarly
interest in Erasmus' pacifism. Implicit in much of the writing on this
subject is what José Chapiro stated explicitly more than forty years ago,
namely that for Erasmus the "*art of peace* is nothing but the art of
avoiding war."[7] Historians have primarily concerned themselves with
the political dimensions of Erasmus' pacifism. Was his resolute
opposition to war or, better put, his steadfast promotion of peace
politically viable or was it, as Pierre Brachin and Michael Howard
believe, politically naive and unrealistic?[8] And how resolutely did
Erasmus oppose war and defend the cause of peace? Did he, even
grudgingly, accept the just war theory which originated with Augustine
and was perfected by the scholastic theologians?[9]

The "renewal" in Erasmian studies, of which Jean-Pierre
Massaut wrote in 1969,[10] did away with the old interpretation of
Erasmus as a skeptic, moralist, and rationalist. It began to take Erasmus'
religious thought seriously. Few would still agree that human reason,
and not religious considerations, dominated Erasmus' pacifism or that
reason alone determined the essence and the structure of Erasmus'
conception of peace.[11] Few would disagree that Erasmus' pacifism "is
rooted in his theology, and it is an essential part, a very fundamental
part of his understanding of the nature of Christianity and the Church,"
or that it sought "peace among the nations of Europe and above all
among Christians, [and] man's peace with God."[12] Nevertheless, the
theological and spiritual roots of his pacifism still remain to be
explored.

An important place to start this exploration is Erasmus'
conception of Jesus. Erasmus' religious thought is thoroughly

Christocentric. His "philosophy of Christ" seeks to understand and put into effect Christ's teaching as revealed in the New Testament. Most scholars would agree that Christ's teaching served as the supreme inspiration for Erasmus' advocacy of peace and condemnation of war. Friedhelm Krüger remarks: "When Erasmus appeals for peace he speaks of Christ as a Christian to Christians."[13] Erasmus acclaimed Jesus the Prince of Peace, referring to the source of this title in Isa. 9:6. Christ's teaching, Erasmus believed, attacked warfare, but his Jesus was not the prince of a peace that was an absence of war or that was in essence a political phenomenon. Peace was a spiritual quality, and as Prince of Peace Jesus ruled the hearts of Christians as prince of mutual love and forgiveness.

II.

 To be sure, Erasmus did not discount the political dimension of peace. A good prince will strive to avert war and promote peace so as to bring prosperity to his subjects. In carrying out this responsibility Christ is his great example. Erasmus explains in 1504 to Archduke Philip of Austria: "the chief glory of the Christian prince, who ought never to take his eyes off his model, should be to cherish, to honour, and to extend with all his might and power that which Christ, the prince of princes, left among us to be the best and greatest possible thing: namely, peace."[14] What is this peace that Erasmus calls "a good thing in itself"? It is the spiritual unity of Christians in the Church of Christ. The "Christian church is one family," Erasmus declares to Philip, and, invoking the Pauline image of the Church as the body of Christ, he insists that the "leaders of our own faith" consider that "we are all members of the same body, ruled by the same head in Christ Jesus, and animated by the same spirit, that we are redeemed at the same price, called on an equal footing to the same inheritance, and that we receive sacraments which are common to all."[15]

 In 1516, Erasmus published his *Education of a Christian Prince*, dedicated to the youthful Prince Charles, the future Holy Roman Emperor, Charles V. Erasmus concludes with a prayer "that Christ, perfect and supreme, will continue to favour your noble

enterprises." Jesus' kingdom has not been stained by blood. Erasmus hopes that Jesus, who "rejoices to be called Prince of Peace," may help Charles's reign be free of bloodshed "that your goodness and wisdom may at last give us relief from these insane wars."[16] Earlier, in the final chapter of the treatise, Erasmus refers to "the true Solomon, Christ, the lover of peace, who reconciles all things in heaven and on earth."[17] The allusion here is to Col. 1:20. God was pleased through Christ "to reconcile to himself all things, whether on earth or in heaven, making peace by the blood of his cross" (RSV). In the midst of his efforts to dissuade princes from waging wars, Erasmus remembers that the peace Christ loves is not simply a cessation from war but the reconciliation between God and humankind, the redemption of human beings brought about by Christ's death on the cross.

The *Complaint of Peace*, published in 1517, is the most famous statement of Erasmus' pacifist beliefs. Here again Erasmus portrays Christ as the example for all princes. The goddess Peace calls on all princes "on whose assent especially the affairs of the world depend, who bear amongst men the image of Christ the Prince: heed the voice of your King, who summons you to peace."[18] In her plaintive declamation, she had already argued that princes "represent him who is the Teacher and Prince of concord" and had implored the Christian prince, "if you are truly a Christian, to look at the example of your Prince, behold the manner of his entry upon his reign on earth, his passage through it, his departure thence, and then you will understand how he wishes you to rule in such a manner that peace and concord are the chief of your concerns."[19] Christ's kingdom of course is not a civil state, nor is his teaching of peace a political doctrine. His life and teaching manifest to all Christians the very ground of civil peace: a spiritual harmony and a union of hearts. Erasmus asks in the *Complaint of Peace*: "Survey the life of Christ from start to finish, and what else is it but a lesson in concord and mutual love?"[20]

This lesson begins with Jesus' birth and endures unto his death. "When Christ was born," Erasmus asks in the *Complaint of Peace*, "did the angels sound the trumpets of war?" The answer is obvious: "No, it is peace they proclaim."[21] In the *Paraphrase on Luke* (1523), Erasmus explains the meaning of the angels' hymn: "Glory to God in the highest, peace on earth, and good will to men." The song of the angels signifies that all glory is due to God and that on earth nothing should be the object of human hope other than peace, "which

with the wiping away of [our] sins reconciles us to God and which binds us together with mutual charity." This peace comes not from the world, but from God. It is freely offered to the human race through the "conciliator" between God and human beings.[22] Jesus is the conciliator. He was born to bring about peace between God and human beings through the forgiveness of sins and to unite his followers in mutual love.

Jesus' birth heralds the peace of forgiveness; at the hour of death, forgiveness is on Jesus lips. Erasmus ponders Jesus' prayer recorded in Luke 23:34: "Father, forgive them. They know not what they do." In the face of the jeers of his enemies beneath the cross, Jesus wanted to present "the perfect example of supreme tolerance."[23] God should not punish but pardon his executioners. "Truly," Erasmus comments, "this was the holy prayer of our high priest on the altar of the cross as he sacrificed once and for all the paschal lamb for the salvation of the whole world."[24] Erasmus proceeds to reflect on the significance of Christ's "holy prayer." When one considers the supreme innocence and kindness of Jesus and recalls his prayer of forgiveness, does it not seem quite impudent when a Christian, a sinner, punishes a fellow sinner, even when he is provoked by a serious offense? And yet how much do they deviate from Christ's example who because of some peccadillo thrust a sword into the bowels of a neighbor? Christians ought to imitate their king and conquer only under the banners of their prince, contemplating how their high priest atoned for the sins of the nations with an efficacious sacrifice.[25] We may infer from Erasmus that Christians ought to march under the banners of forgiveness and peace. They ought to imitate their prince, Jesus, the Prince of Peace, by forgiving one another.

III.

Jesus' earthly ministry was taken up in teaching what his life exemplified. Referring to Jesus in the *Complaint of Peace*, Erasmus poses the rhetorical question: "What do all his commandments and parables teach if not peace and love for one another?"[26] Erasmus makes sure that Jesus' sayings are not misconstrued so as to justify war.

Shortly before his arrest, according to the Gospel according to Luke, Jesus advises that the time has come to sell one's cloak in order to buy a sword. When the apostles point out that they have two swords, he comments: "It is enough" (Luke 22:36,38,RSV). To use Jesus' command to buy a sword as a proof text for even "a temperate self-defence against persecution" is in Erasmus' opinion both ignorant and impious. Why, he asks in his famous essay on the adage *Dulce bellum inexpertis (War is sweet to those who have never tried it,* hereafter *Bellum*), did the martyrs never use the sword?[27] In Erasmus' *Paraphrase on Luke,* Jesus says: "Now a terrible war is threatening, and a sword is necessary." After recommending the purchase of a sword, he affirms: "One must come very lightly equipped to this war; one need be equipped with nothing other than a sword." But the apostles do not understand what Jesus means when they tell him that they have two swords. Jesus for the time being leaves them to their unrefined feelings "so that their weakness will teach us perfect tolerance." The battle that Christ has in mind is a spiritual one, the battle against the world and Satan. In this battle victory is won by a mind completely free of worldly desires and solely armed with "the sword of heavenly teaching." This teaching comes from "the unassailable writings of the Old and New Testaments" so that, as Erasmus notes, "you may understand there to be two swords, but held out by the same spirit."[28]

Erasmus alludes to this passage from Luke in his *Paraphrase on Matthew* (1522). Peter erred when he cut off the ear of Caiaphas' servant in the Garden of Gethsemane, but he did so "out of a certain pious love for the Lord." He and the other apostles did not understand what Jesus meant when he told them to sell their tunics to buy swords and when he said that the two swords that they had were sufficient. They thought that Jesus spoke of a sword of iron when he had really intended a spiritual sword. In order to disabuse them of their error, he "fiercely scolded" Peter: "'Put back,' he said, 'your sword in its place. Whoever lives by the sword perishes by the sword.'" Then Erasmus puts these words into Jesus' mouth: "Such a defense is not required of us. We conquer better through endurance than through killing."[29] In *Bellum,* Erasmus denied that Christians may imitate Peter. Yes, he fought, "but still as a Jew, who had not yet received a truly Christian spirit," and he fought not for his own advantage but in defense of Jesus. Erasmus cannot refrain from a final sarcastic quip: "He did fight—but it was not long before he denied his Lord. If the example of his fighting

attracts us, then the example of his denial should too."[30] Jesus did not condone violence. Christians who employ violence are in effect denying their Lord.

At Matt. 10:34 Jesus states: "Do not think that I have come to bring peace on earth; I have not come to bring peace, but a sword." Luke 12:51 presents the parallel passage: "Do you think that I have come to give peace on earth? No, I tell you, but rather division." Consequently, families will break down: children will be divided against their parents, and parents against their children (Matt. 10:35, Luke 12:52–53). According to Erasmus, Jesus and his Gospel are the source of division inasmuch as some will accept while others will reject the Gospel. In the *Paraphrase on Luke,* Jesus refuses to bring about the peace that the world loves, the sort of peace in which the wicked agree with each other. Jesus has not come to support the concord of the wicked. He points out: "Not everyone obeys the Gospel, and on account of the Gospel all things are despised."[31] In the *Paraphrase on Matthew*, Erasmus has Jesus remark that great dissensions will necessarily arise even among those most closely related to each other, between those who are in love with the world and those who have been touched by "the ardor of Gospel charity." Jesus exclaims: "Happy the dissension that promotes all that is sincere and cuts away all that is rotten. Happy the sword that cuts away all the harmful desires from the soul." Jesus announces: "I offer salvation to all. If everyone embraces it, there will be no division. Indeed, the Gospel in and of itself is a peaceful thing, but unrest is stirred up through the vice of other people."[32] The discord that Jesus brings to the world is a health-restoring drug. While it disturbs the body, it intends the "tranquillity of all the members [of the body]." "In fact," Jesus says, "it is necessary to amputate the harmful parts all the more to preserve true and holy concord among the pure."[33] In a sense, Erasmus' Jesus does come with the sword, and he does foment division. Yet in so doing he promotes the cause of peace by separating those who are united in their faithfulness to his Gospel from those who are united by their rejection of his teaching. In his famous manual of Christian piety, the *Handbook of the Christian Soldier*, first published in 1503, Erasmus criticizes those Christians for whom peace is really slavery to vice and asserts: "This is that hapless peace which Christ, the author of true peace, who made the two one, came to destroy by stirring up salutary warfare between father and son, husband and wife, and between those things which a base accord has badly joined

together."[34] Christ is still "the author of true peace" as he cuts away evildoers from his body, the Church, with the sword of the Gospel.

Erasmus' interpretation of the Sermon on the Mount, especially of the beatitudes, presents Jesus as a teacher of peace. Indeed, in *Bellum*, Erasmus invokes the beatitudes as proof that in Jesus' teaching one "will find nothing anywhere which does not breathe the spirit of peace, which does not savour of love."[35]

Who are the poor in spirit whose reward is the kingdom of heaven? A reading of the *Paraphrase on Matthew* reveals that they are possessed of a spiritual humility. They claim nothing for themselves, they give way to everyone, they are dissatisfied with themselves, and they neither push anyone aside, nor do they harm anyone. To those who do not understand what these lowly and downtrodden ones have to do with royal rule, Erasmus objects that the violent have nothing to do with the kingdom. They are the servants of servitude and are tormented by "greed, anger, envy, the desire for vengeance, fear, and foreboding." "The kingdom of the world," Erasmus writes, "is obtained by violence and defended by ferocity," while the kingdom of heaven is the product of moderation and is protected by and founded upon humility. The heavenly kingdom belongs to those who are free from every vice, who with a "peaceful heart" despise the things of the world and pursue the good things of heaven.[36]

The meek are no different from the poor in spirit. They abstain from all violence. When they are hurt, they easily forgive an injury. They would rather lose something than fight for it. Bringing about harmony and peace of mind is more important to them than managing a large estate. Their preference is for a "peaceful poverty," not for "strife-filled riches."[37] The merciful do everything out of "fraternal love." They treat the unhappiness of others as their own. They feed the hungry, clothe the naked, admonish those who have gone astray, and forgive sinners.[38]

Jesus of course blesses the peacemakers, who are very much like the merciful. According to Erasmus' Jesus, they first suppress the rebellious desires of their hearts and then devote themselves to establishing harmony among those who are divided by discord. They do much more than merely shun revenge, for they invite those who have harmed them to be at peace with them. Since they are called the children of God, peacemakers must imitate their divine Father. God freely forgives sins and offers all human beings peace and friendship,

but the heavenly Father disowns those who hate peace and foment strife.[39]

To be sure, wicked people may be found everywhere, and it is impossible to be at peace with them. The pious, however, must do all they can to show all human beings friendship, gentleness, and generosity. Even though it is impossible to establish peace everywhere, nevertheless Jesus' followers will be blessed because of their pursuit of peace when the godless persecute them on account of the justice of the Gospel. Jesus asks much more of those who are persecuted for his name's sake than to endure physical suffering, the hazards of life, insults, and assaults upon their reputation. His disciples should consider themselves blessed or happy when they endure evil. They should be more inclined to pity their persecutors than to take offense at them. They should bless those who curse them and present the prospect of eternal salvation to those who are contemplating their ruin.[40]

IV.

Erasmus and like-minded Christians of the sixteenth century developed a theology or, to be more precise, a Christology of peace, but "a Christology of life and praxis rather than principally a Christology of doctrine."[41] Through his religious writings, Erasmus encouraged his contemporaries to adopt the cause of peace because of their common devotion to Christ. If they could not keep from war, they might as well no longer call themselves Christians. Towards the end of *Bellum* Erasmus expostulates:

> If Christ is a figment, why do we not frankly reject him? Why do we glory in his name? If he is really the way, the truth and the life why is there such a great contrast between our way of life and this example? If we acknowledge Christ as our authority, Christ who is love, and who taught nothing, handed down nothing that is not love and peace, come let us follow him, not only in name, not by wearing his badge, but in our actions, in our lives.

Let us embrace the cause of peace, so that Christ in return
may acknowledge us for his own.[42]

In order to put his Christology of peace in practice, that is in order for
Christians to follow the Prince of Peace in their actions and their lives,
Erasmus sought to influence his contemporaries as they prayed.

In the *Complaint of Peace* Erasmus writes: "To wish good
health for anyone is an excellent thing, but a prayer for peace is prayer
for the sum total of happiness." He also reminds his readers of the
prayer that Jesus taught his disciples. Does Jesus not by the opening
invocation, "Our Father," provide "a wonderful suggestion of Christian
concord?" Christians pray to the same God, and their prayer is common
to them all, "for they are all one household, one family, dependents of
one Father." Thus it is absurd for them to wage war against each other.
Erasmus asks: "How can you call on a common father if you are
drawing a sword to thrust in your brother's vitals?"[43]

Erasmus returns to the Lord's Prayer after he expresses his
outrage at the display of the cross and the administration of the
sacraments in armed camps of Christian soldiers. He refuses to believe
that soldiers can say the Lord's Prayer with sincerity, rebuking them by
demonstrating, petition by petition, how the prayer cannot be
reconciled with their conduct. God's name cannot be hallowed by
violence. The coming of his kingdom has nothing to do with acquiring
kingdoms by bloodshed. Those who prepare for war are at odds with
God's will for peace, while those who burn their brother's crops have no
right to ask the common Father for their daily bread. Murder defies the
petition for forgiveness with its promise to forgive others. It is absurd
on the one hand to "be spared the danger of being put to the test," while
on the other one runs a risk to one's own life by endangering that of a
brother. Finally, why ask for deliverance from the evil one while
"plotting the worst of evils" against a brother at the prompting of the
devil?[44]

Erasmus employs the prayer that Jesus taught in his anti-war
polemic, but he also understands the prayer's deeper spiritual meaning.
He has interpreted the Lord's Prayer several times: in the *Paraphrase
on Matthew* and *Paraphrase on Luke*; in his treatise on prayer, the
Modus orandi Deum (1524); in his catechism, the *Explanatio symboli*
(1533); and in a prayer to God the Father which opens his prayer book,
the *Precationes aliquot novae* (1535). The *Precatio Dominica digesta*

in septem partes iuxta septem dies (1523) is Erasmus' most sustained treatment of the Lord's Prayer. This work is a lengthy paraphrase in the form of seven prayers based on the seven petitions of the Our Father.

The Lord's Prayer is a prayer of peace, uniting God's children under a common Father. God takes no offense at being called "Father" by Christians, whom Jesus, God's Son, was pleased to call brothers. In the *Precatio Dominica,* Erasmus bids his readers say to God: "Hear the prayers of concord. For it is not fitting that brothers, whom your goodness has freely made equal in dignity, should disagree among themselves on account of ambition, strife, hatred, and envy." All Christians pray for the same things because they all depend on the same Father. No one desires anything for himself except as a member of the one body and as someone quickened by the same Spirit. That is why "we ask for whatever is necessary for all in common."[45] The Lord's Prayer is the prayer of the Christian Church, of the Body of Christ, to use the Pauline image of the Church, in which all Christians are united as members of the same body.

Christian peace and unity manifests itself in the mutual forgiveness of sins. The fifth petition of the Lord's Prayer, "Forgive us our trespasses as we forgive those who trespass against us," is a prayer for peace, and Erasmus always insists on this interpretation. For him the petition signifies peace with God and peace with one's neighbor, a peace that is the product of and is sustained by forgiveness. In the *Paraphrase on Matthew*, Erasmus has Jesus expound the prayer. We beseech the Father to forgive our sins "so that we might have peace with you, just as we nourish each other with concord by pardoning each other, whenever someone offends another."[46] From Erasmus' exposition in the *Paraphrase on Luke* it becomes evident that mutual forgiveness establishes peace among Christians and peace with God.[47] In his catechism, he teaches that we pray for forgiveness "so that there might be complete concord both for the children with the Father and for the brothers among themselves."[48] The prayer to God the Father in the *Precationes aliquot novae* asks for the Father's forgiveness so that "we might persevere in that peace by which you reconciled us to yourself through the blood of your only begotten Son." We also request that God grant us to forgive each other our faults "so that we might foster among ourselves mutual peace, concord, and charity."[49]

At times it seems that Erasmus accords greater priority to encouraging human concord than to praying for peace with God.

Perhaps this is because God forgives more easily than human beings. In the *Modus orandi Deum*, Erasmus writes that the fifth petition "pertains to the preservation of fraternal concord and of peace with God."[50] The order here is significant: peace with one's neighbor precedes peace with God. Although in the *Precatio Dominica* God's children ask their Father to correct their faults,[51] the fifth prayer concentrates on their sins against each other and the consequent need for human concord. It opens with a recognition that it is the will of the heavenly Father, "the author of peace and lover of concord," that his children live in unity within his family, and that there should be no dissension among the members of the body of Christ, the Church, but that they should be united with mutual charity. Their offenses would "cloud over," if not extinguish, "the serenity of fraternal concord" unless God did not daily forgive sinners.[52]

Erasmus' insistence on the need to preserve love and harmony among God's children shows that the second part of the petition, "as we forgive those who trespass against us," takes on at least as much importance for him as the request for God's forgiveness. In the first edition (1516) of the *Annotations on the New Testament* he holds that the clause added to this request represents a comparison between human forgiveness and God's, not a condition for receiving God's mercy.[53] Despite this judgment, Erasmus also believes that the fifth petition imposes on Christians the condition of mutual forgiveness before they can attain God's pardon. His most explicit expression of the condition for being forgiven by God occurs in the *Precatio Dominica*. God's children know that their Father in his mercy will "forgive our sins if we in turn forgive from our hearts whatever sin a brother has committed against us." The pardoning of one's neighbor from the heart is "the most just condition of obtaining mercy," that is, God's mercy. This condition is a "remedy" for sins and a "sure hope" that God will forgive them. It rests upon the authority of Jesus' command to forgive and upon his teaching to leave one's gift at the altar in order first to reconcile oneself with one's brother (Matt. 5:23–24).[54]

If mutual peace and concord reign in the hearts of Christians, their prayers will certainly be heard by God. Erasmus employs Jesus' confirmation that "if two of you agree on earth about anything they ask, it will be done for them by my Father in heaven" (Matt. 18:19,RSV) as a pretext for underlining the necessity for concord in prayer. In the *Paraphrase on Matthew*, Erasmus has Jesus say that our "consensus,"

our agreeing with one another, will take effect not only through a mutual forgiveness of each other's sins. It will also be manifest when Christians pray in a spirit of concord, and God grants what they ask. Jesus teaches.

> . . . if at least any two people are found on earth who are truly of one heart (*concordes*) with my spirit, that is, who are not influenced by human desire but in harmony (*concorditer*) love divine things, whatever they ask, they will receive from my Father who is in heaven. So much does the Father love the holy concord of the Gospel.

Jesus makes it clear again: "there is nothing so difficult or unbelievable which my Father cannot bestow upon you if you petition him in harmony with one another (*concorditer*)."[55]

V.

When Erasmus wrote the *Paraphrase on Matthew* and the *Precatio Dominica*, he knew how little harmony, love, and forgiveness existed among Christians. The Reformation was beginning to divide Western Christendom. As religious controversy ruptured the peace of the Church, Erasmus advocated prayer to Christ as a remedy. He saw "no way out unless Christ himself, like some god from the machine, give this lamentable play a happy ending."[56] Although he lamented the schism that afflicted the Church, Erasmus never lost hope that Christ, moved by prayer, would intervene. Erasmus liked to compare the schism to the storm that Christ pacified in the Gospels (Matt. 8:23–27 and parallel passages). One must not despair, he wrote in 1530 to the Prince Bishop of Würzburg, Konrad von Thüngen:

> Long ago in the time of St. Jerome, [the Church] endured more serious tumults, and even now Christ lives, who with a word calms the sea, however much it roars and threatens destruction. Only let us rouse him with our prayers and pluck at him until he awakes and bids this

storm to grow still. He wants this glory to be attributed to himself, not to our prudence.[57]

With his *Precatio ad Dominum Jesum pro pace ecclesiae* Erasmus invited Christendom to pray for an end to the storm. He first published the prayer in 1532, and in 1533 he appended the *Precatio* to his commentary on Psalm 83 (84), the *De sarcienda ecclesiae concordia*. Erasmus also used this psalm commentary, as the title suggests, as an opportunity of recommending ways of restoring peace to the Church. In every subsequent edition of the *De sacrcienda*, the *Precatio* appeared along with it.[58] In 1535, Erasmus included the prayer in his prayer book, the *Precationes aliquot novae*.

Erasmus begins the prayer for the peace of the Church by invoking Christ's almighty power, his wisdom, and his goodness. As a coda to goodness Erasmus adds mercy. He has his readers beseech Christ:

> . . . you who according to your boundless mercy have restored what has fallen apart, refashioned what has collapsed, brought back to life that which has died: be pleased, we ask, to turn at last your face to your bride the Church, chosen especially for you, but that gentle and gracious face with which you brighten everything in heaven, on earth, above the heavens, and beneath the earth.[59]

The opening of the *Precatio* is more than a rhetorical *captatio benevolentiae*. Its purpose is not to remind God of his essential characteristics or to find favor with him by acknowledging them. Erasmus believes that prayer is not for God's benefit but for that of human beings.[60] The objective of the *Precatio* is, while forcefully conveying the crisis of a disintegrating Christendom, to instill within its audience the belief that Christ not only can but also in his goodness and mercy will come to the help of the Church.

The Church is Christ's sheepfold invaded by many different wolves, each one crying "Here is Christ, Here is Christ!" in order to lead even the perfect into error. Erasmus also calls the Church Christ's "navicula," a frail ship tossed this way and that by the wind and the waves of a storm.[61] The present tempest, which overwhelms all human

power, is far more serious than the one Christ calmed in the Gospel. At stake are not simply the bodies of a few people but rather countless souls. Thousands now cry: "Lord, save us, we are perishing."[62] Far worse than the primeval chaos out of which creation was born is the chaos in which Erasmus' contemporaries find themselves: a world without charity, faith, trust, law, respect for authority, and consensus in doctrine.[63]

For plunging the Church into the depths of discord Christians deserve all the bitter fruits of strife, but Erasmus directs their sight beyond their sins, beyond the divine punishment that is their due, to the mercy of Jesus.[64] His merciful goodness knows no limits. The *Precatio* is essentially a pressing cry for Christ's mercy. Those who pray with Erasmus implore their "most gentle Savior" and "most merciful Jesus" to have mercy on them.[65] They ask that Christ may look upon the Church with the same merciful eyes both with which he gazed at Peter, the supreme pastor of the Church who eventually repented of his denial, and with which he beheld the crowd that wandered about like scattered sheep for want of a shepherd.[66] He was willing to spare sinful Sodom if ten just men were found in that city. Will he not now put away his anger and remember his mercy when thousands love the glory of his name and long for the beauty of his courts? Will he not convert human folly and wickedness to the cause of his glory and of the good of the Church? The answer to these questions is "yes," for Christ's mercy is especially forthcoming when human strength and ingenuity are incapable of averting disaster. Christ alone can turn discord into concord; he is "the sole author and guardian of peace."[67] Since human efforts are useless, Erasmus includes this petition: "Your voice is needed, Lord Jesus. Say only the word, silence the storm, and the longed for tranquillity will dawn right away."[68]

Christ's agent of concord is the Holy Spirit. Through this Spirit he has reconciled earthly and heavenly things and joined together so many languages, nations, and different types of people into the one body of the Church, which adheres to him as its head through the same Spirit.[69] Erasmus' readers ask Christ to send forth his Spirit to drive out from every heart the impious spirits of extravagance, greed, ambition, and lust, the masters of vengeance and discord.[70] Since the Spirit holds all things together and possesses the knowledge of language, Christians pray that just as there is one law, one baptism, one God, one hope, and

one spirit among those in the Church, Christ may grant that there be "one voice professing Catholic truth."[71]

The *Precatio* ends with a final plea for Christ's help, invoking him through authoritative titles: Creator, Redeemer, Savior, Lord, Head [of the Church], King, Prince of Peace, and God. A final petition directed to Christ as God again asks for his mercy "so that the whole chorus of the Church with concordant hearts and harmonious voices may, for the mercy she has obtained, give thanks to the Father and to the Son and to the Holy Spirit," the triune God who is "the absolute example of concord."[72]

VI.

In the *Modus orandi Deum,* Erasmus writes that Jesus, "princeps noster," handed down no type of spiritual sacrifice more diligently than the sacrifice of prayer.[73] Jesus is not only the guide or "princeps" in matters of prayer; he is also the "princeps pacis," the Prince of Peace. He is not only peaceful, but he is also the origin of peace. At 2 Thes. 3:16 the Vulgate translation refers to "the Lord of peace" (*Dominus pacis*), but Erasmus paraphrases: "the Lord Jesus, the author of peace" (*Domins Jesus pacis auctor*).[74] Christ, who at Eph. 2:14 is called "our peace" (*pax nostra*), becomes the "author of peace and concord" (*auctor pacis & concordiae*) in Erasmus' paraphrase.[75]

This peace is primarily spiritual, not political or worldly. Two passages from John's Gospel allow Erasmus to repeat this point. After the feeding of the five thousand, Jesus withdrew from the multitudes who "were about to come and take him by force to make him king" (Jn. 6:15, RSV). In his *Paraphrase on John* (1523) Erasmus imagines the many who had had their fill of bread scheming "together to snatch up Jesus and make him their king, promising themselves goods in abundance, plenty of grain, wealth, freedom, and the other comforts of this world if they were lucky enough to have such a king." Jesus, however, did not want to rule over an earthly kingdom, and Erasmus supplies the lesson of the story: "the kingdom of heaven has nothing in common with the kingdom of earth, no more than light has with darkness."[76] Erasmus again takes the opportunity to distinguish

between the ways of Jesus and the ways of the world when paraphrasing John 14:27, where Jesus gives his peace to the apostles, but "not as the world gives" (RSV). Erasmus' Jesus assures the apostles: "Whoever has my peace cannot be overturned by any storm in the world." The world bestows upon its adherents an "untrustworthy peace," but Jesus says: "My peace that I am giving to you joins you to God. . . . The peace I leave you, attaching you to each other in mutual harmony, will make your friendship invincible against everything that the world or Satan the prince of the world can do." [77]

In 1517, the year that Martin Luther publicly questioned papal indulgences, Erasmus wrote in the *Paraphrase on Romans* that the pursuit of peace, concord and mutual love was "the substance of our profession," and through Paul he announced: "The essence of your profession is peace." [78] These remarks anticipated the famous formula of Erasmus' religious pacifism written in 1523: "The sum and substance of our religion is peace and concord." [79] Erasmus' reverence for Jesus as the Prince of Peace helps us understand that in identifying Christianity with peace Erasmus was not reducing the Christian religion to a concept or an attitude or a virtue. When he wrote that peace is the sum and substance of Christianity, he meant that Christianity was a peaceful religion. The peace that is God's gift to the world is the means by which human beings pursue their relationship with God and with each other. Salvation and peace are intimately linked, for salvation is about the reconciliation between God and humanity achieved by Christ. Erasmus equates peace with forgiveness and reconciliation in his paraphrase of Acts 10:36, where Peter says: "God sent word to the children of Israel, announcing peace through Jesus Christ" (Vulgate: *Verbum misit Deus filiis Israel, annuntians pacem per Iesum Christum*). Erasmus explains that God "through his only Son Jesus Christ" offered to the children of Israel "the forgiveness of sins and reconciliation with himself." [80] For *pax* Erasmus substitutes *abolitio peccatorum* and *reconciliatio*. In forgiving sins, God makes peace with human beings, who in turn demonstrate their peace with God through repentance and mutual forgiveness.

For Erasmus, Jesus as the Prince of Peace unites human beings with God and with each other in friendship, a friendship based on forgiveness. That is why Erasmus urges all Christians to pray for the peace of the Church by appealing to the mercy of Christ, by beseeching their "most gentle Savior," their "most merciful Jesus" to pardon their

sins which have destroyed the unity of the Church. Although the religious conflict fueled by the Reformation remained beyond remedy, Erasmus continued to cling to his conception of Jesus as the Prince of Peace, the conciliator and the bestower of mercy.

NOTES

1. Abbreviations:
 Allen = *Opus epistolorum Des. Erasmi Roterodami*, 12 vols., ed. P.S. Allen, H.M. Allen, and H.W. Garrod (Oxford: Clarendon Press, 1906-1958).
 ASD = *Opera Omnia Desiderii Erasmi Roterodami*, ed. C. Reedijk et al. (Amsterdam: North Holland Publishing Company, 1969-).
 CWE = *Collected Works of Erasmus* (Toronto: University of Toronto Press, 1974-).
 LB = *Desiderii Erasmi Roterodami Opera Omnia*, 10 vols., ed. J. Leclerc. (Leiden: 1703-1706).
 *I gratefully acknowledge Professor Mechtilde O'Mara, CSJ, who assisted me in improving some of my translations from Latin into English.

2. Jaroslav Pelikan, *Jesus through the Centuries: His Place in the History of Culture* (New Haven: Yale University Press, 1985), 175. For Erasmus' influence on the pacifist beliefs of Anabaptism see Peter Brock, *Freedom from Violence: Sectarian Nonresistance from the Middle Ages to the Great War* (Toronto: University of Toronto Press, 1991), 34, 75.

3. Georges Chantraine, "Mysterium et sacramentum dans le «Dulce Bellum»," in *Colloquium Erasmianum* (Mons: Centre Universitaire de l'Etat, 1968), 33: "Dans l'héritage érasmien, le pacifisme est la part non seulement la plus durable, mais aussi la mieux inventoriée."

4. *Dulce bellum inexpertis* (1515), in Margaret Mann Phillips, *The "Adages of Erasmus": A Study with Translations* (Cambridge: Cambridge University Press, 1964), 323.

5. Stanton K. Tefft, "Warfare Regulation: A Cross-Cultural Test of Hypotheses," in *War, Its Causes and Correlates*, ed. Martin A. Nettleship, R. Dalegivens, and Anderson Nettleship (The Hague and Paris: Mouton Publishers, 1975), 694.

6. Michael Howard, *The Causes of Wars* (London: Temple Smith, 1983), 8.

7. José Chapiro, *Erasmus and Our Struggle for Peace* (Boston: Beacon Press, 1950), 60.

8. Pierre Brachin, "Vox clamantis in deserto: Réflexions sur le pacifisme d'Erasme," in *Colloquia Erasmiana Turonensia*, 2 vols.,

ed. Jean-Claude Margolin (Paris: Librairie Philosophique J. Vrin, 1972), 1:257-264; Michael Howard, *War and the Liberal Conscience* (London: Temple Smith, 1978), 16.

9. See Roland Bainton, "The 'Querela Pacis' of Erasmus: Classical and Christian Sources," *Archiv für Reformationsgeschichte* 42 (1951): 32-47; J. A. Fernandez-Santamaria, "Erasmus on the Just War," *Journal of the History of Ideas* 34 (1973):209-226; Ross Dealy, "The Dynamics of Erasmus' Thought on War," *Erasmus of Rotterdam Society Yearbook* 4 (1984):53-67; Rudolf Padberg, "Pax Erasmiana: Das politische Engagement und die 'politische Theologie' des Erasmus von Rotterdam," in *Scrinium Erasmianum*, 2 vols., ed. J. Coppens (Leiden: E.J. Brill, 1969), 2:301-312, and "Erasmus contra Augustinum: Das Problem des bellum justum in der erasmischen Friedensethik," in *Colloque Érasmien de Liège*, ed. Jean-Pierre Massaut (Paris: Société d'Édition "Les Belles Lettres," 1987), 278-296; and Otto Herding, "Erasmus--Friden und Krieg," in *Erasmus und Europa*, ed. August Buck (Wiesbaden: Otto Harrassowitz, 1988), 13-32.

10. Jean-Pierre Massaut announced: "Les études érasmiennes sont en plein renouvellement." See his essay "Humanisme et spiritualité chez Erasme," in *Dictionnaire de Spiritualité*, vol. 7/1 (Paris: Beauchesne, 1969), col. 1006.

11. Kurt von Raumer, *Ewiger Friede: Friedensrufe und Friedenspläne seit der Renaissance* (Freiburg and Munich: Verlag Karl Alber, 1953), 3, 7.

12. John Olin, "The Pacifism of Erasmus," in Olin, *Six Essays on Erasmus* (New York: Fordham University Press, 1979), 20; Jean-Claude Margolin, *Guerre et paix dans la pensée d'Erasme* (Paris: Aubier Montaigne, 1973), 9.

13. Friedhelm Krüger, *Humanistische Evangelienauslegung: Desiderius Erasmus von Rotterdam als Ausleger der Evangelien in seinen Paraphrasen* (Tübingen: J.C.B. Mohr [Paul Siebeck], 1986), 229.

14. *Panegyric for Archduke Philip of Austria*, CWE 27:56-57.

15. CWE 27:56.

16. CWE 27:288.

17. CWE 27:287.

18. CWE 27:320.

19. CWE 27:297, 300.

20. CWE 27:299.
21. CWE 27:300.
22. LB 7:299 E-F.
23. LB 7:462 A.
24. LB 7:462 B.
25. LB 7:462 C-E.
26. CWE 27:299.
27. Phillips, *Adages*, 337.
28. LB 7:453 E-F, 454 A-B.
29. LB 7:135 D-E.
30. Phillips, *Adages*, 337.
31. LB 7:394 B-C.
32. LB 7:63 E-64 A.
33. LB 7:64 A.
34. CWE 66:47.
35. Phillips, *Adages*, 328.
36. LB 7:23 E-24 B.
37. LB 7:24 B-C.
38. LB 7:25 B.
39. LB 7:25 E-26 A.
40. LB 7:26 A-B, F.
41. Pelikan, *Jesus through the Centuries*, 176.
42. Phillips, *Adages*, 352.
43. CWE 27:301.
44. CWE 27:309-310.
45. LB 5:1219 D-1220 A.
46. LB 5:37 C-D.
47. LB 5:380 F.
48. ASD 5-1:319.
49. LB 5:1198 B.
50. ASD 5-1:159.
51. LB 5:1226 C.
52. LB 5:1225 F-1226 A.
53. *Erasmus' Annotations on the New Testament: The Gospels*, ed. Anne Reeve (London: Duckworth, 1986), 35.
54. LB 5:1226 A, B.
55. LB 7: 101 A-C.
56. CWE 8: Ep. 1225, ll. 343-344.
57. Allen 9: Ep. 2361, ll. 55-60.

58. ASD 5-3: 251.
59. LB 5:1215 E.
60. *Modus orandi Deum*, ASD 5-1:138.
61. LB 5:1215 F.
62. LB 5:1216 F. The quote is from Matt. 8: 25.
63. LB 5:1217 B.
64. LB 5:1216 E.
65. Ibid.
66. LB 5:1215 E-F.
67. LB 5:1217 A.
68. LB 5:1216 F.
69. LB 5:1217 D.
70. LB 5:1217 C.
71. LB 5:1217 D-1218 A.
72. LB 5:1218 D.
73. ASD 5-1:121.
74. *Paraphrase on 2 Thessalonians* (1520), LB 7:1032 B.
75. *Paraphrase on Ephesians* (1520), LB 7:977 E.
76. CWE 46:78.
77. CWE 46:174.
78. CWE 42:81, 85. Erasmus is paraphrasing Rom. 14:19 and 15: 5 respectively.
79. CWE 9: Ep. 1334, l. 232.
80. *Paraphrase on Acts* (1524), LB 7:710 B.

Can the Center Hold?
Thomas More and Vaclav Havel on Social and Personal Integrity

Patrick Henry

The people of the future, according to British theologian Don Cupitt, who counts himself among them, "have no insides." Cupitt says the last vestiges of the old notion that there is such a thing as "human nature" have been erased by the postmodern discovery that the world is all on the surface, and the surface itself is nothing but words. We construct reality by our speech at every moment, and are as free as God ever was to create whatever we want. Indeed, the echo is precise and undistorted: when Cupitt says the new view "vindicates everything right now," it is just like God's looking on everything at the end of six days and calling it good.[1]

Cupitt says we are simply the sum of our external relations; there is no more to be accounted for.[2] When Robert Bolt, in the preface to *A Man for All Seasons*, his play about Thomas More, says we describe "ourselves to ourselves in terms more appropriate to somebody seen through a window. We think of ourselves in the Third Person,"[3] or when Václav Havel says that in the modern world, both East and West, the fundamental problem "is much more than a simple conflict between two identities. It is something far worse: it is a challenge to the very notion of identity itself,"[4] Cupitt would say we have grown up and achieved a great liberation, for to have "no insides" is wonderful, and to

see "identity" as illusion is mature enlightenment. For Robert Bolt, and for me, this new news is not good news, but a dangerous delusion. The measure of its danger is Cupitt's tacit adoption of Ivan Karamazov's famous declaration that "all is lawful" without a trace of Ivan's shudder.[5] Cupitt says we're all on the surface, and then writes as if that surface is angelic, that people will create a heaven on earth.

Christian faith is not for angels. It is for human beings and for their insides, but not simply their insides, as though there is some private spiritual realm that is sealed off from public, communal life. Robert Bolt's Thomas More challenges the Duke of Norfolk to acknowledge some core of identity: "Is there no single sinew in the midst of this that serves no appetite of Norfolk's but is just Norfolk?" and then carries the challenge one decisive step further, the Christian humanist step: "There is! Give *that* some exercise, my lord!"[6] The core of identity is not to be hermetically sealed in a museum case to be admired; it is to be *exercised*, put into play, made to count in the public realm.

We do not have any coherent way to think about the connections between character and public life. Every president seems fated to have a "Scandal-Gate" of some sort, and the alternative to scandal appears to be vacuity. Garry Trudeau gave us in "Doonesbury" a George Bush whose presence is empty space, the ultimate expression of a totally fluid identity so dependent on polls that you can never locate it, because as soon as one set of poll results is in, another survey is already underway. Scandal or emptiness: with such a choice it is little wonder that cynicism about public life infects our society at every level.

But then, as if rousing us from a drugged sleep, there comes a voice reminding us that politics, community, public life is not best understood as dirty work that somebody has to do, but as a gift God has given us. From a most unexpected quarter, Eastern Europe, we have been reminded almost overnight in a fresh and exhilarating way of the great debates about human and divine purpose that lie behind the founding of our own country. Is politics the hedge against chaos and barbarity, the desperate response to a life characterized by Hobbes as "solitary, poor, nasty, brutish, and short," or is it, as in Locke and, before him, preeminently in Aristotle, the best expression of full humanity? President Václav Havel's New Year's Day 1990 Address to the Czechoslovak people is political talk of a sort we have not heard in

a long time. *Newsweek* even suggested we have to go back to Lincoln's Second Inaugural to find a parallel.[7] Havel raises the question of "insides," of human nature, when he wonders: How is it that through decades of official corruption, decades in which the distinction between lies and truth vanished as people became "used to saying something different from what [they] thought," decades in which all the powers of the state were devoted to the obliteration of all traditional surfaces and the fashioning of an entirely new order, the people of Czechoslovakia maintained a sense of identity that meant when the signs and times and seasons were right, they "found the marvelous strength to shake from their shoulders in several weeks and in a decent and peaceful way the totalitarian yoke"?[8]

How can I gauge the difference in feeling about the world between my generation and that of today's college students? When I was their age Nikita Khrushchev pounded his shoe at the United Nations, and claimed that the Soviet Union would bury us. Their perception of the world is formed by the Berlin Wall's tumbling down almost as rapidly as the walls of Jericho, by the award of the Nobel Peace Prize to the President of the Soviet Union and by his subsequent oblivion as the Soviet Union, between the August coup and Christmas Day of 1991, disappeared from the face of the earth. Reality rears its head, of course: tribalisms threaten everywhere; Czechoslovakia is already a memory. But the fact remains: there is hope and excitement about the possibilities of public life as an arena for experiment, creativity, and fulfillment. Eastern Europe has given us a spiritual jolt, has awakened us out of our cynical slumbers. In the depths of political darkness, in 1975, Havel wrote: "Life rebels against all uniformity and leveling; its aim is not sameness, but variety, the restlessness of transcendence, the adventure of novelty and rebellion against the status quo."[9] "The Spirit blows where it wills" (John 3:8) is these days a sober journalistic observation, not simply a pious biblical phrase.

Bolt's play, *A Man for All Seasons*, had its premiere in 1961, the year after I graduated from college. In the preface Bolt says his intent was to use a person dead more than 400 years to bring us face to face with ourselves, and the critical acclaim and popular attention the work got, especially when it became a movie, suggests Bolt did what he set out to do. Almost thirty years before Cupitt's book, Bolt was saying this:

Socially, we fly from the idea of an individual to the
professional describers, the classifiers, the men with the
categories and a quick ear for the latest subdivision, who
flourish among us like priests. Individually, we do what
we can to describe and classify ourselves and so assure
ourselves that from the outside at least we do have a
definite outline. Both socially and individually it is with
us as it is with our cities—an accelerating flight to the
periphery, leaving a center which is empty when the hours
of business are over.[10]

Fifteen years later Havel made the same point with a different image:

It's as if we were playing for a number of different teams
at once, each with different uniforms, and as though—and
this is the main thing—we didn't know which one we
ultimately belonged to, which of those teams was really
ours.[11]

Bolt says the center was abandoned. Cupitt says the center was
always an illusion. Havel reasserts the center, says that the most
momentous events of our time can be understood only as the
emergence into public view of an integrity, a sense of self, that has
weathered the most brutal and sustained assaults modern totalitarianism
could mount against it. Bolt says of Thomas More, what Havel seems
to be saying of the Czech people: "He knew where he began and left
off." Knowing and maintaining limits, far from straitjacketing the spirit,
is the precondition for freedom. Bolt makes the point clear and sharp:

What first attracted me [to More] was a person who could
not be accused of any incapacity for life, who indeed
seized life in great variety and almost greedy quantities,
who nevertheless found something in himself without
which life was valueless and when that was denied him he
was able to grasp his death. . . . He parted with more than
most men when he parted with his life, for he accepted
and enjoyed his social context.[12]

More was, in the phrase of Robert Whittinton, one of his contemporaries, a "man for all seasons,"[13] not because he was a chameleon who could adjust himself to any surroundings, but precisely because he had that core sense of self, that knowledge of where he began and left off, that freed him up to respond as situations developed and changed. He could be available to others because he was not in danger of losing himself.

We have, then, four characters before us: Thomas More, Lord Chancellor of England; Robert Bolt, a modern playwright who presents More as a foil to us; Václav Havel, a modern playwright who soon after being sprung from prison finds himself president of his country; and the people of Czechoslovakia who manage to pull off, in a few weeks, what quickly came to be called the "velvet revolution." All four of these characters shatter the barriers that would restrict Christian life to what happens within the institutional church—indeed, Bolt disclaims being a Christian "in the meaningful sense of the word."[14] But to see it another way, each of these characters expands enormously our understanding of what church is, and we begin to understand that the church as "the people of God in the world" blurs lines, messes up boundaries, confuses categories. The institutional church is necessary, but not sufficient.

Of the dozens of routes back to the center that could be investigated in *A Man for All Seasons*, in Havel's New Year's Address, and in Havel's earlier writings that clearly prepare the way for his great oration, three are interconnected, and are particularly compelling for us today: Friendship, Hope, and Language.

First, then, *Friendship*. Thomas More had an extraordinary gift for friendship. As Bolt says with a certain amazement, "A visitor's book at [More's] house in Chelsea would have looked like a sixteenth-century *Who's Who*,"[15] but in the play Bolt portrays not only the More who was sought out by the likes of Erasmus and the painter Holbein, but also the More who genuinely befriended all sorts and conditions of persons. He could banter with the steward as well as he could match wits with King Henry VIII. And Bolt leaves no doubt that More and Henry, different as they were—perhaps because they were so different—were genuine friends. There is a delicious bit of conversation of a sort that marks true friendship:

Henry: How did you like our music? That air they played, it had a certain—well, tell me what you thought of it.

More: Could it have been Your Grace's own?

Henry: Discovered! Now I'll never know your true opinion. And that's irksome, Thomas, for we artists, though we love praise, yet we love truth better.

More: Then I will tell Your Grace truly what I thought of it.

Henry: Speak then.

More: To me it seemed—delightful.

Henry: Thomas—I chose the right man for Chancellor.

More: I must in fairness add that my taste in music is reputedly deplorable.

Henry: Your taste in music is excellent. It exactly coincides with my own. [16]

With the playwright's ability to make more than one point in few words, Bolt here causes us to laugh at the king's criterion for excellent taste—"it exactly coincides with my own"—and to wince at the sinister implications, for it will be when More's tastes do not exactly coincide with Henry's own, and indeed stand adamantly athwart those tastes, that More's head will be chopped off. Power corrupts friendship. The human warmth of this conversational interchange is suddenly chilled because we know that, for the king, friendship, even such a friendship as this, is subordinate to power. What is writ large in the person of the king is copied in smaller print, often without a veneer of good humor, throughout the realm, especially in the villainous Thomas Cromwell, but also in the venal Cardinal Wolsey and the slowly, willingly corrupted Richard Rich, whose equation of friendship with advantage, even with cash, stands in the sharpest possible contrast to More's genuine feeling for other people. There are not many moments in drama more bittersweet than More's feigning a fight with Norfolk near the end of the play, when being known as More's friend could cost you your life. [17]

Havel, in his New Year's Address, acknowledges how the corruptions of power in the political system have eroded friendship. "We learned not to believe in anything, to ignore each other, to care only about ourselves." People were taught to be warily suspicious of one another, and for good reason: rich rewards, or at least rewards as rich as a strangled and strangling system could produce, were held out in return for spying on one another.

> Concepts such as love, friendship, compassion, humility, or forgiveness lost their depth and dimensions, and for many of us they represented only psychological peculiarities, or they resembled gone-astray greetings from ancient times, a little ridiculous in the era of computers and spaceships.[18]

Earlier, in 1975, Havel had described what happened to friendships in Prague:

> You're always having to worry about whom you'll be getting into trouble by visiting them, whom you can invite to your place knowing they won't just come because if they don't, you'll think they're afraid. You're always worrying about silly problems like whom to admit you know and whom not, where you can go and where you shouldn't so as not to make someone nervous or cause them unpleasantness with the police.[19]

Our system in the United States has not been without incentives to sacrifice friendship in the name of prestige, or even national security. Thousands of people have uncovered substantial files the government was keeping on them. But the network of suspicion and informing that we have known is slight compared to that of More's England, and almost as nothing compared to the nightmare of Czechoslovakia. Still, friendship among us is undermined by all sorts of more subtle power relationships, and, I believe, by the very lack of a personal center about which Bolt has spoken. If I do not know who I am, if I am nothing but the sum of my external relations, then I am going to be skittish about those relations, since at any point they present the threat that I will become something I don't want to be. I will try to

control my external relations, and this means I will do everything to avoid the fearful uncertainty of giving myself unreservedly to a friendship. Power corrupts friendship, but so does powerlessness, the powerlessness of lack of any identity.

If we are incapable of friendship, we are incapable of hope. So, we are at our second theme: *Hope*. A leading feature of despair, the absence of hope, is isolation, loneliness, the conviction that I am disconnected from everyone and everything. For four and a half years the area where I live has been a case study of hope. Solidarity, mutual support, community, connectedness have all taken on fresh and palpable meaning in the determination not to let die the hope for the safe return of Jacob Wetterling, a classmate of my daughter's, abducted at gunpoint in 1989 when he was eleven. Nothing like this sustained outpouring of concern and activity has been seen before in the annals of missing persons. Everyone acknowledges the role of the Wetterling family, especially their refusal to let their pain isolate them, disconnect them, from other people. From the beginning they have said, not, "Why us, God?" but "Jacob is everybody's child." They have welcomed, sought, nurtured friendships.

But I think the phenomenon of Jacob's Hope depends also on the strong religion of central Minnesota, a religion that has kept communities together. Jacob's Hope has not so much created community as illuminated the community that was there already. Saint Joseph, Minnesota can tell other places much about how to organize, but it also knows the other side of an equation phrased memorably by a great Christian a couple of generations ago: "Organize as if there is no prayer; pray as if there is no organization."[20] There is hope in this balance, so different from the snide and clipped cynicism of Cardinal Wolsey when he says to Thomas More: "Yes. All right. Good. Pray. Pray by all means. But in addition to prayer there is effort."[21]

Ours is in many ways a cynical time. The publisher of *Minnesota Monthly* magazine sent a reporter to do a story on the anniversary of Jacob's abduction, and admits: "When I assigned the story, I believed Patty Wetterling was making a mistake. She should give up, I thought, and resign herself to the fact that Jacob was dead." But the story itself converted the editor, who goes on to say, "I don't feel that way any longer. If I were she, I know now, I would continue on as she has. But I doubt that I could maintain her fortitude."[22] The story convinced him that her hope was deeper, more genuine, than his

own sophisticated cynicism: the mystery, he recognizes, is in her *maintaining* fortitude.

Patty Wetterling's hope does not have the hue of rose-colored glasses. She admits she does not know whether Jacob is alive. But she says: I will never give up hope that he will return home safe. "Hope does not disappoint us," says Saint Paul (Romans 5:5). Notice that he does not say "Our hopes are not disappointed"; he knows perfectly well they often are, and he has no illusions that the power of positive thinking will put a happy face on grief. But genuine hope, even if it proves to be dashed, does not disappoint us, for it is grounded in our conviction that we have what we need—as the editor of *Minnesota Monthly* puts it, Patty Wetterling "believes in the human community."

Václav Havel's message is full of hope because he knows the difference between a hopeful people and something to hope for, the fundamental distinction between hope and expectation. Their previous rulers had always been holding out to the people the promise of *things* they could hope for—and never got. Havel reminds the people of his country that they already have what they need—indeed, they managed a revolution when they had, effectively, nothing, having been robbed of everything—except their identity—by their government. The hope of the Czech people, like that of the Wetterlings, is grounded more deeply than the expectation of a particular outcome.

We tend to think hope is single-minded, and there is a kind of magnificent obsession in Jacob's Hope. But hope lasts because it draws so many themes, so many incentives, into itself. And Havel helps us understand why variety feeds hope. In Havel's play called *Protest*, written in 1978, a decade after the "Prague Spring" that was so brutally mowed down by Soviet tanks, the character Stanek says to his friend Vanek, recently released from prison, "What have they made of us, old pal? Can this really be us?"[23] Then Stanek, who despises the regime but has accommodated himself to it just enough to avoid arrest, says to Vanek, in words prophetic of Havel's own speech to the Czechoslovak nation a dozen years later, "You and your friends have taken on an almost superhuman task: to preserve and to carry the remains, the remnant of moral conscience through the present quagmire! The thread you're spinning may be thin, but—who knows—perhaps the hope of a moral rebirth of the nation hangs on it."[24]

To underscore this talk of moral renaissance, Havel makes Stanek into an avid gardener, and creates an image of a pluralist world

radically different from the drab, monochrome uniformity of socialist realism: "I've got thirty-two shades [of gladioli], whereas at a common or garden nursery you'll be lucky to find six." And then, the note of hope: Stanek proposes to send bulbs home with Vanek for his wife, and says, "There's still time to plant them you know."[25] In this one line— "There's still time to plant them you know"—signs and times and seasons all come together in a convergence of nature, politics, and renewal.

And now, having moved from Friendship through Hope, we come to our third theme: *Language*. I began with a critique of Don Cupitt's grandiose claims for language—that it is all there is, that the world we inhabit is nothing but a construct of the language we manipulate, which in turn manipulates us. Cupitt is wrong, but he is no fool, and he alerts us to the enormous power language has. Language is not a prison, but it is a strong fortress, and we have to be careful lest all the drawbridges are pulled up and all the shutters locked. Both Bolt and Havel are conjurers with words. As playwrights they deal daily with the mystery that words are simultaneously action and comments on action, revealers and concealers, windows and smokescreens, highways and roadblocks. The playwrights are experimenters with words, tentative, deathly afraid of anyone who pretends that words can fix reality for all time. Here is Havel, the wordsmith, on words:

> Words are a mysterious, ambiguous, ambivalent, and perfidious phenomenon. They can be rays of light in a realm of darkness. . . . They can equally be lethal arrows. Worst of all, at times they can be one or the other. They can even be both at once![26]

A fundamental problem of Christian faith at all times, and acutely so now, is that of how to speak the truth not only in love, but also intelligibly. Certain words mean something entirely different in different contexts; Havel uses religious and values terminology—he says, for example, that "the issue is the rehabilitation of values like trust, openness, responsibility, solidarity, love"[27]—in a way that would be not only offensive in some American ears, but downright silly on the lips of many American politicians. Are the words backed up with a life? This is a feature of serious politics almost forgotten in our country, where politics has become the plaything of media consultants, and

where those who speak the truth, as Walter Mondale did in 1984, find, as Thomas More did (though with less drastic consequences than More suffered), that truth is a death warrant. The measure of our plight is our paralysis—we recognize lies as lies, but believe them anyway, or at least act as if they were true. We are not as far removed as we like to believe from the condition Havel characterizes as "saying one thing and thinking another." Indeed, our condition may be even more dangerous—"saying one thing *and* thinking it too."

Cupitt's claim that language creates reality is plausible not because it is fundamentally true, which it is not, but because, in Bolt's image, we have moved out of the center of our identity into the suburbs of external relations. It is not, as Cupitt asserts, that there is no center and never has been. It is simply that we have abandoned the center. Havel and the Czech people, and Thomas More, startle us because in them the center has held, and the center has held not by a dogged adherence to uniformity, but precisely by the celebration of variety— the thirty-two shades of gladioli in Stanek's garden, More's reveling in the richness and diversity of the life of the Renaissance.

Because for Havel the center has held, he is able, in the New Year's Address, to make the move that wipes away much of the dust that obscures the language of morality when spoken in the political arena. He talks about responsibility and repentance.

> We are all—though naturally to differing extents— responsible for the operation of the totalitarian machinery; none of us is just its victim: we are all also its co-creators.

> Why do I say this? It would be very unreasonable to understand the sad legacy of the last forty years as something alien, which some distant relative bequeathed us. On the contrary, we have to accept this legacy as a sin we committed against ourselves. If we accept it as such, we will understand that it is up to us all, and up to us only, to do something about it. . . If we realize this, hope will return to our hearts. [28]

There is a premonition of this language in something Havel wrote in 1976: "We stand once more face to face with the most important question of all: How do we settle accounts with ourselves?" [29]

Havel thus reverses the magnetic field in which our language is set. Bolt has diagnosed our sickness as the abandonment of first person discourse for third person. Havel challenges his people to give up the self-serving blame of "Them" and accept the self-enhancing responsibility of "We." For he knows that the only way from the third person to a genuine regard for the second person—You, the neighbor, the friend, even the enemy—is through a recovery of the authenticity and integrity of the first person, both singular and plural.

Setting the scene in *Nineteen Eighty-Four*, George Orwell says: "The pen was an archaic instrument, seldom used even for signatures," and "To mark the paper was the decisive act." In Havel's play, *Protest*, Stanek, stonewalling Vanek's request that he sign a petition for freeing a prisoner, exclaims: "Fifty signatures should be enough! Besides, what counts is not the number of signatures, but their significance." To which Vanek replies: "Each signature has its own significance!"[30] Václav Havel and Thomas More show us with dazzling clarity that until we recover the first person voice—until each signature has the significance of the decisive act of personal commitment—our language will remain sounding brass and tinkling cymbal.

Bolt and Havel, More and the people of Czechoslovakia, the Wetterling family, pose three questions to us that highlight both our despair and our hope as Americans, as Christians, as human beings, questions of social and personal identity and integrity:

The question of Friendship: What will bring us together and keep us together?

The question of Hope: What will get us started and keep us going?

The question of Language: What will transpose us from third person complacency into first person responsibility for the sake of second person community?

Can the center hold? It depends, at least in part, on the way we answer these questions.

NOTES

1. Don Cupitt, *Radicals and the Future of the Church* (London: SCM Press, Ltd., 1989), pp. 141, 157.
2. Cupitt, p. 19.
3. Robert Bolt, *A Man for All Seasons* (New York: Vintage Books, 1962), "Preface," p. x.
4. Václav Havel, "The Power of the Powerless" (1978), in *Open Letters: Selected Writings 1965-1990* (New York: Alfred A. Knopf, 1991), p. 145.
5. Cupitt, p. 98, where he says "everything is permitted."
6. Bolt, pp. 71-72.
7. *Newsweek* (January 15, 1990), p. 42, printed excerpts from the speech, and suggested the parallel with Lincoln's Second Inaugural. For an account and analysis of some of the major sources of Havel's political thought as expressed in the New Year's Address, see Jaroslav Pelikan, "Jesus, Not Caesar: The Religious World View of Thomas Garrigue Masaryk and the Spiritual Foundations of Czech and Slovak Culture," The Westminster Tanner-McMurrin Lectures on the History and Philosophy of Religion at Westminster College, III (1991), published by Westminster College of Salt Lake City, Utah, esp. pp. 13 and 19-20.
8. "New Year's Address" (1990), *Open Letters*, pp. 391, 392.
9. "Dear Dr. Husák" (1975), *Open Letters*, p. 71.
10. Bolt, p. xi.
11. "It Always Makes Sense to Tell the Truth": An Interview with Jirí Lederer (1975), *Open Letters*, p. 95.
12. Bolt, pp. xi, xiii.
13. Cited as an epigraph in Bolt, p. v.
14. Bolt, p. xii.
15. Bolt, p. xiii.
16. Bolt, p. 32.
17. Bolt, pp. 70-72.
18. "New Year's Address" (1990), *Open Letters*, p. 391.
19. "It Always Makes Sense to Tell the Truth" (1975), *Open Letters*, p. 89.
20. John R. Mott, quoted in Robert S. Bilheimer, *Breakthrough: The Emergence of the Ecumenical Tradition* (Grand Rapids, Michigan:

Wm. B. Eerdmans, Publishers; Geneva: WCC Publications, 1989), p. 4.

21. Bolt, p. 12.
22. Leonard Witt, "Editor's Note," *Minnesota Monthly*, October 1990, p. 8.
23. Václav Havel, *Protest* (first published in Czech, 1978; English translation by Vera Blackwell, 1984), in *The Garden Party and Other Plays* (New York: Grove Press, 1993), p. 245.
24. *Protest*, pp. 246-47.
25. *Protest*, p. 249.
26. "A Word About Words" (1989), *Open Letters*, p. 381.
27. "The Power of the Powerless" (1978), *Open Letters*, p. 210.
28. "New Year's Address" (1990), *Open Letters*, p. 392.
29. "The Trial" (1976), *Open Letters*, p. 107.
30. George Orwell, *Nineteen Eighty-Four* (New York: Harcourt, Brace and Company, 1949), p. 8; Havel, *Protest*, p. 255.

The Commerce Between the Mind and Things: A Re-shaping of the World in the Seventeenth Century

William S. Babcock

I.

Francis Bacon's chief works—and most especially the *Instauratio Magna* and the *Novum Organum*—arose from his deep sense that what passed for knowledge in his age had lost its moorings in reality. Far from counting as true knowledge, it represented nothing more than a massive intellectual subterfuge in which ignorance masqueraded as learning and so prevented the mind from coming to grips with the true nature of things. It is not too strong to say that, in his view, the "learning" of his culture, along with the academic traditions which buttressed and sustained that "learning," had completely missed the mark. It had utterly failed to "close," as he would put it, with things as they actually are.[1]

To this breakdown in learning and the learned traditions, Bacon responded with an audacity that still—almost four centuries later—takes the breath away. He undertook nothing less than "to try the whole thing anew upon a better plan, and to commence a total

reconstruction of sciences, arts, and all human knowledge, raised upon the proper foundations."[2] This, he believed, was the only course left open to him if he was to restore "that commerce between the mind of man and the nature of things, which is more precious than anything on earth . . . to its perfect and original condition"—or, failing that, at least to reduce it "to a better condition than that in which it now is."[3] The *Instauratio Magna* and the *Novum Organum* are meant, then, to provide a kind of blueprint for this project, a guide to the laying of the proper foundations on which a whole new edifice of human knowledge might be erected.

Bacon's project has attracted far more attention from historians and philosophers of science than it has from historians of theology and religion; and it has generated a lively and enduring debate over whether his famous "method of induction," with its disinterest in mathematics and its deliberate rejection of hypotheses, should count as a version (or perhaps as an antecedent) of the scientific method in something like the modern sense or whether, for all the appeal that it exercised among scientists in the seventeenth century, it should really be regarded as a mere cul-de-sac without significant methodological value.[4] But this debate has tended to obscure what would appear to be the key feature of Bacon's diagnosis of his culture's epistemic ills: his deep-seated conviction that its prevailing forms of "knowledge" had simply lost all contact with things as they are, that they simply failed to come to grips with the reality of things.

The antidote that Bacon prescribed was that we dwell "purely and constantly among the facts of nature," that we withdraw the "intellect from them no further than may suffice to let the images and rays of natural objects meet in a point, as they do in the sense of vision."[5] Bacon wanted first of all to induce his contemporaries to look carefully at things and to do so without assuming that they knew already what was there to be seen. His aim was to lead our minds "to things themselves"; and he wanted above all to avoid "all that premature human reasoning which anticipates inquiry, and is abstracted from the facts rashly and sooner than is fit."[6] What the historian of culture—and therefore the historian of doctrine—should see here is not so much a dubious version of scientific method, but rather a stark—and to all appearances deliberate—reversal of an ancient Platonic theme. "The understanding," Bacon insists, "must not therefore be supplied with wings, but rather hung with weights, to keep it from leaping and

flying." The Platonic dream of restoring to the soul its lost wings is here completely repudiated. Bacon's hope is to achieve exactly the opposite, what "has never yet been done," to weigh down the mind so as to restore its commerce with things as they are, as they meet the naked eye.[7]

II.

Behind Bacon's audacious project, then, lies his sense that things, the facts of nature, have eluded the prevailing modes of "knowledge." And the character of the project itself, its primal attempt to force the eye to look, registers just how great the distance was that seemed to him to have opened up between the mind and the nature of things. What a delineation of Bacon's project does not tell us, however, is which had drifted away from which, the mind from things or things from mind. Our natural, almost automatic, inclination is to presume, of course, that the things must be the constant in this equation and the mind the variable. We tend to construe the history of human culture, at least insofar as it is engaged in inquiry into the natural order, as a series of approximations, some of which do and some of which do not genuinely come to grips with the nature of things as they are. The history that preoccupies the cultural historian in this regard is the history of the mind's attempt to delineate its world, not the history of the world that it seeks to understand.

Yet there may also be a sense in which the things themselves are variables, and thus have a history of their own. One has, of course, to be careful in how one states the point. What is at issue here is not so much the history of things taken entirely in themselves, utterly without regard to any human interaction with them. What is at issue rather is the "look" that things have to human beings and the way in which that "look" serves as the basis for human orientation to them. And there is good reason to believe that things had, in fact, taken on a distinctively new "look" for broad stretches of European culture in the seventeenth century.

Bacon himself, at least at moments, seems to have sensed that he was trying to catch up with appearances. In Aphorism 129 of the

first book of the *Novum Organum*, he urges his readers "to observe the force and virtue and consequences of discoveries," especially "those three which were unknown to the ancients, and of which the origin, though recent, is obscure and inglorious; namely, printing, gunpowder, and the magnet." These three discoveries, he claims, "have changed the whole face and state of things throughout the world."[8] More recently, in her study of seventeenth-century Dutch art, Svetlana Alpers has made a similar suggestion. It was not advances in natural knowledge that evoked the descriptive and representational character of Dutch "picturing," as she calls it, but rather the other way round: "It would seem to have been . . . the established practices of the craft, its age-old recording of light and reflecting surfaces, its commitment to descriptive concerns in maps or in botanical illustrations, in short, its fascination with and trust in the representation of the world, that in the seventeenth century helped spawn new knowledge of nature."[9] If we want to understand how the world came to change its face, then, we need to look not so much at the birth of new modes of natural knowledge in the "scientific revolution" as to the more obscure and older practices—such as map-making, botanical illustration, and the painter's craft—which produced the "world" that science set out to investigate.

The history of map-making is, of course, a complex tale; and I cannot hope to tell it here in anything like its full detail.[10] Instead I want to single out certain elements in the story which will be especially useful for our purposes. Perhaps the key point is simply the sheer flood of maps that came into European culture in the late sixteenth and seventeenth centuries. The first great modern atlases were Abraham Ortelius' *Theatrum Orbis Terrarum*, published in Antwerp in 1570, and Gerard Mercator's *Atlas sive Cosmographicae meditationes de fabrica mundi et fabricati figure*, its three parts published in 1585, 1590, and 1595 respectively, and then in a single volume in 1602. It is hard to know how widely these folio volumes might have circulated; but it is clear that they were immensely popular: the *Theatrum* had gone through 28 editions by 1598 (not counting abridgments not published by Ortelius himself); and the plates for Mercator's *Atlas* were acquired by Jodocus Hondius and then by Hondius' son-in-law, Jan Jansson, who continued to add to and to reprint the work for some fifty years.[11] Nor was the world-atlas the only form in which maps were produced and circulated in seventeenth-century Europe. There were also globes, smaller collections of more specialized maps, and individual maps,

whether of the world or of particular regions, that were meant to serve either utilitarian or decorative purposes. By 1636, according to Alpers, "a traveler in Holland confirmed that even the houses of shoemakers and tailors displayed wall-maps of Dutch seafarers from which . . . they know the Indies and its history";[12] and Dutch paintings of the period confirm the report. A particularly dramatic example is Vermeer's *Art of Painting* which shows a remarkably fine map of the Netherlands hanging on the rear wall behind the artist and his model who are the subject of the painting. But wall–maps also occur in the less lush decor of Jacob Ochtervelt's *The Musicians* or Vermeer's *Officer and Laughing Girl*.[13] How far can one extrapolate from Holland to other areas of Europe? I am not certain on this point; but I presume that, even if the Netherlands represent an extreme instance, they represent an extreme instance of a trend that ran both wide and deep in seventeenth-century Europe. The factors that made maps both desirable and available were by no means limited to Holland.[14]

What, then, did the maps convey to those who used them—or who simply looked at them, turning the pages of an atlas or gazing at a hanging on the wall? Part of the title of the map in Vermeer's *Art of Painting* is clearly—evenly prominently—visible: it labels the map a *descriptio* (of the Netherlands). If we did not know better, we might think that Vermeer, in introducing and highlighting the word, was simply serving the complex purposes of his art (as he did in signing his name in the lower left corner of the map as if he were himself its maker). But, in fact, Vermeer was not inventing, but reproducing the map he shows;[15] and, in any case, *descriptio* was a common title for maps, widespread among the printed maps of the sixteenth and seventeenth centuries and going back, apparently, at least as far as the sixth century when Jordanes referred to Ptolemy as *orbis terrae descriptor egregius*.[16] And Ptolemy himself provides a clue as to how we should understand the term *descriptio* when it is applied to maps. The opening sentence of his *Geography*, in Latin translation, reads: *Geographia imitatio est picturae totius partis terrae cognitae*;[17] and the recovery, republication, and repeated reprinting of Ptolemy's work in the late medieval and early modern era placed this pictorial view of maps squarely at the center of European culture.[18]

What maps offered to their users, then, was a description or a picture of the world and of its various parts, a picture that was significantly different from any picture that had been available in

Europe prior to the recovery of Ptolemy and the subsequent explosion of maps and map–making in the sixteenth and seventeenth centuries. It is not, of course, that the new maps were completely free of either geographical error or of geographical whimsy. The map of Scandinavia and the North Atlantic in Ortelius' *Theatrum* of 1570, for example, shows several islands that are not, in fact, there; and in a blank area of the Arctic it carries the fanciful legend, *Pigmei hic habitant*.[19] But the key point is that such errors and fancies do not, in this case, determine the basic orientation or carry the basic meaning of the cartographical representation of the world. Such medieval world–maps as there were tended to be plotted around a vertical axis established by the line drawn through Jerusalem, shown at the center of the map, and Eden, to the east, shown at the top of the map; and thus they were given a shape determined by a religious and, specifically, a Christian "picture" of the world.[20] In contrast, the imaginary islands and the fanciful pygmies of Ortelius' map determine nothing of its shape or import. They are, as it were, momentary occupants of a representational scheme in which they have no future. In less than a century, they will be gone; and their elimination will not alter in any significant way the basic "picture" of the world in which they temporarily appeared. In fact, it is, so to speak, the gathering force and momentum of that "picture," its drive toward geographical accuracy, that will ensure their elimination. Once this "picture" has taken hold, as it does through the dissemination of maps in the seventeenth century, our fancies, whether mere whimsy or of deep religious import, will have either to relocate to a non-geographical realm or to accommodate themselves to a geography that is no longer malleable to the imagination.

A similar drive for accuracy marks the striking emergence of botanical and zoological images in the late sixteenth and seventeenth centuries, a similar drive to represent things as they actually are (which means, in this case, to represent them as they in fact appear to the senses).[21] Here we are in the arena of what Alpers has aptly labeled the "observational craft" and has defined—in a happy phrase—as "attentive looking, transcribed by the hand."[22] Once again the story is too complex to be told here in any detail. We can take a cue, however, from the preface of Robert Hooke's *Micrographia*. For Hooke, as Alpers puts it, "The eye . . . was a means by which men were able to turn from the misleading world of Brain and Fancy to the concrete world of things"; and, in Hooke's own words, his work was designed,

among other things, to show "that there is not so much requir'd towards it, any strength of *imagination*, or exactness of *Method*, or depth of *Contemplation* . . . as a *sincere Hand* and a *faithful Eye*, to examine, and to record, the things themselves as they appear."[23] Despite the disparaging reference to method, Hooke is plainly pursuing the Baconian project. His aim is to dwell among the facts of nature, to see them clearly, and to record them accurately just as they appear.

Hooke's own observations, of course, were taken chiefly through the microscope. He might just as well, however, have been stating explicitly the implicit aims that were becoming more and more dominant in the illustrations made by the naturalists of the sixteenth and seventeenth centuries. The herbals and bestiaries of the medieval era had already established, it is true, a European tradition of visual renderings of plants and animals. But the images in these works are rarely, if ever, to be construed as representations of what the eye saw. Only in the margins and in the foliate decorations of some late medieval manuscripts do there begin to appear images that represent plants and animals in recognizably realistic form.[24] And it is not until the sixteenth century that images drawn from nature, faithful renderings of what the eye saw, begin to accumulate and multiply. Especially important, in this regard, were Conrad Gesner's *Historia animalium* for its zoological drawings and Otto von Brunfels' *Herbarum vivae eicones* for the plates provided by Hans Weiditz, Brunfel's illustrator.[25] Gesner's work, in particular, was a very mixed bag, its illustrations sometimes rendering animals with striking naturalism and sometimes rendering entirely mythical beasts with no realism at all. But the significance of the two works—and others like them that rolled off the printing press with increasing frequency—lay in the way in which they redirected interest in plants and animals. The point was no longer medical (as in the medieval herbals) or moral and allegorical (as in the bestiaries), but rather to record—and to record accurately—the things as they appeared.

That point had become explicit as early as 1542 when Leonard Fuchs, in the preface to his *De historica stirpium*, made it clear that he had not allowed the craftsmen who illustrated the work "so to indulge their whims as to cause the drawings not to correspond accurately to the truth."[26] The same aim spilled over from the illustrators to artists who were not putting together compendiums of plants and animals, as in the case of the Dutch painter Jacques De Gheyn who produced (*inter alia*)

a marvelous page of insects in one of his drawing books or, in what became a cultural platitude, the flower painters of the seventeenth century.[27] In fact, painting itself could be construed as a "science for representing all the ideas or notions which the whole of visible nature is able to produce and for deceiving the eye with drawing and color."[28] Ironically, the realistic rendering of what the eye saw was meant to do its job so well that it would deceive the eye itself; and there is some evidence, as a matter of fact, that seventeenth-century viewers responded to paintings of natural objects in just this way. Samuel Pepys records in his diary in 1669 that the drops of dew hanging on the leaves of a flower piece by Simon Verelst forced him "again and again to put my finger to it to feel whether my eyes were deceived or no."[29]

When we spill over from the area of botanical and zoological illustration to the region of painting writ large, we enter a realm of immense complexity that defies a simple story line even more stubbornly than do maps and the art of the naturalists. Nevertheless I want at least to evoke a development that seems crucial to the process in which the world of things acquired a new—and, as it turned out, an enduring—"look" in the era that culminated in the seventeenth century. What I have in mind is the gradual emergence of landscape—or, more broadly, of background—as the setting in which the subject of a painting is located.[30] Landscape has to do, of course, with the question of the space that a painted subject commands or occupies; in short, it provides a space for the subject that is internal to the picture itself rather than created between the picture and its viewer. The most obvious contrast, I suppose, is a single-figure icon, presenting its subject frontally, staring outward from the surface of the picture-plane, against a gold ground.[31] The space to which the icon belongs, the space that it occupies and commands, is the space created when a viewer stands (or kneels) before the painting and responds to its address. Landscape, on the other hand, locates what the painting shows within a world internal to the picture itself and makes that world the space which the subject occupies and to which it belongs.

The process in which landscape emerged in—and came to dominate the space of—European painting was by no means unambiguous or unambivalent. Consider, for instance, Rogier van der Weyden's *St. Ivo*.[32] In the foreground, set in a dark and ill-defined interior space, is the figure of the saint, hunched slightly forward in a three-quarters view as he reads a document that he holds in both hands.

Wholly caught up in the act of reading, the saint's figure is most definitely not addressed to the viewer; but neither does it occupy any clearly delineated space defined by the picture itself. Leaning forward, St. Ivo emerges from a shadowed darkness which we recognize as an interior only because, in the upper left corner of the painting, a window is thrown open on a bright green landscape that recedes to the horizon and a blue, lightly clouded sky. And it is the landscape, seen through the open window, that creates the picture's tension and ambivalence. It does not reinforce the saint, who leans forward to the right, away from the window, but rather competes with him as an alternate and rival focus of interest within the picture. And perhaps the most striking point of all is that the picture's window does not open onto a landscape washed with religious (or any other) meaning. What is alternate to the saint, what rivals his claim on our attention, is simply the world as it is seen by the senses.

Which brings us to a further point. From the perspective of the late twentieth century, we know that landscape—or, for that matter, any other setting internal to a painting—need not be rendered realistically or naturalistically, that it need not be rendered in such a way as to deceive the eye into taking it for real. And so there is reason to stress that the rendering of landscape—or, more generally, of setting—that emerged in the period leading up to the seventeenth century was precisely a realistic or naturalistic rendering. What, then, is the effect of such a rendering of setting? The chief thing to remark, I think, is its tendency to compel the things that it contains to conform to its own scale, to force them to fit the setting that it not only provides for its subjects but also imposes on them. We can take as an example Pieter Bruegel's famous *Landscape with the Fall of Icarus*.[33] The lower left quarter of the painting shows, on high ground, a ploughman ploughing his field in sweeps that lead up to a fringe of trees and, beyond the ploughman, a shepherd gazing indifferently at the sky while his flock grazes around him. In the lower right, the ground drops sharply to a bay that spreads out from the lower right corner to occupy almost the whole central portion of the painting and then recedes towards a mountainous horizon and the misty sun setting into the sea. On the bay, a large ship, the two sails it is flying billowed out by a following breeze, makes its way outward toward the horizon; and, behind the ship, quite unnoticed by anyone or anything in the picture, the two thrashing legs of Icarus disappear into the sea with barely a splash. The painting seems to elicit

its own interpretation: it registers the indifference of the world, naturalistically rendered, to the events and meanings conveyed by myth.

But the painting is more complex, more ambivalent, than that. Half-hidden in the fringe of trees beyond the ploughman there appears a human skull which, once noticed, has the effect of canceling the neutrality of the picture's landscape and transforming the whole into a *momento mori*, a reminder of the fragility, transience, and deceptiveness of this all too finite world. The striking point, however, is that the skull is a completely unmotivated presence in the picture. It has no reason for being there that is internal to the picture itself; and so it has the status of an alien intrusion at odds with what the picture shows and the terms in which it shows it. The presence of the skull jars against its setting, a setting that does not support the message that the skull conveys. It is in this sense, then, that the naturalistically rendered landscape or setting tends to reduce the things it contains to its own scale—and even to dictate what it can contain. What does not conform to the setting is made to look odd, out of place, a violation, something that does not belong. To see the world naturalistically, in the end, is to exclude what cannot be rendered naturalistically from the very field of vision itself. Christopher Braider's comment, itself sparked by Bruegel's painting, is apt.

> Naturalist art has so thoroughly schooled us in the notion of a realm of preexisting objects readily amenable to neutral reproduction that it is hard to remember the radical formative power it exerts. . . . Reshaping painting in the image of empirical perception, lending its objects the aspect shown an incarnate observer, the formal realism epitomized by perspective made it possible to depict persons, places, and things as they "really are," autonomous inhabitants of space and time relative to a worldly witness.[34]

But Braider is also right to continue as he does: "what begins as possibility ends in coercion."[35] Henceforth, until painting again breaks with naturalism, "to qualify as suitable, a theme must be susceptible to embodiment in a natural form."[36] Along with maps and botanical illustration, painting itself—if less widely disseminated,

perhaps more powerful in its effect—gave the world of the seventeenth century a new "look" that proved irresistible in its impact on European culture. Its "radical formative power" drove from the scene both pygmies dwelling in the Arctic and skulls lurking among the trees.

III.

When Bacon set out to restore the commerce between mind and things, then, he was trying to close a gap that had opened up not only or even primarily because "mind" had wandered off from "things" but because, in a complex process of cultural change, "things" had taken on a "look" which they did not have before. That shift is what underlies his deep conviction that "all depends on keeping the eye steadily fixed upon the facts of nature and so receiving their images simply as they are."[37] "Those . . . who aspire not to guess and divine, but to discover and know, who propose not to devise mimic and fabulous worlds of their own, but to examine and dissect the nature of this very world itself," he insisted, "must go to facts themselves for everything."[38] Just what they would find in going to "the facts themselves" was not, of course, a foregone conclusion. Later proponents of the Baconian project such as Sir Thomas Browne in his *Religio Medici* or Joseph Glanvill in his *Sadducismus Triumphatus* would argue, without any obvious sense of incongruity, for the reality of witches and the truth of ghostly apparitions.[39] And among the followers of Bacon's program, few, if any, believed that a constant dwelling among the facts of nature would yield a world that lacked for God. In fact, the very opposite was true: virtually all were caught up in the sheer wonder of discovering the imprint of the divine in the intricate, hidden workings of the natural world as it presented itself to human sight. We should not underplay the religiosity of a Hooke, a Boyle, or a Newton.[40] Their religion was no mere discreet or tactful cover for essentially irreligious findings in an all too religious age. Despite occasional skirmishes over specific findings, the warfare between science and religion did not break out in the seventeenth century.

What marked the seventeenth century was rather a deep struggle over just what form religion would take under the impact of a

newly discovered world of things, a struggle over just how the modes of human intercourse with the divine would be conceived and enacted in such a world. [41] And I want to conclude by calling attention—far too briefly, I am afraid—to one aspect of that struggle: the debate over the place of mystery in religion that broke out at the end of the seventeenth century. [42] When Thomas Browne wrote his *Religio Medici*, in 1640 or so, he could affirm a quite unchastened belief in what he called "those wingy Mysteries in Divinity": "Methinks there be not impossibilities enough in Religion for an active faith. . . . I love to lose my self in a mystery, to pursue my Reason to an *O altitudo*! 'Tis my solitary recreation to pose my apprehension with those involved Aenigmas and riddles of the Trinity, with Incarnation, and Resurrection. I can answer all the objections of . . . my rebellions reason with that odd resolution I learned of Tertullian, *Certum est, quia impossibile est.* "[43]

Browne could make the same point even more provocatively: "Yet do I believe that all this is true, which indeed my Reason would persuade me to be false; and this I think is no vulgar part of Faith, to believe a thing not only above but contrary to Reason, and against the Arguments of our proper Senses."[44] Here Browne is already using, before the middle of the century, the vocabulary—"above reason," "contrary to reason"—that would set the terms of the great debate about Christianity and mystery at the end of the century; and his usage exposes just how vulnerable the position he had taken was. In the *Essay Concerning Human Understanding*, first published at the end of 1689, John Locke, using the same terms, argued that revelation could contain nothing contrary to reason or to "the evident Knowledge the Mind has of its own clear and distinct *Ideas*"; and even with regard to things above reason, Locke maintained, they can be accepted as revealed by God only when reason has ascertained that the revelation does, in fact, come from God and, further, only when reason understands "the signification of the Words, wherein it is delivered."[45] For Locke, then, Tertullian's famous quip provides no warrant for belief in absurdities: *Credo, quia impossibile est* "might in a good Man pass for a Sally of Zeal; but would prove a very ill Rule for Men to chuse their Opinions, or Religion by."[46]

In Locke's case, in fact, even things above reason are in danger of losing their character as mysteries of God. They are, to be sure, "purely matters of faith"; but that is not because they exceed human comprehension. They are matters of faith, rather, only because

reason cannot determine their truth by its own principles alone.[47] John Toland's *Christianity Not Mysterious,* published in 1696, drew Locke's line of thought to what seemed its inevitable conclusion: the deliberate elimination, from the arena of religion, of what lies beyond the reach of human understanding. Taking "to be above reason" and "mystery" as synonymous terms, Toland identified two senses in which the phrase "above reason" might be understood, either as designating "a thing intelligible of itself," but so covered by figurative words or ceremonies that reason cannot discern it until the veil is removed, or as signifying "a thing of its own Nature inconceivable, and not to be judg'd of by our ordinary Faculties and Ideas, tho it be never so clearly revealed."[48] In neither of these senses, however, does Christianity contain anything "above reason." In the first case, he argues, Christianity is itself the removal of the veil that formerly covered things intelligible in themselves; and, in the second, the whole point of revelation is precisely that its deliverances should be comprehensible, not incomprehensible, through the ordinary faculties and ideas of human beings. Thus Toland can conclude, "That what is reveal'd in Religion, as it is most useful and necessary, so it must and may be as easily comprehended, and found as consistent with our common Notions, as what we know of Wood or Stone, of Air, of Water, or the like."[49]

In taking aim at things above reason, Toland was, of course, taking aim at mysteries in Christian theology. And the mysteries in question, it need hardly be said, were precisely those "wingy Mysteries in Divinity, and airy subtleties in Religion" which Browne had identified as the "Aenigmas and riddles of the Trinity, with Incarnation, and Resurrection."[50] Between Locke's *Essay* and Toland's *Christianity Not Mysterious*, these mysteries had found a defender in Edward Stillingfleet, the bishop of Worcester and a vigorous, if not especially acute, theologian and controversialist. In a sermon preached at St. Laurence-Jewry in London in 1691, Stillingfleet argues that God "may justly require from us in general, the Belief of what we cannot comprehend." He goes on, however, to make it clear that what he has in mind are not things totally beyond human comprehension, but rather things partly known and partly unknown to us. There is, he insists, nothing out of the way in applying the word "mystery" in such cases, just as we do in other areas of human affairs: "Are there not *Mysteries* in Arts, *Mysteries* in Nature, *Mysteries* in Providence? And what

Absurdity is there to call those *Mysteries*, which in some measure are known, but in much greater unknown to us?"[51]

The "Atheistical Men" who consider the trinity and incarnation to be, not mysteries, but outright and monstrous contradictions seem to be caught in special pleading; they allow other things to be above our comprehension, but not these. "They will allow no *Mysteries* in Religion; and yet every thing is a *Mystery* to them. They cry out of *Cheats* and *Impostures* under the Notion of *Mysteries;* and yet there is not a Spire of Grass but is a *Mystery* to them; they will bear with nothing in *Religion* which they cannot comprehend, and yet there is scarce any thing in the World which they can comprehend."[52] Stillingfleet's defense, however, amounted to an unwitting concession of his opponent's point. Toland—whose *Christianity Not Mysterious* was, in fact, a direct response to Stillingfleet's sermon—was quick to see that the argument could be reversed. If all that is meant by *mystery* is what applies in the case of any spire of grass, then Toland is quite content to let mysteries abound.[53] In effect, Stillingfleet had given the game away. Although Toland was hardly a typical or representative figure of the late seventeenth and early eighteenth centuries, his was the position that would carry the day so far as the question of mysteries was concerned. In the re-shaped world that established itself in the seventeenth century, the "wingy mysteries in Divinity" could be sustained, if at all, only insofar as they were reduced to size, leveled with the mystery of any spire of grass, and made "as consistent with our common Notions, as what we know of Wood or Stone, of Air, of Water, or the like."[54]

It would still be quite wrong, however, to suppose that the re-shaped world of the seventeenth century was inhospitable either to religion in general or to Christianity in particular. Unlike Ortelius' Arctic pygmies and Bruegel's lurking skull, both remained central and even dominant features of the newly established natural and human landscape. Only Browne's "wingy mysteries in Divinity," the riddles of the trinity and incarnation, were largely driven from the scene. They represented a form of the intercourse between the divine and the human which the re-shaped world would not or could not sustain; and with them, the shape that had been given to Christianity and to the Christian doctrinal tradition in the patristic era was also thrown into eclipse.

We can let Stillingfleet have the last word. In a moment of singular acuity, he saw what was at stake in the quarrel over mystery in

religion: not a puzzle over whether or not we can rightly be expected to believe more than we can understand, but a far deeper question about the love of God, both God's love for us and our love for God. "Some Men," he remarks in his sermon at St. Laurence-Jewry, "may please themselves in thinking that by taking away all *Mysteries* they have made their *Faith* more easie, but I am certain they have extremely lessen'd the Argument for our *Love, viz,* the Apprehensions of the wonderful Love and Condescension of Christ in coming into the World *to save sinners.* "[55] The alternative to reading Christ as God incarnate, come into the world to suffer for our sake, is to reckon him "a *meer Man*" whom God made "to be his Son, and after he had preached a while here on Earth and was ill used and crucified by his own People, he Exalted him to be *God* and gave him Divine Attributes and Honours." This view, however, constitutes "an Argument of great Love [i.e., on God's part] to the Person of Christ, but not to the rest of Mankind."[56] It is not, Stillingfleet insists, a rendering of Christ that will "inflame our affections" for God. Rather "the Argument for the *Love* of *God* [i.e., on our part] is taken from what his *Son* was," from "the Antecedent Relation between him and the Father":

> If he were the *Eternal Son of God* who came to suffer for us, there is a mighty force and *Emphasis* in this Expression, and very apt to raise our Admiration and Love . . . This is indeed an Argument great enough to raise our Admiration, to excite our Devotion to inflame our Affections . . .

The alternative, Stillingfleet sees, has the very opposite effect:

> but how flat and low doth it appear, when it comes to no more than this, that there was a *Man*, whom, after his Sufferings, God raised from the dead and made him a *God by office*? Doth this carry any such argument in it for our Esteem and Love and Devotion to him as the other doth upon the most serious Consideration of it?[57]

But Stillingfleet's acute sense that more was at stake in the question of the mysteries of God than the issue of belief exceeding understanding did not, in fact, stand up to "the most serious

Consideration of it" at the end of the seventeenth century. The new "look" acquired by the world in that era, the "look" that sparked Bacon's audacious attempt to restore the commerce of mind and things, may have come as gain. But it also carried a loss; and what was lost was nothing less than the mode in which the interchange between divine and human love had previously been conceived: God's incarnation and the "inflamed Affections" it evoked. From the patristic era on, that interchange had given its most basic shape to Christianity and to the Christian doctrinal tradition; and with its loss, Christianity itself would have, uncertainly, to find a new pattern in which to mold its most fundamental forms of faith and practice. In the end, the weights that Bacon hung upon the mind proved too heavy for those "wingy mysteries in Divinity" that Sir Thomas Browne was among the last to celebrate. [58]

NOTES

1. The standard edition of Bacon's writings is *The Works of Francis Bacon*, ed. James Spedding, Robert L. Ellis, Douglas D. Heath, 14 vols. (London: Longmans, 1861-74; New York: Garrett Press, 1968). Far more readily available, however, is Francis Bacon, *The New Organon*, ed. Fulton H. Anderson (Indianapolis: The Bobbs-Merrill Co., 1960); and I cite this edition for all references to the *Instauratio Magna* and the *Novum Organum*. Bacon insists from the outset that "the state of human knowledge is not prosperous nor greatly advancing" (p. 7); he portrays philosophy and the intellectual sciences "like statues, worshipped and celebrated, but not moved or advanced" (p. 8); and behind the sorry state of knowledge, he finds, "the entire fabric of human reason which we employ in the inquisition of nature is badly put together and built up, and like some magnificent structure without any foundation" (p. 3). Bacon develops his critique of the "learning" of his day at length in his well known discussion of the "idols of the mind" and of the "signs" and "causes" of the prevailing intellectual disarray and error (pp. 47-100). For the claim that his own approach, by induction rather than by syllogism, does "close" with nature, see p. 20.
2. Bacon, 4.
3. Bacon, 3.
4. For an apt discussion of the issue, see Mary Hesse, "Francis Bacon's Philosophy of Science," in *A Critical History of Western Philosophy*, ed. D. J. O'Connor (New York: Macmillan and Co., 1964). Peter Urbach's more recent *Francis Bacon's Philosophy of Science* (La Salle, IL: Open Court, 1987) defends the scientific value of Bacon's method rightly construed.
5. Bacon, 13-14. Bacon's appeal to the sense and imagery of vision here is characteristic not only of his own program, but also of wider stretches of seventeenth-century European culture. For the Dutch setting in particular, see Svetlana Alpers' discussion of developments that she associates with Huygens and Kepler in *The Art of Describing: Dutch Art in the Seventeenth Century* (Chicago: University of Chicago Press, 1983), 1-71. Seeing, however, was only a first step for Bacon. He was acutely aware that the senses, uncorrected, could lead us badly astray; and he insisted that "it is a

great error to assert that the sense is the measure of things" (Bacon, 21). Nevertheless seeing remains essential, the only safeguard against fable and folly: "For I admit nothing but on the faith of the eyes . . . so that nothing is exaggerated for wonder's sake, but what I state is sound and without mixture of fables or vanity" (Bacon, 26).

6. Bacon, 14, 16.

7. Bacon, 98. For Plato's myth of the soul's loss and recovery of wings, see *Phaedrus* 246A-256D; and for a later use of the theme, see, e.g., Plotinus *Enneads* 1.3.3; 4.8.4; 5.9.1; 6.9.9. Although Bacon does not cite Plato here, it is hard to believe that he is not deliberately reversing the Platonic image.

8. Bacon, 118.

9. Alpers, 71 (Alpers explains her choice of the word *picturing* on p. 26). See also the remarks of Christopher Braider in his *Refiguring the Real: Picture and Modernity in Word and Image, 1400-1700* (Princeton: Princeton University Press, 1993), 79-80. Speaking of the emergence of perspective in European painting, southern as well as northern, he links it with several other devices—"so-called aerial or atmospheric perspective, the introduction of oil-based paints, the creation of a consistent light-source, mastery of human and animal anatomy, and the use of chiaroscuro in modeling volumetric forms"—which combine in a single project, "a certain realism reproducing the look of the world of ordinary secular experience" (79). And like Alpers, on whom he is partly dependant here, he too finds this pictorial realism to anticipate science in significant respects: "Indeed with perspective, painting crosses a threshold science itself does not properly reach before Galileo and Descartes—why Kepler, for instance, casting about for a model for the faculty of sight adjusted to the requirements of rational scientific explanation, invokes painting as the standard against which optical analysis should be judged: *ut pictura, ita visio*" (80).

10. For a brief, accessible history of early maps and map-making, see Carl Moreland and David Bannister, *Antique Maps*, 3d. ed. (London: Phaidon Press, Ltd., 1989). For more detail, see Lloyd A. Brown, *The Story of Maps* (Boston: Little, Brown and Co., 1949) or John N. Wilford, *The Mapmakers* (New York: Alfred A. Knopf, Inc., 1981). All of these works provide additional bibliography; and Moreland and Bannister include a most useful catalogue of

early map-makers and their principal printed works. For reproductions of early printed maps, see especially Rodney W. Shirley, *The Mapping of the World: Early Printed Maps, 1472-1700* (London: Holland Press, 1983) or, for a volume more manageable in size, A. L. Humphreys, *Antique Maps and Charts* (New York: Dorset Press, 1989), originally published in 1926 under the title, *Old Decorative Maps and Charts* (London: Halton and Truscott Smith, Ltd., and New York: Minton, Balch & Co.). For the influence of what she calls the "mapping impulse" on seventeenth-century Dutch art, see Alpers, 119-168.

11. For the publication histories of the two atlases, see Brown, 162-166, or Moreland and Bannister, 97-100.

12. Alpers, 159.

13. For Vermeer's *Art of Painting*, see Alpers, Plate 2 (between pp. 84 and 85) or Braider, Plate 5 (between pp. 50 and 51). For Ochtervelt's *The Musicians*, see figure 63 in Alpers, 121; and for Vermeer's *Officer and Laughing Girl*, figure 60 in Braider, 175.

14. See Brown, 150-179.

15. On the map in Vermeer's painting, see Alpers, 119-122, and James Welu, "The Map in Vermeer's *Art of Painting*," *Imago Mundi* 30 (1978): 9-30. A single copy of the map survives today.

16. *De origine actibusque Getarum* 3.16. There is an English translation in C. C. Mierow, *The Gothic History of Jordanes*, 2d. ed. (Princeton: Princeton University Press, 1915; Cambridge: Speculum Historiale, 1966). For examples of *descriptio* as a title for early printed maps, see Humphreys, 66-67, 70, 85, 87, 93-95, 129, 141, 150.

17. Cited in Alpers, 133. As Alpers, 133-134, indicates, the *Geographia* goes on to make the pictorial reference even more explicit. It distinguishes between geography and chorography and defines the difference in pictorial terms: the former, concerned with the world as a whole, is like making a picture of a person's full head; the latter, concerned with particular places, is like picturing specific facial features such as the eye or the ear. See also Brown, 154.

18. For a list of printed editions of Ptolemy's *Geographia*, see Moreland and Bannister, 301-302.

19. See Humphreys, 21.

20. On medieval world maps, see David Woodward, "Medieval *Mappaemundi*," in *The History of Cartography*, vol. 1: *Cartography in Prehistoric, Ancient and Medieval Europe and the Mediterranean*, ed. J. B. Harley and David Woodward (Chicago: University of Chicago Press, 1987).

21. See the aptly titled chapter, "Learning to Look," in Daniel J. Boorstin, *The Discoverers* (New York: Random House, 1983), 420-429. More detailed, and extensively illustrated, is Ray Desmond, *The Wonders of Creation: Natural History Drawings in the British Library* (London: The British Library, 1986). See also Alpers, 72-118, where, although she does not deal specifically with the art of the naturalists, she does trace the importance of careful observation and accurate recording in the painter's craft.

22. Alpers, 72.

23. Alpers, 73, citing *Micrographia* (London, 1665), unnumbered p. 4 of the Preface. Hooke, like Bacon, was acutely aware of the inadequacy of the observational powers of the senses (thus his use of the microscope); but again like Bacon, his aim was not to discount but rather to achieve more exact visual observation. A facsimile reproduction of the *Micrographia* was published by Dover Publications, Inc., New York, in 1961.

24. See Desmond, 27-32 and Plates 7-10.

25. See Desmond, 45, 47 and figures 20 and 21.

26. Cited in Desmond, 47.

27. For De Gheyn, see Alpers, 7 and figure 3; for the flower painters, Desmond, 64.

28. Samuel van Hoogstraten, *Inleyding tot de Hooge Schoole der Schilderkonst: Anders de Zichtbaere Werelt* (Rotterdam, 1678), 140, cited by Alpers, 77, in her own translation.

29. Cited by Desmond, 64.

30. A more or less standard work on the history of landscape painting is Kenneth Clark, *Landscape into Art*, 2d. ed. (London: John Murray, 1976); and I have found especially helpful for the purposes of this study the chapter to which Clark gave the title, "The Landscape of Fact" (pp. 33-71). Chiefly, however, my discussion follows—and unavoidably abbreviates and simplifies— Braider's much denser work, especially pp. 37-99, which is also concerned with precisely the question of how the world came to be represented naturalistically in the art of the period from 1400-1700.

31. For reproductions of icons, see, e.g., Kurt Weitzmann, *The Icon: Holy Images—Sixth to Fourteenth Century* (New York: George Baziller, 1978). See also Braider's remarks on pp. 90-92. His comment on Pieter Bruegel's *Adoration of the Magi* is especially apt. Once naturalism is introduced, he notes (p. 92), "the religious theme no longer wholly dictates the terms of its representation: our attention is drawn to a whole universe of collateral presences in themselves largely irrelevant to the sacred theme, yet available as an expression of the structure and reference of realist space." As we shall see, the setting provided for a picture begins, once it is rendered naturalistically, to determine what the picture can contain.

32. See Braider, Plate 2 (between pages 50 and 51), and the whole discussion on pp. 37-70, especially pp. 67-70.

33. See Braider, Plate 3 (between pp. 50 and 51), and the whole discussion on pp. 71-99.

34. Braider, 88.

35. Braider, 88.

36. Braider, 90.

37. Bacon, 29.

38. Bacon, 23.

39. See Basil Willey, *The Seventeenth-Century Background* (London: Chatto and Windus, 1934), 55-57, 175-184, which provides the relevant citations.

40. See, in general, Richard S. Westfall, *Science and Religion in Seventeenth-Century England* (New Haven: Yale University Press, 1958), especially pp. 26-48. On Boyle, see, e.g., Margaret J. Osler, "The Intellectual Sources of Robert Boyle's Philosophy of Nature: Gassendi's Voluntarism and Boyle's Physico-Theological Project," in *Philosophy, Science, and Religion in England, 1640-1700*, ed. Richard Kroll, Richard Ashcraft, and Perez Zagorin (Cambridge: Cambridge University Press, 1992); and on Newton, Frank E. Manuel, *The Religion of Isaac Newton* (Oxford: Clarendon Press, 1974).

41. For studies of aspects of this struggle, see, in addition to Westfall, Peter Byrne, *Natural Religion and the Nature of Religion: The Legacy of Deism* (London: Routledge, 1989); and Peter Harrison, *'Religion' and the Religions in the English Enlightenment* (Cambridge: Cambridge University Press, 1990). Also helpful is John Redwood, *Reason, Ridicule and Religion: The Age of*

Enlightenment in England, 1660-1750 (Cambridge, MA: Harvard University Press, 1976).

42. Jaroslav Pelikan is one of the very few historians of the Christian doctrinal tradition to take this debate significantly into account; see *The Christian Tradition: A History of the Development of Doctrine*, vol. 4: *Reformation of Church and Dogma (1300-1700)* (Chicago: University of Chicago Press, 1984), 322-331. I have attempted to set out one aspect of the debate in "A Changing of the Christian God: The Doctrine of the Trinity in the Seventeenth Century," *Interpretation* 45 (1991): 133-146.

43. *Sir Thomas Browne's Religio Medici, Letter to a Friend, and Christian Morals*, ed. W. A. Greenhill (London: Macmillan, 1881; Peru, IL: Sherwood Sugden & Co., 1990), 17-18; cited hereafter as Browne. Browne could afford to tangle belief in impossibilities and irrationalities, however, because he also had another, less perplexing, and perhaps more appealing, arena of access to the divine. "There are two books," he wrote, "from whence I collect my Divinity; besides that written one of God, another of His servant nature, the universal and publick Manuscript, that lies expans'd unto the Eyes of all" (27). The trope of the two books, the book of nature and the book of scripture, had, of course, a long history before it came to Browne (see, e.g., Elizabeth L. Eisenstein, *The Printing Revolution in Early Modern Europe* [Cambridge: Cambridge University Press, 1983], 187-254). But now it was being subtly reworked so that the two were set in contrast, the book of nature clear, public, and immediately available to all, while the book of scripture became increasingly obscure. Scripture might convey the great mysteries of God—the trinity, the incarnation, the resurrection, the whole divine economy of salvation as it had been traditionally construed—but it did so in a way that seemed more and more to cut against the grain of human rationality as it functioned in its ordinary intercourse with the world of things. We are on the threshold here of the development chronicled by Hans Frei in *The Eclipse of Biblical Narrative* (New Haven: Yale University Press, 1974), 17-50, in which scripture comes to be interpreted according to an externally delineated world rather than the world construed in conformity with a scripture that encompasses and interprets it.

44. Browne, 20.

45. *Essay* IV. xviii. 8 (694). I cite the *Essay* by book, chapter, and section number and give, in parentheses, the page number(s) from *An Essay Concerning Human Understanding*, ed. Peter H. Nidditch (Oxford: Clarendon Press, 1975), which is the standard edition.
46. *Essay* IV. xviii. 11 (696).
47. *Essay* IV. xviii. 9 (695). Actually, in speaking of things above reason (which are, for him, "the proper matter of faith"), Locke seems to have two points in mind: (1) things above reason are things "beyond the Discovery of our natural Faculties" such as "that part of the Angels rebelled against GOD, and thereby lost their first happy state" or "that the dead shall rise, and live again" (IV. xviii. 7 [694]); and, as we have seen, (2) things "of whose Truth our Mind, by its natural Faculties and Notions, cannot judge" (IV. xviii. 9 [695]). Combining the two points, we could say that things above reason are (1) items of information which we are incapable of discovering on our own, stated (2) in propositions whose truth or falsity we cannot determine on our own. In neither respect, however, are they things which to some degree or other exceed human comprehension; and so they evoke from Locke no echo of Browne's *O altitudo!*
48. *Christianity Not Mysterious* (London, 1696; facsmile reprint, New York: Garland Publishing Inc., 1978), 67. On Toland, see especially Robert E. Sullivan, *John Toland and the Deist Controversy: A Study in Adaptations* (Cambridge, MA: Harvard University Press, 1982).
49. Toland, 80; and, in general, see the entire discussion in the third section of *Christianity Not Mysterious*, 67-176.
50. Browne, 17-18.
51. *The Mysteries of the Christian Faith Asserted and Vindicated: In a Sermon Preached at S. Laurence-Jewry in London, April the 7th. 1691*, 2d ed. (London, 1691), 14. Stillingfleet's aim, obviously enough, was to suggest a notion of mystery sufficiently commonplace to make its application in the realm of theology unexceptionable. As it turned out, however, in doing so he unwittingly drained the notion of any specifically theological weight or import beyond its ordinary usage.
52. Stillingfleet, 17.

53. See Toland, 81: "They trifle then exceedingly, and discover a mighty Scarcity of better Arguments, who defend their *Mysteries* by this pitiful shift of drawing inferences from what is unknown to what is known, or of insisting upon adequate ideas; except they will agree, as some do, to call every Spire of Grass, Sitting and Standing, Fish or Flesh, profound *Mysteries*. And if out of a pertinacious or worse Humour they will be still fooling, and call these things *Mysteries*, I'm willing to admit as many as they please in *Religion*, if they will allow me likewise to make mine as intelligible to others as these are to me."

54. Toland, 80.

55. Stillingfleet, 31-32.

56. Stillingfleet, 32. On this view, Stillingfleet insists, we do not see the "great Love" of God to us expressed in Jn. 3:16 and 1 Jn. 4:9-10; rather, "Herein was the Love of God manifested to his Son, that for his Sufferings he exalted him above all creatures" (32-33).

57. Stillingfleet, 33-34. In referring to a man made "a *God by office,*" Stillingfleet was not striking at an imaginary enemy. Intimations of such a view were circulating in (and perhaps beyond) the Socinian strand in English Christianity; see, e.g., *The Racovian Catechism*, trans. Thomas Rees (London, 1818; Lexington, KY: American Theological Library Association, 1962), 55, 131, 135-136, 162, 164-165, 360, 368. The *Catechism*, originally published in Polish (1605), had entered England in Latin translation by 1614 and in English translation by 1652. In each case, it was publicly burned by order of Parliament, but continued to circulate in subterranean fashion; and, of course, numerous editions were available on the continent.

58. A final note: I intend this essay, whatever its faults and flaws, as an expression of gratitude to Jaroslav Pelikan who has taught me, among many other things, to pay attention to things that I would not otherwise have paid attention to.

Leander van Ess (1772–1847):
Enlightened German Catholic Ecumenist

Milton McC. Gatch

Leander van Ess, if he is known at all today, is known as a translator of the Bible or as a collector of books and manuscripts. A certain number of bibliophiles will know, especially, of manuscripts he sold to Sir Thomas Phillipps. Some biblical scholars will remember that he was the originator of the edition of the Septuagint continued by Eberhard Nestle in this century or the author of a German translation of the Scriptures. Jaroslav Pelikan (and perhaps other children of ministerial households in Germany and German-rooted communities in America) recalls that both the Septuagint and the biblical translation were in his father's library.

The purpose of this paper is to suggest that Leander van Ess was, as well, an interesting and symptomatic figure in the institutional and intellectual life of the Catholic Church in Germany in the Napoleonic era and the period of the rise of Prussia, even though he was hardly a figure of the first rank. Professor Pelikan has on several occasions used books in the Burke Library of Union Theological Seminary that were purchased from Ess. This offering to honor him is a byproduct of studies of Ess's collections of manuscripts and books, seeking to define the larger context of the German pastor-scholar's activities.

Because so little information about Leander van Ess has been published in English, this study must begin with a brief overview of his life.[1] Baptized Johann Heinrich van Ess at his birth in Warburg in the diocese of Paderborn in 1772 and educated by the Dominicans in that city, Ess became a Benedictine at Marienmünster under the name of Leander in 1791, at the age of eighteen. Before the dissolution of Marienmünster (as of many Westphalian men's monasteries) in 1803, Ess was already serving as pastor to the Catholic community in Schwalenberg, a nearby village under the pastoral care of his community; secularized and pensioned in 1803, he continued to minister at Schwalenberg until 1812.[2] In 1807, he had published a translation of the New Testament, with contributions by his cousin Carl, who had been a Benedictine of Huysburg.[3]

In 1812, Ess was called to Marburg as pastor of the Catholic community at the Elisabethkirche and as Professor *für kath. Kirchenrecht und Theologie* in the University of Marburg. He was awarded a doctorate in these fields by the theological faculty of Freiburg in Breisgau in 1818. We shall return anon to the Marburg period, full of stress and controversy, which also saw the addition of the New Testament translation to the *Index librorum prohibitorum* at the end of 1821.[4] When Ess resigned his posts in Marburg in 1822, he relocated at Darmstadt. There his household was managed by Elisabeth Hoffmann van Ess von Elliott, who was introduced as his sister and who assisted with his foreign correspondence. With support until near the end of the decade from the British and Foreign Bible Society, he worked actively on the distribution of his New Testament (with which his cousin Carl had ceased to be identified after 1816). With the silent collaboration of Heinrich Joseph Wetzer, who lived with Ess as a student in Marburg,[5] he undertook a translation of the Old Testament, publishing Genesis through Esther in 1822, the Psalter in 1827, and the remainder of the Old Testament in 1836. A complete Bible appeared in 1840.[6] Along the way, he had also published an edition of the Vulgate, a Greek New Testament with the Vulgate in parallel and a Septuagint.[7] In Darmstadt in 1824 he sold to the voracious English collector, Sir Thomas Phillipps (then only at the beginning of his career), a collection of approximately 370 manuscripts, which he had described in a catalogue of the previous year, and over nine hundred incunabula.[8] Many of these volumes had recently been acquired, perhaps for resale;[9]

he seems to have been involved in other ventures in the book trade as well.

In 1835, the Ess household relocated to a farming property near Alzey, across the Rhine, which was to be worked by Frau von Elliott's son, Leo, and Leander Heidenreich, the son of Leander's sister, Anna Maria, who (with his brother Andreas) had lived in the Ess household at Darmstadt and had his education there.[10] Although his scholarly work was largely ended with the publication of the Old Testament in the Alzey years, Ess's household continued to entertain visitors seeking out the scholar and translator. His guest book shows that he was regularly visited by admiring Americans and Britons (usually of an evangelical bent), and a copy-book of letters records correspondence with German church-people as well as continued intercourse with persons active in the British and Foreign Bible Societies.[11] Ess's library was so large that separate quarters were hired in Alzey to house it, and evidently efforts were made for several years to find a buyer for the collection. In 1838, Ess sold his working library, a collection of some 4209 titles in theology, history and canon law, along with over 430 incunabula and 37 manuscripts which may have been acquired in the interim since the sale of 1824. The purchaser, the New-York Theological Seminary (now Union Theological Seminary), counted the haul at 13,500 volumes. In 1844, another move was made across the Rhine, to Affolterbach in the Odenwald, where Ess died in the household of Leander Heidenreich and was buried in 1847.

Leander van Ess was a scholar of comparatively little formal education, and certainly no training in the university mold; and he was a man of modest means, albeit his family was *klein-bürgerlich*. Given his background, his intellectual convictions seem remarkable and set him in a small company of German Catholics whose ideas were shaped by the Enlightenment.[12] In the present paper, three aspects of Ess's career will be reviewed briefly: his attitude concerning monastic culture at the beginning of the nineteenth century; his advocacy of biblical translation; and his view of the role of the pastor, especially in connection with the vexed issue of mixed marriage. Johannes Altenberend has much new evidence to put forth concerning Ess's life and work; the conclusions of this paper must be regarded as provisional until his findings are published. Although Altenberend has not yet published his evidence for the ways in which Leander van Ess discovered and appropriated the thought of the Enlightenment, the

validity of his central thesis becomes clear when one reads Ess's writing and considers his work: that—although he is hardly a philosophical champion of the primacy of reason—he had been profoundly influenced by such social ideals of the Enlightenment as tolerance, justice and the furtherance of humanity's moral well being.[13]

The Obsolescence of Monasticism

In 1802, having already for several years been involved with the pastorate of Schwalenberg and clearly disappointed with the quality of both learning and practical pursuits at his monastery,[14] Leander van Ess wrote a memorandum on the condition of Marienmünster with recommendations for its reform to the commission considering the future of the monastic foundations in the diocese of Paderborn.[15] It is a remarkable document, headed "Kürzerer Entwurf, der Benediktiner-Abtey Marienmünster im königlichen preußischen Erbfürstenthum Paderborn eine bessere Bestimmung zu geben."

Ess opens by observing that Marienmünster is surrounded by communities and a population in great need of education and pastoral care. The resources of the monastery could, to the great profit of the kingdom, be reorganized as an abbatial seminary[16] to serve as an educational establishment for priests, schoolteachers, pastoral formation and youth (§ I). The monastic rule, having become an anachronism, is to be abolished, but celibacy, community life and submission to seniors are to be maintained as useful and economical disciplines (§ II). The monastic offices are to be abolished, as are other peculiarities of monastic life. The disciplines of reading the breviary "zu trocken und zu nakend sind, und zu wenig Salz und Würze haben." Persons involved in so high a calling need to develop a more personal and heartfelt spiritual life. The duty should be to read daily from the New Testament with the aim to read the whole once in a year (§ IIIa-b). The incumbent abbot, Benedikt Braun, had been in his post since 1785.[17] Being 73 years old "und gar nicht empfänglich für diesen Plan," he should be pensioned and retired, and the office of prior (since it oversees the choir activities) should be abolished and the incumbent sent away (§ IIIc). The Royal Commission should establish a new governance for the

Marienmünster *Seminarium* with authority to carry forward the plan, under five headings:

> a) to recruit new persons to the community and establish a new and better arrangement for studies;
> b) to arrange the the training and governance of the seminarians;
> c) to organize instruction in religion and work (*Industrie*) as well as a Sunday-school;
> d) to create a position of schoolmaster and, in place of secular teachers, place as many as possible of the seminarians and priests, taking responsibility for the oversight of all of the teaching posts annexed to the Seminary; and
> e) to oversee all priors, pastors, chaplains (both local and other clergy) who are connected with the Seminary (§ V, amplified in §§ VI–10).[18]

Ess's remarks concerning the academic organization of the Seminary (§ VI) are especially important. He continues to be highly critical of the recent history of Marienmünster with reference to its intellectual and pedagogical undertakings, as well as of the anachronistic regulations of the monastic order and the shortcomings of the superiors of the community. Ess ordains for the Seminary a general curriculum comparable with that of a diocesan seminary: the course of study for professed members of the community (the highest group whose education is to be undertaken) is to include philosophy (especially metaphysics), natural law (*Naturrecht*), philosophical ethics, mathematics and physics as basic; further there is to be instruction in natural history (*Naturgeschichte*), theology, Bible, exegesis, dogmatics, Christian ethics, ecclesiastical history and law, popular and practical theology, homiletics, catechetics, pastoral theology and philology. A library is necessary to the fulfillment of this mission; but, the abbots in the last thirty years having bought hardly a hundred books (even these being in chaotically bad condition), there is an entire lack of recent writings. Thus it will be necessary to reorder the library and to make extensive acquisitions in current literature. To this end, the new superior, the *Regens,* must have the power to make extensive purchases from the seminary's income.[19] Young monks, who have had to buy their

own books in recent times "und sehr viele angeschaft haben" (Ess probably thinks of himself), are to hand over their holdings of appropriate books inalienably ("unveräußerlich") to the Seminary's library. An annual budget is to be established for the library, and the archive of the community, now in absolute disarray ("gänzlicher Unordnung") is to be put in good order.

The entire thrust of the document is to replace the monastic choir-centered community with an educational enterprise to be supported on the monastic foundation while continuing and enhancing the pastoral mission that had been traditional at Marienmünster. The common table is maintained without silence; the habit is to be a long black cassock with cincture and white or black neckband (§ XI). After the educational and bibliographical reforms suggested in the memorandum, however, the most interesting and symptomatic aspect of its provisions is its lack of appeal to ecclesiastical authority. The Royal Commission should have full authority over the organization of the Seminary (§ 14); "Das Seminarium bleibt mit allen seinen Pertinentzen, Güttern und Rechten unter dem allerhöchsten Schutze Sr. königlichen Majestät von Preußen" (§ 16).

Ess, in other words, pins his hopes of reforms on the state rather than on the monastic order or the ecclesiastical hierarchy. It was, of course, one of the hopes of the religious adherents of the Enlightenment that a benevolent, rational and tolerant state would make better use of the resources of the ecclesiastical establishment; and the orders were among their chief targets for reform.[20] It seems very clear that Ess's effort to find a better vocation (*Bestimmung*) for Marienmünster was profoundly influenced by the German Catholic *Aufklärung*. The question to be answered is where Ess at the age of thirty in 1802, having been since his eighteenth year in 1790 under the tutelage of the ignorant and incompetent abbot of Marienmünster, came by his ideas. One suspects that at least some of his own books were influential in his formation.[21]

The Rationale for the Biblical Translations

Ess's biblical translations were beset with controversy, an adequate introduction to which can (for present purposes) be had from a

partial sketch of their publishing history. The first edition of the New Testament, with approbation not only from a prominent Protestant pastor, F.V. Reinhard,[22] but also from the diocesan vicar of Hildesheim, was privately printed in 1807 at Braunschweig, a city divided at its river between the dioceses of Halberstadt (where Carl van Ess was "Bischöhflischem Commissarius"[23]) and of Hildesheim. The third edition of 1816 was published in Sulzbach in the Palatinate, then in the kingdom of Bavaria and bore approbations by the king (dated 1810), the archbishop of Vienna (1816), the episcopal vicars of Breslau in Poland (1815), Hildesheim (1807 and 1816) and Ellwangen near Augsburg (1816).[24] In other words, approbation for the undertaking (never received from Carl's or Leander's dioceses of Halberstadt and Paderborn) was being obtained from farther afield. This was the last issue to bear the name of Carl van Ess, who must have needed professionally to distance himself from the undertaking;[25] and the new approbations of 1817 and 1818 were from the theological faculties of Freiburg i.B. and Würzburg and the vicars for Fulda, Constance and Aschaffenburg—all distant from the Paderborn and Hildesheim/Halberstadt regions.

Already in 1816, there was a note to guide Protestant readers in negotiating differences between their Bibles and the Vulgate structure of this edition; and in 1819 there first appeared a note defending the occasional adoption of Greek readings.[26] The title page of the first part of the Old Testament noted that the translation was "mit Abweichungen der lateinischen Vulgata,"[27] but the second part printed translations from the Vulgate under the translation of the Hebrew,[28] and Greek readings became the only apparatus for the New Testament text in editions of the complete Bible. The full history of the controversies that swirled about Ess's biblical translation remains to be written. But it should be clear from these spare details that Ess himself was intent on serving the needs of both Protestants and Catholics. He lost the patronage of the British and Foreign Bible Society in part because of his refusal to omit the apocrypha, which were required for his Catholic constituency;[29] his insistence on bringing a translation of the Hebrew and Greek texts rather than only the Vulgate to his audience (in combination with his political liabilities) gave cause to his enemies among Westphalian and Prussian Catholics to condemn his work.

In support of the translations, there appeared a number of tracts intended to justify the reading of the Bible in the vernacular, especially

by the laity. The first, *Auszüge aus den heiligen Vätern und anderen Lehrern der katholischen Kirche über das nothwendige und nützliche Bibellesen, zur Aufmunterung der Katholiken,* appeared the year after the first New Testament.[30] Subsequent publications grew more polemical as controversy arose over the translation, leading to its being added to the *Index librorum prohibitorum* in 1821.[31]

At the outset, Ess had sought influential endorsement of his work. In 1804, he requested support for the translation project from Johann Michael Sailer, one of the most influential and irenic, but progressive, teachers and leaders of pastors of the time, who was to die in 1832 as bishop of Regensburg. Sailer was supportive of Ess's ambition to translate the Bible, but he also supported the tradition that, although most of the New Testament can without fear of misunderstanding or misuse be put in the hands of the laity, the Apocalypse and the Old Testament require intermediary interpretation.[32] In 1814, Sailer was to comment of Ess's New Testament that it was "zu modern. . . . Man liest den Uebersetzer." On the whole, Sailer felt Luther's German—based on Erasmus's Greek— should stand, so far as possible.[33] His reservations foreshadow the ecclesiastical pressures on Ess to conform more closely to the Vulgate than to the *Grundtext.*

Whether or not the translation had begun to excite controversy in the year of its publication, the *Auszüge* of 1808 is irenic in tone and addressed to the laity. Hearing scripture read in church does not suffice, one needs to read it oneself; and the Christian writers—the Fathers—are inaccessible and expensive. Hence "kennen sie nicht, was die Geschichte der Vor-und Mitzeit von dem nothwendigen und nüzlichen Lesen der Bibel sagt" (p. ii). Beginning with quotations from the New Testament itself, Ess collects passages dealing with the centrality of scripture. More of the "Fathers" cited here are medieval or modern than ancient. Among the interesting passages (in part because it shows Ess's bibliographical knowledge at an early stage of his career) are a long quotation from Otto of Passau, which is quoted with parallel columns from the Dutch translation, *de Gulden Throon* (Utrecht, 1480), and a German translation (pp. 95–101). This is but one of several instances where both dialect and High German are quoted in parallel. Many of the authorities are quite modern: Sailer is twice quoted, once from a book published in 1808 that had just come from the press (pp. 152- 4, 213- 4).[34] Although the method of the *Auszüge* is simply the presentation of

proof-texts—a method of argumentation Ess would prefer to exposition throughout his life—he is, of course, presenting authorities of the Christian tradition against the authority (or, better, the traditions) of the church; and his argument is directed primarily to Catholic laity (who have been deprived of an aspect of spirituality open to Protestants) based upon pastoral concerns for their well-being.

A second edition of the *Auszüge,* with little change—but dedicated to the British and Foreign Bible Society—appeared in 1816 from the press of J.E. Seidel[35] where the publication of the New Testament had moved with its second edition in 1810, and coincided with the publication of the third edition. Yet another variant, without attribution to Ess on the title page, appeared (without indication of the place of publication) in 1816: *Die heilige Schrift das Buch für alle Menschen, oder unwidersprechlicher Beweis aus dem einstimmigen Zeugniße der Kirchenväter aller christlichen Jahrhundert, daß das Bibellesen für alle Katholiken ohne Unterscheid des Standes, Alters und Geschlechtes die heiligste Pflicht, und eben so nützlich als unentbehrlich sey.*[36] These are but two of several items published in 1816, perhaps as part of a concerted effort to market the third edition of the New Testament, although it was more often distributed free through the agency of the Bible Society.[37] These publications included *Gedanken über Bibel und Bibellesen und die laute Stimme der Kirche in ihren . . . Lehren über die Pflicht und den Nutzen des allgemeinen Bibellesens* and *Was war die Bibel den ersten Christen? . . . ,* prefaces to the 1816 edition also published separately.[38] *Pragmatica doctorum catholicorum Tridentini circa vulgatam Decreti sensum . . . ,* a tract on the role given the Vulgate by the Council of Trent, was published in both Latin and German.[39] An anonymous tract of 1818, published elsewhere, is also to be associated with him: *Die Bibel nicht, wie Viele wollen, ein Buch für Fürst und Volk. Ein Wort zur rechten Zeit, wo mehr als je des heilgsten Buches die Thronen zur stärksten Stütze, und Fürst, Priester und Volk für Glauben, Liebe und Sitten bedürfen. Von einem nicht römisch-sondern christkatholischen Priester herausgegeben.*[40] The self-characterization as "christkatholischen Priester" probably reflects the growing controversy. A final work in this line was published in Darmstadt in 1824: *Die heilige Chrysostomus, oder die Stimme der katholischen Kirche, über das nützliche, heilsame und erbauliche Bibellesen,* based on the Maurist edition of Chrysostom by Montfaucon, which had been unknown to Ess when he first collected

sayings from ecclesiastical authorities in support of Bible-reading by the laity.[41]

A last and somewhat different publication related to the promotion of the New Testament translation is a challenge to the clergy to join the cause: *Ihr Priester, gebet und erkläret dem Volke die Bibel! Das will und gebietet die katholische Kirche. Nebst beigefügtem Generalrechnung-Schlusse seines Bibelverbreitungs-Fonds* (1824).[42] This pamphlet is an accounting and justification of his work with citations of texts in support of Bible-reading from Fathers and Councils and a section on the importance of preaching.

All of this activity—let alone the translation of the scriptures by a man self-tutored in biblical languages—was undertaken in the conviction that the Protestants were correct about the importance of scripture to the laity. Ess's was a reforming and pastoral calling, and its most remarkable feature was his insistence throughout his career on addressing all Christians. To this can be attributed a number of the peculiarities of his editions. His numerous tracts on Bible-reading belong both to the effort to convince Catholics of their great need and to winnow financial support for the cause.

Controversial pastoral issues

Ess moved from Schwalenberg to Marburg, it will be recalled, in 1812 to become pastor of the Roman Catholic community in Marburg and the Catholic theologian at the University. The history of these posts in Ess's tenure was written by Carl Mirbt in separate essays for each, which detail the outlines of his career there without evincing much interest in Ess's personality and convictions.[43] Here the ground covered by Mirbt can be recapitulated only briefly. In the reign of Napoleon's brother, Jérôme Bonaparte, as king of Westphalia (1807–1813), it was decided (after removing the great shrine of St. Elisabeth to the royal chapel in Cassel) to create a *Simultanäum* at the Elisabethkirche, whereby the Lutheran community would have use of the nave of the church and the Catholics the choir, both sharing the organ. Ess was called to the joint post of pastor and professor, and he maintained the positions after the fall of the Napoleonic kingdom and

the restoration of the electorate of Hesse at the end of 1813; but it can be imagined that the progressive priest with support from the rationalist French would not have received enthusiastic support from conservative Catholics, who strongly embraced ultramontanism in the wake of the Napoleonic defeat. Ess evidently had a large and bipartisan following for his preaching.[44] Yet in May of 1813 he sued for a more generous arrangement for the Catholics in the Elisabethkirche: for access by means of the west portal rather than an eastern doorway, removal of the choir screen, replacement of the Lutheran altar before the screen in the crossing with a table on casters that could be removed during Catholic services at the high altar, and use of the church the whole morning on Sundays. The issue was still pending after the restoration of the Kurhesse, and the Lutherans were (predictably) disinterested in furthering Ess's case. The *Simultanäum* was allowed to persist provisionally for the rest of the decade, but it was clear from about 1816 that the state was set upon the removal of the Catholics to the Kugelkirche, St. Johannes. Ess left Marburg in 1822, and the ouster of the Catholics from the Elisabethkirche was finally accomplished under his successor, Johannes Christian Multer, at the beginning of 1828. The whole affair cast Ess in a paradoxical role. Evidently an effective pastor to the Catholic flock and respected as a preacher by the Protestants, he seems to have been bent upon proposals for the arrangement of the great medieval pilgrimage church that would seem exclusivist and anti-ecumenical; and a protagonist of reform of the church by the state, he was put in office by a regime of dubious legitimacy and found himself defenseless against the restored Hessian electorate. All the while, his New Testament and his activities distributing Bibles were coming increasingly under attack.

Near the end of his sojourn in Marburg, Ess entered another fray, on an issue that would become a notorious battleground in the struggle between the Romanists and the Germanists in the 1830s. Prussia, which assumed control of Westphalia and the Kurhesse in the settlements of 1815, had applied to these areas its own tolerant legislation on mixed marriage (between Protestants and Catholics). Ess as a reformer was quite content with this situation, to which Rome and many members of the German hierarchy took strong exception.[45] In 1821, Ess signed the introduction to an anonymous volume, *Rechtfertigung der gemichten Ehen zwischen Katholiken und Protestanten, in statistich-, kirchlich-und moralischer Hinsicht, von*

einem katholischen Geistlichen.[46] In the short preface, he says formulaically that the author had asked his advice about the publication of the book and that, despite its stylistic shortcomings, he happily supported its appearance because of the information it offered on a subject that was controversial at a time when sectarian zeal was being rekindled. Those who are Catholics in the original sense will welcome the book; sectarians will not. The main point of the book is that Protestants and Catholics alike are Christians, and the former are not to be equated in the marriage laws of the church with the non-Christians (*Ketzer*) of ancient prohibitions against mixed marriage.[47]

Ess may well have been the single author of the booklet; he was, whatever the case, the only person publically associated with theses that quickly caused the booklet to be indexed.[48] When Multer, at this time Ess's assistant at Marburg, asserted his authorship of the pamphlet and claimed the royalties from the press, there ensued a legal conflict in which Ess asserted he had done the principal work. He lost, the court accepting Multer's oath that he was the author.[49]

Ess seems to have been author of a subsequent volume on mixed marriage, published anonymously in 1827.[50] This pamphlet begins with quotations of Prussian legal decrees of 1819 stating that Catholics are subject to civil law on marriage and that recent intolerance of mixed marriage where there is no assent to rear progeny as Roman Catholics will no longer be brooked ("die Unverträglichkeit, deren die Katholische Geistlichkeit in neuren Zeiten beschuldigt worden"). The encyclical response of the episcopal vicar in Paderborn, Richard Dammers,[51] dated 1825, is subjoined and attacked in the body of the booklet. In Ess's response we see the teacher of canon law—a major aspect of his pedagogical career that has not been explored here.[52] Against Dammer's insistence that *allgemeines Kirchegesetz* requires the rearing of the children of mixed marriages as Catholics, Ess marshalls massive textual evidence, largely from eighteenth-century canonical materials but also from recent scholarship. Both Protestant and Catholic states, he concludes, have the obligation to adopt regulations against the kinds of ecclesiastical intolerance that have shaken family happiness and (in consequence) the state.[53]

Once again, Ess turns to the state as the potential source of support for ecclesiastical reform and the pastoral well-being of the people. His stance was hardly politic and doomed to failure, if only because he had received his position at the hands of the Napoleonic

regime. Yet most markedly in his pastoral career and writings, Ess showed a largeness of spirit and ecumenicity of vision that reached out to Protestant Christians at the same time as he demanded equal dignity for the Catholic community in Marburg.

Leander van Ess was a minor figure in many ways, and it would be possible to count him a failure as success in an ecclesiastical and academic career might be measured. But it is quite evident that behind his notoriety and his apparent iconoclasm, there are qualities of deep conviction, of considerable learning, of pastoral concern and of a profoundly ecumenical bent. These qualities would have been admirable in a nineteenth-century German churchman of better education and higher social standing; they are remarkable in an ex-monk of provincial background and limited education. They befit the translator of scripture into German whose work has, after Luther's, had the largest circulation.[54]

NOTES

1. The best biographical notice to date is by Wilhelm Fischer:
 "Leander van Eß: Ein Leben im Dienst der Bibel," *Jahrbuch der
 hessischen kirchengeschichtlichen Vereinigung* 4 (1953):74-100.
 Fischer's notes were destroyed in World War II, and the paper is
 inadequately documented; he had access, however, to the archives
 and oral traditions of the descendants of Ess's nephew, Leander
 Heidenreich, which gave him far more information than other
 authors of biographical sketches. A new biography is being
 prepared by Johannes Altenberend who has to date published only
 an article on Ess's youth in Warburg: "Carl und Leander van Ess:
 Zur sozialen Herkunft aufgeklärter Benediktinermönche aus
 Westfalen," *Jahresbericht des Historischen Vereins für die
 Grafschaft Ravensberg*, Jahrgang 1992-1993 (Bielefeld, 1992): 62-
 83. I rely heavily on Fischer for my outline of the biography,
 supplemented by materials provided by the learned and hospitable
 keeper of the family archive at Affolterbach (near Wald-
 Michelbach in the Odenwald), Frau Dr. Magda Heidenreich. My
 greatest indebtedness in forming a view of Ess's intellectual and
 ecclesiastical position is to Altenberend, whose generosity to a
 newcomer in a field of research he had thought to be his own is
 gratefully acknowledged. Many of the numerous bibliographical
 and biographical notes on Leander and his cousin Carl from the
 nineteenth century have been collected on microform in *Deutsches
 biographisches Archiv* (Munich and New York 1982-), fiche 294,
 pp. 393-442. Among the biographical notices, that of Eberhard
 Nestle (in *Realencyklopädie für protestantische Theologie und
 Kirche*, ed. A. Hauck [1896-1913; rpt. 1969]) is of particular
 authority, especially on the biblical studies and translations. One
 ought also to note the testimony in the biography of Professor
 Heinrich Joseph Wetzer of Freiburg i.B. in *Kirchen-Lexikon oder
 Encyklopädie der katholischen Theologie und ihrer
 Hilfwissenschaften*, ed. Wetzer and Benedikt Welte (Freiburg:
 Herder, 1847-56), although an article devoted to Ess did not appear
 until the 2nd ed., *Wetzer und Welte's Kirchenlexikon*, ed. Joseph
 Cardinal Hergenröther et al. (St. Louis: Herder, 1882-1901);
 Wetzer was reared in Ess's household in Marburg and remained

close to him throughout his life, naming a son Leander Heinrich. A starting point for Ess's bibliography is *Gesamtverzeichnis des deutschsprachigen Schrifttums (GV) 1700-1919*, ed. Hilmar Schmuck et al. (Munich: K.G. Saur, 1981); I have seen all the works cited except *Plan eines christl. Buderbundes z. Verbreitung d. heil. Schriften* (Sulzbach, 1814), but the list does not exhaust all the printings of work by Ess and may be otherwise incomplete. Altenberend is preparing a complete bibliography of publications of both Leander and Carl van Ess.

2. See Wolfgang Knackstedt, "Marienmünster," *Westfälisches Klosterbuch: Lexikon der vor 1815 errichteten Stifte und Klöster von ihrer Gründung bis zur Aufhebung*, ed. Karl Hengst, 2 vols., Veröffentlichungen der Historischen Kommission für Westfalen, 44: Quellen und Forschungen zur Kirchen-und Religionsgeschichte, 2 (Münster: Aschendorff, 1992), 2:568-573, esp. at pp. 570-71. (*Klosterbuch* replaces L. Schmitz-Kallenberg, *Monasticon Westfaliae* [Münster: Coppenrath, 1909]).

3. 1st ed. published "ImVerlage der Übersetzer" (i.e., privately) at Braunschweig by F. Vieweg; 2nd ed., 1910, published by J.E. Seidel of Sulzbach, with whom Ess was to have a long association. The best bibliographical resource on the Ess Bibles (although hardly complete) is T.H. Darlow and H.F. Moule, *Historical Catalogue of the Printed Editions of Holy Scripture in the Library of the British and Foreign Bible Society, 2 vols.* (London: Bible House, 1903-1911) (cited by catalogue number as BFBS); the 1807 NT is BFBS No. 4273; BFBS does not know the 2nd ed. of 1810 but cites the 1816 3rd ed.: BFBS No. 4294. See also Wilhelm Gundert, *Geschichte der deutschen Bibelgesellschaften im 19. Jahrhundert*, Texte und Arbeiten zur Bibel 3 (Bielefeld: Luther-Verlag, 1987), pp. 82-95, for references to some editions not owned by the BFBS. A complete publishing history of Ess's Bibles has yet to be assembled—a difficult task, even with the aid of *Gesamtverzeichnis 1700-1919*, before the catalogue of nineteenth-century German Bibles appears in *Die Bibelsammlung der Würtembergische Landesbibliothek Stuttgart*. See also Nikolaus Adler, "Leander van Ess und seine Übersetzung des Neuen Testamentes," in *Universitas: Dienst an Wahrheit und Leben* (Festschrift für Bischof Dr. Albert Stohr), ed. Ludwig Lenhart

(Mainz: Matthias-Grünewald-Verlag, 1960), 1:17-27, on the distribution of the New Testament and the controversy it raised.

4. *Index librorum prohibitorum SS. MI. D. N. PP. XII iussu editur* (Vatican: Typis Polyglottis, 1948), p. 479.

5. Gundert, *Geschichte*, p. 91. 6. *Die heiligen Schriften des Alten Testaments . . . I. Theil* (Sulzbach, 1822) BFBS No. 4330; Psalter not BFBS, copy in the Burke Library; 2. *Theil* (Sulzbach, 1836) BFBS No. 4355; *Die heiligen Schriften des Alten und Neuen Testamentes* (Sulzbach, 1840) BFBS 4361 and 4362.

6. *Die heiligen Schriften des Alten Testaments . . . I. Theil* (Sulzbach, 1822) BFBS No. 4330; Psalter not BFBS, copy in the Burke Library; 2. *Theil* (Sulzbach, 1836) BFBS No. 4355; *Die heiligen Schriften des Alten und Neuen Testamentes* (Sulzbach, 1840) BFBS 4361 and 4362.

7. *Biblia sara vulgatae editionis juxta exemplar ex Typographia Apostolica Vaticana* (Tübingen, 18[22-]24) BFBS No. 6280; *Novum Testamentum Graece et Latine* (Tübingen,1827) BFBS 4807, 4808, 4809 (the Greek was Erasmus); _ Πα_a__ Δ_a____ _at_ t___ __ß∂_μ____ta, *seu vetus Testamentum graecum juxta septuaginta interpretis . . . Editio stereotypa* (Leipzig, 1824) BFBS 4801. The latter (called by Darlow and Moule, *Historical Catalogue*, 2:644, a "handy edition of the bare text, prepared for the use of theological students,") continued in print into the twentieth century in its Tauschnitz edition, thanks to stereotyping, a process in which a long-lived metal plate is produced from a mold made from the forme of moveable type.

8. Ess, *Sammlung und Verzeichniss handscriftlicher* [sic] *Bücher . . . welche besitzt Leander van Ess, Theol. Doctor, vorhin Professor und Pfarrer in Marburg* (Darmstadt, 1823) and [Phillipps] *Catalogus Incunabulorum Professoris et Doctoris L. van Ess, Darmstaelt* [sic] *Nunc in Bibliothecâ Phillippicâ deposit* [Middle Hill, n.d.]; both republished in microfiche from exemplars in the Bodleian Library, Oxford: *Catalogues of Manuscripts and Early Printed Books sold by Leander van Ess to Sir Thomas Phillipps, Bart., 1824*, intro. by M.McC. Gatch (New York: Burke Library, Union Theological Seminary, 1993). I am tracing the manuscripts (see "Untraced Ess/Phillipps Manuscripts," *The Book Collector* 42 [1993]:547-52) and incunables and hope, with Dr. Sigrid Krämer of Munich, to publish all of Ess's book catalogues and lists. Ess's

correspondence with Phillipps (protracted and anguished because the latter was so slow to make payment) is at the Bodleian Library, Oxford.

9. Hermann Knaus, "Die Handschriften des Leander van Eß," *Archiv für Geschichte des Buchwesen* 1 (1956):331-335. Although I do not share Knaus's negative view of Ess's integrity, there are certainly signs that he was involved in the book trade: e.g., the sale of books (some recently acquired) to Phillipps, the work on distribution of his New Testament and related publications, and his efforts to market the voluminous sermons of the Protestant Oberhofprediger, F.V. Reinhard. (See the introduction, note at the foot of the title page and note on p. 114 of *Wesenlehren des christlichen Glaubens und Lebens . . . vom seligen Oberhofprediger Reinhard,* ed. Leander van Ess [Sulzbach, 1823]; I owe my knowledge of this publication to Dr. Roland Folter of Pelham, New York, whose copy, inscribed by Ess [apparently] to Phillipps, is probably the only one in America. Reinhard had endorsed the first edition of the NT, BFBS No. 4273.)

10. Magda Heidenreich, *Wesentliches und Unwesentliches aus einer weltoffenen südhessischen Familie* (Darmstadt: Eduard Roether Verlag, 1980), p. 99.

11. Documents in the collection of Dr. Heidenreich, Affolterbach.

12. The term here is something of an anachronism, the *Aufklärung* strictly defined being a phenomenon of the preceding century and the Napoleonic age being also the age of Goethe and romanticism. Yet Ess and others like him were clearly inspired by aspects of the Enlightenment and represent a later, and quite different, manifestation of some of its ideas. *Aufgeklärt,* to traditionalists, was, of course, a term of opprobrium with the connotation "broad-minded" (see, e.g., Bonifaz Wöhrmüller, "Literarische Sturmzeichen vor der Säkularisation," *Studien und Mitteilungen zur Geschichte des Benediktiner-Ordens und seiner Zweige* Ergänzungsband, N.F. 14 [1927]:12-44).

13. "The Enlightenment in Germany shades off into the romantic period because *Aufklärung* was never more than one element in a varied scene. . . . Beyond the Rhine [in contrast with France] the *Aufklärung* was not run by *philosophes,* and by the former pupils of the Jesuits in revolt against their masters, but by men who had studied theology, who read the Bible, by prince-bishops,

pedagogues and reforming pastors, by men with a moral purpose whose zeal was not set upon the extermination of the Church but the purification of Christianity" (Alexander Dru, *The Contribution of German Catholicism*, Twentieth Century Encyclopedia of Catholicism, ed. Henri Daniel-Rops [New York: Hawthorn Books, 1963], 109: 24). See also Georges Goyau, *L'Allemagne religieuse: Le Catholicisme (1800-1848)*, 2 vols. (Paris: Perrin et Cie., 1905) 2:161-67.

14. See Fischer, "Leander van Ess," pp. 75-6; Altenberend, "Carl und Leander," pp. 82-3.

15. Staatsarchiv Münster, Spezialorganisationskommission Paderborn, Nr. 105, fols. 12-17. I owe my knowledge of the document and a copy of his transcription to Johannes Altenberend. See his "Carl und Leander," p. 82 n. 88. The document has been excerpted by Broermann, "Leander van Eß als Reformator," *Heimatborn. Monatszeitschrift für Heimatkunde des ehem. Hochstifts Paderborn under der angrenzenden Gebiete* (1951/52), Nr. 21, pp. 83f.; Nr. 22, pp. 87f. (not seen). On the secularization of Marienmünster, see Wilhelm Richter, *Preussen und die Paderborner Klöster und Stifter, 1802-1806* (Paderborn: Bonifacius-Druckerei, 1905), pp. 103-18; Knackstedt, "Marienmünster."

16. Ess uses the Latin *seminarium* and the German *Seminar* interchangeably. I translate both terms, consistently but perhaps a little anachronistically, as *Seminary*.

17. Knackstedt, "Marienmünster," p. 574.

18. After VI, Ess mixes roman and arabic numerals.

19. "Da die Aebte seit 30 Jahren kaum für 100 r. Bücher in die Bibliothek angeschaft haben, selbst diese in verworrenem schlechten Zustande, und Mangel an allen neueren Schriften ist, so muß jene geordnet, und dieser Mangel gehoben werden, wozu der Regens die Vollmacht erhält, neue Bücher maßgeblich nach des Seminars leidenden Einkünften anzuschaffen." Granted that recent abbots have had no interest in the current literature of theological studies, the records of the secularization process do not indicate the extent of Marienmünster's library, for they only record that the archives were in disarray: "Die zum Archiv gehörigen Dokumente, Kopialbücher [etc.], 'welche in höchster Unordnung in einigen Wandschränken der Abteiwohnung lagen', wurden am 6. April vom Abt übergeben. Die Kommissare schickten sie nach Paderborn. Ein

Verzeichnis der Handschriften und Bücher war nicht vorhanden" (quoted by Richter, *Preussen . . .* , p. 109; see also Knackstedt, "Marienmünster"). Albeit small, outdated and ill-preserved, the Marienmünster library held a number of books and manuscripts. Ess's sale to Phillipps included some remnants, both manuscript and incunabula. On the manuscripts, see Sigrid Krämer, *Die Handschriftenerbe des deutschen Mittelalters,* 2 vols. (consecutive pagination), Mittelalterliche Bibliothekskataloge Deustschlands und der Schweiz, Ergänzungsband I [Munich: C.H. Beck, 1989], p. 560. I have discovered a number of books from Marienmünster among the incunabula at the Huntington Library in San Marino, California, that once belonged to Ess (of which Phillipps had printed a list): "Catalogus Incunabulorum Professoris et Doctoris Theol. L. van Ess, Darmstaelt [sic]. Nunc in Bibliothecâ Phillippicâ deposit." (I am preparing a study of these books.) It remains unclear how much of the collection at the Burke Library, Union Theological Seminary, is from Marienmünster, but Ess evidently implied when he sold the books that many if not most of his books came from Marienmünster. Thomas McAuley, first president of the seminary, related his understanding of the origins of the library (presumably received at first or second hand from Ess), as follows: "This collection of books was commenced in the Monastery of Saint Mary, in Paderborn, in Westphalia, during the time of the Reformation. At that time, the writings of the Reformers, and those of their opponents were colected by the monastery, and kept in a room, the door of which bore the inscription, "PROHIBITED BOOKS," the key of it being kept by the Superior of the Society of Monks. When the King of Prussia issued his edict for the suppression of monasteries, the monks divided among themselves the moveable property of their institutions, and Dr. van Ess, who had, in the Monastery of St. Mary, the charge of the "Prohibited books," took them as his share in the division. Thus there came into his possession this cabinet of rare works, containing, among others, at least 500 productions that bear the name of Luther. One must make some allowance for Ess's salesmanship in reading this account, but a full survey of surviving books from Ess's collections will help to recover some sense of the library's scope. Ess makes a further reference to the monastery's books and his access to books while at Marienmünster in the preface to the second edition of

Auzüge über das nothwendige und nützliche Bibellesen (Sulzbach, 1816), p. viii, where he is apologizing for his failure to give full citations of the works from which he quotes: "Wenn ich aber die Editionen jener Bücher nicht immer bestimmt angegeben, so wolle man gütigst Entschuldigung darin finden, daß ich ehemals, als ich bei meinem stillen literarischgeschäftigen Klosterleben, wo ich diese und viele andere Auszüge sammelte, nicht ahnete, dereinst öffentlichen Gebrauch davon zu machen, und deßhalb die Bemerkung der Editionen mir von weniger Wichtigkeit schein, die mir aber nachher nicht mehr zur Hand standen" Thus, clearly many of the Marienmünster books were no longer available to Ess after 1803.

20. For an unsympathetic view of the matter, see Wöhrmüller, "Litterarische Sturmzeichen."

21. See, again, § VI.4: "Den jüngern Geistlichen, die für ihr eigen Geld sich Bücher anschaffen mußten, und sehr viele angeschaft haben, muß für alle gute und nützliche Bücher das Geld vom Seminar zurüchgegeben werden, die denn vom dem neu anzustellendem Bibliothekar der Bibliotheck einregestrirt werden und unveräußlich dem Seminar verbleiben."

22. See note 8, above.

23. According to the title page of 1816, BFBS No. 4273. 2nd ed. (first from Sulzbach), 1810, not recorded in the United States or Britain, not seen.

24. BFBS No. 4294. I have examined a copy at the American Bible Society, New York (hereafter, ABS). According to Darlow and Moule, *Historical Catalogue*, 2: pp. 517-518, this version was revised to conform to the Vulgate.

25. BFBS does not have the 4th ed. of 1817 or the 5th of 1819; the copy of the latter at ABS lacks the title page, but the new approbations for this issue are to Leander alone.

26. Page following p. 460: "Ich erwähne, daß, wenn ich den griechischen Text nenne, ich den critisch berichtigten bessern verstehe."

27. BFBS No. 4330.

28. BFBS No. 4355. There were two versions of the complete Bible in 1840. BFBS No. 4361 was translated from the *Grundtext*. No. 4362 added an apparatus of translations from the Vulgate. In both, the NT was translated from the Vulgate with notes on variants in Greek

at the foot of the page. (The preface to the *Psalmen* [1827] makes it clear that this scheme for Bibles suitable for Catholics and Protestants was integral to an ecumenical publishing scheme.) Ess always insisted, however, on printing the apocrypha, which his British patrons could not support. When BFBS acquired the rights to the Ess Bible from his family after the death of Professor Wetzer (Gundert, *Geschichte*, pp. 94-95) in 1853, the apocrypha were dropped, as were the Vulgate readings for the OT; the NT continued to be presented as in 1840. (I have seen editions at ABS dated Sulzbach, 1877, and Vienna: Britische und Ausländische Bibelgesellschaft, 1964—the latter even retaining all but the royal Bavarian approbations of 1807-26 for the NT.)

29. See William Canton, *A History of the British and Foreign Bible Society*, vol. 1 (London, 1904), pp. 423-41, and Richard B. Cox, Jr., "The Nineteenth Century British Apocrypha Controversy," (diss. Baylor University, 1981), pp. 188-94. This is not the place to discuss the matter, but (as Canton implies at p. 441) examination of the correspondence of Ess with the Society at the end of his formal relationship with them at the end of the 1820s shows that the efficient cause of the rupture may have been as much personal as doctrinal—a fact the Society was at some pains to conceal because of the generally kindly disposition of its leadership to Ess. (The archives of the Society are now on deposit at the University Library, Cambridge.)

30. Bielefeld, 1808.

31. On the conflict over Ess's New Testament, see Adler, "Ess und seine Übersetzung," pp. 20-24; Alex. Schnütgen, "Zur Vorgeschichte der Indizierung Leanders van Eß im Jahre 1821," *Theologie und Glaube* 5 (1913): 627-33; Wilhelm Auer, "Leander van Ess: eine bibelgeschichtliche Studie," *Bibel und Kirche* 14 (1959):66-73; and Gundert, *Geschichte*, pp. 82-95.

32. Johann Michael Sailer, *Briefe*, ed. Hubert Schiel, 2 vols. (Regensburg: Verlag Friedrich Pustet, 1952), 2:294-5; the original of the letter to Ess is at Affolterbach, and it is also printed in Fischer, "Leander van Ess," pp. 77-8. On Sailer, sometimes classed as a figure of the Romantic movement, see Dru, pp. 41-7; Goyau, 1:251- 310; and Thomas Franklin O'Meara, *Romantic Idealism and Roman Catholicism: Schelling and the Theologians* (Notre Dame: University of Notre Dame Press, 1982), pp. 40-7.

33. Fischer, "Leander van Ess," p. 79, quoting a passage I do not find in the Sailer *Briefe*. It begins, "Die unternehmungen des van Eß gefallen mir ausnehmend gut; nur seine Uebersetzung nicht." Perhaps it was with Sailer's encouragement that Ess changed his earlier expressions, *wahrer Frömmigkeit/Gottwohlgefälligkeit*, to the Lutheran expression, *Gerechtigkeit* in the translations from the Pauline literature (Fischer, pp. 80-1).

34. The latter is from *Das Heiligthum der Menschheit für gebildete und innige Verehrer desselben* (Munich). A copy with variant title, dated 1810, appears in the list in the Burke Library of books sold to New York as Nr. A1854.

35. The title is somewhat abbreviated: *Auszüge über das nothwendige und nützliche Bibellesen aus den heiligen Kirenchvätern und andern katholischen Schriftstellern, zur Aufmunterung der Katholiken*. At the back of the 1816 NT, Seidel added an "Anzeige" listing Ess's works in print and related publications.

36. The Burke Library has two copies: one bound with *Auszüge* and another anonymous work, probably by Ess, *Die Bibel, nicht . . .* (see below); the other in paper wrappers.

37. A French translation of *Auszüge* was published in Brussels in 1820 as *Extraits sur la nécessité et l'utilité de la lecture de la Sainte Bible, tirés des saints Pères et autres écrivains catholiques, pour l'encouragement des catholiques* ..

38. Pp. xiv-lxiv. Pp. xxxiv-xxxvi of the 1820 edition are a "Nachtrag" to "Gedanken"

39. The German translation, *Pragmatisch-kritische Geschichte der Vulgata im Allgemeinen, und zunächst in Bezeihung auf das Trientische Dekret: oder: ist der Katholik gesetzlich an die Vulgata gebunden?*, was published at Tübingen, 1821.

40. (Breslau, etc.). The work is attributed to Ess by H.E. Scriba, *Bibliographisch-literarisches Lexikon der Schriftsteller des Großherzogthums Hessen*, lst ed. (1831), rpt. in *Deutsches Biographisches Archiv*.

41. Ess is making use of books in his own collection, perhaps new acquisitions. He refers at p. 1 to his source: the edition of Chrysostomus by the Maurist "Bernhard von Montfaucon," which he identifies as Paris 1718, 1735. A68 and A69 of the collection sold to New York are copies of Montfaucon's Chrysostom, both in 13 volumes, published in Paris, 1728 [*sic:* 1718-38] (A69, from

Guldern: "Bibliothecae Bae. M, de Aureâ valle") and Venice in 1734[-41] (A68).

42. I have seen only the second ed. with additions (n.p.,1825). The volume begins with an accounting that acknowledges grants from the British and Foreign Bible Society and gifts ("Milde aus England/Gaben), totalling *fl.*327.264.25 to October 1822 and the distribution of 513,099 copies of his NT plus over 10,000 copies of other versions of the NT and almost 12,000 Bibles.

43. *Die katholisch-theologische Fakultät in Marburg: ein Beitrag zur Geschichte der katholischen Kirche in Kurhessen und Nassau* (Marburg: N.G. Elwert, 1905), at pp. 1-14, and *Der Kampf um die Elisabethkirche in Marburg: ein Beitrag zur Geschichte kirchlicher Simultanverhältnisse* (Marburg: Quelle & Meyer, 1912) (also published in *Aus Deutschlands kirchlicher Vergangenheit* [Festschr: Theodor Brieger] [Marburg, 1912], pp. 223-88). Fischer also gives an account of the Marburg period ("Leander van Ess," pp. 81-90).

44. A number of his sermons survive at Affolterbach; they merit some attention, perhaps even an edition.

45. See R. Lill, "Cologne, Mixed Marriage Dispute in," *New Catholic Encyclopedia*; Goyau, *L'Allemagne Religieuse*, 2:142-201.

46. (Cologne, 1821).

47. See Fischer, "Leander van Ess," p. 87, on Ess's practice of communicating Protestants in two kinds in his work at a military hospital in Marburg.

48. *Index*, p.392, s.v. *Rechtfertigung*. In fact, this work was indexed on 17 December, two days before the New Testament translation, and its notoriety may have inspired the action against the scriptural translation. 49. Fischer, p. 88. Fischer believes, probably correctly, that the furor over the publication of this work was the occasion for Ess's resignation from Marburg.

49. Fischer, p. 88. Fischer believes, probably correctly, that the furor over the publication of this work was the occasion for Ess's resignation from Marburg.

50. *Ueber die gemischten Ehen. Oder: Ist es ein allgemeines katholisches Kirchengesetz, daß bei gemischten Ehen die Kinder katholisch werden müssen? Verneinend beweisen, und zunächst gegen das Rundschreiben des apostolischen Vicars, Herrn* Dammers *in* Paderborn, *gerichtet; nebst einer practischen*

Anweisung, wie das Brautpaar kirchlich legal die gemischte Ehe eingehen könne, wenn der katholische Pfarrer die Proclamation und Copulation weigert (Stuttgart, 1827). One evidence for the authorship is that a number of copies of the title page (with quotations from Bernard, Leo I and Cyprian on the verso) are to be found in the Heidenreich archive at Affolterbach. I owe a microfiche copy of this booklet and of the 1821 *Gemischte Ehen* to the kindness of Johannes Altenberend.

51. Later (1841-1844) to be bishop of Paderborn, Dammers had been rector of the university from 1803 to 1819 and General-Vicar of the diocese from 1803 to 1826; he was consecrated suffragan bishop in 1824 (Diözese Paderborn, *Real-Schematismus herausgegeben und verlegt vom Bischöflichen General-Vikariate* [Paderborn: Bonifacius- Druckerei, 1913], p. 92).

52. See Mirbt *Fakultät zu Marburg*, p. 6. The scope of the holdings of Ess's library in canon law testifies to the depth of his engagement with this aspect of his calling in Marburg.

53. "Möchte es doch den katholischen und protestantischen Regenten in Deutschland gefallen, einmal eine durchgreifende gesetzliche Maßregel zu fixiren gegen der Art Neckereien und Unduldsamkeiten bei gemischten Ehen, die das glückliche Familienleben, und dadurch selbst den Staat erschüttern und schwankend machen" *(Über die gemichten Ehen,* p. 88).

54. Adler "Leander van Ess," p. 17, speaks (I would think unassailably) of Ess as a man "der in seiner Bedeutung und seinem Erfolg als Übersetzer der Bibel nur von wenigen, warscheinlich sogar nichte Martin Luther übertroffen wird."